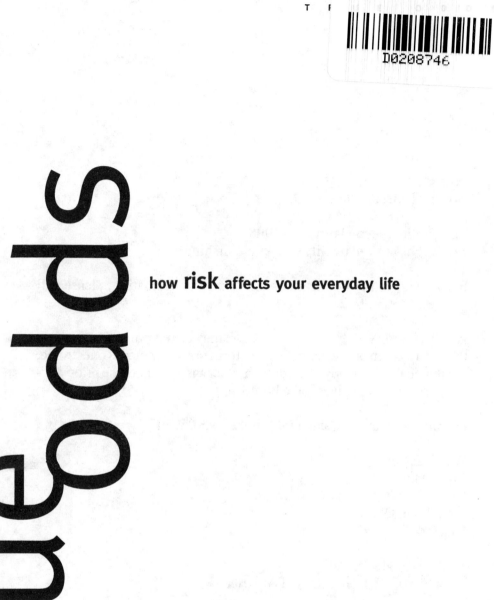

true odds

how **risk** affects your everyday life

by
james walsh

SILVER LAKE PUBLISHING

True Odds
How risk affects your everyday life

First edition, second printing, 1998
Copyright © 1998 by Silver Lake Publishing

For a list of other publications or for more information, please call
+11 (323) 663-3082.

Library of Congress Catalogue Number: 95-079500

Walsh, James
True Odds
How risk affects your everyday life.
Includes index.
Pages: 401

ISBN: 1-56343-114-9
Printed in the United States of America.

acknowledgments

Most books about the role of risk in everyday life are either dense technical volumes or daffy oversimplifications. My goal in this book has been to apply the complex tools of risk assessment and management to ordinary issues that we all face.

As a result, *True Odds* was a big project—both in terms of information-gathering and analysis. I have many people to thank for their help.

The staff at Merritt Publishing has been hugely helpful, as always. Luisa Beltran, Amy Gordon, Pat Sheppard and Ericka Weeks all did reporting that made the technical detail of the book possible. Cynthia Chaillie, John Hartnett and Linda Lagerstrom all offered useful editorial suggestions. Simone Hirzel and Ginger McKelvey have made the edit and production process run smoothly. Kathie Baumoel helped put together the final package.

There have been so many people who've offered facts or insight that I can't name them all here. I've tried to credit everyone appropriately in the course of the book.

Specifically, I have to thank John Graham of Harvard University, Sam Peltzman of the University of Chicago and John Stossel of ABC News for reading a draft version of the book and offering their thoughts.

Finally, I have to thank James MacKinnon Walsh. His arrival started this whole process.

James Walsh
November, 1995

contents

True Odds

How risk affects your

everyday life

introduction

The Nature of Risk

The origin of this book traces back to a personal experience.

In early 1994, my wife and I were expecting our second child. We'd been members of a big, California-based health maintenance organization for a short time and had some hesitations about the level of attention she would receive from an HMO during a pregnancy.

But my wife was healthy and our first child—a daughter—had been born healthy and happy, with no problems. So, we figured things would go smoothly.

A few months into the pregnancy, we got some disturbing news. A routine ultrasound scan of the baby indicated that its kidneys were slightly enlarged. *Dilated* was the technical word.

My wife was referred to the HMO's critical pregnancy unit, where a second ultrasound was done. A few days later, we went in to meet with one of the doctors on the critical pregnancy staff.

The silver-haired woman looked nervous as she told us that the staff was concerned because dilation in the kidneys could mean a number of things.

It could simply mean a slight physical problem—the valve between the kidneys and bladder wasn't closing all the way and urine was

backing up. This condition posed a slight risk of infection, but nothing dire. It would probably clear up by itself.

It could also mean the child had Down's syndrome, a genetic condition that includes mental retardation and short life expectancy.

Specifically, the doctor said that dilated kidneys reflected an elevated rate of incidence of Down's syndrome. While she couldn't recommend a course of action—the HMO's policies prohibited that—one course of action would be to perform an amniocentesis to determine for certain whether the child had Down's syndrome.

She suggested that amniocentesis was the safest response. To us, it seemed dangerous.

Amniocentesis is a test in which doctors extract a small amount of amniotic fluid from a pregnant woman's womb. The fluid can then be tested to determine the genetic condition and gender of the child. The test is commonly given to pregnant women older than 35, because their children are generally more susceptible to genetic problems. My wife was just 30, though, and not part of the normal "amnio" risk profile.

We hadn't intended to have an amnio because, about two percent of the time, the test induces miscarriage.

So we had to get some more information and do some thinking.

Most of all, we had questions. What exactly did the doctor mean when she said the dilated kidneys reflected an increased chance of Down's syndrome? Were dilated kidneys a symptom of the condition? She hesitated to say anything that predicted anything.

We found out that the answer was no. The connection was correlative. That meant medical experts didn't think there was a direct symptomatic link between the two conditions—instead, the condition that causes Down's syndrome seems also to cause kidney dilation.

How strong was the correlative link between the enlarged kidneys and Down's syndrome? In our case, it wasn't very strong. Our baby's kidneys were slightly enlarged—several of the doctors we consulted had seen much more severe cases. Their consensus: The kidneys suggested a minute chance—less than 1 in 100—that the child had Down's syndrome.

After talking to a number of doctors and people we trusted, my wife and I told the HMO critical pregnancy staff that we would continue without an amniocentesis. The less than 1 in 100 chance of Down's syndrome seemed a better risk to take than the 2 or 3 in 100 chance of inducing a miscarriage of what was probably a healthy baby.

The staff at the HMO offered little information, encouragement or suggestion. We didn't talk to the nervous, silver-haired woman doctor again. But the others said they could only tell us the options available. They couldn't suggest any specific response. That was frustrating.

Other experts we talked to throughout the pregnancy generally agreed with our decision—though a couple told me they wouldn't have chosen what they considered a tough path.

At some points during the next several weeks, I also questioned the tough decision. Some days more than others, the 1 in 100 chance of the baby having Down's syndrome loomed large for me. My wife told me she felt the same way.

We were able to monitor the baby's development with monthly ultrasounds. While the kidneys didn't get any worse, they didn't get any better either. On all other counts, the baby progressed nicely.

At several points, other HMO doctors reminded us that we could choose an amniocentesis. But that issue quickly became moot. Even if the baby did have Down's syndrome, we were prepared to welcome its arrival.

In late July of 1994, when my wife went into labor, we felt the same edgy excitement we'd felt when our daughter had been born. We'd

lived with the 1 in 100 chance of a problem long enough that it had become one more risk in a risk-prone process.

I took my wife to the hospital in the early morning of July 26. About nine hours later, our second child—a son—was born. He was just under ten pounds, crying furiously and perfectly healthy.

The kidney dilation turned out to be a slight mechanical problem. He stayed in the hospital one night for observation, took antibiotics for a few months to prevent any infection and never looked back.

In the days after our son was born, two things occurred to me. First, we had to get out of the HMO. Second, in an age of massive electronic information, decentralization and professional services sold like commodities, people have to make all kinds of essential decisions by themselves.

SOME BACKGROUND

The object of this book is to explain the basic concepts of risk and how they influence your everyday life. In a world where fast-moving information is the currency, traditional notions of safety and security are as outmoded as dictaphones and three-martini lunches.

In the post-industrial world, people are free agents—in their work lives and their personal lives. This allows them great freedom, but it also exposes them to larger levels of personal and professional risk. The odds are you don't have a corporate employer or big family living under your roof to help you absorb a personal or professional loss.

You probably have to fend for yourself, which means you have to be able to identify, assess and manage risk.

Businesses, government agencies and people who understand risk are able to make decisions and respond to news fast and well. To some extent, they'll even manipulate risk issues to their advantage. Insurance companies structure policy premiums to cover their costs

and exclude situations they don't like to face because they understand risk. Government agencies propose rules and regulations that assure their own importance because they understand risk. Industry groups and consumer groups publicize friendly research because they understand risk.

And all of this affects you. So you need to understand risk and how various interest parties use it.

Risk analysis is a broad term that refers to a variety of analytical tools, including: risk assessment, risk characterization, comparative risk assessment, risk ranking, risk based priorities, risk-benefit analysis and cost-benefit analysis.

A one-in-a-million risk means that in every million people affected, one will die. That's on the average, however, and averages don't tell the whole story. The calculations can be very rough and uncertain. Most risk experts prefer to consider relative risks.

Relative risks and odds ratios are the same thing. They both compare the odds that something will happen to a specific group with the odds that the same thing will happen to an entire population. Relative risks are in positive numbers—like 0.8 or 5.3—that mean the specific group is that many times more or less likely than the entire population to have the kind of experience in question.

Risk estimates aren't ever exact—and, as we'll see, they're susceptible to various and conflicting interpretations. Still, risk theory offers the best way to minimize loss of life and limb.

IMPORTANT RISK TOOLS

You don't have to be a mathematician or even mathematically inclined to use this book. It's structured in four parts, each relating to some part of the risk management process:

1) how information is gathered,

2) how results are analyzed,

3) how analysis is interpreted, and

4) how response is influenced.

Within each section, separate chapters use events of current interest to illustrate some aspect of the identification, assessment and management process. These events range from the off-beat (the cellular phone cancer scare, the Ebola virus) to the mainstream (second-hand tobacco smoke, breast cancer). They should be as interesting as they are informative.

In the process of all this analyzing, this book aims to debunk bogus conventional wisdom about the dangers that we face in life. One of the most frustrating things about the way risk is used in public debate is how misleading information (for instance, the common assumption that 1 in 9 women will get breast cancer) becomes accepted truth.

In this sense, this book should be a feast for people of skeptical and inquisitive nature. It offers not only tools for deciding how to choose life insurance, politicians and diets—but also tools for deflating the pompous bore at a cocktail party who's certain that driving from L.A. to Chicago is safer than flying.

Two of these tools are worth mentioning right away. They apply to almost all risk issues.

First, it's important to remember that correlation is not the same as causation. Separating the two is a key constant effort in risk analysis. To some people, a newspaper headline that reads "Bottled water linked to healthier babies" might seem to suggest that bottled water actually makes kids healthy. But it doesn't. A more likely explanation: Wealthy parents are more likely to drink bottled water and have healthier kids because they can afford better care.

Second, one of the most important planks of risk theory is the law of large numbers. The mathematical law provides a key connection between theoretical probability and observed results of random processes.

In repeated, independent trials of the same experiment, observed results approach the theoretical probability.

It follows from the law of large numbers that if you repeatedly take bad risks—or play unfavorable games—though you're uncertain of the results of any given outcome, in the long run you'll be a loser.

PERCEPTIONS OF RISK

How people perceive a risk can affect chances of loss as much as hard numbers can. For example, a one in a million risk of mortality is so small it can barely be measured in most situations. But it can have a big impact.

When European terrorism reared up in 1986, 2 million Americans changed their travel plans. The reality, of course, was that most of these people could have done a lot more to enhance their life expectancies by losing 10 pounds and going to Europe as planned.

Conventional risk estimates downplay the kinds of catastrophic risks that fill the nightmares of ordinary Americans. That's because people worry a lot about disasters that may never occur, such as massive radioactive waste spills or genetic technology ran amok.

Most of the urgent issues people face in their lives have to do with common risk—the chance of losing something of value or of suffering some ill effect.

In an affluent society, people are more concerned with what they might lose than with what they might gain. But the explosion of information in this affluent society has thrown conventional notions of opportunity and risk into confusion.

As we try to insulate ourselves from the dangers posed by a dangerous world, we've seemed to surrender our ability to handle the chances of loss which are unavoidable. So, despite their access to data, a shocking number of people have a bad sense of risk.

People need to identify, prioritize and manage the risks they face in life. But they often ignore serious risks (driving, having heart dis-

ease) and obsess about trivial ones (pesticides, breast implants, flesh-eating bacteria).

Some experts in risk analysis call this response statistical homicide—the triumph of long odds over common sense. In other words, the risks that kill people and the risks that scare people are different. Behind these misperceptions is a wealth of information about how and why Americans are willing to take some risks and unwilling to take others.

Statistics are numbers that carry information pertaining directly to samples and indirectly to populations.

MISPERCEPTIONS OF RISK

Vincent Covello, an academic at the Center for Risk Communication at Columbia University, has written "strong beliefs about risks, once formed, change very slowly and are extraordinarily persistent in the face of contrary evidence."

This is because our notions of risks reach deep into mankind's evolutionary history. The so-called "fight-or-flight" instinct that dominates the basic impulses that all people feel is a crude version of risk assessment. It works on a gut-instinct level.

On the other hand, technical experts have a different approach to risk assessment. They focus on how likely it is there will be a harmful reaction, and if it happens how bad it will be. Something could have very serious consequences—but if it is judged to be very unlikely, it is not seen as a serious risk.

Most people seem to be more superstitious.

We are warned about benzene in our Perrier, Alar on our apples, and asbestos in our school buildings. The truth: The benzene in Perrier wouldn't have hurt you[1], the Alar scare was essentially fabricated and the asbestos in schools is least harmful if left in place.

[1] David Gaylor, head of biometry at the National Center for Toxicological Research, estimated the additional cancer risk of lifetime exposure to a 1-liter bottle of the contaminated Perrier every day for 70 years to be somewhere between 1 in 100,000 and 1 in 10 million. So, if every American were to drink a liter of contaminated Perrier every day from birth to death, there might have been a couple of hundred extra deaths a year.

A 1994 *Los Angeles Times* poll found that people's "feelings about crime" were based 65 percent on what they read and see in the media and 21 percent on experience. The truth: If you're not an inner-city resident engaged in crime and carrying a gun, your chance of being murdered is probably no greater than it was 25 years ago.

Most people think their chances of dying of a heart attack is about 1 in 20. The truth: It's closer to 1 in 3.

People also figure the odds of dying in an auto accident during a given year are about 1 in 70,000. The truth: The real figure is 1 in 5,000.

By underestimating common risks while exaggerating exotic ones, we end up protecting ourselves against the unlikely perils while failing to take precautions against those most likely to do us in.

SENSATIONALISM IN THE INFORMATION MIX

People often perceive risk by their ability to control dangerous activities. They're usually less afraid of risks they think they control, and they're less afraid of risks that they understand. So, the things that people are most afraid of are things they can't control and don't understand.

If people can choose not to take part in certain activities, their perception of risk decreases.

Today, most media coverage of risk to health and well-being focus on shock and outrage. The media pays attention to issues and situations that frighten—and therefore interest—readers and viewers. It fills its coverage with opinions (usually from interested parties) rather than facts or logical perspective.

The shock-and-outrage approach can create interesting stories, but it doesn't help people assess risks. The fact that someone is upset about a loss they've suffered doesn't say anything about how likely the same loss is to happen to you.

As a result, we're scared—and often scared by the wrong things.

"Studies have shown that people get more information about risk and hazard from the media than they do from their physicians or anyone else," says Walter Willett, professor of epidemiology and nutrition at the Harvard School of Public Health.

Government decision-makers also get their information from the media more than any place else. So, the government is no better about assessing risk than the average person. It spends money trying to regulate risks that aren't really risky, while ignoring genuine risks. The EPA admitted as much in a 1987 report that said, "Overall, EPA's priorities appear more closely aligned with public opinion than with our estimated risks."

The popular media's focus on startling losses and colorful opinion misdirects people's attention toward trivial risks. We end up terrified of violent crime, crashing airplanes, and AIDS among drug-free heterosexuals—all tragedies, but rare ones.

Even when media attention turns to more likely risks, it often misses the important points. For example, many news stories involve charges that this chemical or that pesticide causes cancer. But Bruce Ames, a biochemist and molecular biologist at the University of California at Berkeley, says the three main causes of cancer are not the much-publicized pesticides or other chemicals developed since World War II, but "smoking, dietary imbalances and chronic infections."

Although media coverage invariably focuses on pesticides and other artificial chemicals, Ames says that one cup of coffee contains 10 grams of natural carcinogens—the amount the average American consumes in pesticide residues in one year. He argues that the average American ingests 10,000 times more natural pesticides than artificial pesticide residues every day.

The main reason the media bungles risk reporting: It's time-consuming, nuanced and long-range. As sociologists Eleanor Singer and Phyllis Endreny wrote in the technical journal *Risk: Health, Safety & Environment*:

To communicate information about hazards and risks in a way calculated to foster rational decision-making means providing detailed and precise information and immediate and long-term consequences, to weigh the costs and benefits of a hazard and its alternatives for the individual and for society, and to discuss the issues, moral and economic, that inhere in hazardous processes and events.

But reporting about hazards is ordinarily reporting about events rather than issues, about immediate consequences rather than long-term considerations, about harms rather than risks....

THE MISGUIDED HUNT FOR ZERO RISK

One of the most problematic offshoots of misunderstanding of risk is the idea that we can live risk-free lives. This idea underlies the attempts that so many people make to insulate themselves from the toughness of the real world.

The average intelligent person with a personal computer has access to virtually all the data people have ever gathered on any subject. But what does that person do with all that data? Which data does he or she even try to understand?

Modern technology has made it possible to detect tiny amounts of potentially harmful chemicals that would have eluded discovery in previous generations. This means the government can enact regulations to protect Americans from previously hidden dangers. But when this technological capability is combined with Americans' zeal for zero risk, the result can both distort the political process and disrupt the economy.

As Harvard professor John Graham has said, "We all want zero risk. The problem is if every citizen in this country demands zero risk, we're going to bankrupt the country."

The urge to live risk-free isn't new. Twenty years ago, the political pundit Henry Fairlie wrote that the desire for an existence free of risk is "one of the most debilitating influences in America today,

progressively enfeebling the economy with a mass of safety regulations and...threatening to create an unbuoyant and uninventive society."

Put in more practical terms, environmental engineers say 90 percent of the toxic material could be removed from many waste sites in a relatively reasonable time at a relatively reasonable cost. But in an effort to provide absolute safety, many years and tens of millions of dollars are often spent trying to remove the last 10 percent. Or the last 5 percent. Or the last 1 percent. Or the last 0.0001 percent.

"Removing that last little bit can involve limited technological choice, high cost, devotion of considerable [Environmental Protection] Agency resources, large legal fees and endless argument," Stephen Breyer wrote in his 1989 legal textbook, *Breaking the Vicious Circle: Toward Effective Risk Regulation*.

"EPA rules, regulating sources such as benzene storage vessels and coke byproduct recovery plants, save a total of three to four lives per year, at a cost of well over $200 million," Breyer—who has since been appointed to the U.S. Supreme Court—wrote. That's an average cost of more than $50 million per life saved.

In contrast, vaccinating toddlers against hemophilus influenza Type B (a leading cause of meningitis) would save lives at a cost of only $68,000 each.

The EPA isn't the only regulatory agency that indulgently seeks zero (or close-to-zero) risk. Groups as diverse as the Occupational Safety and Health Administration, the Nuclear Regulatory Commission and the Federal Reserve all have considered or enacted zero-risk policies in various guises.

In the mid-1990s, improving risk management techniques have become a hot topic in Washington, D.C. In February 1995, Harvard's John Graham talked to Congress about expanding the role of risk analysis in drafting regulatory laws:

> ...Each day Americans are confronted with new information about potential dangers to their health and safety: childhood leukemia

from exposure to electric and magnetic fields, male infertility from exposure to chlorinated chemicals, brain cancer from using cellular telephones, subtle neurologic effects in children who ingest house dust contaminated with lead paint, breast cancer from consuming fruits and vegetables with minute amounts of pesticide residues, non-Hodgkin's lymphoma from farmworker exposure to phenoxy herbicides in agriculture, premature death among the elderly from inhaling fine particles in outdoor air, aggravation of asthma from breathing smog in urban areas, heart disease from eating margarine and other sources of trans-fatty acid, nausea from exposure to [toxic fumes] in regions where reformulated gasoline is used, and lung cancer from exposure to environmental tobacco smoke.

News stories about these alleged dangers populate both the electronic and print media. In fact, there is a tendency for reporters to give special attention to potential hazards that are "new," unfamiliar, invisible, frightening, bizarre and mysterious. Less attention is given to more "routine"—yet widespread and deadly— hazards such as acute injury from motor vehicle crashes, falls, drownings, and violence in our homes and communities.

At the government level, the purpose of risk analysis is to provide information (including indications of how much confidence to place in the information) in a form that is useful to decision-makers. When this information is placed in a relative context, it can be useful in helping people decide which dangers deserve the highest priority and which can be safely ignored until better information is available.

This book aims to provide the same kind of useful context, so you can consider the risks you face critically and deal with them effectively.

TRUE ODDS

The title of this book comes from casino gambling. In the dice game craps, most bets give a slight statistical advantage to the casino. But, if you wager your money in the right way, the casino will give up its

advantage and let you bet on the plain statistical odds of various rolls.

In order to use this leveling device, you have to understand the game pretty well. That's true for life in general as well as games at a casino.

The key to understanding risk is the ability to compare and prioritize different potential losses. This is another way of describing the relative context of risks. It's the object of risk assessment.

Risk assessment shouldn't be foreign to anyone. When medical teams in a hospital emergency room use triage to make sure they treat the most severely injured or ill patients first, they are evaluating risks and assessing "costs" in their broadest sense. When family breadwinners borrow against a life insurance policy to pay medical expenses, they are doing the same thing. These are prudent, common-sense procedures for making difficult choices.

Risk estimates are typically calculated in one of two ways. Experts look at either the loss of average life expectancy that stems from an activity, or they measure the increased chance of premature death. The two methods—morbidity and mortality—present risk in different lights.

For example: The loss of life expectancy from being 20 percent overweight is 900 days; from radiation emitted by nuclear power plants, 0.02 days.

According to the Harvard Center for Risk Analysis, smoking one pack of cigarettes a day for 40 years gives a person a 13 percent chance of premature death. In contrast, the lifetime chance of premature death due to a multicar crash with a drunk driver is only 0.3 percent.

A number of technical distinctions mark these statistics. The estimate of loss of average life expectancy puts a higher premium on accidents that affect the young. That's because young people have the most life expectancy to lose. In this view, an 85-year-old women who dies in a car accident has lost nothing because she has already

outlived her original life expectancy (about 77 years). But a 12-year-old boy who drowns has about 63 potential years of life. This approach downplays the impact of diseases that take a long time to develop, such as many cancers.

The other approach—measuring the probability of premature death—places more weight on risks that tend to occur later in life. Such analyses put more weight on cancer and less on accidents.

People who can't find a way to compare risk effectively are more inclined to make bad decisions. A number of important miscues suggests that Americans, as a society, make these mistakes fairly often:

- Despite widespread concern about the number of crimes committed in the United States, FBI and Justice Department statistics show that the national crime rate has remained fairly level for 20 years. It even dropped slightly in the early 1990s. What has changed is the kind of crime being committed—it's grown more violent and more random.

- According to some studies, as many as three-quarters of older white women worry about being the victim of violent crime; black teens don't seem much bothered by that prospect. But the responses should be reversed. The odds of an older white woman being a violent crime victim in a given year are 1 in 370. For a black teenage male, the odds are 1 in 6.

- Statistics from the Centers for Disease Control make it clear that the media—which long ignored or underplayed the threat in the gay community—has overstated the threat in the general heterosexual community. AIDS remains confined, by an overwhelming margin, to gays, bisexuals and intravenous drug users.

- Although the number and percentage of heterosexual AIDS deaths have increased considerably in recent years—especially among women—only 6 percent of all adult and adolescent AIDS cases have involved heterosexual contact, the CDC says—and two-thirds of those involved are people who had sex with someone who already had (or was in a known

risk group for) HIV infection. Only 2.2 percent of AIDS cases have involved heterosexuals with no other known risk factor.

- We worry about planes, which kill about 200 people a year; we shrug off cars, which kill more than 40,000.

The relative odds of dying from hyped diseases and behaviors aren't often compared. Doing so, even in a basic format, begins to prioritize risks.

Consider the odds, over the course of an average life span, that you will die from:

the flesh-eating bacteria ... 1 in 1 million

pesticide poisoning ... 1 in 200,000

AIDS contracted in a blood transfusion 1 in 96,000

drinking water with EPA limit of chloroform 1 in 60,000

heart disease from eating a broiled steak a week 1 in 48,000

a lightning strike .. 1 in 30,000

cancer from eating a peanut butter sandwich a day ... 1 in 5,000

disease caused by drinking one beer a day 1 in 1,000

living with a smoker ... 1 in 700

cancer caused by an average number of X-rays 1 in 700

cancer caused by background radiation on nature 1 in 700

disease caused by indoor radon 1 in 440

murder, if you live in a big city 1 in 160

a home accident ... 1 in 130

disease caused by smoking one cigarette a day 1 in 100

disease caused by heavy alcohol consumption 1 in 100

a motor vehicle accident .. 1 in 60

disease caused by smoking a pack of cigarettes a day 1 in 6

If you don't smoke or drink heavily, these numbers should be pretty encouraging. On average, you're thirty times more likely to be struck by lightning than contract AIDS from a blood transfusion. And you're 1,400 times more likely to die because you live with a smoker than from the sensationalized flesh-eating bacteria.

If you smoke a pack of cigarettes a day, though, you're playing a slow form of Russian roulette.

In fact, nine of 10 premature deaths are linked to one of six behaviors. These are:

- smoking cigarettes,
- overeating,
- misusing alcohol,
- failing to control high blood pressure,
- not exercising, and
- not wearing seat belts in cars.

But even comparing numbers like these invites various caveats and qualifications. As we've seen, statistics having to do with dying focus on one of two factors—morbidity or mortality.

Also, some people might question the various sources that provide these numbers and the manner in which they gathered the data. (That last point—the nagging matter of methodology—is a central debate in risk management.)

We'll look at technical arguments throughout this book—and some of these arguments are pretty interesting. But a person trying to make a smart decision about risk has to see past technicalities.

In my experience researching this book, some people who object to risk assessments on technicalities don't want comparative assessments made at all. The fact is that, as a decision maker, you have to find a point at which you're satisfied that the information you have is reliable. And then you have to make your decision.

It's this pragmatic approach that many people refer to as a tough decision. Others think of it as simply being harsh. A good example of this supposed harshness came in a May 1995 *Time* magazine opinion column by political commentator Robert Wright:

> Of all the grim facts surrounding Oklahoma City, perhaps the grimmest is the one nobody talks about: against the backdrop of everyday American tragedy, 167 deaths is not many.... In a typical year, guns kill 38,000 Americans and about that many die on our roads. These numbers routinely go up or down 2 percent or 3 percent—half a dozen Oklahoma bombings—without making the front page.

> ...a single explosion scares people more than the background noise of highway death.

The great U.S. Supreme Court Justice Oliver Wendell Holmes made the same point in another way: "Most people think dramatically, not quantitatively."

The difficulty of evaluating risk is that it requires us to think quantitatively. We have to see beyond the visceral intensity of the Oklahoma City bombing to the dramatic but more lethal number of auto accidents. We have to find data we can trust in order to realize that the chances are better of being struck by lightning than getting AIDS from a blood transfusion. We have to keep asking questions until we find out that having an amniocentesis test poses a greater threat to a baby than a condition correlative to a disease.

Getting the true odds takes work—some of it tedious. But true odds are the best bet we have.

How information is gathered

1

1

Who's most likely to contract AIDS?

The most intense risk issue to emerge over the 1980s and 1990s is Acquired Immune Deficiency Syndrome. AIDS systematically erodes the human body's ability to fight infection and illness, leaving its victims to die from diseases which would not normally be lethal.

AIDS is communicable. Generally, it moves through the exchange of certain bodily fluids—primarily blood and semen. However, the specific mechanics of how it travels from person to person is a matter of dispute.

AIDS has publicized and politicized the conduct of scientific research. Many of these changes are profoundly disturbing to the research community, not merely because they challenge ingrained patterns, but because they strike at the scientific method itself.

Most health experts believe that the Human Immunodeficiency Virus is the means by which AIDS moves through a population. In this scenario, people contract HIV, which lays dormant for some time before it grows into so-called "full-blown" AIDS.

Some experts disagree with this scenario, though. Experts also disagree over exactly how easily AIDS can be spread from one person to another.

These disagreements have become highly politicized and partisan, which makes them a great example of how partisans use different approaches to risk identification to make political points.

The politics of AIDS reaches to the most basic level of risk assessment: information-gathering. If you disagree with or can't trust the way information is assembled, you can't make systematic decisions about risk.

In September 1994 congressional testimony, Centers for Disease Control and Prevention Associate Director Helene Gayle plainly stated the political element of AIDS research:

> Although we all know race and ethnicity are not risk factors for HIV transmission, they are markers for underlying social, economic, and cultural factors and personal behaviors that affect health. Low socioeconomic status in particular is associated with morbidity and premature mortality; unemployment, poverty, racism, and illiteracy can be barriers to accessing health education, preventive services, and medical care, resulting in an increased risk for disease.

This statement combines the language of risk assessment and management with the language of hot-button politics. And its message is weighted more toward the hot-buttons than the risk assessment.

Gayle's goal was to convince members of Congress to continue funding of CDC programs for AIDS education in the economic underclass. Her pitch needed to sound scientific as well as sociological—which it certainly did.

But Gayle's pitch doesn't tell people the thing they most want to know: The odds they'll contract AIDS in the ordinary course of their lives. That information is harder to find, hidden behind various debates over funding, scientific methodology and social policy.

AIDS has become an example of how the specialization of risk analysis and public policy interests can work against a population as a

whole. AIDS research and policy is so politicized and fragmented that reliability becomes an issue in many studies.

Calculating the odds of a given person contracting AIDS is difficult because the reliability of AIDS information remains unclear. AIDS policies, education and study are so politicized, you have to take everything you hear or read with a dose of skepticism and inquiry.

SOME BACKGROUND

AIDS was first described as a cluster of rare cancers and infections in otherwise healthy homosexual men. In the United States, 58 percent of all AIDS cases reported through 1995 have been among homosexual or bisexual men, with another 8 percent who are also injection drug users.

In early 1995, the CDC reported that among all Americans the AIDS epidemic was stabilizing at a 3 percent annual increase.

Up to 20 million individuals may be infected with HIV worldwide by the end of 1995. About 6.4 million will have developed AIDS, more than in the entire previous decade. Based on information from a 1993 study by the Harvard AIDS Institute, the number of people infected with HIV may climb to 100 million in the year 2000. In that scenario, 1 million adults will die each year from AIDS, and another million HIV cases will be reported.

But projections on AIDS infection rates are sometimes exaggerated.

In May 1994, the Centers for Disease Control released a study estimating that one in 250 people in the United States was infected with HIV. However, later that year, the CDC lowered that estimate to 1 in 300.

The reduction reflected some sensationalism in the way in which preliminary AIDS information was gathered. The CDC had based its earlier number on a mathematical model extrapolating from so-called "pilot sentinel studies." These studies draw from data col-

lected from progressive hospital AIDS programs and clinics. Like the CDC official testifying before Congress for funds, these facilities have every incentive to aim high in their initial findings and projections.

The 1994 figures came on the heels of a year in which the CDC changed its definition of AIDS. The definition had been a list of named diseases. If a person who'd tested positive for HIV came down win one of these diseases, he or she had AIDS. The CDC expanded the list of diseases and added a second criterion: If an HIV-positive person's white blood cell count fell below a certain level, he or she had AIDS—even without any disease. The expanded defition added more than 85,526 to the CDC's count of AIDS patients.

Comparing the rate of growth in any statistic from one year to another tends to be volatile and therefore a tactic that activists of one sort or another use. If a growth rate in one year is 3 percent and the next it's 4.5 percent, the increase doesn't sound horrific. But 4.5 is 150 percent of 3—and that sounds more dramatic. (This is a common trick politicians use when talking about government budget items.) A more useful number is the real growth over several years from a consistent base.

The CDC reported that from 1990 to 1995 AIDS grew steadily, at a rate of between 3 and 5 percent a year. The number is disturbing but not explosive.

This information says something about how quickly AIDS has grown as a disease. It still doesn't say very much about who's most likely to contract the disease—that's an issue best addressed by considering various risk groups.

In December 1994, Anthony Fauci, director of the National Institute of Allergy and Infectious Diseases, went on a television talk show to talk about the state of AIDS. He summed up the status:

> It used to be upwards of 90 percent of the people getting HIV...were gay men. And most of them were white gay men. Now we're

looking at a situation where the highest incidence new infection group are black males. White American males have an incidence rate of infection of AIDS of 30 per 100,000; but for black males, it's 266 per 100,000.

We're seeing a greater and greater shift demographically away from the old paradigm of the gay community transmission—not to say that's stopped, but proportionately more and more of it is occurring in the communities of poverty, in communities of color, in communities associated peripherally with intravenous drug use.

Notice that he said that the highest rate of incidence of AIDS has shifted from gay white males to black males. But the numbers he offers compare black males to white males—they don't say anything about gay males.

He gives the recent rates of incidence for white males (1 in 3,333) and black males (1 in 370). They do look dire for blacks—though other studies pegged the number among black males at nearly half that rate.

But what is the recent rate of incidence for gay white males, the group to whom he made the initial comparison? Why didn't he offer the rate of incidence to compare gay men to blacks and whites?

Which begs the question: How does Fauci know that the risk has shifted from gays to blacks?

This lack of clarity undermines the credibility of all of Fauci's statements.

That credibility is further undermined by the rate of incidence tracked per 100,000 people in a group. That basis tends to exaggerate the number in most people's minds. The odds of something happening being 30 in 100,000 sounds far more ominous than 1 in 3,330.

DATA RELIABILITY AND VALIDITY

Data reliability is one of two important parts of how risk information is gathered. The reliability of a statistic is determined by its variability. The smaller the standard error, the more reliable a statistic is.

The two important ways of describing a statistical sample are by its central tendency—which indicates the general level of the scores—and by its variability—which tells the extent to which individual scores deviate from that tendency.

If you're interested in measures of central tendency, the mean average is the statistic that meets your requirements. The mean is also a companion to other stable statistics. In fact, it is a prerequisite for calculating many of them.

In most situations, a standard deviation is the most stable measure of variability.

The standard deviation is a kind of average of the individual deviations from the mean of a group of numbers. The mean of the squared deviations is called the variance—and the standard deviation is the square root of the variance.

Some samples are easier to evaluate than others. One of the reasons that the spread of AIDS serves as a good example of risk assessment is that the data relating to the disease has been carefully gathererd. The information is reliable—even if the conclusions certain people make about it aren't.

In addition to reliability, the other important aspect of risk information is validity—which is usually defined as the accuracy in the estimation of a measure of effect.

Another important point about the reliability and validity of data: Although correlation is a necessary part of causation, it isn't sufficient to establish causation. This is an observation that applies to all kinds of risk issues.

People who design research studies usually distinguish between correlational and experimental studies. Most correlational studies are interested in relationships among variables that occur naturally—that is, without the intervention of the investigator.

As John L. Phillips writes in his book *How to Think about Statistics*:

> If there is a unique entity called "poverty" that can be measured, and if there is another unique entity called "intelligence" that can also be measured, then an investigator can examine the relationship between poverty and intelligence and report a numerical link.
>
> If there is a link, then the investigator can make an inference about a correlation between poverty and intelligence—but he can't make a causal link.
>
> Traditionally, experimental tests are designed to test causality. An investigator will manipulate poverty within a controlled environment, he might be able to establish a causal link between it and intelligence.
>
> The object of maintaining this test in a controlled environment is that it assures that no indepedent variable affects the outcome of the test. If it does, the test loses its validity.

Despite the fuzziness of some official risk assessments, there's enough data to make some useful observations about AIDS. And there's certainly enough to consider how methods of information-gathering affect risk assessment.

Drawing from statistics provided by the CDC, National Institute for Allergy and Infectious Disease and other government agencies, here are the chances that members of various sub-populations would contract AIDS in 1993:

Residents of the U.S. about 1 in 3,000

Asian-Americans ... about 1 in 8,330

Native Americans ... about 1 in 4,160

White people .. about 1 in 3,330

Hispanic people ... about 1 in 1,110

Black people ... about 1 in 620

Gay men .. about 1 in 245

Because the spread of the disease is influenced most by behavior, the controlling factor in sorting out who's most likely to contract it is what they do. As University of California AIDS research chief Peter Lurie has written, "[AIDS] is one of the few important infections where the maintenance of relatively few behavioral measures could substantially reduce or even eliminate the risk of becoming infected."

For this reason, we'll start by considering behavioral risk groups. Then, we'll test the advice of experts like Helene Gayle and Anthony Fauci and consider risk groups based on race, gender and economic status.

MALE HOMOSEXUALS AND BISEXUALS

Homosexual communities in the United States and other developed countries have worked hard to educate and encourage their members in the ways of minimizing the risk of contracting AIDS. However, the most likely way to contract AIDS is to be a man who has sex with other men.

The rate of growth of AIDS among the U.S. population of male homosexuals and bisexuals has fallen since the mid-1980s. Annual incidence rose at rates between 43 percent and 113 percent from 1984 to 1986. By the early 1990s, the growth rate had dropped to less than 10 percent a year.

That's a hopeful trend—but it still means the number of new cases diagnosed each year is growing. That may surprise people who remember reading that the number of gay men with the disease was shrinking. A number of newspapers and TV news reports portrayed the slowing of the growth rate as though it were a drop in the real number of cases reported.[1]

Another way to consider who's getting AIDS is to focus on what groups constitute the new cases reported each year.

In 1993, the Centers for Disease Control reported more than 100,000 new AIDS cases. Of these cases, more than half (58,538) were reported among racial/ethnic minorities, 66 percent among African Americans, 32 percent among Hispanics, 1 percent among Asians/ Pacific Islanders, and 1 percent among American Indians/Alaskan Natives. But how many of these people were gay?

According the CDC's Gayle, "during 1993, for the first time, cases reported among homosexual/bisexual men did not represent the majority of cases reported in a calendar year."

Indeed, that was true. But homosexual men still made up the largest group of new AIDS cases for the federal government's fiscal 1993. They accounted for 48 percent of the new cases, down from 53 percent the year before.

Assuming that 10 percent of the U.S. population is homosexual or bisexual (and, therefore, homosexual or bisexual men make up slightly less than 5 percent)[2], Dr. Gayle might have said that a gay or bisexual male is about 17.5 times more likely than someone who isn't a gay or bisexual male to contract AIDS. That's because 5 percent of the population is responsible for 48 percent of new AIDS cases—whereas the other 95 percent is responsible for only 52 percent.

[1] The media may have been conditioned to make this erroneous implication by the way the federal government reports the growth of its budget deficit. It reports a drop in the growth rate as though it were a drop in the deficit.

[2] Estimates of the number of homosexual or bisexual people in the population range from 1 to 10 percent. The number varies according to the definition of "homosexual/bisexual" and other factors. In this context, the lower this number, the greater the difference in concentration of new AIDS cases between homosexual or bisexual men and everyone else.

Every 1 percent of the 5 percent of the population that are gay or bisexual males produces 9.6 percent of the new AIDS cases; every 1 percent of the 95 percent that's not produces just over half (0.547, to be exact) of one percent. Those are bad odds for gay men.

Some public health officials defend skewing numbers in a way that diminishes the significance of gay men among new AIDS cases because it reinforces and encourages responsible behavior. This is a common rationalization for using misleading numbers. The problem is: Misleading numbers can lead people to make bad risk decisions. They assume odds are in their favor when they aren't.

Also, bad numbers can undermine the credibility of all health statistics.

A slowing trend in the growth of rate of incidence doesn't mean a risk has diminished substantially or permanently. In the case of homosexuals and AIDS, there's some anecdotal evidence that safe sex practices may not be rigidly adhered to by younger people. Some older homosexuals and bisexuals also may be returning to unprotected sexual practices.

Anecdotal evidence isn't reliable when it comes to making informed risk decisions. But one thing is clear about the issue of unprotected sex—it's a bigger issue for male homosexuals and bisexuals than for other groups. If the odds that a gay man will contract AIDS in a given year are 1 in 245 and condoms are 90 percent effective in blocking the transmission of AIDS, a gay man who uses condoms every time he has sex will improve his odds to 1 in 2,450. That's nearly the same odds that the average American faces.

INTRAVENOUS DRUG USERS

Next to being a man who has sex with other men, the most likely way to contract AIDS is to use intravenous drugs. These drugs commonly include heroin and certain forms of cocaine—but they can include any substance that's administered with a syringe.

According to the CDC, IV drug use is the primary risk factor in 31 percent of adult AIDS cases, accounting for 20 percent of male AIDS cases. Injection drug use is the leading risk factor for women, accounting for about 50 percent of the cases. (The lower number among men reflects the prevalence of male homosexual sex as a risk factor.)

As with male homosexuals, the growth in AIDS incidence among IV drug users in the United States showed signs of leveling in the early 1990s. This pattern reflects the leveling of incidence in major metropolitan areas, like Newark and New York City, Boston, and Washington, D.C. In other areas, the rate of increase of AIDS among this risk group is unabated.

High risk behavior is endemic to the IV drug culture. Sharing needles and sexual contact among users in exchange for more drugs remain prevalent.

IV drug users also represent a primary bridge of the disease from the homosexual to the heterosexual communities. Having sex with an IV drug user is also a likely way to contract AIDS. This kind of exposure accounts for about 20 percent of the AIDS cases reported among women.

The National Commission on AIDS has expressed no doubts on the relationship between AIDS and IV drug use. It has recommended expanding drug abuse treatment and removing legal barriers to the purchase and possession of injection drug equipment.

But making drug paraphernalia easier to get raises other risk issues. If illegal IV drugs become easier to use, more people may do so. This clearly isn't a good thing.

Using the already-troubling assumption that 3 percent of the population has used IV drugs at some point or had sex with someone who has, you're 14.5 times more likely to contract AIDS if you're an IV drug user or have sex with an IV drug user than if you're not and don't.

OTHER FORMS OF TRANSMISSION

AIDS transmission among heterosexuals who don't use IV drugs is growing faster than any other exposure group in the United States. But the base rate of incidence on which that growth rate is taken remains significantly lower than the rates of incidence for male homosexuals and IV drug users.

Heterosexual sex transmission in the United States accounted for 9 percent of reported AIDS cases in 1993, up from 7 percent in 1992 and less than 2 percent in 1985. Some public health experts expect the rate of incidence among heterosexuals to rise to 20 percent by the late 1990s.

According to the CDC, among persons with heterosexually acquired AIDS, adolescents and young adults, women, African Americans, and Hispanics have been disproportionately affected. People at highest risk for heterosexual HIV transmission are those who have multiple sex partners, sex with a high-risk partner, or other sexually-transmitted diseases.

Anecdotally, the common denominator among non-IV drug using heterosexuals with AIDS is promiscuity and prostitution. In some parts of the world—particularly southeast Asia and parts of Africa—the AIDS infection rates among heterosexual prostitutes is 40 and even 50 percent. While numbers in the U.S. remain comparatively low, sex-for-money is clearly a bad deal when the risk of AIDS is factored in.

Among heterosexuals, sexual diseases remain the key to transmission. Genital ulcerative diseases—such as syphilis and gonorrhea—have been associated with an increased risk of heterosexual transmission of AIDS.

The CDC and other public health groups predict that incidence of women with AIDS will increase much faster than it will for men during the 1990s. These groups predict that heterosexual contact may eventually overtake IV drug use and homosexuality as the main

means of transmission in the industrialized world, as it has in parts of Asia and Africa. This would be a major development in the odds that any given person would contract AIDS.

Aside from those with sexual diseases and multiple sexual partners, the other significant group of heterosexuals who get AIDS is people who have used blood or tissue products tainted with HIV. In the United States, 7,272 cases of AIDS attributable to blood or tissue products were reported through 1994.

AIDS is now the leading cause of death among hemophiliacs in the industrialized world. In the United States, 50 percent of persons with hemophilia are infected; among those with severe hemophilia type A, the rate of infection is between 80 and 90 percent.

Using the same assumptions we've used before, 87 percent of the population in the U.S. are heterosexuals who don't use IV drugs or have sex with IV drug users. If these people account for the balance of all AIDS cases not attributable to male homosexual sex or IV drug use—a simplification which inflates the number—that means the 87 percent account for 21 percent of all cases.

It also means a heterosexual, who doesn't use IV drugs or have sex with someone who does, is about twenty-five times less likely to contract AIDS than someone who's not.

So, AIDS is a real risk to people who aren't in the two primary risk groups, but it's a relatively small one.

PEDIATRIC AIDS

There is one group of people whose behavior has nothing to do with how they contracted AIDS—the children born to mothers with HIV or full-blown AIDS. Pediatric AIDS infections exceeded 1 million worldwide in 1992.

All told, 441,528 people contracted AIDS between 1981 and 1994. Babies constitute about 1.7 percent of the total number of people with AIDS in the U.S.

This means that pediatric AIDS cases account for a small slice of the total. But it's a high-profile slice. The effect of fund-raising appeals for tiny children dying from a cold is profound. But the fact remains that the number of pediatric AIDS cases has no bearing on helping you make a risk decision. These babies are, unfortunately, a closed community from adults. They probably won't live long enough to have any impact on outsiders.

The risks of mother-child transmission are not well understood. Some studies have found rates of transmission of between 7 percent in the industrialized world to over 40 percent in certain areas of East Africa. Infants can acquire the virus at various stages of gestation, during birth or after birth by drinking their mothers' breast milk.

Children infected in utero seem to do worst, often dying within the first year of life. Others, who become infected later, seem to develop a less aggressive form of the disease or resist it better. Still, 50 percent of infants with AIDS die by age 2 and 80 percent before age 5.

Although pediatric AIDS is more deadly more quickly than AIDS in adults, there are hopeful signs. The overall numbers of children born with AIDS remain low. And studies have found that mother-to-child infection may be stopped by certain kinds of intervention.

Treatment with AZT and immunoglobulin is among the therapeutic strategies being explored at various stages of pregnancy in attempts to reduce the risk of transmission. There is apparently some correlation between asymptomatic HIV and increased odds of delivering an HIV-free baby.

The results of a study released in February 1995 of 364 babies found that the rate of transmission dropped from 25.5 percent to 8.3 percent when women took AZT during pregnancy and labor and the child received it for six weeks after birth.

But doctors say women should be aware that many questions about the treatment remain unanswered, including whether the drug

causes birth defects. The National Institute of Allergy and Infectious Diseases (Anthony Fauci's group), which sponsored the trial, made no recommendations about the treatment because its long-term effects are still unknown.

FROM WHAT YOU DO TO WHO YOU ARE

These are the essential, causal risk factors in who's likely to contract AIDS. Regardless of political or public policy ends that various groups wish to achieve, AIDS is a condition largely controlled by patterns of behavior. If you don't use dirty syringes or have sex with homosexual or bisexual men, the odds you'll get AIDS are something less than 1 in 3,000—no matter who you are.

There are other things that you can do to make the odds even slighter. Using condoms when you have sex helps—mostly if you're a homosexual or bisexual man, but also if you're a woman having sex with a man who might be in one of the risk groups. Not having sex with prostitutes helps; not having sex with anyone helps more.

To the extent that more data needs to be gathered, it should probably monitor the rates of incidence among risk groups to identify any new behaviors that transmit a significant number of AIDS cases.

Most of the reporting of who contracts AIDS has focused more on who the sick are than what they did to get sick, though. The reporting makes race and gender a bigger issue than patterns of behavior. Race and gender classifications may help public health educators direct their efforts, but they don't help people make risk decisions.

A decision-maker can't do anything to affect his or her race or gender.

Worse still, the way some public health agencies collect their information makes race and gender classification a stated purpose, which may skew results away from behavior patterns. Race and gender are irrelevant to risk assessment in AIDS cases—and possibly counterproductive to risk management of AIDS.

One reason public health officials like to focus on race and gender may be that the control numbers for these groups—their percentages of the total population—are easy to determine. As we've seen, there's dispute over how many people are gay and how many use IV drugs.

However, race and gender aren't causal factors in the spread of AIDS. A black man and a white man face the same odds of contracting AIDS if they have sex with each other, a prostitute or shoot heroin from the same dirty needle—regardless of the fact that, overall, white men have lower incidence rates than black men.

But race and gender do influence the way AIDS information is reported. So, we'll consider these reports—with a keen eye toward whether the reports influence the way data is gathered.

RACIAL AND ETHNIC MINORITIES

In 1993, the number of new AIDS cases reported among racial and ethnic minorities increased 135 percent over 1992 numbers. The number of new cases among whites increased 114 percent. Although much of the increase was due to the 1993 expansion of the CDC's AIDS definition, the greater increase in cases among minorities was consistent with trends in the number of AIDS cases reported in previous years. The condition increased more quickly among minority populations, particularly blacks and Hispanics.

These were the rates of incidence for various racial and ethnic groups, as published by the CDC:

Blacks .. 162 per 100,000

Hispanics .. 90 per 100,000

Whites .. 30 per 100,000

Native Americans .. 24 per 100,000

Asian-Americans .. 12 per 100,000

Black women, with an AIDS rate of 73 per 100,000, were about 15 times more likely than white women to get the disease. Black males, with a rate of 266 per 100,000, were nearly five times more likely than white males to get AIDS.

The CDC also reported that AIDS mortality hit minority groups harder than whites. Of the 106,949 AIDS deaths reported in the United States in 1993, 58,538 (54.7 percent) occurred among racial and ethnic minorities.

In the U.S. population as a whole, blacks represent 12 percent and Hispanics 9 percent. Following these numbers, black men are three times more likely to die from AIDS than white men; black women, nine times more likely than white women.

According to the CDC's Helene Gayle:

> Provisional mortality data for 1992 indicate that HIV infection was the second leading cause of death among African-American females ages 25-44 years, and remained the leading cause of death (since 1991) among African-American males in that age group. In the United States, through December 31, 1993, more than 5,000 children under the age of 13 have been reported with AIDS. Of that total, 2,866 (nearly 55 percent) are African American.

Overrepresentation of blacks and Hispanics in the AIDS population are reflections of the same behavioral patterns we considered before, just concentrated in groups that tend to be poorer and less educated than the rest of the U.S. High rates of sexually transmitted diseases and IV drug use, which are more prevalent in black and Hispanic communities than society as a whole, favor the spread of AIDS.

One possible danger with focusing on these correlative statistics: They might convince a white, Asian-American or Native American person that somehow he or she is less likely to contract AIDS than a black or Hispanic person.

A white man might think he's relatively safe if he hires a white prostitute for sex. He's not. Racial distinctions are an artificial contrivance that a race-conscious public health establishment projects onto the epidemic. The condition itself doesn't recognize race.

GENDER DISTINCTIONS

Because AIDS started out as a condition concentrated among gay men, the public health establishment has had trouble projecting the course of the syndrome among women. The real numbers of women with AIDS remains small, relative to the numbers for men. And, again, the controlling factors for the women who do have AIDS are behavioral—linked either to drug use or sexual practices.

While overall AIDS prevalence in U.S. women is only 0.015 percent, the CDC reported in early 1995 that cases among women were increasing by roughly 17 percent a year—and growing numbers of women are contracting AIDS through heterosexual contact as opposed to IV drug use.

Between 1981 and 1994, 58,428 women had contracted AIDS. That accounts for 13 percent of the national total. (Worldwide, women constitute 40 percent of AIDS cases.) In 1994, women accounted for 14,081, or 18 percent, of the 79,674 new AIDS cases among adults in the U.S.

The behavioral breakdown: 41 percent of infected women reported contracting AIDS through IV drug use, while 38 percent reported contracting AIDS from a male partner. But many regional agencies report that sexual contacts outrank IV drug use.

Clinging to its racial models, the CDC dutifully reported that AIDS continued to hit minority women much harder than whites. Black and Hispanic women accounted for three-quarters of the 1994 AIDS cases among women. The rate of black women, 62.7 per 100,000 people, was 16 times higher than for white women, 3.8 per 100,000. The rate of Hispanic women was 26 per 100,000.

An interesting fact: The majority of infected women are either married or divorced. This reflects general demographic trends—but runs against the norm among men, where young singles dominate the infected. In other words, because a woman is married or has been doesn't make her any less likely to have AIDS.

A more interesting fact: Women are 12 times more likely to be infected by men than they are to infect men.

Spermatic fluid, which is designed to suppress antibodies in the genital tract so that sperm won't be rejected as a foreign protein, may suppress any mucous membranes involved in sexual activity. By locally suppressing mucous membranes, the spermatic fluid facilitates the absorption of itself and its contents (including HIV) into the bloodstream.

Another simple but often overlooked fact: Heterosexual sodomy will transmit the disease just as effectively—and fatally—as homosexual sodomy does.

Women seem to develop full-blown AIDS more quickly than men and to die at an earlier age, for reasons experts don't yet understand. In general, HIV-positive women are both younger and sicker than men when they enter treatment programs. They are more than twice as likely as men to die before developing AIDS-associated conditions, such as Kaposi's sarcoma or Pneumocystis carinii pneumonia.

AGE AND AIDS

By 1993, the CDC reported that AIDS had become the top killer of American men aged 25 to 44. That number wasn't so surprising. Since young people die less frequently than older people, they're more susceptible to volatile fluctuations in mortality trends. (In 1992, unintentional injuries had been the number one killer of young men.)

More surprisingly, the CDC found that the condition had become the fourth-leading killer of women in the same age group.

In 1994, AIDS became the leading killer of young adults—the combination of statistics relating to men and women—in the United States. It accounted for one in every five deaths among those aged 25 to 44.

There were 80,691 new cases of AIDS in 1994, says John Ward of CDC, but the number of new cases is leveling off, growing by only about 3 percent per year. "The epidemic is slowing, and we can take comfort in that—but small comfort," he said.

The risk of dying from AIDS, if you die from anything, plummets as you get older—from 1 in 4 among 30-to-34-year-olds to 1 in 100 for those over 65. This is because people usually contract AIDS before they're 40 and don't usually live much more than ten or twelve years afterward.

This said, 1994 also turned up another odd statistic: While something like 10 percent of HIV and AIDS patients had been over 50, that year the percentage rose to 11 percent.

Leonard Kooperman, an expert on AIDS and aging at Golden Gate University in San Francisco, offered a possible explanation for the rising numbers. He said most studies had found older homosexual and bisexual males continue to be sexually active but generally use sexual practices considered lower risk. However, in a study Kooperman had made in 1994, 11 percent of older gays had had five or more sexual partners in one month—an increase over earlier numbers.

While behavior remains the key risk factor for AIDS at all ages, age itself contributes to faster progression of the condition. By middle age, many people's immune systems already are compromised by stressful lifestyles, alcohol intake, smoking, poor nutrition and pollution, says Raymond Keith Brown, a New York physician and author of *AIDS, Cancer and the Medical Establishment*.

Though most people's immune systems aren't seriously suppressed, a hedonistic lifestyle that compromises the immune system—re-

gardless of sexual orientation—can make them "sitting ducks when the HIV virus comes along," Brown says.

Other factors relating the transmission

What you do is more important to your odds of contracting AIDS than who you are. But there are a few characteristics of the condition that affect how easily it can be passed from one person to another.

Primary among these: People are more capable of spreading the virus that causes AIDS to others during the first 60 days of their infection than previously thought. A 1995 study performed by University of Michigan scientists revealed that rates at which people contract HIV during the first sixty days of a sex partner's infection may be 100 to 1,000 times higher than in the long period, sometimes several years, when patients usually show no symptoms.

"We're saying the initial two-month period immediately following infection is the key factor controlling transmissions of the virus and the spread of the [AIDS] epidemic," says University of Michigan epidemiologist James S. Koopman.

The infection rate for gay men during the initial period may be as high as one in three, Koopman says. After that period, the rate drops to in 100 or more. (Outside of male homosexual sex, the rate may be as low as one in 3,000 encounters.)

This timing issue is important because antibodies to HIV do not appear until near the end of the primary infection phase. Negative results on a blood test taken during this period—which is normally about two months—do not guarantee a sex partner is free of the virus.

Many people are not ill during the primary infection phase, so it's a mistake to rely on symptoms to alert one to the presence of the virus. A newly infected, seemingly healthy person can be what AIDS specialists call "a walking time bomb."

This threat confirms conventional wisdom about AIDS. Having many sexual partners boosts the risk of infection because of the increased odds of having relationships with persons in the primary infection period.

Other changes in the understanding of how AIDS progresses make multiple sex partners seem like a bad idea. Traditional concepts of AIDS held that the virus would hide out in the immune system and effectively lies dormant for years. In the mid-1990s, epidemiologists found stronger evidence indicating that the virus is engaged in an all-out war with the victim's immune system on a scale that is unprecedented in infectious diseases.

Every day, 100 million to 1 billion new viruses are produced in an infected person's body, which pumps out 1 billion new disease-fighting white blood cells to battle them. It is this high rate of reproduction, researchers believe, that allows the virus to mutate and develop resistance to drugs.

The same intense warfare happens in a normal viral infection, but that generally ends in few days, with either the virus or the immune system emerging victorious. If the immune system wins, the patient returns to health. If the virus is successful, as often happens when the influenza virus attacks the elderly, the patient dies.

With AIDS, however, it's a stalemate that persists for years, until ultimately the immune system succumbs.

An HIV infection "is like an acute infection that never ends," said Ashley Haase of the University of Minnesota School of Medicine.

It is at this crucial point that many researchers now believe that the symptoms of AIDS first appear. At first, the body is not able to fight off opportunistic infections while holding the virus in check. Eventually, it can no longer continue the stalemate and the body is overwhelmed by the virus.

As a result, the clinicians who develop drugs to combat AIDS are abandoning the standard model of AIDS as a simple infection that

can be treated with a single drug in the same way that a bacterial infection is cleared up with an antibiotic. Instead, they look to models based on cancer therapy, where a single tumor is aggressively attacked with a "cocktail" of different drugs in which each exploits a separate vulnerability of the cancer cells.

Clinicians couldn't adopt this shotgun approach to AIDS before because they had only bullets—AZT and two other drugs—that targeted the same viral weakness. But the new discoveries coming after 1992 have stocked their armory.

But even more than the success of the multi-drug approach, scientists are encouraged by what they see as the first visible weakness in the AIDS virus. In mutating to escape one drug, the virus apparently becomes more susceptible to others.

One key implication of this finding, experts speculated, is that even with its great ability to shift its structure and escape destruction by mutating, HIV may have limitations in the number of new forms it can assume—and may thus be susceptible to attack with a barrage of drugs.

Perhaps even more promising were several studies with a new class of drugs called protease inhibitors, which attack a different HIV enzyme than does AZT. At least seven protease inhibitors are now in clinical trials in humans and at least two more are being studied in animals. Results presented at the meeting for two of the drugs indicate that they are 10 to 20 times more potent than AZT at suppressing HIV replication and that they have fewer side effects.

Researchers are also optimistic that the discovery of a protein in saliva that blocks the entry of HIV into cells can be translated into a drug that will inhibit infection. Studies of long-term survivors of HIV infections may lead to the identification of other proteins that also control AIDS replication, and these may lead to new treatment regimens.

DRUG THERAPY VERSUS BEHAVIOR MODIFICATION

Because behavior is the key to AIDS transmission, any drug therapy will have limited impact. Peter Lurie, the head of AIDS research at UCSF, considered the roles of drug therapy and behavior modification in a 1994 article in the *Journal of the American Medical Association*:

> ...Another challenge will be to optimally allocate already scarce HIV prevention funds if a vaccine is ultimately proven effective. Funding for the vaccine should not replace behavioral prevention efforts, which should continue at existing levels even after vaccine approval.
>
> These issues are further magnified if, as is likely, the vaccine is less than 100 percent effective.
>
> While the purchase of a 90 percent effective vaccine would almost certainly be cost-effective, this would not clearly be so for a 30 percent effective vaccine, the purchase of which might divert funds from needed prevention or treatment efforts for HIV and other diseases. Further research into the costs (and opportunity costs) of vaccine trials and vaccine dissemination programs must be undertaken.

More than any drug research, efforts by the CDC and other groups to inform people that condoms are an effective means of preventing AIDS have staunched the spread of the condition among high-risk groups.

Among gay males, for example, some communities have changed their behaviors dramatically. As a result of those changes, they've seen a much better prevention program.

According to CDC analysis, counseling and testing programs tend to reduce AIDS-related risk behaviors in specific populations—especially among heterosexual couples in which one partner is infected and the other is not, and among gay men testing HIV-positive.

However, the CDC finds less evidence that counseling and testing leads to favorable behavior change among persons who are engaging in risky behavior but receive negative test results.

A 1992 study conducted in Milwaukee, Wisconsin, offered a disturbing example of this problem. The survey suggested that changes in behavior patterns are difficult and slow in developing.

Homosexual men in Milwaukee reported only occasional use of condoms and other preventative measures. "We have a high-risk population engaging in sexual behaviors that put them at risk," said a spokesman for the Milwaukee AIDS Project, which released the survey. "One-half of them are not protecting themselves."

Among findings of the survey of 329 homosexual men were:

- only 30 percent regularly used condoms;
- 50 percent of those who had multiple sex partners did not use condoms; and
- 43 percent of those who had sex with men they knew were infected with HIV did not use condoms on a regular basis.

Of course, the fact that these results were based on a survey group of only 329 people made the results suspect. With more than million people living in the Milwaukee metropolitan area, there are probably more than 10,000 homosexual or bisexual men there. The survey was based on little more than 3 percent of this subpopulation. Even though it may be difficult to get these people to answer a survey, 3 percent isn't much of a base for building conclusions.

This kind of survey shows how the systematic undermining of credibility of AIDS surveys influences the information gathered. AIDS reporting has become a cacophony of specialized data and analysis, customized for specific groups. That specialization limits the applicability of information across all demographic lines of a population.

CONCLUSION

"AIDS has devastated the personal lives and social communities it has touched, but the epidemic has had little effect on American society as a whole or its way of doing business," reported a panel monitoring the social impact of AIDS for the National Research Council of the National Academy of Sciences.

AIDS is not a major killer in the United States in the population at large. Deaths from AIDS totalled about 30,000 in 1991 and 28,000 in 1990. By comparison, 500,000 people die from cancer every year. Even among infectious diseases, AIDS ranks relatively low.

Because the absolute numbers of persons affected by AIDS is low compared to other diseases, the net burden on societal resources is reduced.

Among individual risk groups, the pattern is radically different, however. As we've seen, it's the major cause of death for men under 50. For gay men, the odds of contracting AIDS from a random sex partner can be as high as one in three.

Though the rate of growth of AIDS in the United States is slowing, the real number of cases continues to be higher each year. A major concern in this count: The obsession of public health experts for classifying AIDS cases by race and gender may inspire false confidence in supposedly non-high-risk groups.

Worse yet, this erosion of credibility in public reporting on AIDS may undermine all studies done on the subject—skewing the manner in which information is gathered and biasing the responses survey subjects may give.

2

New York City
is safer than
Tallahassee, Florida

Crime statistics are hugely misunderstood. For most Americans, the odds of being the victim of violent crime stayed the same—or diminished—through the 1980s and 1990s. But people think they're at greater risk.

For example: A 1993 Gallup Poll commissioned by *Parenting* magazine showed that 54 percent of parents feared their children might be kidnapped at some point. According to federal government statistics, a child's odds of being kidnapped are 1 in 300,000.

Criminologists say that even though violent crimes touch very few lives, they are a key to people's sense of safety. Does larceny make you fearful about crime? Probably not. Does homicide make you fearful? Probably. This makes crime statistics particularly vulnerable to sensationalism and manipulation.

Every 22 minutes, on average, someone is murdered in America. Someone is raped every four minutes, robbed every 26 seconds, seriously assaulted every 17 seconds. But what do these numbers mean in a nation of 250 million people? Not as much as you might think. The odds of the average American becoming a victim of violent crime in a given year are about 1 in 135 (a rate of incidence of 746 per 100,000 people in 1993).

As Darrell Steffensmeier, a Pennsylvania State University criminologist, said in a 1995 interview: "All this talk about a crime wave is

more myth than reality. The risk of being a victim of a violent crime for most Americans is really very small and actually lower than it was 10 years ago."

It's easy to blame the popular media for exaggerating the importance of violent crime risk. Unlike other risk issues, crime reporting has a long, sensationalized history in popular media. But the media isn't solely to blame for hyped impressions.

Like any other kind of risk assessment, crime statistics are only as reliable as the information that supports them. As with AIDS and other risk issues, crime stats can be skewed by biases or preconceptions that blur the information-gathering process.

Figures collected by the Bureau of Justice Statistics suggest that more than 90 percent of Americans are safer today than they have been during much of the past two decades. Figures released by the Federal Bureau of Investigation in 1994 showed a 1 percent decrease in violent crime during the previous year.

The drop in crime was consistently underreported by the media, but it came from the Census Bureau and the Justice Department's twice-yearly victimization surveys, begun in 1973. According to these estimates, in 1973 there were 35.7 million rapes, robberies, assaults, burglaries, and thefts. By 1992, crime had fallen 6 percent to 33.6 million.

Since the total U.S. population was about 210 million in 1973 and 250 million in 1992, the average American's odds of being a victim of either a property crime or a violent crime fell from 1 in 5.9 to 1 in 7.6 during that period (as we saw above, the odds of being the victim of a violent crime are much slighter).

It's rarely possible to describe an entire population directly. Instead, you have to infer characteristics of the population from the sample. These inferred characteristics of the population are called parameters.

Statistic and *parameter* are parallel terms, one referring to a sample and one referring to a population. Several issues control a risk analyst's ability to use statistics and parameters.

The limits within which you can be reasonably certain that the population mean resides is called the confidence interval. The "reasonably certain" is called the level of confidence. Each of these concepts relies on the other for its definition.

When you're considering the relationship between two statistics, you need a measure that represents the scale from low to high degrees of correlation. This measure is called a *coefficient of correlation*.

A coefficient of correlation provides a scale of between 0.0 and 1.0. It also carries information about direction—it can be either positive or negative.

Behavior has something to do with your chances of being the victim of a violent crime—if you're a drug dealer, the odds you'll be shot increase. But behavior doesn't control the odds of being a victim of violent crime as it does the odds of contracting AIDS. Other factors—especially who you are and where you are at a given time—control crime statistics.

For this reason, the sociological and demographic patterns that emerge from crime numbers are important to the odds that you'll be mugged, raped or killed in the coming year. And, because the manner in which sociological and demographic information is gathered is notoriously unpredictable, this chapter will cover some interesting material.

SOME BACKGROUND

The main sobering influences on crime statistics are a series of studies done on an annual basis by the FBI and the Justice Department.

The largest and most sophisticated study from victims is the National Crime Victimization Survey (NCVS).

Every six months, NCVS interviewers contact a national sample of more than 65,000 households. More than 100,000 individuals aged 12 years or older are interviewed and asked to report their experience with crime. Victims are also asked to report any instances of self-defense. Strict confidentiality is assured. The NCVS has been progressively refined over the past 20 years, and it is widely considered to be the best source of information about rates of crime and violence in the United States.

Some criminologists say the reason for the decline in crime numbers during the 1980s and 1990s is demographics. Generally speaking, the crime rate is contingent upon the number of young men in the population. According to the FBI and the Justice Department, more than 80 percent of those arrested are male. Men aged 15 to 24 account for 40 percent of all arrests, and men 15 to 34 account for 70 percent.

Selective sampling can be made to produce almost any result, but the demographic influence on crime rates is a historical trend. "You don't need a crystal ball to predict a rising crime rate in the first decade of the next century," says Richard Girgenti, New York state's director of criminal justice. "Demographics have always been the best predictor of future crime."

During the Great Depression of the 1920s, hard times took a bite out of the birthrate; by the time that generation of young men became adolescents, many left the country to fight in World War II. For those reasons, the 1940s gained a reputation as an era of comparative safety on the streets.

Then came the post-World War II baby boom. By the mid-1960s, "juvenile delinquency" had become a major problem. The baby bust followed, and by 1973 the crime rate began falling.

But, in the mid-1990s, the drop in violent crime could be turning. Demographers predict the most violent-prone segment of the popu-

lation (15- to 19-year-olds) will grow nearly twice as fast as the overall U.S. population through the year 2010.

The FBI says the number of people under age 18 arrested for carrying or owning a weapon jumped 106 percent between 1983 and 1992, compared with a 14 percent increase in arrests for those 18 and older. Even more frightening, many kids don't mind pulling the trigger.

A 1991 Justice Department survey of predominantly minority male high school students in 10 high-crime areas found that 10 percent of the students agreed it was acceptable to shoot someone "if that is what it takes to get something you want," and 28 percent believed it was okay to shoot a person "who hurts or insults you." The result: Teenage robberies or assaults that once resulted in beatings are now more likely to end in lethal shootings.

POVERTY, RACE AND CRIME

One of the most common mistakes people make about crime is that it's motivated by poverty. As Marvin Wolfgang, a professor of criminology and law at the Wharton School of the University of Pennsylvania says:

> There is no consistent correlation between poverty and crime. The studies go back 100 years, and they show only a weak correlation at best. Most poor people are law-abiding, and many rich people break the law.

According to the Justice Department, your risk of being a victim does not increase as you make more money—it actually declines. Your odds of being victimized are two to three times lower if you make $50,000 or more a year than if you earn less than $10,000.

Ironically, the fact that crime rates are so low among the affluent may partly explain their disproportionate concern, according to Mark Cohen, a Vanderbilt University professor who specializes in the economics of crime. Says Cohen: "When you don't know what vio-

lence really looks like firsthand, you may have an exaggerated fear of it."

As people grow older and more cautious, they feel the streets are meaner than ever—even when it's clear that they're not. The chances of a white woman 65 or older becoming a victim of serious violent crime are just one-seventieth the odds a black male teen faces. But older women worry about crime more than any other group.

There's much more dispute over how much impact race has on crime statistics. Even allowing for racist police who arrest more innocent black men than innocent members of other racial groups, blacks—who comprise 12 percent of the population—still account for a disproportionately high 30 percent of all arrests.

Black men are also disproportionately the victims of crime. The rate of homicide among young black men, ages fifteen through 35, grew two-and-one-half times worse between the mid-1980s and mid-1990s. In 1994, these numbers stood near 1 in 1,000—about ten times the statistic for the whole population.

Black men kill more black men each year than the total number of blacks whites lynched from Reconstruction to the 1990s.

Still, the fact remains that whites commit more violent crimes—54 percent versus 45 percent for blacks, according to FBI arrest statistics. But relative risks underscore fearful perceptions: Every 1 percent of black Americans accounts for 3.5 percent of all violent crimes, while every 1 percent of other Americans accounts for about 0.8 percent of these crimes.

These numbers vary widely depending on the crime, with blacks responsible for more murders and robberies (55 percent and 61 percent of these crimes, respectively) and whites committing more rapes and aggravated assaults (56 percent and 60 percent).

Blacks and whites are most often victimized by someone of their own race. For example, of the 5.1 million violent crimes with white

victims in 1992, the perpetrator was white 66 percent of the time and black only 21 percent. And in the 1.1 million crimes with black victims, the criminal was black 86 percent of the time and white 7 percent.

While a white person is far more likely to be victimized by a black than the other way around (21 percent versus 7 percent), the chances are three times as great that a white person will be victimized by another white than by a black. The exception here is robbery. Whites are held up by blacks 49 percent of the time and by whites only 37 percent.

Still, though violent crime is predominantly white on white or black on black, it is also true that black criminals commit more crimes against white victims (nearly 1.1 million in 1992) than they do against blacks (just under 1 million).

THE COST EFFECTIVENESS OF CRIME

Violent criminals tend to be young because few people make a career out of crime. At some point, most criminals make the realization that crime poses enough risks to life and liberty that a straight job—even one near minimum wage—is usually a better deal.

Larceny is a risky and low-profit line of work. In 1992, the average mugging netted $672 in cash and property (watches, jewelry, etc.); the average burglary, $1,278. If a thief nets 50 percent of what he or—less likely—she steals, he or she would have to commit six or eight crimes a month just to live at a subsistence level.

A 1985 Rand Corp. study of 2,190 repeat offenders found that they averaged about 15 major crimes per year. At that rate, the bad guys better keep their day jobs.

A point worth repeating here: young men tend to prey upon other young men. Street criminals are not masterminds. A Justice Department survey released in January 1995 showed that men were victims of violent crime 40 percent more often than women from 1987 through 1991.

Put another way, your chances of being attacked vary tremendously according to your age, race, sex and neighborhood. The risk of becoming a victim of a serious violent crime is nearly four times higher if you're 16 to 19 years old than if you're 35 to 49; almost three times higher if you're black instead of white; two times higher if you're male rather than female; and again double if you live in a city rather than in a suburb or in the country.

CRIME AS A DISEASE...AND AN OPPORTUNISTIC ONE

Law enforcement officials and politicians often refer to crime as a pathology or disease. This rhetoric usually has little bearing on the odds an average person will be a victim of crime in a given period.

However, in the June 14, 1995, issue of the *Journal of the American Medical Association*, a group of academics from Emory University in Atlanta and the city's Police Chief performed an epidemiological study of home invasions during a three-month period in 1994. The results were interesting. They essentially support the characterization of crime as an opportunistic phenomenon.

Between June 1 and August 31, 1994, Atlanta Police Department reports were screened to identify every case of unwanted entry into an occupied, single-family dwelling. Cases of sexual assault and incidents that involved cohabitants were excluded.

A total of 198 cases were identified during the study interval. A few key distinctions emerged:

- exactly half (99 cases) involved forced entry into the home;
- the ethnic makeup of victims closely resembled the demographic composition of the city; women were victimized more often than men;
- the victim and offender were acquainted in nearly a third of the cases;

- a firearm was carried by one or more offenders in 32 cases—fewer than 1 in 8; seven offenders carried knives;

- stealth was the most common method of entry (80 cases), followed by force (59 cases); offenders used deception (for example, knocking on the front door) followed by force in 12 cases;

- fifteen percent of the intruders entered through the front door of the house; twenty-four percent, through a back or side door; almost all of the rest gained entry through a ground floor window;

- 47 percent of the crimes occurred between midnight and 6 a.m.; 17 percent occurred between 6:01 a.m. and noon; 16 percent, between noon and 6 p.m.; and 20 percent, between 6:01 p.m. and midnight; and

- in 42 percent of cases, the offender fled without confronting the victim.

In each case the sequence of events fit one of three general patterns. No confrontation occurred in 42 percent of cases because the intruder either entered and left silently or fled the moment he or she was detected. Forty-nine victims (25 percent of the total) confronted the offender but did not attempt to resist. Sixty-two victims (31 percent of the total) resisted the offender. Some resisted passively, by running away, locking a door, or holding on to their property; most resisted actively, by fighting back, screaming, or calling 911.

Victims who avoided confrontation were more likely to lose property but much less likely to be injured than those who were confronted by the offender. Resistance was attempted in 62 cases (31 percent). Forty cases (20 percent) resulted in one or more victims' being injured, including six (3 percent) who were shot. No one died.

Three victims (1.5 percent) used a gun in self-protection. All three escaped injury, but one lost property. The odds of injury were not significantly affected by the method of resistance.

The group concluded:

> A minority of home invasion crimes result in injury. Measures that increase the difficulty of forced entry or enhance the likelihood of detection could be useful to prevent these crimes. Although firearms are often kept in the home for protection, they are rarely used for this purpose.

There are extrapolations but no firm figures on how many criminals are frightened away by someone brandishing a gun or firing a warning shot.

THE ODDS OF BEING ARRESTED AND CONVICTED

Another way to consider the odds you'll become a victim is to consider the odds that a criminal will be arrested and convicted for committing a crime against you. This evaluates the impact of deterrence.

"Swift and certain punishment is more effective than severe penalties," says James Q. Wilson, a professor of management at the John E. Anderson Graduate School of Management at UCLA.

While crime may not pay very much, policy analysts like Wilson complain that, if the potential cost of committing crime isn't high enough, opportunistic criminals will take their chances—even for small gains.

And there's another reason why criminals act opportunistically: They aren't in the mental condition to plan complex crimes. According to The Sentencing Project, a Washington, D.C.-based organization specializing in criminal justice policy, "Half of all violent offenses are committed by people intoxicated on alcohol or other drugs."

George Akerlof, a sociologist at University of California, Berkeley, has argued that community action—specifically block groups in close contact with the police—raised the cost of crime to the criminals by increasing the certainty of punishment.

This theory stresses the importance of that certainty. In 1992, 79 percent of all crimes in the FBI's standard survey never produced an arrest. For violent crimes—defined by the FBI as murder, aggravated assault, forcible rape, and robbery—55 percent went unsolved. The unsolved rate for property crimes—defined as burglary, larceny, and motor vehicle theft—was 82 percent.

These figures would be worst yet if all crimes were reported to the police. Law enforcement officials estimate that probably half of all burglaries go unreported. So do many rapes and aggravated assaults.

The National Center for Policy Analysis (NCPA), a Texas-based think tank, computes a useful measure of the justice system's deterrent effect—or lack thereof.

The NCPA correlated the FBI's national clearance rate statistics for 1990 with figures for convictions and time served for each of the FBI's crime categories. The results, dubbed "expected punishment," were based on the probabilities of arrest, prosecution, conviction, and imprisonment.

For the crime of murder, the NCPA's "expected punishment" figure was 1.8 years in prison. Would-be rapists, calculating the collective odds of being caught, prosecuted, convicted, and doing time in 1990, could expect to spend 60 days in jail for each sexual assault.

For armed robbers, the figure was 23 days behind bars; for people committing aggravated assault, 6.4 days per assault. Burglars could anticipate 4.8 jail days per offense.

The NCPA reported that of those arrested for burglary in 1990, 87 percent were prosecuted. Of those prosecuted, 79 percent were convicted. Of those convicted, only 25 percent were imprisoned. Thus, a burglar had only a 1.2 percent probability of going to prison for each act of burglary in 1990.

Given the NCPA's "expected punishment" calculation of 4.8 jail days for each burglary, this crime remains at least theoretically prof-

itable if what is stolen is worth more than the statistical risk of five days behind bars.

That risk may be worth $500 in ill-gotten gains to a greedy person with a reasonable knowledge of the odds. Imagine how it looks to a crackhead with no mind for numbers.

THE METHODOLOGY OF CRIME STUDIES

Crime tends to be a geographically-sensitive risk. Robert Figlio, a University of California, Riverside, sociology professor, says, "It's where you are even more than who you are that determines whether you will be a victim."

But this is a difficult factor to calculate in terms of odds.

In 1993, the violent crime rate was highest in the nation's biggest cities, which collectively registered 975 violent offenses per 100,000 population. The suburban counties' rate was 461. For rural counties, it was 233.

Nationally, the highest violent crime rate for a metropolitan area in 1993 was Miami with 2,136 offenses per 100,000 population. The safest was the Wausau, Wisconsin, area with only 66.5 offenses per 100,000 people.

The title of this chapter refers to a much-ridiculed conclusion drawn from the 1993 FBI Uniform Crime Reports Program. The FBI numbers suggested that Tallahassee had a serious crime rate nearly 80 percent higher than in New York.

In 1993, New York's 600,346 reported crimes, from a population of 7.3 million, gave it a crime rate of 82 crimes per 1,000 people; Tallahassee's 19,426 crimes, from a population of 132,252, gave it a rate of 147 crimes per 1,000 people.

The seven crimes covered by the FBI survey are murder, rape, robbery, aggravated assault, burglary, larceny and auto theft. The 1993

nationwide serious crime rate of 746 per 100,000 was 2 percent lower than the 1992 rate, 13 percent above the 1989 rate and 38 percent above the 1984 rate. But the national numbers weren't as problematic as the local ones.

The FBI reported that Tallahassee's larceny rate of more than 80 thefts per 1,000 people was a major factor pushing up the city's overall crime standing. With only 32 such incidents per thousand, New Yorkers at first blush seemed far safer from larceny—defined as theft with no threat of violence.

Tallahasseeans were nearly 60 percent more likely to be assaulted and almost three times as likely to be raped.

New York led in murders and robberies. But the FBI reports count all crimes with equal weight, so Tallahassee emerged as the more dangerous place.

Of course, law enforcement professionals—and anyone who's ever lived in the two cities—laughed at the FBI results.

For example, according to the FBI, residents of the two cities were equally likely to have their cars stolen. But Allstate Insurance charged only $110 a year to insure a Ford Taurus against theft and vandalism in Tallahassee and as much as $880 a year for the same coverage in New York City.

One reason for the difference: More than 60 percent of cars stolen in Tallahassee are recovered. In New York, only about a quarter of cars stolen are recovered.

How crime statistics are gathered

The respective car insurance numbers highlight the flaws in the way information is gathered for the FBI studies. Most importantly, local law enforcement authorities have wide discretion in the way crimes are reported and classified.

Edward Shihadeh, professor of criminology at Louisiana State University in Baton Rouge, argued that the aggravated assault statistics were easily manipulated. "The reality is that the best measure really is homicides and robberies because they offer the least amount of discretion to police agencies," he said. "What happens is that Baton Rouge and Alexandria are simply more aggressive in terms of defining aggravated assaults, while the city of New Orleans doesn't classify anywhere nearly as many as aggravated assaults. And many may not even be reported to them in the first place."

The FBI counts only crimes reported to the police—just a fraction of actual crime. The Justice Department, which surveys victims, agrees with Shihadeh and concludes that nearly two-thirds of all crime goes unreported nationally. So, even a small difference in willingness to report crimes can have a big effect on the "crime rate."

Criminologists complain that the annual crime rankings are inaccurate, a creation of headline-hungry journalists who oversimplify a report that was never intended for comparisons among cities and states. "These rankings...aren't accurate," said William Wilbanks, a criminal justice professor at Florida International University in Miami. "There are too many differences in the data to use it to make these comparisons."

"Crime statistics generally stink," says Gary Kleck, a professor of criminology and criminal justice at Florida State University in Tallahassee. "Whatever drives the crime rate to be high also produces an overwhelming result: Why should I bother the police? There are so many crimes that my crime looks petty compared with everyone else's experience."

When it releases its report each December, the FBI assigns no rankings and does no calculations to compare different cities or states. It even warns against doing so. "The problem is, there are too many other factors that come into play," said FBI spokesman Bill Carter.

Among those factors: population density, degree of urbanization, high concentrations of youths or transients, poverty, unemployment, family stability, even climate.

Crime numbers can vary dramatically—even within a single metropolitan area. An *Atlanta Journal-Constitution* study of all 1993 crime reports for a five-county area found that violent crime is jampacked into pockets of metropolitan Atlanta's poorest and most crowded neighborhoods.

Residents living near the new Olympic stadium or Clark Atlanta University had a one in 14 chance of becoming a violent crime victim. Residents of suburban Gwinnett County faced odds of 1 in 476.

Atlanta's population is 67 percent black, 31 percent white, and 2 percent other minorities. In 1993, a total of 69,914 FBI Uniform Crime Reports Program crimes were reported to the Atlanta Police Department. The racial identity of reported victims closely followed the city's overall racial composition.

Another problem: The FBI report considers metropolitan areas, not individual cities. So, the cities with the highest crime rates sometimes are in metro areas farther down the list. For example, in 1993, Washington, D.C. had one of the highest violent crime rates in the country at 2,922 offenses per 100,000 residents. But its metro area included northern Virginia and parts of suburban Maryland—thus pulling it way down on the violent-crime list with a rate of 771 per 100,000.

Orlando, Florida—about three hours south and east of Tallahassee—vaulted from twenty-fifth place to eleventh among major cities in the nation during 1993. The FBI figures said 21,952 serious crimes were reported inside Orlando city limits that year, resulting in a rate of 12,785.5 crimes per 100,000 people.

That rate reflected a 7.4 percent increase in serious reported crimes from 1992. But Orlando politicians insisted the FBI had erred by using the same population figure for both years, although the city had grown substantially.

The FBI's ranking of 1993 violent-crime offenses per 100,000 residents in metropolitan areas:

Miami ... 2,136

New York ... 1,866

Los Angeles .. 1,682

Tallahassee ... 1,546

Baton Rouge ... 1,510

Size alone doesn't make a city dangerous. Little Rock, Arkansas—with a population of 176,000—ranks among the ten most dangerous cities. Madison, Wisconsin—with a population of more than 210,000—ranks among the ten safest.

The rate of violence tends to be higher, for instance, in places with larger minority populations (36 percent in Little Rock) and a concentration of single-female households with children under 18 (9 percent in Little Rock versus 5 percent in Madison).

CONCLUSION

The FBI Uniform Crime Reports Program is the lightning rod for most media attention on—and misinterpretation of—crime statistics. But it's certainly not the only place that shaky information is gathered and processed into inaccurate odds assessments. A number of other bits of conventional crime wisdom turn out to be untrue when shown in the light of reality.

To close out this chapter, we'll consider a number of these myths in quick succession.

Myth: Most murders involve friends or family members.
Reality: In Chicago during 1992, intrafamilial homicides—with and

without firearms—represented 69 of 940 murders (7 percent). The largest categories were non-friend acquaintances (252 murders or 26 percent of the total) and "relationship not established" (344 or 36 percent). In other words, gang violence and the random (and hence untraceable) acts of criminals overwhelm other numbers.

Myth: Most people who shoot to kill are not convicted felons.
Reality: In 1992, 72.4 percent of murder perpetrators and 65.5 percent of victims had criminal histories. In 1993, the numbers were 71.7 percent of perpetrators and 59.3 percent of victims.

Myth: The United States has become a more dangerous place since the early 1980s.
Reality: The country as a whole has been getting noticeably more law-abiding. The number of violent crimes hit a high of just over 6.6 million in 1992. But what really counts is your chance of becoming a victim, which is reflected in the overall violent-crime rate. And that rate, now 32.1 per 1,000 people per year, is actually down about 9 percent from its 1981 peak of 35.3, according to the Justice Department.

Myth: The murder rate exploded during the 1980s.
Reality: The 1993 estimated rate of 9.5 murders per 100,000 people, which is based on FBI figures, remains lower than the 10.2 peak back in 1980. But the murder rate for black males under 40 did increase—to 159 per 100,000 people.

Myth: Wild black youths usually attack older or single white women.
Reality: Black male teens are the most likely victims of violent crimes—often perpetrated by other black youths. Black teenage girls are the second most likely to be victimized, following black male teens, out of 16 demographic groups normally tracked. White women ages 20 to 34—commonly misidentified as a leading victim profile—actually rank ninth. White women 65 and older are the least likely victims of violent crime. Their victimization rate of roughly 1 per 1,000 makes them the safest of all demographic groups.

Myth: Women are attacked by strangers more often than men are.
Reality: The opposite is true. Men are roughly twice as likely as women to be attacked by strangers. Women, on the other hand, are five times more likely than men to suffer at the hands of someone intimate with or related to them.

Worse, a woman victim is twice as likely to be injured—59 percent versus 27 percent—if her assailant is a spouse, ex-spouse or boyfriend rather than a stranger.

3

Cancermania

No risk creates as much popular outrage—or calls as much attention—as the threat of cancer. The disease kills more than half a million Americans every year. That's five times the number who die in all types of accidents. It's more than ten times the number of people who die each year from AIDS. And cancer's only the second-leading cause of death among Americans.

Even though heart disease kills more people, cancer evokes special feelings of dread. This stems mostly from a familiar pattern of facts. While many forms of cancer are affected by behavior, some are not. Heart disease rarely strikes people under 40; cancer does more often. And many forms of cancer maim as well as kill.

A 1992 study done by researchers Robert Lichter, Stanley Rothman and Mark Mills supported Berkeley risk specialist Bruce Ames' arguments that the media bungles risk assessment. The study of 1,147 stories on cancer over 20 years found that the major print and broadcast media gave the most attention to artificial carcinogens that scientists generally think are low risk, while neglecting the often natural carcinogens that the scientists think are higher risks.

Information about cancer rates is itself controversial. According to the (now defunct) U.S. Office of Technology Assessment, ninety

percent of the causes of cancer are environmental or behavioral and, in theory, preventable. Still, statistics on environmental cancer risks are often built on assumptions that lead to worst-case scenarios bearing little resemblance to the real world.

Standard cancer tests—feeding chemicals at high doses to rats, then extrapolating to lower doses for humans—are not a good way to find out if a substance will cause cancer in humans. Large doses cause cells to proliferate and the new, mutated cells to form tumors. Under normal circumstances, a body repairs cell mutations before cancer develops. But a rat—or any other animal—cannot do this if its metabolism is overwhelmed by a massive dose of chemicals.

At the present rate, if you believe more reliable National Cancer Institute statistics, one out of three Americans will contract some form of cancer and one in five will die of it.

A whole book could be written—and many have been—on the odds and risks associated with the various kinds of cancer. For the purpose of this chapter, breast cancer serves as the best focal point in the cancer debate. It mixes hard science with soft science, bad science, politics, emotions and cultural biases. It's influenced by interested analysis—designed to make memorable conclusions rather than useful projections.

As a result, a reasonable person has to turn a skeptical eye toward any number he or she hears linked to cancer. It's difficult. But it's an urgent requisite to people who want to make good risk decisions.

SOME BACKGROUND

Epidemiologists have identified hundreds of kinds of cancer, affecting the human body from head to toe, skin to bone. What these cancers share is the common trait altering the normal cellular structure of the human body in a manner that conflicts with essential functions. This alteration ultimately expands (*metasticizes* is the technical word) into other parts of the body until the victim has lost so much normal body function that he or she dies.

In 1994, an estimated 182,000 women were diagnosed with breast cancer. About 14 percent, or 25,000 of these women, were under 45 years old. Breast cancer kills 46,000 American women a year, making it the second-leading cause of cancer death in women.

A 1995 report from the National Cancer Institute concluded:

> To some extent, breast cancer incidence rates appear to be linked to the conditions of life for modern women, such as earlier menstruation due to better nutrition, foregoing or postponing childbearing to pursue education or careers, use of hormonal contraceptive medications and late menopause.

The lifetime risk of breast cancer has risen in the past 20 years, but that is also misleading. Increased screening has detected more cases early, and women are living to older ages where the incidence risk is higher.

If you know anything about breast cancer, you're waiting to hear the statistic that sticks in most people's minds. It's a shining example of the manipulation of risk assessment...and the distortion of odds. It's defended as an exaggeration that means well. But it probably does more than any other statistic to make people doubt all risk numbers they hear. It's 1 in 9.

The American Cancer Society promotes the statistic that 1 in 9 women will get breast cancer in her lifetime. The Cancer Society started publicizing this breast cancer rate in the early 1970s—when it was 1 in 16—as a way to persuade women to get mammograms. There's some disagreement over whether it has resulted in as many mammograms as Cancer Society PR wizards had hoped. There's no disagreement over whether it's frightened a lot of women.

A spokesman for the Amercian Cancer Society told the *New York Times* that "The one-in-nine is meant to be a jolt....It's meant to be more of a metaphor than a hard figure."

There's a seed of truth in the Cancer Society metaphor. One woman in nine will get breast cancer—but only if you assume she'll live to age 85. The younger a woman is, the lower the odds she'll have breast cancer in her lifetime. A 25-year-old woman has a lifetime risk of 1 in 1,000; at age 50, 1 in 63; and at age 75, 1 in 15.

(An alternate report that some women quote pegs the lifetime risk at 1 in 8. This supposes an even less likely lifetime of 95 years.)

"Many of the women I see think that the 1-in-9 statistic refers to their odds of getting breast cancer and dying right now," says Patricia Kelly of Salick Health, a California-based chain of cancer treatment centers. "When they realize that the average risk of developing breast cancer is 2 percent up to age 50, they're enormously relieved."

Kelly goes on to say:

> Often in the course of attempting to state their beliefs about risk, patients realize they are unsure about the meaning of high or low risk, or the difference between a 20 or 40 percent risk. Even quite intelligent and well-educated people may be confused about the meaning of risk.

Kelly says that some patients assume that a relative risk factor of 4, found with some types of nonmalignant breast lesions, can be multiplied by the "average" risk of 11 percent to arrive at an approximate risk of 44 percent.

Actually, according to one comprehensive study, a risk of approximately 1 percent a year was found for the 15 years following the diagnosis of nonmalignant lesions.

Technically, the Cancer Society's 1-in-9 number is misleading because it is an incidence rate. Most people confuse the incidence rate with a mortality rate—which it isn't. Even accepting the Cancer Society's questionable assumptions, the mortality risk for breast cancer would be 1 in 28.

Because incidence rates for cancer are affected by environment and behavior, numerous cases can sometimes appear in a common area or specific subpopulation. Some experts—and many non-experts—find these occurrences compelling proof of corporate or government misdeeds.

But cooler minds generally characterize the clusters as statistical anomalies—like a coin toss that turns up heads 70 times out of 100. Statistical anomalies are a fact of life for risk takers.

A more useful number would be one that tells a woman the odds that she will contract breast cancer in the near future. And this statistic is available from the CDC and the National Cancer Institute.

In 1994, the average 30-year-old woman faced a 1 in 5,900 chance of getting breast cancer within the next year. At age 50, she has a 1 in 430 chance. Even when she reaches age 80, the risk is 1 in 300.

Another important point: The risk of breast cancer isn't spread evenly among all women, as a statistic like 1 in 9 suggests. Jumbled into that statistic are all kinds of women—those with a very high risk of breast cancer and those whose risk is much lower.

None of this is to downplay the threat of breast cancer—it remains the second-leading killer of women in America. But there are less sensational ways in which to crunch the numbers. For instance: The average woman has an 89 percent chance of never developing breast cancer. And heart disease kills about ten times as many women each year.

SELF-FUELING OVERREACTION

Women worry more about breast cancer than about any other health threat, and several surveys have shown that this concern prompts most women to overestimate their chances of developing the disease. Anxiety also prompts many women to overreact to poorly documented reports.

The special terror of breast cancer lies in the fact that it mutilates as well as kills, and that it attacks the most visible symbol of a woman's sex.

Says Kathleen Mayzel, director of the Faulkner Breast Centre in Boston:

> It happens all the time. A 27-year-old woman comes into my office with lumpy breasts. She's already had two mammograms because her lumpy breasts mean it's difficult for her doctor to do breast exams. The mammogram comes back showing dense breast tissue—which is normal in a 27-year-old woman, but makes a mammogram hard to read. So the doctor throws up his hands and says, "Look, you've got lumpy breasts, dense breast tissue—I don't know what to do." And she thinks she's going to die of breast cancer.

At least half of all women have noticeably lumpy breasts during their reproductive years. Lumpy breasts have no connection with breast cancer. It's only when a woman has a single, dominant lump, rather than general lumpiness, that doctors want to investigate further.

Even then, the overwhelming majority of biopsied lumps—about 70 percent—are found to be benign.

The Cancer Society statistics were striking enough to appeal to various special interests. In a June 1995 congressional testimony a senior attorney with the Natural Resources Defense Council (a group responsible for all kinds of artful risk statistic manipulation) tied the number to environmental risks:

> Breast cancer will now strike 1 in 9 women. A Mount Sinai School of Medicine study showed that women with higher levels of the environmental estrogen DDE (a breakdown product of DDT) in their breast tissue were more likely than others to get breast cancer....

Given the level of statistical hyperbole defining the 1 in 9 figure, everything the NRDC lawyer said was suspect.

RISK FACTORS

When women ask about their odds of getting breast cancer and what they can do to improve those odds, most cancer specialists point to a series of environment- and behavior-related risk factors that impact averages.

Women face sharply higher (four times or more than average) rates of incidence for breast cancer if they:

- are over 60 years old;

- have had previous cancer in one breast;

- have a family history of breast cancer (this means two or more immediate family members with the disease); or

- have had severely abnormal cells or abnormal cell divisions in previous breast biopsies.

Women face higher (two to four times the average) rates of incidence if they:

- are older than 30 at the birth of their first child;

- have had any cell or cell division abnormality in past breast biopsies;

- suffer from postmenopausal obesity; or

- have a history of poor, fatty diet.

Women face slightly higher (less than two times the average) rates of incidence if they:

- had their first menstruation before age 12;

- experienced menopause after age 54;

- have never had a child;

- have used hormone therapy for more than 15 years; and

- consume moderate to heavy amounts of alcohol.

What these risk factors share in common is variations or differences in the kind and level of hormones in a given woman's body. Hormones and heredity are the two primary risk factors that affect a woman's odds of getting breast cancer.

But risk factors are far from the whole answer. An individual woman can defy hormones and genes. But, more importantly, more than 70 percent of the women who develop breast cancer had no traits known to increase their risk.

This isn't a reassuring statistic for any woman, but it's an important one for someone who feels doomed by her risk factors.

Another ray of hope for women whose risk factors point to breast cancer: Some doctors have become harsh critics of the whole risk factor exercise.

In her book, *Preventing Breast Cancer: The Politics of An Epidemic*, British physician Cathy Read argues that the lifestyle theories allow scientists to redistribute blame. "Simply translated, the lifestyle explanation says one thing—you have brought breast cancer on yourself because of something you have done."

Blaming patients for their unhealthy lifestyle makes them more malleable, says Read. They are forced into a position where they have no option but to feel thankful.

"Women are made to feel grateful: grateful that their cancers were picked up by screening, grateful for their treatment and lucky to still be alive," she says.

BREAST CANCER AND GENES

Polemics from British surgeons don't hold a lot of weight against a genetic history of breast cancer. The women who pay most anxious attention to risk factors are those who have lived through mothers or sisters or aunts living with—or dying from—the disease.

Cancer specialists estimate that genetics is the source of 60 percent to 90 percent of all types of cancer. Environmental factors, from pollution to bad habits to food make up the remainder, 10 percent to 40 percent.

About five to 10 percent of breast cancers stem from a unique genetic mutation. In families with these unique genes, daughters have a 50 percent chance of breast cancer.

The younger a mother develops breast cancer, the higher her daughter's risk. According to the NCI, cancer in a mother who's 40 or younger means a four to five times greater risk for a daughter.

On the other hand, for women diagnosed at age 75, their daughters' added risk is minimal.

And so is an isolated occurrence of breast cancer in an immediate family. Most daughters or sisters of women with breast cancer do not develop breast cancer, or even face a greatly increased risk of the disease. Some researchers estimate that only 5 to 9 percent of breast cancers are inherited.

Barbara Blumberg of the Baylor/Susan G. Komen Breast Centers in Dallas, Texas, says:

> Most women grossly overestimate their risk. It's not unusual for me to hear someone say, "I think my risk is 70 to 80 percent, or 90 to 100 percent." And that's because they "know" the average woman's risk is one in nine, and their mother had breast cancer, and so they triple it. Or they quadruple it.

Most breast cancers start with a mutation in a breast cell, a mutation that allows the cell to slip free of normal controls on growth. Such a mutation—unlike one in the genes carried by sperm or egg—can't be passed on from parent to child, so it can't affect the next generation.

For this reason, family patterns have to be pronounced to suggest an inherited susceptibility for breast cancer. Most doctors look for

two immediate relatives with breast cancer. If their cancers developed before menopause or in both breasts, it's another sign that the cancer may have been inherited.

What these doctors are looking for is a cancer syndrome—the most striking family pattern of all, with several different kinds of cancers occurring early and running through the generations. Cancer syndromes are believed to be caused by a mutation in one or more "control" genes, which regulate other genes.

But even a woman with a clear-cut family history of breast cancer has a lifetime risk of just under 50 percent. She's still more likely not to get breast cancer.

DIET AND ALCOHOL

The risk factor that many women focus on most intently is their diet. A few cautious warnings about cutting down on dietary fat become the centerpiece of their efforts to sway the odds of breast cancer. This is another classic misinterpretation.

The more closely researchers have looked at dietary fat, the harder it has been to pin down the breast cancer connection. In one of the largest studies on the subject, epidemiologist Walter Willett, of the Harvard School of Public Health, tracked some 90,000 nurses for four years. About 600 of the nurses developed breast cancer—but it didn't seem to matter whether they got as little as 32 percent of their calories from fat or as much as 44 percent.

About five years into a follow-up study, Willett reported that diets as low in fat as 25 percent showed no ability to protect women against breast cancer.

Willett concluded:

> ...Although fat intake has clearly been low historically in many countries with a low incidence of breast cancer, such as Japan, numerous other differences in diet and lifestyle (including reproductive variables) could account for variation in breast cancer rates.

One particularly attractive alternative to the dietary fat hypothesis is that early dietary energy restriction (relative to energy expenditure) sufficient to limit adult stature can reduce breast cancer incidence.

The most promising studies connecting diet to cancer risk are anecdotal and correlative. For example, only 10 percent of the calories in the traditional Japanese diet come from fat—and the rate of breast cancer there is five times lower than in countries that live high on the hog, like the United States. And, if a woman emigrates from Japan to the United States, her risk of breast cancer rises.

Other so-called "scientific findings" have proved to be anything but scientific. In 1993, a tabloid newspaper carried an article which said that eating soya beans can reduce the risk of death from breast cancer. The research—from scientists at the Dunn Nutrition Centre in Cambridge, England—involved just six women in the preliminary trials.

Evidence on the link between drinking alcohol and breast cancer risk is also inconclusive. Several studies have pointed to an increase in breast cancer among women who drink any amount of alcohol. But moderate drinking appears to have compensatory benefits that may outweigh that risk.

A 1995 study, published in *The New England Journal of Medicine*, showed that among nearly 86,000 nurses overall death rates were lowest among women who had only one to three alcoholic drinks a week.

Those who consumed up to two drinks a day also had a lower mortality rate than abstainers, even though this amount of alcohol has been shown to raise estrogen levels (and therefore, presumably, breast cancer risk) in premenopausal women.

While the research results remain muddled, doctors continue to give safe—though possibly meaningless—advice. Cutting back on fat will protect against heart disease; if it also turns out to lower the risk of breast cancer, so much the better.

Most health experts share a sort of philosophical detachment about cancer risk factors. For the average woman, the odds are she won't get breast cancer. And, if she does, odds are she won't die of it—especially if it's caught early.

This may not be the promise of prevention and cure that women hope they'll hear from their doctors or other cancer specialists. But it is a realistic approach to dealing with the odds.

HORMONES AND THE PILL

The biggest breast cancer risk factor for any woman is that she is a woman.

Researchers don't know quite what the female sex hormones do that increases the risk of breast cancer, but it's clear that they do something. How else to explain the fact that if a woman has surgery early in life to remove her estrogen-producing ovaries, her risk of breast cancer drops dramatically?

A woman's risk rises slightly if she began menstruating early or if she stops menstruating late; in other words, the longer she's exposed to monthly hormonal surges, the greater her risk.

Estrogen and other sex hormones may also underlie the added risk a woman may face if she has no children or has them later in life. During pregnancy, birth, and breast-feeding, hormones signal the breasts to go through massive changes—changes that somehow "set" breast cells, and make them more resistant to genetic mutations.

The more menstrual cycles a breast is exposed to before it goes through these changes, the greater the risk of cancer. A woman who gives birth for the first time at age 40 has three times the risk of a woman who had her first child at 18.

Since naturally occurring hormones can increase the risk of breast cancer, some doctors wonder about the extra hormones women put into their bodies when they take oral contraceptives or hormone replacement therapy during and after menopause.

Those questions remain unanswered, in part because studies have had a moving target—over the years, the Pill and hormone replacement therapy have involved different types of hormones in various combinations and doses.

In the spring of 1995, researchers at Harvard University triggered renewed angst among millions of older women when they published a study confirming that taking estrogen at menopause significantly increases the risk of breast cancer.

They also found that a second hormone, a synthetic progesterone called progestin, did not offset this risk. Researchers had hoped it would because it clearly prevented uterine cancer in women who take estrogen.

But with breast cancer, progestin may make things worse. While estrogen alone increases breast cancer risk by about 30 percent, estrogen with progestin raises the risk about 40 percent (though this difference was small enough to be statistically insignificant).

A *New England Journal of Medicine* article concluded that women who use hormone replacement therapy for five or more years have a 30 or 40 percent greater chance of developing breast cancer than women who don't.

To Graham Colditz, the leader of the ongoing Harvard study, its message was clear: "Don't take hormones for the long term if you can avoid it."

His pronouncement sent waves of panic through doctors' offices—and women's lives. Some women stopped hormones cold turkey—a bad idea. Others kept taking their pills, trading relief from menopausal night sweats for the cold sweat of fear.

Of course, there were some doctors who criticized the nurses' study as vague and inconclusive. It found increased risk among women who had been taking hormones for more than five years, but no increased risk among long-term hormone users who had stopped.

In the book *Save Yourself From Breast Cancer*, California surgeon Robert Kradjian discredited a Harvard Nurses' Study report published in 1992, which concluded that there is no connection between dietary fat and breast cancer. He offered a glimpse into the funding sources for the Harvard study, which included several giants of the food industry.

There were also some methodology problems with the Harvard report. Most importantly, it was an observational study, not a randomized trial with a control group to provide comparison. This means the women themselves had decided whether to take hormones, rather than being assigned to take them or not. That may have skewed the results in various ways.

According to epidemiologist Louise Brinton of the National Cancer Institute, who has been involved in many of the largest studies on breast cancer risk factors, there does seem to be a wavering trend in the research, suggesting a very slight increase in risk for women who take hormones for long periods.

The debate over the therapeutic use of hormones for women going through menopause will continue past the year 2004, when the first conclusive, randomized trial is due to be completed. With both sides armed with partial data, the dispute balances the possibility of increasing the risk of getting breast cancer at age 60 to prevent a heart attack at age 70 and a hip fracture at age 80.

MAMMOGRAMS

In the early 1990s, another debate focused on whether getting yearly mammograms between the ages of 40 and 50 might somehow predispose women to breast cancer. Newspaper headlines leaked the preliminary results of one study, which suggested that women in that age group were twice as likely to die of breast cancer if they'd had mammograms every year than if they'd never had the exam.

The news came from the Canadian National Breast Screening Study, which followed nearly 90,000 women for seven years. When the fi-

nal results were released in 1994, however, mammograms appeared not to affect the death rate at all.

As in the case of the menopausal hormone therapy, it was unclear precisely what the results of the mammogram study meant.

Larry Green, chairman of the department of family medicine at the University of Colorado School of Medicine, says the chances of a healthy woman in her 30s, with no family history of breast cancer, getting the disease are so small that the harm from the X-rays can be greater than the benefit from finding a cancer.

Other experts argued that the results could reflect the fact that mammograms in the study were poorly done. In the early years of the study, only 50 percent of the exams were found to be acceptable by outside radiologists. And getting a poor mammogram may well be worse than not getting one at all, since a woman whose mammogram gives an all-clear may ignore a lump that crops up the next day.

Many radiologists dismissed the Canadian data as inconclusive and insisted that women in their forties should be systematically tested. In fact, since tumors sometimes grow faster in younger women, many think that 40- to 50-year-olds should get mammograms every year instead of biannually.

In a January 1995 issue of the *Journal of the American Medical Association*, researchers Herman Kattlove, Alessandro Liberati, Emmett Keeler and Robert Brook considered the four main decision points in the diagnosis and treatment of early breast cancer: screening mammography, primary surgery, adjuvant therapy, and follow-up care. They then applied their conclusions to a hypothetical group of 500,000 women.

Among their conclusions:

> ...Studies of screening mammography found a 30 percent reduction in mortality for 50- to 69-year-old women who were screened,

but no statistically significant benefit for those older than 70 years or younger than 50 years.

...Although the literature does not support a statistically significant benefit of screening on mortality for woman aged 40 to 49 years, we performed a sensitivity analysis based on the 13 percent nonsignificant survival benefit contained in the overview of [several international] studies.

[That assumption] indicates that eight additional lives might be saved over 7 years.

Screening women aged between 70 and 74 years might add 1.8 days of life to each woman screened at an extra cost of $1.6 million over 3 years, but does not increase their survival at 10 years. No benefit data exist for women older than 74 years, but the rapid drop-off in benefit after 70 years of age suggests this group would benefit little from screening mammography.

The annual cost of repeated screening in the hypothetical group would be $8.8 million to screen all women older than 40 years annually and $4.4 million to screen them biannually. This cost would be reduced to $2 million by screening only women aged 50 to 69 years (the group that benefits most).

If a plan adopted this strategy with regard to women aged 40 to 49 years, it would have the support of the National Cancer Institute, which has changed its screening recommendations and now recommends screening only women older than 50 years, but not of the American Cancer Society, which—clinging to its extreme perspective—still recommends screening for all women older than 40 years.

ABORTIONS

One of the most controversial disputes over an alleged risk factor for breast cancer flared up in 1993, when a study conducted by Seattle researchers for the National Cancer Institute suggested that abortions raised the odds of breast cancer in women.

The Seattle study, the largest ever devoted to examining the association between abortion and breast cancer, contradicted earlier studies that found no link. It supported a theory that an abortion interrupts development of breast cells that later can become cancerous.

Janet Daling, an epidemiologist with the Fred Hutchinson Cancer Research Center and the University of Washington's School of Public Health, lead the group that interviewed 1,800 Seattle-area women (845 women diagnosed with breast cancer between 1983 and 1990 and 961 others selected at random) under age 45. The researchers found that on average an induced abortion increased the risk of breast cancer by 50 percent to nearly 1 in 50 for the oldest women interviewed.

For younger women, the news was even worse. For women under 18, the risk was increased by 150 percent. For women over 30 years old, it went up 110 percent.

Daling's study found that women who'd had an abortion before they were 18 had a relative risk of 2.5 times the general population. Women who'd had an abortion over 30 had a relative risk of 2.1 times the general population. Among all women who had had abortions, the relative risk was about 1.5 times those who hadn't.

The study's confidence interval was 95 percent—that is, it reached statistical significance—at between 1.2 and 1.9 times higher risk for women who had had abortions.

To rule out the possibility that women diagnosed with cancer might be somehow more inclined to reveal an abortion to their doctor, the Seattle researchers interviewed 214 women diagnosed with cervical cancer and 341 others selected at random. They found no link with abortion.

Spontaneous abortions or miscarriages did not appear to increase the risk of breast cancer. Daling said this was because the link between abortion and breast cancer is thought to come from changes in breast tissue driven by the hormonal changes of pregnancy. A

woman's body may adjust to these changes when a miscarriage occurs—but not so well after an induced abortion.

Multiple abortions did not appear to increase the risk for women.

Daling emphasized the finding that young women who terminated their pregnancies earlier had a significantly lower risk of breast cancer than those who waited. "Should you choose to have an abortion, the earlier [in the pregnancy] you get it, the better for your health," she said.

There were many caveats to the study's conclusions. For instance, when the researchers compared their findings to statistics for women who had never been pregnant, the increased risk linked to abortion was not statistically significant.

And most breast cancers occur in older women, so the study was addressing increases in relatively small risks. Women aged 49 and younger have about a 4 percent risk of developing breast cancer sometime during those decades. So, a 50 percent increase adds only two or three extra percentage points.

Tallking about the response to her study, Daling said:

> I don't know how the right wingers used this study or what became of it. Many people in the scientific community were not very receptive to results because most scientists are pro-choice. They felt [there was] more chance of biased recall—where cases may be more likely to say they had an abortion when they didn't. We did consider this. We clearly indicated in the paper that this was unlikely.

Louise Brinson of National Cancer Insititute remained skeptical of Daling's results:

> I'm not convinced that there are reasons for concern in the terms of abortions. The problem with most of the studies is that they are not specifically designed to assess the relationship between induced abortion and breast cancer risk.

A number of them couldn't adequately separate induced and spontaneous abortion....Other studies couldn't control for related lifestyle factors, such as delayed child-bearing, oral contraceptives, screening history, alcohol or diet.

The media likes controversy, so they like pitting this [issue] against special interest groups. Some special interest groups—right-to-life groups—seized on it.

Another criticism of the study was the manner in which the women in the general population were surveyed. Researchers called women on the phone, randomly, and asked them if they'd ever had an abortion. If those women didn't admit that they'd had an abortion to strangers calling on the phone, that could skew the results and undermine their reliability.

Daling countered these charges by arguing that some of the other popularized risk factors for breast cancer—such as a high-fat diet—have less scientific support than the abortion link.

The Seattle survey followed more than 40 published studies during the previous decade that examined whether women who have had abortions have a greater risk of developing breast cancer. Most had concluded there was no connection. Cancer researchers at the National Cancer Institute and the American Cancer Society called the entire body of research inconclusive at best.

Nevertheless, anti-abortion activists cited the Seattle study as the concluding piece in a series of surveys proving a link between abortions and breast cancer.

Another study that the activists relied on had been published by the *International Journal of Epidemiology* in 1989. That study had found a higher rate of abortion among 1,451 women in New York State (excluding New York City) younger than 40 who had had breast cancer than among a control group of the same number of women.

The issue reached the activists' agenda through the independent

efforts of New York-based science professor Joel Brind and Virginia-based attorney and political activist Scott Somerville.

By averaging the results of various studies, Brind concluded that a woman who has had one abortion has increased her risk of breast cancer by 50 percent. And with an estimated 800,000 women a year aborting their first pregnancies, Somerville said, "It's very easy to come up with the 40,000 or 50,000 or so unexplained breast cancer cases we've got each year. So the numbers are right."

"Having an abortion," Brind argued in a *Washington Post* article, "is equivalent to having an aunt or a mother who had breast cancer" in terms of increased risk. "Having multiple abortions is like having two relatives with breast cancer."

The NCI's Louise Brinton disagreed, warning: "The danger is in scaring women who've had an abortion, given that we really don't know whether there really is any association at this point in time. We're certainly not trying to cover up any data. I think good data are just not out there."

Most previous studies—including her own in 1983—are not statistically significant, Brinton said. They involve too few women or older women who were past their childbearing years before abortion was widely available, or they fail to control for other crucial factors, such as diet, the use of oral contraceptives and age at first childbirth.

SOME ECCENTRIC THEORIES GET PRESS

While the establishment experts debate political issues like how much—or whether—factors like the Pill or abortions impact breast cancer incidence, some more offbeat theories gain support on the fringes of the cancer research community.

After interviewing women about their bra-wearing behaviors, the medical anthropologist Sydney Ross Singer came to the conclusion that women should throw away their bras to reduce their risk of breast cancer. His research took place over two and a half years and in-

volved 4,730 women—half of whom had been diagnosed with breast cancer and half of whom had no known diagnosis of the disease.

Singer feels he has uncovered strong evidence that brassieres—especially ones worn more than 12 hours a day and so tightly that they hurt or cause red marks on women's skin—are another risk factor for breast cancer.

His conclusions, published in the book *Dressed to Kill*, suggest that the risks and incidence of breast cancer increase directly with the number of hours a woman wears a bra.

Because so much breast cancer is unexplained by current risk factors, Singer began looking for other triggers. He complains that traditional medicine views disease at the cellular level. Doctors typically diagnose breast cancer and then determine if it has spread to nearby lymph nodes or organs.

Singer thinks the process also may act in reverse—that a poorly functioning lymphatic system sets up the breast for disease and cancer by not giving the cells and tissues a fighting chance.

According to Singer, the possibility increases the more hours each day that a bra is worn. He even offered some figures to support his theory:

Overall rate among women ... 1 in 8

Bra is not worn ... 1 in 168

Bra is worn less than 12 hours daily 1 in 152

Bra is worn more than 12 hours a day, but not to sleep . 1 in 7

Bra is worn 24 hours a day ... 3 in 4

Like the lawyer from the NRDC, Singer—the director of the Institute for the Study of Culturogenic Disease in Hawaii—casts doubt on all of his numbers by using the Cancer Society's exaggerated figure as a baseline number.

And Singer turned positively metaphysical when offering an alternate theory for how cancer spreads. He proposes that a "build-up of toxins" enters the body through pesticides in food and "cancer-causing substances in the air." These toxins are stored in the fatty parts of the body until they reach such levels that they cause cancerous tumors.

In May 1995, UC Berkeley cancer specialist John Gofman announced results of research that indicated at least two-thirds—and maybe as much as three-fourths—of the 182,000 cases of breast cancer diagnosed each year are caused by radiation from x-rays.

Gofman said, "The good news is that a great deal of breats cancer is preventable. You don't have to buy my estimate of 75 percent—"

Which is a good thing, because most cancer experts don't.

"—what's important is that my study alerts the medical profession and the public that ionizing radiation may be an important or the dominant cause of breast cancer."

Gofman reached his conclusions after spending more than six months researching medical literature on past use of x-rays. Some routine x-rays in the 1940s delivered up to 400 rads of radiation. By contrast, modern chest x-rays deliver about 15 thousandths of one rad.

For comparison, the average yearly dose of radiation from natural sources is about a tenth of a rad.

Critics said that Gofman vastly overstated the effects of x-rays. "That 75 percent figure is ludicrous....The worst possible outcome of Gofman's study would be for women to stop having mammograms," said Fred Mettler, chairman of radiology at the University of New Mexico School of Medicine.

Clark Heath, an epidemiologist with the Amercian Cancer Society, took an even more aggressive stand against Gofman's conclusions:

> Gofman applies a number of conversion factors before extrapolating the risk. One of these factors, which he calls a super-linearity adjustment, is based on his assumption that low doses of radiation are more rather than less carcinogenic per unit dose than higher doses of radiation.

> Most published estimates of radiation cancer risks use a linear model, which assumes that—per unit dose—low-level exposure has the same degree of risk as higher-level exposure. For example, patients who recieve .001 rad of x-rays have 1/1000 the risk of developing radiation-induced cancer as patients who absorb 1 rad.

Another error, Heath said, was Gofman's extrapolation of the relative risk of radiation-caused breast cancer in Japan to overall breast cancer incidence rates in the United States, where cancer is much more common.

Applying the Japanese relative risk factor had the effect of attributing the entire excess incidence rate of breast cancer in the U.S. to radiation—rather than diet, reproductive patterns and other factors. Heath argued that this error led to a six-fold overestimation of the effects of radiation on the U.S. breast cancer rate.

Through the early 1990s, the popular media was filled with stories of cancer and other diseases attributed to silicone breast implants. But in June 1994, researchers at the Mayo Clinic reported that they could find no connection between silicone implants and the diseases that had been attributed to them. In August, researchers at Massachusetts General Hospital said preliminary tests in a small study suggested that silicone seeping from implants may actually help fight breast cancer.

Although some doctors have challenged the methodology and provenance of studies that seem to exculpate breast implants, Elinor

Brecher, who has written widely on the issue for the *Miami Herald*, says: "There has yet to be a credible study supporting the women—and their lawyers—who claim they have this disease or any of those diseases."

Brecher—who had breast cancer, and two silicon breast implants—acknowledges that "some women have had some problems" with the implants, but she says she has been "deeply disturbed ... outraged" by the way the media has overplayed the risk and underplayed studies repudiating the risks.

"It was pure horror, creating needless panic," she wrote.

CONCLUSION

The sheer volume of information and data relating to cancer that is generated each year—each month—makes sensible number crunching difficult.

The important fact remains that many cancer cases stem from causes—environmental and otherwise—that are avoidable. If they take the right actions, individually and collectively, smart people can improve their odds of getting cancer.

Perhaps the most exciting recent news about preventing breast cancer emerged from a study by Leslie Bernstein of more than 1,000 California women. She found that moderate but regular physical exercise appeared to reduce the risk of breast cancer in premenopausal women by as much as 60 percent.

While the greatest benefit was associated with four hours a week of an activity like jogging, tennis or swimming laps, women who exercised for only two or three hours a week also had a significantly reduced risk.

Bernstein, a professor at the University of Southern California, suggested that exercise might counter breast cancer by occasionally blocking ovulation and therefore reducing the output of cancer-stimulat-

ing ovarian hormones. Exercise may also curb the amount of body fat, which is a supplemental source of these hormones.

"Because physical activity can modify menstrual cycle patterns and alter the production of ovarian hormones, it may reduce breast cancer risk; yet few epidemiologic studies have assessed this relationship," Berstein said.

Bernstein interviewed 744 women under 40 who'd been diagnosed with breast cancer and an equal number of women at random. The control subjects were chosen for age and residence similarities with the case subjects. After adjusting for potential confounding factors, Bernstein's group concluded:

> The odds ratio of breast cancer among women who, on average, spent 3.8 or more hours per week participating in physical exercise activities was 0.42 (95 percent confidecne interval of between 0.27 and 0.64) relative to inactive women. The effect was stronger among women who had had a full-term pregnancy.

> ...The protective effect of exercise on breast cancer risk in the women we studied suggests that physical activity offers one modifiable lifestyle characteristic that may substantially reduce a woman's lifetime risk of breast cancer.

Berstein says, "I'm giving lots of talks to breast cancer survival groups. Everyone wants to hear about it because women are concerned not only for themselves but for their daughters."

There is some hope on the cancer front. According to the National Cancer Institute, the age-adjusted mortality rate for all cancers combined except lung cancer has been declining since 1950, except for those 85 and over.

An even more hopeful sign: In February 1995, the National Cancer Institute announced the first decline in breast-cancer deaths for the total population since 1950.

4

The dangers of
old age

In the 1,400 years from the fall of the Roman Empire to 19th century America, the lifespan of an average person living in the most developed society increased just nine years—from 38 to 47. In less than 100 years since 1900, it has increased almost four times as fast—to nearly 80.

One group of researchers at Duke University has projected that if everyone born in the mid-1990s took the steps needed to control the major risk factors for coronary disease and cancer, the average lifespan could reach 100 years.

Other longevity experts predict that life expectancy could expand as far as 110 or even 125 years in the coming century.

Life expectancy is essentially an intricate series of averages. One of the most common errors in risk assessment is mistaking an average for a norm. Averages are observations made from a long-term perspective. The short-term, in which we all live, encourages exceptions to every average and rule.

Life expectancy charts used by life insurance actuaries and health insurance groups usually follow a complex pattern of calculating the years a person has left, based on the age he or she has reached. The pattern usually recognizes demographic peaks and valleys. For instance, a 40-year-old male can usually expect to live until he's 76; a 40-year-old female, until she's 81.

Other turns are more complex. Life expectancy on most charts actually increase for men between the age of 24 and 29, because the late 20s are a demographic plateau. If a man lives to that age, he's survived the combination of life-shortening risks that plague his early 20s.

As a result of these trends, buying life insurance is a good deal if you die soon. But if you reach life expectancy—at almost any point in our life—it's a bad deal. For example, a $200,000 term life policy purchased at age 37 will be worth less than $40,000 at age 70, allowing for a 5 percent annual inflation.

A dramatically lengthening lifespan changes many things in a society and its institutions (not all of these things are good). It can make increased demands of health care systems. It can alter investment plans and other financial models. It can change the shape and size of families.

Long life expectancy changes all sorts of projections. During the infamous panic over contaminated Perrier water, the EPA announced that drinking two liters of water contaminated with 12 parts per billion of benezine[1] over a 70 lifespan would create a 1 in 100,000 chance of contracting cancer. The odds of dying from all forms of cancer, no matter what you do, over a 70 year lifespan is 202 in 100,000.

In other words, if you don't drink contaminated water, your chances of dying from cancer during a 70 year lifespan are .12. If you do drink the water, your chances over the same period are .1200002

Most importantly, a longer life expectancy can change other expectations people have. It can alter their sense of risk. This happens most often when people misinterpret life expectancy figures as a prediction of how long they—as individuals—will live.

The economist John Maynard Keynes said famously that, in the long-term, we are all dead. That applies well in the context of life expectancy. A smart person trying to manage the odds of his or her lifespan has to find ways to make a lifetime of short-term decisions that don't

[1] The contaminated Perrier—which was pulled off supermarket shelves—had 15 parts per billion of benezine.

undermine his or her long-term goals. The same is true of a society at large.

In this chapter, we'll consider some of the results that can follow from people living longer. But we'll focus on how long lives change the way people think of risk. Nothing changes a person's sensibility faster or more surely than a sense of mortality.

SOME BACKGROUND

As recently as the 1930s, many physicians argued that high blood pressure was a natural and possibly beneficial adjustment to the decline with age in the kidney's ability to filter wastes out of the bloodstream. This viewpoint lost out because of evidence of excess deaths among those with higher blood pressure and the development of new tools to lower blood pressure.

There is surprisingly little evidence to support the most common conception of an influential genetic role in longevity, that the life span of your parents and grandparents provides a reliable indication of your prospects.

A 1995 finding from a study of 17,300 Harvard alumni suggested that longevity is enhanced by vigorous—not moderate—exercise. This surprised leading researchers, who struggled to reconcile it with other studies that pointed to a lifesaving benefit from moderate exercise.

Ralph Paffenbarger of Stanford University, a co-author of the 1995 study, was also the author of an earlier study of the Harvard men which had concluded that moderate physical exercise in adult life could significantly increase life expectancy.

Paffenbarger's research had found that men who participated in activities like walking and climbing stairs had death rates one-quarter to one-third lower than those who were least active. Therefore, he had concluded that a person did not have to become an athlete to reduce the risk of developing diseases that can shorten life.

Using the same subjects, but with 10 more years of data, Paffenbarger's collaborator, I-Min Lee of the Harvard School of Public Health, found a significant increase in life expectancy only among those who regularly engaged in vigorous exercise like jogging and fast walking. She found no such connection to those whose activities rarely caused them to break into a sweat.

Actually, life expectancy may have nothing to do with the level of exercise a person undertakes. Paffenbarger's conclusion made a mistake common when drawing a generalized theory from specific examples. Life expectancy is a backward-looking system of averages. It doesn't offer causal connections on which to draw conclusions or personal inferences.

In a way, Paffenbarger's assumption made the same kind of mistake that people make when they assume life expectancy projections will apply to them.

Some researchers speculate that a select group of genes may extend life; others look for therapies to halt the processes that damage cells and lead to the body's deterioration and eventual death.

And still other scientists say the answer to longevity is far more mundane: a healthy diet, regular exercise and positive social interaction.

Healthy habits don't guarantee that you'll live a long life. However, diet and lifestyle have dramatic effects on life expectancy. But there is evidence that suggests staying active, both mentally and physically—along with eating a nutritious diet—strengthens the brain, muscles, heart and immune system.

When you think about what contributes to longevity, remember that sweeping pronouncements about what is or isn't good for you are often less important than modest, common-sense improvements in your environment.

Most of the dramatic gains in lifespan haven't come from intellectual giants at research hospitals. They've come from more modest

workers at clinics and public health departments, who make small changes in the way people live.

The great life expectancy advances made by industrial society have more to do with the condition of city streets than recombinant DNA. Sanitation, vaccination and diet—everything from eradicating the source of diphtheria to immunizing against polio—have saved tens of millions of lives and added the critical mass of years to the average lifespan.

By 1990, about 80 percent of the world's children were vaccinated, leading to dramatic global declines of polio and other diseases.

HOSPITALS ARE DANGEROUS PLACES

The marvels of modern medicine—gene therapy, chemotherapy, cutting-edge surgery—have saved a relatively few lives and had little impact on the average lifespan. According to the American Medical Assocaition, coronary artery bypasses usually add only three years to life expectancy. Coronary pacemakers add just six months; kidney transplants or kidney dialysis add a mere 20 days.

This distinction leads to an important realization in figuring the odds for a long life: Hospitals are risky places.

About 100,000 deaths result each year from hospital-acquired infections. That's about the same as the number of people killed in all types of accidents—in cars, planes, boats, around the house and at work.

Hospitals are supposed to help you get better, not worse. But the average person loses six months of lifespan by spending an average amount of time in a hospital. One out of every 20 people who enter the hospital acquire an illness—most often some form of infection—they didn't have when they got there.

Hospital-acquired infections, called nosocomials, affect nearly 2 million people each year. This fact remains little known outside the

medical world. But the Centers for Disease Control identified nosocomials as a significant threat to an aging population.

Medical devices—like catheters and various kinds of implants, invasive hospital procedures and the hands of health care workers can give bacteria a chance to infect the body. New medical technologies put patients at higher risk for this kind of infection because they probe deeper into the body and stay there longer.

The issues aren't just technological, though. The average older patient who enters a hospital today is often sicker than patients in the past. And, importantly, cash-strapped health insurance companies push patients out of the hospital earlier than some doctors think wise.

All of these constraints on resources can be traced back to the growing number of older people.

The drain on resources echoes throughout the health care system. Maryann McGuckin, an epidemiologist at the University of Pennsylvania, studied how people washed their hands in airport restrooms versus those who worked in intensive care units. She found the travelers washed their hands longer than the health care workers.

Doctors, regulators and others worry that infections are directly related to the thinning of trained hospital staff. "Over the last few years there have been massive cutbacks," Washington-based attorney Robert Deutscher, who specializes in medical negligence cases, told a local newspaper. "Hospitals are replacing nurses with licensed practitioners, or aides, which means the hospital staff has not passed any sort of certifications for doing the functions that used to be done by trained personnel."

COMPUTER MODELS OF LIFESPAN

In 1984, after his daughter was born, Duke University demographer James Vaupel crunched some numbers, factored in encouraging trends in the death rate, and announced in a scientific paper that his daughter and other newborns had a life expectancy of 100 years.

Vaupel argued that the formulas most demographers use to compute life expectancy were based on extremely conservative assumptions. If the 2 percent per year improvement in the death rate during the 1970s continued, it would translate into a gain of 2 years in life expectancy every decade.

University of Chicago demographer Jay Olshansky and his wife also had a baby girl in 1984. Sparked by Vaupel's predictions, Olshansky also ran some numbers. He assumed that there was no way that a 2 percent per year improvement in the death rate could be maintained indefinitely and concluded the young girls' life expectancy was 85 years.

One of the primary services that computer automation offers people is the ability to calculate numerous averages. Therefore, the explosion of computer processing technology should make more intricate—and more accurate—life expectancy projections possible.

The projections have gotten more intricate, but whether they're more accurate is anyone's guess.

That uncertainty is based on relatively straightforward modelling with known variables. It doesn't take into account potential breakthroughs in the biology of aging. More importantly, it has no bearing on how an individual lives—how many packs of cigarettes a day he or she smokes, how many banks he or she robs, how many quarts of bourbon he or she drinks, etc.

Nevertheless, governments and insurance companies who bet on long-term trends want to know how long people can be expected to live. So, demographers continue to develop more intricate computer models.

When demographers make projections of total population size, they use three factors: live birth rate, net immigration and total mortality rate. But when they try to answer questions like how many 85-year-olds there will be in the year 2050, they focus on death rates—because everyone who will be 85 by 2050 is already 30 or older.

The trouble is, though they start with the same census data, they make different assumptions about changes in the death rate. And different assumptions lead to vastly different projections.

If you assume mortality rates will not decline, by 2050 there will be 9.9 million Americans 85 and older—the current low estimate of the Census Bureau. But, if you assume that the impressive 18 percent decline in the death rate seen in the 1970s will continue, there could be 27.3 million 85-year-olds by 2050. That's the Census Bureau's high estimate—and a potential nightmare for Social Security and Medicare.

ALLOCATING ASSETS

When Social Security was initiated in 1935, life expectancy at birth was about 61 years, and there were 40 workers to support each retiree. Today, according to federal figures, life expectancy is 75.8 years and there are three workers per retiree.

The system is financed by payroll taxes—6.2 percent of each worker's paycheck goes to Social Security and another 1.45 percent to Medicare, for a total of 7.65 percent. Employers also kick in 7.65 percent per worker.

So far, it has worked. But, with life expectancy rising and Baby Boomers poised to retire in 2011, the system appears headed for collapse unless either payroll taxes are increased or benefits are changed.

According to 1994 government estimates, if no changes are made, the Old Age Survivors and Disability Insurance fund (paid out to retirees, survivors and people with disabilities) will have more money going out than coming in by the year 2013. At that point, trustees will have to dip into reserves to keep paying benefits. By 2029, if nothing is done, the reserves will also be depleted.

Another trust fund, the Hospital Insurance fund, also called Medicare Part A, will run out of money even sooner—by 2002, according to a 1994 report from its trustees.

To forestall insolvency of the Social Security system, Congress passed a law more than a decade ago stipulating that the age at which a person may retire with full benefits will go up to 67 from 65 by the year 2027.

In a society which finds a growing number of older people using a shrinking supply of health care assets, everyone has to make some decisions about where they will allocate their personal assets. The society as a whole also has to make these decisions.

One example: U.S. policy makers are so obsessed with the fear of manmade chemicals that they spend $31 billion a year that could be spent more effectively on other lifesaving programs.

This was the conclusion of a 1994 study released by the National Center for Policy Analysis.

According to the NCPA report, reallocating money spent on regulations of marginal value to areas where the payoff is high could add an average of 10 years to the life expectancy of 60,000 people every year. The study was based on the "Lifesaving Database," an information system created and maintained by Harvard University's Center for Risk Analysis.

Among other things, the system measures the cost of a "life-year saved" by each of 587 toxin controls, health care and injury prevention programs. A life-year saved is a statistical measure of the difference between an average life span and a premature death. Federal law forbids using this kind of analysis in government programs.

"We are, in effect, committing statistical murder by not comparing the costs and benefits of health and safety programs and spending the money where it does the most good," said John Graham, director of the Harvard Center and author of the NCPA study.

In this sense, an older population and environmental hazards are competing risks to the well-being of society as a whole.

CALCULATING INDIVIDUAL RISKS

Some computer modelling programs try to account for people's activities in their life expectancy projections. These programs can calculate long-term trends and adjust trends for individual scenarios, but they have a hard time reconciling the two in a way that's useful.

A health risk appraisal program developed by the Carter Center of Emory University in Georgia can make risk-sensitive projections for individuals. The program can tell a 25-year-old man who speeds and drinks while driving, fails to use seat belts, and smokes that he's already more than 30 years old in risk-adjusted years. His chances of dying over the next decade are more than twice the average for men his age. By changing his behavior, he could reduce his risk to that of a 19-year-old.

A major 1993 study by the Carter Center estimated that two out of three deaths and one of three hospitalizations in the U.S. are linked to a few key risk factors that are potentially preventable causes of illness and death. The study, called *Closing the Gap*, singled out six main personal health risks: tobacco, alcohol, injury risks, high blood pressure, overnutrition (as measured by obesity and high cholesterol levels) and gaps in primary care, particularly in prenatal and reproductive services.

These risk factors also account for 70 percent of "potential years of life lost," a numerical measure of the killers that most affect younger Americans, the Carter project found. (This was an ironic conclusion. Many of the federal government's policies against considering this kind of statistic stem from Jimmy Carter's presidential administration.)

Dozens of other health risk appraisals, including one distributed by the federal government, are already on the market. But many of these computer programs have been criticized for sometimes mixing science and pseudo-science, for failing to explain how their health risk was computed and for using outdated information.

"Health risk appraisal differs from health screening and diagnostic medicine: it does not presume to detect or diagnose an illness already in progress. Instead, it seeks to identify precursors associated with premature death or serious illness and to quantify their probable impact for each individual participant," explained one CDC life expectancy expert.

The origins of the health risk appraisal date back to the late 1940s when large-scale studies first looked into the causes of heart disease and other chronic disorders.

RISK ASSESSMENT PROGRAMS

Computer-based risk assessment tools are applied increasingly in the workplace. A 1994 survey for the government's Office of Disease Prevention and Health Promotion found that about 7 percent of private employers with 50 or more workers use such surveys.

But the health risk appraisal can backfire if recipients perceive it as too intrusive into their personal lives. An attempt by Seattle City Light, a public utility, ran into fierce opposition among some workers there. In August 1993, a lawsuit contended that the elaborate 17-page questionnaire violated constitutional privacy rights.

Employees were asked whether they picked up hitchhikers, carried a gun, lived or worked at night in high-crime areas or sought entertainment in high-crime areas or bars, whether they used drugs or medication that affected their moods or helped them to relax, as well as their opinions about the utility's management.

Unlike the City Light questionnaire, the Carter Center appraisal is a much more cautious four-page document that sticks to health-based questions and avoids controversial areas like drug use.

Although there are questions about diet and exercise, which are used in providing general health advice to the individual, they are not specifically used in computing a person's health risk. Instead, the Carter Center team evaluated the effects of both exercise and

diet in medical measures such as cholesterol level, blood pressure and weight.

Meanwhile the public health role of computerized risk assessments continues to be debated by the medical community. In a study in the *American Journal of Public Health*, D.W. Edington of the University of Michigan found that the CDC appraisal proved "very good in predicting mortality" when compared to the actual experience of a large community health study in Tecumseh, Michigan.

An unpublished study, conducted for the Kellogg Foundation on 1,700 patients near Tuscon, Arizona, found measurable benefits— less smoking, weight loss, cholesterol reduction—among those who received health risk appraisal.

"We found that mortality information has a bigger impact on people over 40. People under 40 want to feel good. People over 40 are starting to be real concerned," said the president of the Arizona company that conducted the study.

Insurance companies have also shown interest in these programs. The Prudential Insurance Company, whose foundation has pledged $500,000 to the Carter Center project, recently developed its own voluntary program to offer health risk appraisals to all Prudential employees.

Earlier, the insurance company pilot-tested a more basic lifestyle questionnaire that resulted in a 20 to 25 percent group premium discounts for certain employers, said one Prudential executive. "I really think that you will see insurance rating done on health risk appraisal in the future, both on group rates and on individual rates."

A similar program, developed at George Washington University, helps medical care providers predict when a terminally ill person will die with greater accuracy than doctors using only their own judgment.

The program is designed to help doctors determine which treatments should be given to terminally ill patients and help decide when life-support efforts should be stopped.

"The computer remembers thousands and thousands of cases and keeps the different risk factors in perspective," said William Knaus of George Washington University. "And when we included the survival estimate from the patient's own physician in the model, the two together predicted time until death more accurately than either alone."

The program was developed from June 1989 to June 1991, using information from 4,301 patients. It focuses on nine diseases and conditions, such as liver disease, colon or lung cancer, heart or lung disease and multiple organ failure.

Seriously ill patients with a projected life expectancy of six months were entered in the study when they were hospitalized.

Their heart rate, respiration, blood chemistry and other measurements were recorded when the patients were admitted and repeated four times in a month. The results were used to calculate the life expectancy of a patient.

SOCIOLOGICAL RISK FACTORS

A significant minority of social scientists prefer to look toward socioeconomic environment as the explanation for variances in life expectancy. In a controversial August 1990 article in the *Journal of the American Medical Association*, Mac Otten and colleagues from the CDC argued that socioeconomic status accounts for more than one third of the mortality differential between blacks and whites.

Essentially, Otten claimed that low income results in high risk factors limiting life expectancy.

The problem with this kind of analysis is that it doesn't tell anyone very much for certain. Socioeconomic factors are easy to establish as correlative occurrences. They're very difficult to prove as causal links. As a result, even people who agreed with Otten criticized his information-gathering and methodology.

One letter shows this attitude:

> Excessive drinking could result in being fired from a job. If the researcher's model suggests that risk factors lead to low income and if a number of risk factors are ignored, as Otten et al ignore exercise, then the statistical significance of income may reflect only multicolinearity among income and omitted risk factors, not a true causal relation between income and mortality. It could also be that the true causal factors that lead to both high income and low risk factors are unobserved personality traits, such as tastes for risk or delayed gratification, or unobserved genetic factors.
>
> Finally, odds ratios for the same risk factors may differ between blacks and whites. Their model does not allow for synergistic relationships between risk factors and race. If synergistic relationships exist, as economists have found in studying black/white differences in income, then their simple method of relying on one estimated coefficient...will yield biased estimates of the true black/white differences.
>
> In short, explicit model construction is necessary to test these alternative explanations.

With friendly readers like that in the scientific community, it's not surprising that risk experts generally prefer to avoid sociological issues. Any sentence that includes the phrases "synergistic" and "estimated coefficient" is bound to be trouble for anyone trying to figure reliable odds.

GLOBAL DEMOGRAPHICS

The World Health Organization's statistical yearbook released in 1994 offered a fairly reliable snapshot of life expectancy among various nations and ethnic subpopulations. The United Nations' health agency's report, nearly 600 pages long, contained thousands of statistics on causes of death around the world. It also suggested some counter-intuitive conclusions.

The WHO yearbook said Japanese men had the highest average life expectancy—76.3 years—followed by 75.1 in Israel. It said Swedish men live an average of 74.9 years and Australians, 74.8 years. The United States was further down the list with 71.9 years.

The average Japanese woman lived to the age of 83. French women had an average life span of 82 years, followed by Swiss women at 81.7 years.

Outside parts of Africa, where public-health conditions are often bleak, life expectancies have been rising steadily even as the global population booms. Sri Lanka, which had a life expectancy of 60 in 1950, now has 71; Malaysia, China and Venezuela have life expectancies of 70; Mexico, Surinam, Peru, Guatemala and other nations where poverty and social disorganization are dire problems, nevertheless have brought life expectancies into the high 60s.

Within the generally encouraging numbers, a number of factors acted to shorten life expectancy around the world. AIDS continues to spread; cancer rates are up sharply in absolute numbers; lung cancer caused by cigarette smoking is soaring; and there are worrisome indicators such as the increased resistance to antibiotics of the strep bacteria observed by many physicians.

But a number of health experts point out that lung cancer—and other cancers—are a sign of public health successes. As a rule, cancer is an older person's disease. Growing cancer rates are testaments to the things people aren't dying of at earlier ages—malnutrition, cholera, polio, strep fevers and heart disease.

Still, many preventable diseases remain shocking in their global magnitude. Two million people die annually from malaria, with perhaps another 250 million enfeebled by the chronic malady. Three million people in developing nations die annually of tuberculosis. Hundreds of millions more suffer from malnutrition, which weakens the body, causing otherwise non-fatal diseases to exact a worse toll.

THE RISK MECHANICS OF OLD AGE

The two most frightening prospects for older people are falling down and succumbing to Alzheimer's disease. These fears have some legitimate base—those are two of the most common fatal threats to people over 65.

Falls are the leading cause of injury deaths among the elderly, claiming 10,000 lives annually. People 75 and older account for 59 percent of all fall deaths, even though they are only 5 percent of the population.

"The mortality and morbidity from falls is tremendous," says Susan Baker of the Injury Prevention Center at Johns Hopkins School of Public Health.

Her research shows that falls cause 87 percent of fractures among elderly patients, sending 210,000 to 250,000 to the hospital with hip fractures each year. Women are particularly at risk because of osteoporosis. One study showed that hip fractures accounted for more than $3 billion in direct medical costs in 1986.

Too often, these hospitalizations precipitate a spiral of deteriorating health. As we've seen already, some patients succumb to fatal complications or become more susceptible to chronic health problems, such as heart disease and cancer. The CDC reports that the mortality rate for hip fracture patients in the first year following the injury is as much as 20 percent higher than for patients of comparable age and condition who have not suffered fractures.

Women also face worse odds with Alzheimer's disease. They are more than twice as likely as men to develop at least mild cases of Alzheimer's if they live a normal 80-year life span.

In the study, Harvard researchers examined 642 elderly residents of East Boston. According to the data, about 16 percent of women and 6 percent of men who live an average life span are likely to develop at least mild cases of Alzheimer's disease. Nearly half of those who reach the age of 90 will develop the disease.

"Our oldest age groups are our fastest-growing age groups. Unless we do something about it, we're going to have an even more severe problem on our hands in a few years," said Denis Evans, a study co-author. "Probably our best hope is to increase research efforts into ways to prevent the disease."

The study found that 4.7 percent developed it by age 70, 18.2 percent by age 80 and 49.6 percent by age 90.

Evans defended the randomness of the survey. He said residents were selected by researchers who went door to door in East Boston, also the site of a landmark 1989 study he authored for the National Institutes of Health. The NIH study first pinpointed the prevalence of Alzheimer's in the population—about 10 percent of those over 65.

That study prompted the National Institute on Aging to revise its estimate of how many Americans suffer from the disease—from 2.5 million to 4 million. Some said the new estimate was too high.

Evans said the more recent results showed the rate of incidence of Alzheimer's disease among older people to be substantial and higher than previously reported.

CONCLUSION

Our culture conditions us to hold certain expectations about aging. The truth is that everyone ages a little differently. Some of these differences are determined by our genes, but many are affected by our individual choices.

According to the National Institute on Aging, many of the signs we associate with aging are not caused by age itself, but by inactivity, injury or disease. New research suggests that we may be able to postpone or even prevent certain age-related complications by changing our habits, especially in our younger years.

Diet matters most to older people. Studies by nutritional biochemists at Cornell University, have shown that "the richer the diet in nutrients provided by plant matter, the greater the reduction of degenerative diseases."

Recent research suggests that the earlier one begins eating a healthful diet, the greater the benefit from its protective properties.

Diet is "fundamental" to healthy immune functioning, especially in the very young and the elderly, says Jeffrey Blumberg, associate director of the U.S. Department of Agriculture's Human Nutrition Research Center on Aging. "Infectious disease is the fourth leading cause of death among older people, and a lot of that has to do with the fact that there seems to be a decline in the immune system with age. You have less resistance. You get sicker more easily with any virus or bacteria."

A professor at New Jersey Medical School in Newark, found that a standard over-the-counter multivitamin-and-mineral supplement made a significant difference in immune response among seniors he studied.

Interleukin-2 also has shown promise in the fight against spreading tumors of the kidney and skin. About 5 percent of 283 patients receiving high doses of the genetically engineered drug became cancer free and remained that way for seven months to eight years, the longest any patient in the study was followed.

The lead researcher, Steven Rosenberg, chief of surgery at the National Cancer Institute, said interleukin-2 continues to be promising. But the more exciting recent development: The identification of genetic coding for cancer cells that will trigger an immune response. "That opens a lot of new possibilities for the development of cancer vaccines," Rosenberg said.

In a culture obsessed with thinness, it's hard to imagine that losing weight could be deadly. But if you're older, there may indeed be a point when you should be concerned.

Reubin Andres, clinical director of the National Institute of Aging, part of the National Institutes of Health, is probably the main proponent of the theory that a modest weight gain as you age may be not only acceptable, it may be healthy.

In one well-known paper published in 1993, Andres and his colleagues analyzed data from 13 studies and found the highest mortality rates in those who had lost weight or gained excessive weight. The lowest mortality rates occurred in those who had modest weight gains over the decades. In another re-analysis of weight and mortality in a group of seniors, Andres found no increase in mortality with increased weight gain except at the highest weights.

Based in part on Andres' work, the Department of Agriculture revised its weight tables in 1990 to allow for weight gain—about 15 pounds—over age 35.

But there were some critics of Andres' research. Graham Colditz, an associate professor of medicine at Harvard Medical School, argued that Andres' studies weren't complete. Among other things, Colditz claimed Andres hadn't correctly factored in the effects of smoking.

Smokers tend to be thinner, which may be why thinner people fared less well in Andres' studies looking at overall mortality. And, Colditz argues, the more you gain weight—even modest amounts of weight—the more at risk you are from diseases that can shorten your life, such as stroke or diabetes.

In a study from the ongoing Nurses' Health Study in the Annals of Internal Medicine, Colditz and his colleagues found that even a modest weight gain—between 15 and 22 pounds—after age 18 doubled a woman's risk of developing diabetes over a lifetime.

Of course, many health problems are still linked to a genetic predisposition. While you can't change your genes, most gerontologists say that genetics are more a matter of predisposition than fate. By making yourself aware of disorders that are common to your

family and taking precautions for their prevention, you're doing the best that you can to bolster your odds of a long life.

"Exercise is the closest thing to an anti-aging pill there is," according to Alex Leif of the Harvard Medical School of Gerontology.

Studies at the National Institute on Aging have repeatedly shown that regular cardiovascular exercise and strength training have a profound effect on human aging. Researchers also are finding that exercise may delay disability and disease that we are so used to thinking of as the unavoidable cost of growing old.

Now, we just need to find a way to pay for that longer life.

How

PART TWO:

results are

analyzed

2

5

This is your brain on a cellular phone

In January 1993, David Reynard went on Larry King's television talk show to publicize his civil lawsuit against two cellular phone companies. On the television show, as he had in Florida federal court, Reynard charged that his wife Susan had died of brain cancer caused by the microwaves emitted by her cellular phone. He sought damages from NEC Corp., which had built the phone his wife used, and GTE Mobilnet of Tampa, which supplied her cellular service.

The next morning, U.S. stock markets reacted to the "news" that cellular phones caused brain cancer in their typically panicked manner. They fled from the stock of all the major cellular phone companies, not just the two named in Reynard's lawsuit—simply because a distraught husband wanted to blame someone for his wife's untimely death.

In recent history, few situations have illustrated the faulty crunching of risk numbers so well as the cellular phone panic of 1993 and 1994. In this model, people mistook an unspectacular correlation between an activity and a result for a causal link. It combined elements of urban folklore with the fear of new technology that seems a fact of life in the present age.

In this chapter, we'll look at how the various sides of the cellular phone debate lined up and presented their arguments. Their differences have something to do with the ways in which they collected their information. But, even more so, the differences have to do

with the manner in which different parties processed roughly similar data.

We'll also take a quick look at a related issue: Whether electromagnetic fields (EMFs)—which are in some ways like cellular phone microwaves—cause disease in people who live near the power lines that emit them.

SOME BACKGROUND

The use of cellular phones in the United States exploded from the mid-1980s to early 1990s. The devices, which started out as hand-bag-sized "portable phones" in the 1980s, progressed in a few years to "flip phones" small enough to fit in a shirt pocket.

By 1994, some 14 million Americans were using cellular phones—a third of them hand-held portables. Experts predicted that number would reach 60 million by 2000.

The alleged risks posed by these very small phones are caused by the microwave transmissions that connect them with local cellular networks. Antennas, little more than four inches in length and usually concealed within the device, channel focused microwave blasts through the head and shoulders of people using the phones.

All devices that transmit radio signals—including broadcast towers and cellular phones—emit radio-frequency radiation. This radiation is electromagnetic energy emitted in the form of waves. Cellular antenna foes contend that electromagnetic fields radiating from the antennas are harmful.

(Electromagnetic radiation is known to cause warming in human tissue, which can cause bad side effects. But standard safety limits already address this problem by prohibiting use of the frequencies that cause the warming.)

Some studies have linked stronger electromagnetic fields, usually referred to as EMFs, to cancer. These EMFs are created by the high-

tension power lines that carry electricity between generating plants and substations.

But EMFs of varying strength are created every time a current runs through a wire. They emanate from sources ranging form high-voltage transmission lines to household electrical appliances like the microwave and television set.

Cellular phone companies insist that critics wrongly confuse the microwave radiation generated by cellular phone antennas with the electromagnetic radiation emanating from electric power lines.

Yet the people suing cellular phone companies are persistent. They insist that the small fields of radiation are enough to create a physical or chemical process in the human body.

Research into whether cellular phones and EMFs actually cause cancer is fairly incomplete and vastly misunderstood.

For instance, several news stories covering the lawsuits alleging a connection between cellular phones and brain cancer have stated, usually without attribution, that researchers "have found no statistical correlation between the two."

No such analysis has ever been done. Industry studies have hardly begun, and an epidemiological effort at the National Cancer Institute will not be completed until 1997 or 1998.

David Savitz, an epidemiologist at the University of North Carolina, said "no one has systematically evaluated whether people who use cellular telephones have an increased risk of developing brain cancer," although there is some work in progress.

THE CASE FOR A LINK BETWEEN CELL PHONES AND CANCER

No studies connecting the microwave frequencies used by cellular phones and cancer have been completed yet. However, a number of

partially-completed experiments are sufficiently worrisome that the risk cannot be dismissed.

For instance, a team at the University of Washington has found that a single two-hour exposure to microwaves can cause breaks in the DNA structure in the brains of live rats. This DNA breakdown has been cited in at least two lawsuits that followed in the wake of David Reynard's charges.

Selwyn Eastwood, a Canadian car broker, used to rack up as many as 1,500 minutes a month making business calls. But that all changed when he was diagnosed as having brain cancer—after that he wouldn't stay in the same room as anyone using a cell phone.

Eastwood died in October 1994, three months after he was told of his illness. And, while Canadian government scientists, phone industry officials and the dead man's own doctor said there was no evidence that cellular phone use is dangerous, his widow sued the British Columbia phone company that her husband had used.

It was the biggest cellular phone lawsuit in Canada—and was likely to form the basis for a class action lawsuit on behalf of other Canadian cellular phone users.

The second significant case came from within the cellular phone business. Debbra Wright, a real estate manager for Bell Atlantic Mobile, filed suit against her employer and its corporate parent, Illinois-based communications giant Motorola Corp. Wright claimed that the use of her cellular telephone caused her benign brain tumor.

Though Wright's charges have little conclusive scientific support, she picked the right lawyers to represent her. The law firm she hired had six cases pending against Motorola involving brain tumor allegations. The firm had also represented plaintiffs in an earlier class-action suit, which included some of the plaintiffs in the six other cases. The case had been dismissed but was under appeal.

At the time her lawsuit was being filed, Wright was undergoing the second surgery to remove her brain tumor. An attorney representing her said the surgery could make her well, cause blindness or muteness or leave her in a vegetative state.

Wright had apparently used her cellular phone even more than the Canadian car dealer had. According to her lawyers, she had used her phone from February 1988 until March 1994 from one to six hours per day.

Among other charges, Wright's suit alleged that Motorola and the Cellular Telecommunications Industry Association (CTIA) had withheld information from the public showing a link between the use of cellular telephones and brain tumors.

Motorola said current scientific research does not support that radio energy is absorbed deeply into brain tissue.

"I hate to tell the lawyers, but CTIA hasn't been around that long, and neither have cellular telephones," Mike Houghton, a spokesman for the association, said. "This ought to tell you how well thought-out the suit is."

COUNTERING THE CHARGES

Wright's lawsuit cited one study that showed that "rats experienced breakages in several strains of DNA tissues after being exposed to microwave radiation equivalent to levels transmitted from cell phones for two hours. DNA damage is related to the initiation of cancer."

She claimed that Motorola had concealed these results from the public.

The suit also cited another study in which cells in a petri dish showed no abnormalities after being exposed to radio waves in the cellular phone spectrum.

Motorola had used the study as evidence that cellular phones are safe. The suit claimed that the company "failed to note that these studies showed that the radiation, when modulated, does induce biological changes."

Motorola maintained that DNA breaks do not cause cancer. "DNA in our bodies breaks several times each day, and it is part of the overall biological process," said a company spokesman. "When you run, when you drink orange juice, you get a biological change....There is no relationship between a biological change and a health hazard. These [attorneys] would fail Logic 101 in college."

After David Reynard's lawsuit had been filed in Florida, Motorola had sponsored a study of more than 50,000 employees.

"Since Motorola designs and builds [phones], the hypothesis was that there ought to be a higher ratio of brain tumors from the Motorola population. But in fact, the research found [the ratio] was lower than expected for the people of the same age and sex," a company spokesman said. "You are going to find brain tumors throughout the population whether you use cell phones or not, wear Stetson hats or not or whether you ride a bike. A certain percentage of the population will have a brain tumor."

From a risk assessment perspective, this was a strong argument against linking the brain cancer to the cellular phones.

"We have to deal with the scientific facts, even though they may not be as sexy as emotions and making claims you can't back up," CTIA spokesman Mike Houghton said in response to questions about Wright's lawsuit.

But the cellular phone industry lobby seemed just as willing to play to emotions. Houghton used the image of saving the lives of children to maintain his group's innocence. "The majority of people buy cellular phones for reasons of safety and security. You have to have antenna towers to be able to provide both," he said. "More children's lives can be saved with cellular antennas than without."

THE VARIOUS ONGOING STUDIES

To find more reliable data, you have to get away from the terms of the lawsuits and consider the several scientific studies exploring the possible connections between cellular phones and cancer. Even some of these studies are funded by interested parties, but—as a group—they offer more substance for risk assessment.

The most important piece of research was a 1993 University of Washington study that found rats had trouble learning a maze after 45 minutes of exposure to low-level, pulsed radio-frequency radiation similar to some cellular device frequencies.

A study begun in 1995 at the City of Hope Medical Center in southern California aimed at replicating and expanding on the Washington group's results. It ran experiments on rats in which electromagnetic fields from cellular phones were directed at the animals' heads. A computer map of a rat's head analyzed how the rat was affected by the radio frequency. The tests were scheduled to occur over a three-year period.

In December 1994, UCLA engineers said they had come up with a better computer model for gauging how much electromagnetic radiation the body absorbs from cellular telephones. The new model, one of several being developed by researchers in the United States and overseas, is based on a study of four antenna designs.

Using the computer model, engineers could create antennas that put more of the microwaved telephone signals into the air and less microwave energy into the body.

"As engineers, we can make no determination of the effect on tissues that these levels of absorption may have," said a professor involved in the study. "Now, if physiologists are interested, we can collaborate."

Some of the groups investigating potential hazards said they would take the study into consideration.

"It's another piece of information that the FDA can use in its evaluation of the safe use of cellular phones," said Sharon Snyder, a spokeswoman for the Food and Drug Administration in Washington.

The only federal agency currently conducting research on the safety of the phones is the National Cancer Institute. In 1994, the NCI began interviewing 800 newly diagnosed brain tumor patients and 800 people who don't have brain cancer to determine their risk factors.

"The patients are from three hospitals—in Phoenix, Boston and Pittsburgh," said Martha Linet, co-principal investigator.

While the NCI study was scheduled to be completed in 1996 or 1997, a German research team announced in December 1994 that the results of its studies "have so far yielded no indications that high-frequency alternating electromagnetic fields like those used in mobile communications cause or promote cancer."

The group, called the Communications Research Association, was supported by the German government and several of its research institutes as well as German telephone makers and networks.

The studies, which involved exposure of up to 70 hours, found no increased growth rates or mutations of chromosomes in human cells that could point to an increased cancer risk, and no indication that the cell metabolism was impaired.

Back in the United States, another ongoing research initiative is being undertaken by Wireless Technology Research, a group which the CTIA helped to establish. To date, WTR has found no evidence linking the use of cellular phones to brain tumors.

Ian Munro—a Canadian pathologist who works with WTR—has written that "even direct associations are difficult to establish with epidemiology studies due to a number of potential biases."

However, epidemiology is often the only human data available to investigate possible risks to human health from environmental agents.

That's why it's become such a critical compenent of public health risk analysis.

In epidemiology, an association (usually statistical) between exposure and outcome must be critically evaluated to determine cause and effect. An association which is observed in an epidemiological study can be classified in one of three ways: artifactual, indirect or consistent with and inference of causality.

An artifactual association is one that is false or fictitious resulting from a chance occurrence or from some bias in the design or execution of a study. An indirect association is one in which a factor and a disease are associated only because both are related to some common underlying condition. An association is consistent with causation when:

- the exposure occurs prior to the onset of the disease;

- modifications in the level of intensity of exposure are positively correlated with changes in the occurence of the disease; and

- there is no reason to believe that the changes in exposure and disease occurrence are the result of a prior factor common to both.

Several scientists have written about considerations for drawing inferences of causation from epidemiology studies presenting results consistent with causation. For the most part, these considerations focus on placing interpretational limits around results. They include whether or not:

- biases are present in the study;

- confounding factors account for the observed association;

- chance is a likely explanaton for the association; and

- there is a biological basis for concluding that a cause and effect relationship exists.

The concept of extrapolation is always complex. Making useful conclusions about people from theoretical models, animal tests or cell tests is particularly difficult.

According to WTR:

> Adding to the already complex nature of this topic are particular problems related to the study of cellular phone radiation and the assessment of its potential health effects. For example, the need to consider dose and exposure extrapolations will require both biological and engineering expertise. Additionally, extrapolation of data from diverse endpoints to a very specific outcome is a unique problem possibly requiring new approaches and models.

Debbra Wright's lawsuit alleges that WTR and its peer review board "were chosen by the defendants, controlled by them and set up to frustrate and cover up the truth."

The CTIA emphasizes that its funding of scientific research is funneled through a blind trust, which frees the researchers from any concern about pleasing interested parties. "[The issue] is in the hands of the scientists," the CTIA's Mike Houghton has said. "We are trying to find out if there is a problem. Every day the cellular phone goes through more scrutiny than any unregulated consumer product in history."

Houghton said that if the research group finds a health risk, it would notify the Food and Drug Administration, which would quickly regulate phones.

The Food and Drug Administration has said it is unlikely that radio waves from the phones cause cancer, but the agency has suggested people should not spend hours at a time on a cellular phone.

CELLULAR PHONES AND PACEMAKERS

In 1994, FDA staff met with cellular-phone makers to talk about ways to reduce exposure to electromagnetic waves, the agency said.

One possibility is redesigning the phones to move the antenna away from users' heads.

In May 1995, WTR announced that it was beginning a separate study to determine whether wireless devices affect pacemakers. WTR would conduct tests on volunteers having routine pacemaker check-ups.

The tests would be conducted at the Mayo Clinic, Mt. Sinai Medical Center in Miami and George Washington University in Washington, D.C.

The results of the study might cause some pacemaker wearers to think twice before using a cellular phone. Some pacemaker manufacturers already provide warnings about cellular phone use. Most recommend that people with pacemakers avoid carrying a cellular phone in their breast pocket, keep the handset about 12 inches from the chest, and hold the phone on the side of the head that is opposite the pacemaker's location.

The CTIA viewed the pacemaker study in a totally different light than the brain cancer scare, which was perceived as a health risk that could cause death as a result of use. The CTIA said pacemaker and cellular phone interaction could be managed and not result in death.

An earlier study which used analog and digital phones found interference could occur when a cellular phone was in close proximity to a pacemaker. Another study which involved two analog phones found no interference.

THE GOVERNMENT'S ASSESSMENT

The U.S. General Accounting Office, at the request of Massachusetts Congressman Edward Markey, spent 21 months assessing the status of scientific research into possible health effects from the radiation emitted by the phones.

GAO investigators said some research has found biological and behavioral effects from exposure to low-level radio-frequency radiation. But they went to great lengths to point out the inconclusiveness of the studies. Among the GAO's comments:

- Both FDA and EPA believe that the evidence is insufficient to conclude that these effects pose a health risk to humans as a result of exposure to radio-frequency radiation from low power sources like portable cellular telephones.

- On the basis of present scientific knowledge, FDA and EPA have had no reason to take regulatory actions on the use of portable cellular telephones.

- Studies on exposure to low levels of radio-frequency radiation from sources other than portable cellular telephones have found biological and behavioral effects in animals and certain cell systems. However, both FDA and EPA believe that the evidence is insufficient to conclude that these effects pose a health risk as a result of exposure to radio-frequency radiation from low power sources like portable cellular telephones.

- Researchers found no evidence that radio-frequency treatment altered the course of tumor development in rats.

- Some recent biological and behavioral laboratory studies...have provided information on the potential health effects posed by low-level exposure to radio-frequency radiation, although none has examined radiation exposure specifically from cellular telephones.

"The GAO report concludes that available scientific evidence is insufficient to determine whether radio-frequency radiation from portable cellular phones presents risks to human health," said Congressman Markey, in an open letter he sent to the White House. "This is particularly disturbing because more than 16 million persons in the United States now use cellular phones."

The CTIA immediately took issue with Markey's interpretation. Association President Thomas Wheeler answered Markey's letter with an open letter to the congressman arguing that the studies which

did indicate some connection between electromagnetic fields and cancer "deal with power levels and frequencies different from those used by cellular phones."

Wheeler's letter went on to insist:

Some recent biological and behavioral laboratory studies have provided information on the potential health effects posed by low-level exposure to radio-frequency radiation, although none has examined radiation exposure specifically from cellular telephones.

THE CASE FOR A LINK BETWEEN EMFS AND CANCER

The ongoing studies of cellular phones and cancer lead directly into the bigger question of whether any electromagnetic fields have a connection to the disease.

A study of more than 200,000 electrical workers in Canada and France found an "association" between EMFs and one rare type of cancer, known as acute lymphoid leukemia.

However, the study failed to find any evidence that the risk of cancer rose as the degree of exposure to EMFs increased, a so-called dose-response effect, which would have been a strong hint that magnetic fields might cause cancer.

In 1992, a landmark study appeared from Sweden. A huge investigation, it enrolled everyone living within 300 meters of Sweden's high-voltage transmission line system over a 25-year period. The Swedish researchers went far beyond all previous studies in their efforts to measure magnetic fields, calculating the fields that the children were exposed to at the time of their cancer diagnosis and before.

The resulting study reported an apparently clear association between magnetic field exposure and childhood leukemia, with a risk ratio for the most highly exposed of nearly 4 times normal.

But there were number-crunching flaws in this study. When American scientists saw how many things the Swedes had measured—nearly 800 risk ratios are in the report—they argued that the Swedes had fallen into one of the most fundamental errors in epidemiology, sometimes called the multiple comparisons fallacy.

Put another way, with a large enough sample, outrageous things are apt to happen. Risk theorists call this phenomenon the law of very large numbers or the "Texas sharpshooter problem."

In their thoroughness, the Swedes may have created this kind of problem. Even if nothing is going on due to power lines, hundreds of risk ratios will scatter by random chance around a statistical mean—some above and some below.

You can't infer extreme trends from some extreme results, which may have resulted from chance.

The summary of the Swedish studies highlighted one extreme result: the nearly fourfold increase in risk of childhood leukemia. This was what the popular media picked up and what the public heard.

The flaws in the French-Canadian and Swedish studies reflect a common occurrence in research that tries to link cancer with environmental risk factors: You can't apply disease paradigms to external physical forces. As Patricia Buffler of the School of Public Health at the University of California told one television show:

> Epidemiology is not sufficient in and of itself unless you have a situation where you have an overwhelming disease response, and we have a few examples like that. The vinyl chloride monomer story, where a small number of workers developed a very rare malignancy, angiosarcoma of the liver, and were identified as having very high exposures to vinyl chloride monomer in the process of cleaning out some of the reactors. There we had a risk ratio which exceeded 200.

A relative risk or odds ratio compares a rate of incidence in a specific situation with the rate of incidence in the general population. Most EMF studies have found elevated risks of cancer—but those odds ratios are usually only 1.5 to 2.0.

Paul Brodeur, a scientist and anti-EMF activist argued on the television news show *Frontline* that the disease paradigm can work in studying outside risk factors:

> The first thing you ask is how strong are the correlations when you see them, so my favorite analogy is to cigarette smoking. Cigarette smokers have 10 to 20 times the incidence of lung cancer of nonsmokers. That's a strong association. In the power frequency studies, where we find associations, they've tended to be pretty weak....

> It was through epidemiology that we learned that cigarette smoking was hazardous, through epidemiology that we learned that asbestos inhalation was hazardous, through epidemiology that we've learned that virtually every one of the environmental carcinogens that we know today, and against which we've taken action, has come to light through epidemiology. So the physicists are going to tell us "No, forget epidemiology, let's go into the lab." Give me a break. You know, when have they ever discovered anything about biology?

THE CASE AGAINST A LINK

While laboratory research has shown that EMFs can produce biological changes, the consensus among scientists is that there is insufficient evidence to conclude that normal exposure to EMFs is hazardous or that there is a cause-and-effect relationship between cancer and exposure to EMFs.

The biggest reason for some doubt: Even without cellular phones or power lines, we live in a huge electromagnetic field.

Magnetic fields are measured in milligauss. The fields recorded in most homes are of the order of a few milligauss, at most. But the earth's magnetic field, which causes a compass needle to point north, is hundreds of times larger. In America, it is about 500 milligauss.

The earth's field, physicists argue, would totally dwarf those from man-made electronic devices.

Yale physicist Robert Adair has explained this issue succinctly:

> It's completely lost in the noise. The oscillation from the magnetic fields is absolutely minute compared to the general thermal oscillations. They would be a little like—let's say that you have a windstorm, and an erratic windstorm, where the wind's blowing all over the place, and...your neighbor calls up and says, "Your cat is breathing on my tree. Since he breathes in and out, that causes the tree to be pushed in and out, and that might damage the tree." You wouldn't take it very seriously.

In May 1995, the American Physical Society put out a statement debunking the alleged link between cancer and electric and magnetic fields from electric power lines. It was a rare act for the generally circumspect scientific group.

The group argued that concern over health effects of EMFs was diverting research funds that could be used for better purposes. "More serious environmental problems are neglected for lack of funding and public attention," the APS statement said. "The burden of cost placed on the American public is incommensurate with the risk, if any."

So what is behind the epidemiological studies that show various links between EMFs and cancer? "The evidence is getting weaker and weaker as this goes on," Robert Park, APS spokesman and physics professor at the University of Maryland, said. "And as you get more studies, they are becoming completely inconsistent with each other."

Indeed, one published report referred to an epidemic of male breast cancer among telephone linemen in New York State. A closer look at

the data revealed that, although the cancer cluster produced at a relative risk of something like 6.5:1, there were only two cases that were recorded. And the two people reporting weren't linemen at all. They were phone company office workers. On the basis of these two cases, some scientists and many media outlets concluded—wrongly—that there was a serious problem.

By early 1995, some results from the different labs were beginning to come in. The EMF rodent exposure laboratory in Chicago had completed five studies. The first study explored whether power line magnetic fields caused fetal abnormalities.

As the leader of that study reported:

> We evaluated a total of 3,000 animals. We did complete skeletal evaluations, evaluations of the head, evaluations of all the visceral organs, and that study was completely negative. We found no adverse effects from the magnetic fields at all.

> ...The end points we looked at were number of successful pregnancies, number of litters which were actually delivered, number of pups per litter, birth weight, and a number of other parameters to assess the health of the pups once they're delivered, and again, the results of that study demonstrated no effect of the magnetic field on reproductive performance in either sex.

> ...we found no evidence that magnetic fields stimulated lymphoma production in either strain.

While some studies are still under way, the conclusion to date has been that environmental risk factors like EMFs aren't strong enough to be isolated and identified effectively. High tension power lines probably do increase your chances of contracting certain kinds of cancer, but the effect isn't strong enough to make a significant difference.

If an electrician working around high-tension power lines all day uses an electric blanket at night, he or she may actually get an equivalent amount of exposure at home and on the job.

CONCLUSION

In May 1995, a federal court judge in Florida dismissed David Reynard's lawsuit against NEC and GTE Mobilenet.

Judge Ralph Nimmons threw out the suit on the grounds that Reynard's charges had been based on "junk science."

Reynard, who had originally filed in Florida state court, had been pleased when it was moved to federal court because the defendants weren't located solely in Florida. In the end, that move worked against him.

In dismissing the case, Nimmons cited the U.S. Supreme Court's decision *Daubert v. Merrill Dow*, in which the high court said that assertions such as Reynard's must be based on "sound science."

Nimmons rejected the testimony of Reynard's expert witness, physician David Perlmutter:

> Dr. Perlmutter makes no reference to any independent research regarding the use of the type of cellular telephone that Susan Reynard used or the use of any cellular telephone, or research regarding the type of radiation to which she was allegedly exposed.

As required by *Daubert*, Nimmons noted that the evidence Perlmutter offered had not been peer reviewed or published in a reputable scientific journal.

The cellular phone industry was ecstatic at the result. "The court threw out the suit on the very specific grounds that it represented junk science, not supported by accepted scientific or medical research," said Thomas Wheeler, CTIA's president. "We've been saying the same thing ever since the suit was filed."

Reynard had mounted a high profile public relations campaign over the case. He'd hoped an appeal to popular emotions would carry his claim. In the end, he didn't have the numbers on his side.

As several commentators pointed out, the risk data available for cellular phones (and, to a lesser degree, all EMFs) are so inconclusive, the phones could be shown to prevent cancer as well as cause it.

The sophistic argument goes like this: Assume 840 people who used cellular phones in the United States in a given year developed brain cancer. If there are 14 million cellular phone users in the U.S., the evidence suggest a rate of incidence for brain cancer of 6 per 100,000. But, if 6 per 100,000 is also the rate for brain cancer in the entire population, then it is entirely possible that cellular phones have nothing to do with brain cancer.

Since the reported number of cellular phone users with brain cancer has been below even one year's estimate of 840, and lacking any medical evidence of a cause-effect relationship, it would be just as plausible to argue that cellular phones prevent brain cancer.

That conclusion may seem absurd, but it has a stronger statistical basis than Reynard's lawsuit.

Even if some of the ongoing studies establish a link with brain cancer, we still face the decision of whether modifying all those cellular phones is really worthwhile—especially if the money could cure other diseases in a more effective manner.

Peter Vahlberg, a professor at the Harvard School of Public Health, makes a similar point about power lines and EMFs:

> ...you might argue that if you believe there is an elevated risk from an adjacent nature of the power lines, you could move the children out. But if this, in fact, involves putting them on a vehicle such as a bus and driving them a mile or so, we know from real actuarial statistics that being on a bus does carry some real health hazards, in terms of injury and death. The EMF risk is likely very small, it's hypothetical on several bases, whereas the risk from getting in a car is very concrete. It's very real. We know how to calculate that. And to say that you're going to incur these concrete risks in order to avoid this hypothetical risk doesn't seem to make a lot of sense.

6

The shortest risk
between two points

Most people think of travel risk in terms of the odds that their plane will crash, their train will derail or their boat will sink. This reflects the general trend in popular risk assessment to telescope risk perception.

Telescoping means focusing on the few dramatic losses rather than the many mundane losses. The many mundane losses often pose a greater risk to the average person than the few dramatic ones.

According to the National Highway Traffic Safety Administration (NHTSA), an agency of the U.S. Department of Transportation, the 1993 motor vehicle fatality rate was 1.7 deaths for each 100 million vehicle miles driven. This was the lowest rate since 1921, when the government began estimating vehicle miles on the basis of gasoline taxes and average miles to the gallon.

In 1992, 39,235 Americans died from traffic injuries, 75 percent in cars or light trucks. About 45 percent—17,699 deaths—involved alcohol or controlled substances. "Thirty-nine thousand deaths annually is a very large number. It's the equivalent of a jetliner going down every day. That's how many people die on the roads," said an NHTSA spokesman.

According to the NHTSA, on an 800-mile automobile trip your chances of being killed in an accident are about 1 in 100,000. But, put in the context of daily driving, the odds become a lot more real.

If you cover an average 10,000 miles a year, the annual odds of being killed in an accident that year are about 1 in 4,000.

Drive 10,000 miles every year for a lifetime, and the chance of dying in an accident are about 1 in 60.

This gets back to an old conflict. Scientists talk about group risk, while the public wants to know about individual risk. Statistics for automobile fatalities may yield a lifetime risk of 1 per 100 persons dying in an car wreck—but this doesn't mean that a particular person's chances of dying in a car accident is 0.01.

Numerous variables affect a particular risk—driving skills, location, driving schedule, just to name three. And you don't have to die to suffer from an auto accident. There are more than 3 million non-fatal injuries annually, about 400,000 of them serious. So, the number of injuries may run ten times the number of deaths. And the total estimated economic toll from motor vehicle crashes in 1990, according to one government report, was $137.5 billion when property damage, the loss of future earnings and medical expenses were taken into account.

Efforts taken to control some of these social risk factors have started—slowly—to pay off. NHTSA estimates suggested that in 1992 alone, 5,226 lives were saved by safety-belts, 268 by child seats, 559 by motorcycle helmets and 795 by stricter limits on alcohol use. But people continue to telescope their fear of travel risks.

To understand this telescope, this chapter focuses on the relative riskiness of various forms of transportation—cars, airplanes, boats and a few others.

Essentially, the issue of safety in transit focuses on the odds of mishap or accident in one—say, a plane crash—versus another—say, an auto accident. We'll take apart each and compare all.

SOME BACKGROUND

Social and demographic trends reflect factors that affect the odds of travel-related injury or death. For instance, motor vehicle death rates generally go down as the income in a given area goes up. People in low income areas have a greater risk of car accidents, perhaps because of poorer roads, older cars, different driving practices, differences in alcohol use, lower seat-belt use and inadequate emergency and medical care.

Adolescents and young adults are at highest risk for both fatal and nonfatal injuries related to motor vehicles. Injuries from motor vehicle crashes are the sixth leading cause of death in the United States and the leading cause of death for Americans ages 6 to 33, according to NHTSA numbers.

More than 6,600 U.S. teenagers died in vehicle crashes in 1991.

Motor vehicle deaths account for more than 40 percent of all mortality among those in their late teens. Drivers aged 16 to 20 make up just 7.4 percent of the population but are involved in 15.4 percent of fatal crashes nationwide. That's nearly 2 percent of the deaths for every 1 percent of the young drivers—and a relative risk of 2.3 more than older drivers.

Consequently, even young people with pristine driving records pay higher premiums than adults with clean records, except in a few states that ban insurance rates based on age.

State Farm, the nation's largest auto insurer, says an unmarried male in New York who is under 21 and has his own car pays more than three times the rate for a man over 25. (Single women under 21 do somewhat better, paying 55 percent more than adults.)

Risk analysts in the insurance industry point to studies showing that driver's education does little to reduce accidents and that, in fact, it might have the opposite effect by enabling people to drive younger.

A study by the Virginia-based Insurance Institute for Highway Safety isolated 16-year-olds from other teens, a group that for years has been saddled with higher rates by insurance companies.

The study was based on 1,078 fatal crashes in 1993. It found that 16-year-olds are:

- involved in one fatal crash for every 6 million miles they drive, more than twice the accident frequency of other teens and ten times the average for all drivers;

- involved in more single-car crashes, which account for 44 percent of fatal crashes involving 16-year-old drivers; and

- more likely to be speeding than drivers of other age groups. Thirty-seven percent of all 16-year-old drivers in fatal crashes were speeding.

So, should you be concerned about the neighbor's sixteen-year-old who just got his driver's license? Yes. The odds are ten times greater than average he'll be in a fatal accident; and they're better than not that he'll involve someone else in the process.

But the concerns don't end with your neighbor's sixteen-year-old. If that neighbor's 75-year-old father is still driving, you need to look more carefully for him, too.

The rate of fatal accidents per mile driven is higher for drivers over 75 than it is for teenagers. And seniors die even as a result of low-speed side crashes; at speeds under 33 m.p.h., 86 percent of occupants over 60 died, compared with almost no one under 40, according to a study published in 1993 by the Society for Automotive Engineers.

Nationwide, more than 40 percent of fatal crashes involving drivers over age 80 are side-impact crashes—which auto engineers consider an accident most often caused by inattentiveness. This number is more than double the percentage for drivers between 25 and 50.

Some auto safety experts assign the high per mile driven fatality rate

to the number of older drivers taking some form of prescription medication that may dull reflexes.

The issue of measuring the driving safety of older people is steeped in politics. Seniors argue that age alone does not determine driving ability. They believe no age is too old to drive because everyone ages differently. They'll usually cite the statistic that drivers over 65 get into fewer accidents per capita than any other age group.

"There is no question that driving ability can be affected by the aging process," Ted Bobrow, a spokesman for the American Association of Retired Persons, told one technical journal. "Our concern is that there is no single age you can set as the point at which the risk dramatically goes up. Obviously there are high risk drivers at all ages, so testing needs to be applied to all ages in order to make sure drivers of all ages are safe."

The problem with the AARP's argument: per capita ratios for auto accidents tell you less about risk than per mile driven ratios. Overall, seniors drive far less than the average driver—about a third less—but they get into more fatal accidents per mile driven than any other age group. Even when accidents per licensed drivers are analyzed, seniors have a slightly worse fatal accident rate than the average driver, according to a 1993 study by the University of Michigan Transportation Research Institute.

The AARP has an ally in John Eberhard, a senior research psychologist at the NHTSA. Eberhard sees the concern over seniors driving on prescription drugs as a thinly veiled attempt to get seniors off the road for good. He says that seniors don't begin to pose the same kind of danger as "the hell-raising 25-year-old with a triple six-pack of beer in his back seat."

But, to the average driver—who's closer to 40 than 65—both teens and senior drivers increase the odds of a fatal accident. And the number of licensed drivers over the age of 75 is expected to double by 2020.

MEN, WOMEN AND CARS

Since we've started looking at the demographic factors that contribute to auto fatality rates, one of the oldest automotive canards seems worth exploring: Are women worse drivers than men? Using fatality rates as the guide, they're not. Men die in fatal auto accidents at three times the rate of women—but women are catching up.

A 1992 NHTSA study found the annual average number of women who died while driving a car jumped 62 percent from 1975 to 1990, while the number of men who died each year actually went down about 1 percent.

In 1975, 2.21 men died in traffic crashes per 100 million miles traveled, while the rate for women was 1.08. By 1990, the rate had dropped for both sexes—1.38 for men and 0.80 for women—narrowing the gap between them.

Another way of looking at these numbers: 16 percent of the nation's traffic deaths were women in 1975; by 1990, women accounted for 24 percent of the toll. So, the ratio of male deaths to females dropped from 5 to 1 to 3 to 1.

The explanations statisticians offer for these trends are numerous and unconvincing—typical of explanations offered by statisticians. Among the theories: Women are working more and therefore driving in more dangerous rush-hour traffic....either because of taste or physical size, women drive smaller cars than men, and smaller cars are more dangerous in certain wrecks....women are driving faster and taking more risks behind the wheel.

The NHTSA study barely addressed any of these other issues. It indirectly hinted at the social forces affecting female driving risks. For instance, female driving mileage rose 200 percent between 1975 and 1990, while male drivers increased their travel by 94 percent. That could be explained by more women driving to work today than in the 1970s.

But the fact remains that men die in car wrecks far more often than women do. Even discounting the greater number of men on the road and the greater number of miles they drive compared to women, men still kill themselves driving twice as often.

VEHICLE SAFETY RATINGS

One risk factor that influences your chances of being killed behind the wheel of a vehicle is the vehicle itself. Different kinds of cars pose different levels of danger to drivers and passengers. You can improve your odds of long-term survival by driving safer cars.

Of course, determining which cars are safe and which aren't is a hotly-contested business.

The Insurance Institute, funded by auto insurance companies, issues vehicle rankings based on injury and damage claims. After studying driver deaths involving 168 vehicles over a five-year period, the Institute reported in 1992 that 27 people died in accidents involving the Chevrolet Corvette sports car. During the same period, no one died in an accident involving the Volvo 240 sedan.

"A Corvette invites you to drive it fast," an Institute spokesman said at the time. "Why else have one?"

Other groups challenge the breadth and depth of the Institute's studies—arguing that it doesn't mean much to say a fiberglass sports car is more dangerous than a steel sedan.

In tests that the NHTSA performs on new cars sold in the U.S., a key measurement is called the "head injury criteria." It's an index that includes the severity and duration of crash forces on an occupant's head. A reading of 1,000 or more indicates the likelihood of severe injury or death; a score lower than 300 suggests minimal chance of fatal injury.

The NHTSA tests cars by crashing them into a fixed barrier at 35 miles per hour. But some auto safety specialists argue that this is a much higher speed than the average crash in the real world.

A car that fails to protect its occupants at 35 miles per hour might perform very well in a 30 m.p.h. crash. Indeed, the federal government's safety standards require cars to pass a crash test at 30 m.p.h., not 35 m.p.h. So, it's curious that the NHTSA, as an agency of the federal government, uses a different speed standard.

The Highway Loss Data Institute, a unit of the Insurance Institute for Highway Safety, provides a different kind of safety measurement. It rates the safety of cars based on the frequency of injury claims filed with insurance companies and on the average loss payments for collisions.

Such ratings serve the purposes of the insurance industry, which bases its premiums on predictions of which cars are likely to result in the highest claims. But ratings based on accident statistics can't distinguish adequately between vehicles that are safe by design and vehicles that tend to attract safe drivers—a distinction relevant to auto buyers but not necessarily to insurance underwriters.

Minivans, for example, always show up well in insurance loss statistics, although they handle less well than passenger cars and, with some exceptions, have performed poorly in crash tests. Minivans, however, are more likely to be driven by conservative drivers, including parents transporting children, than by hotrodders.

Another oddity: The Volvo 740/760 sedan shows up less well in insurance claim statistics than the Volvo 740/760 station wagon, which is identical to the sedan except for the rear compartment. The main safety difference between the two would appear to be the caution with which they're driven.

Washington, D.C.-based Consumers Union took a more penetrating look at auto safety and found that some small cars can be safer than big ones. "In a real-world crash between a small car and a large car, the small car will bear more than its share of the crash forces. But a well-designed small car can deal with those forces," the group wrote in its 1994 review of auto safety.

Consumers Union pointed out that the compact Geo Storm, made by a Japanese car company and sold by Chevrolet dealers in the U.S., proved the point. Ironically, it did so in a test intended to illustrate the inevitable advantage of big cars.

In 1992, the Bush Administration opposed higher fuel-economy standards for U.S. auto makers and ordered tests between a big and small car—which it assumed would prove the safety advantages of size. A film of the resulting tests, showed a 1991 Buick Park Avenue weighing 3580 pounds colliding head-on at 35 miles per hour with a 2200-pound 1991 Geo Storm.

To an untrained observer, the crash was disastrous for the Geo's occupants. But, as the trade publication *Automotive News* reported:

> In slow-motion footage, the larger Park Avenue's nose seemed to gobble its way through the Storm's front end, seemingly past the windshield pillar and into the passenger compartment. But afterward, a member of the audience asked for readings from the dummies, who were wired to measure the impact of the crash. Despite the heavy damage to the Geo, the head-injury numbers were 285 for the Geo and 186 for the Buick.

Such low crash forces were considered easily survivable.

Auto safety experts reluctantly conclude that the NHTSA 35 m.p.h. fixed barrier test is the best way to judge the safety of a car. It's the only objective standard that submits all models to the same test. The groups related to the insurance industry calculate claims patterns more than objective safety—useful to insurance companies but irrelevant to you when you're facing your neighbor's father heading straight at you.

DRUNK DRIVING AND FATIGUE

A major risk factor that boosts your odds of being killed in a car wreck is drunk drivers. And you don't have to be the drunk to be affected. The losses caused by alcohol-related traffic fatalities—de-

fined as deaths in which a driver, pedestrian or bicyclist had a blood alcohol content (BAC) of at least .01—are staggering.

Alcohol accounted for 45 percent of the 39,500 traffic fatalities in 1992, down from 57.2 percent of the 43,945 deaths in 1982.

The 1 percent of the nation's licensed drivers arrested each year for drunken driving are at a greater risk of being involved in a fatal crash.

Drivers arrested for driving while intoxicated (DWI) are "at a substantially greater risk" of dying in a motor vehicle accident which involves alcohol, according to a study in the October 1994 issue of *Morbidity and Mortality Weekly Report.*

That risk increases in tandem with the number of DWI arrests, and drivers convicted of DWI are at greater risk of being involved in a fatal crash, "regardless of whether they are killed," the publication—put out by the CDC—said.

Less publicized, however, is the fact that alcohol remains a significant risk factor in auto and other accidents when consumed in amounts below legal measures of intoxication. Even very small amounts of alcohol interfere with the cognitive and physical skills needed to drive an automobile.

Another risk factor that doesn't get enough attention is driving when you're tired. In 1992, 7 percent of 51,881 surviving drivers from fatal accidents cited "inattentiveness" as a cause, according to the federal Transportation Department.

A 1995 symposium on the dangers of drowsy driving emphasized that this can be just as prevalent and as dangerous as drunken driving.

A study of the "Impact of Fatigue on Driving," conducted in New York by a state task force, found through a series of statewide surveys and focus groups that of 1,000 drivers surveyed, 55 percent "have driven drowsy within the past year," 3 percent had fallen asleep at

the wheel and crashed, and 23 percent had fallen asleep but avoided a crash.

About 25 percent of the drivers said they knew someone who had a motor-vehicle crash that was caused by drowsiness at the wheel.

Thomas Roth, chief of the Sleep Disorders and Research Center of Henry Ford Hospital in Detroit, said tests have shown that the impact of sleeplessness is cumulative. "Two things happen to someone who only sleeps five hours," Roth said. "Overall reaction time is slowed, and there is a decaying performance over time." In other words, he said, "five hours of sleep may not be so bad one night, but five hours of sleep over five nights is profoundly bad."

Most of the sleep-related accidents occur between midnight and 6 a.m. or at midday, sleep experts reported. More than 20 percent of the 1.3 million single-vehicle crashes each year occur between midnight and 6 a.m., according to federal figures. (So, the early morning hours are worst for crime as well as dangerous driving.)

Other auto safety experts remain unconvinced that sleep depravation is a major risk factor, though. "We have been unable to correlate any claims," said Steven Miller, director of the Insurance Institute for Highway Safety. "We don't get enough details as to why accidents happen."

So, the longer distances you drive and the more often you drive them, the more likely you are to die in an accident. Youngsters, oldsters, aggressive males, drunks and tired people all raise the risks. In driving, unlike other activities, their behavior can have a mortal impact on you.

FLYING VERSUS DRIVING

For a trip of more than 1,000 miles, flying on a commercial airplane is generally safer than driving a car. Since most plane accidents occur on takeoff or landing, the shorter the trip, the greater the risk per mile. On a trip of up to 1,000 miles, you're probably as safe in

your car as in a jetliner. On trips longer than that, you're probably safer in the jet.

On a per mile travelled basis, U.S. commercial airlines are the world's safest form of mass transportation. Nearly all of more than 7 million flights a year are completed uneventfully. But perception can telescope past these general trends. In 1994, the number of crashes among small commuter airplanes rose noticeably. Commuter air fatalities more than doubled.

This made a lot of travelers hesitant to take a commuter flight.

Following the odds, they shouldn't be bothered so much. The National Transportation Safety Board reported commuter airlines had 0.8 deaths per 100 million miles flown during 1994. Depending on where you live, you may have a better chance of surviving a commuter flight than the drive home from the airport.

Still, 1994 heard a public outcry, calling for certain commuter planes to be grounded and the federal government's regulation of these smaller planes to be intensified. Seeking to allay fears, Transportation Secretary Federico Pena announced a three-step response. First, Pena planned a meeting of senior airline executives, pilots, aircraft manufacturers and safety chiefs for a "focused, highly intensive" look at safety issues. Second, the FAA would launch a complete safety audit of every U.S. airline, supplementing the usual inspections. Third, the rule on bringing commuter airline safety standards up to par with major airlines would be accelerated.

The outcry and response were an overreaction, though. Percentage growth numbers can be misleading when they're taken from small base rates.

The total number of deaths from commuter airplane crashes in 1994 was less than 100. In raw numbers, that was fewer people than died every 20 hours on the nation's highways during the same period, according to the NHTSA.

When you're dealing with small base numbers, it doesn't take much to increase odds ratios geometrically. Any probability or risk assessment you do is going to be volatile. A single incident, like the deaths of 68 people in an American Eagle commuter plane crash in October 1994, can spike an average.

By comparison, an extra 40,000 Americans would have to die in car wrecks to have the same impact on auto safety numbers.

Despite the spate of commuter crashes, U.S. commercial airlines finished 1994 with less than one fatal accident for every million flights, according to the Air Transport Association, which represents airlines carrying more than 95 percent of all passenger and cargo traffic.

COMMUTER PLANES VERSUS JETS

Some people calling for heavier commuter airline regulation may have been confusing private aviation fatality rates with smaller commercial rates. According to fatality numbers from the Federal Aviation Administration, the NHTSA and other federal regulatory agencies, the odds of dying in a private plane crash are about 10 times the odds of dying in a car crash—over the same number of miles travelled.

But those odds only reflect the volatility of private planes and their pilots.

Commercial planes—even the small propeller-driven commuter models—have a much safer performance record. The odds of dying in a commercial plane crash are nearly a hundred times less than the odds of dying in a private plane crash.

However, among commercial planes, it is true that jets are generally safer than propeller-driven commuter planes. For instance, commuter planes had three times as many accidents as jets in 1993.

On a percentage basis, the accident rate for commuter planes hasn't

changed much since the early 1980s. What has changed is the number of commuter flights flown every year. Facing continuous cost pressures, commercial airlines have replaced jets with props throughout the 1980s and 1990s.

Between 1989 and 1993, the number of commuter aircraft in operation increased 16 percent, to 2,208 planes. Passenger traffic increased 41 percent, to 52.7 million. Commuter traffic is expected to increase 8.1 percent annually between 1994 and 2001, according to the Regional Airline Association, a commuter airline trade group.

This may be a legitimate concern to people who fly a lot.

But groups like the Regional Airline Transport Association argue that peculiarities in the way statistics are compiled prevent the commuter industry from eliminating the statistical safety gap with the bigger airlines.

Commuter airlines by definition specialize in short hops, and their planes make more landings and takeoffs per day than most airline jets, often into smaller airports with fewer navigation aids. Since most accidents happen on takeoff and landing, commuter airlines will logically have a higher chance of crashes over the course of a year.

That doesn't mean that your individual flight on a commuter plane will be any riskier than flying in a jet—or than driving. One reason, that usually is forgotten in stories about commuter crashes: Where an airline flies contributes to the probability of an accident.

The Regional Airline Transport Association used federal accident statistics to make a relevant argument:

> If you look at fatal accidents per 100,000 takeoffs, commuter airlines have 12 times the accident rate of major air carriers. But take out accident data for commercial flights in Alaska—which includes everything from scheduled commuter airlines to bush pilots flying supplies into back country—and the fatality rate drops significantly.

Commuter planes still crash twice as often as the jets flown by large airlines. But that's not very often. A commuter plane is still about 35 times safer than a car driving more than 1,000 miles.

One real risk factor that probably influences the higher fatal crash rate of commuter planes is the fact that commuter pilots tend not to have as many hours of flying experience as jet pilots. But no air travel is risk-free and pilot error is a big factor in all of these crashes. More than half the 3,513 fatalities in airline accidents around the world from 1988 to 1993 resulted from the plane's flying into the ground while in the pilot's control, for instance, during a landing approach in bad weather at night.

The specific causes of crashes have become less obvious as technological advances have eliminated some risks. For example, wind shear was suspected as a cause of a USAir crash in September 1994 near Charlotte, North Carolina. That was the first time wind shear—the violent combination of winds moving in different directions—had been a factor in a jet crash anywhere in the world since 1987, when shear warning systems had been developed.

While airline officials generally don't oppose any measure that will improve safety, they also argue that safety is a matter of relative risks and trade-offs in a system that is already very safe.

"If the public absolutely demands that flying be totally safe," said Stuart Matthews, president of the aviation industry's Flight Safety Foundation, "you are going to have to ban flying."

PERCEPTION FLAWS ABOUT FLYING

Airline passengers don't seem to have absorbed the fact that all travel is risky and safety is a matter of relative risk. People who build, fly and regulate planes recognize that travelers demand perfectly safe transport and their confidence in commercial aviation may erode if current demographic trends continue.

With airline traffic expected to grow about 5 percent a year for the foreseeable future, Washington-based plane builder Boeing Co. has

projected that the number of jet crashes worldwide could more than double between 1995 and 2010. If the average accident rate per mile flown from the early 1990s holds steady, the airline industry would be facing one crash a week by 2010.

There are strong psychological constraints on people's perceptions of airplane safety. Taken together, they are as good an example as any of why risk telescoping happens.

- Airplane crashes make big news, at least in part, because most people—including those in the media—consider flying an unnatural act.

- The commuter plane's smaller size may make for a bumpier ride and less legroom, but not necessarily for less safety. That runs against the most intuitive response, which assumes a 300 passenger Boeing 747 is safer than a 20 passenger Dash-8.

- When people die in a plane, it's the result of a "crash" and the Federal Aviation Administration tries to learn why it happened. When people die in cars, it's called an "accident" and seldom makes the news, and there's no government agency making an inquiry into the cause.

You can take a few basic measures to improve your odds of surviving an airplane flight. These include:

- stick with commercial airlines;
- make your trips long ones;
- don't fly in bad weather;
- avoid high-traffic or high-risk airports;
- pay attention to safety instructions you get on the plane; and
- choose an aisle seat near an exit to get out quickly if you have to.

Most of all, look at the freeways connecting cities below you and think about how much safer you are in the air than you would be driving down there.

BOATS AND OTHER PERILS AT SEA

According to BOAT/U.S., the largest boat owners association in the country, the national average for nautical mortality is 3.9 deaths a year per 100,000 boats registered. While this statistic is useful for tracking the relative safety of boating over several years, it tells you little about the odds of dying during a given boat trip.

U.S. Coast Guard statistics serve that purpose better. They indicate more than 75 million Americans go boating each year on more than 20 million pleasure crafts. On average, almost 1,000 fatalities result each year from 7,000 accidents involving 9,000 boats.

So, generally, your odds of dying when you go out on a boat are something like 1 in 75,000. This is, plainly, a far more dangerous proposition than either driving or flying in a commercial airplane.

Of course, a number of factors raise or lower nautical risks.

The Coast Guard reports that most boating accidents involve three situations: capsizing, someone falling overboard or collision. The vast majority of boating deaths are caused by drowning. This explains the fact that most fatal boating accidents involve a single vessel. And, whatever the situation, smaller boats get in more accidents than large ones. Seven out of 10 fatalities occurred on boats less than 21 feet long. Most occur in calm waters with light winds and good visibility.

Another risk factor: The calendar has something to do with odds of a boating accident. Half of all boating deaths occur in May, June and July.

Geographic location says less about boating risks. Generally, places with more boats have more accidents and fatalities per accident than others. But even this observation doesn't work consistently. In 1994, Texas recorded 56 fatalities in 164 boating accidents. Over a comparable period, Florida reported 63 boating deaths in 1,017 accidents.

A boating accident in Texas would seem to be a more dangerous proposition than a boating accident in Florida. However, one Coast Guard accident specialist who had worked in both states said the difference had more to do with the way the states recorded accidents. "The Texas Bureau of Public Safety doesn't regulate boating as heavily as Florida does. [The Coast Guard] encourages more reporting in Florida—even for minor accidents. My guess is there are hundreds of minor accidents in Texas each year that officials never hear about."

A familiar problem recurs in boating fatality rates: drunk driving. According to the Coast Guard, alcohol is involved in 50 percent of the boating fatalities nationwide.

Even people with boating experience are usually more comfortable behind the wheel of a car than at the helm of a boat. However, alcohol consumption remains an accepted social aspect of recreational boating.

Drinking is just as dangerous at sea as it is on the road, if not more so. It can result in delayed reaction time in sudden, high-demand situations—such as navigating through stormy weather, rough currents or boat-clogged waterways. According to the Coast Guard, a person who operates a boat while intoxicated is 10 times more likely to die in an accident.

Coroners sometimes find mud under the fingernails of intoxicated boaters who have drowned in murky rivers where they couldn't see underwater. Says one Coast Guard spokesman: "They were so disoriented they were trying to claw their way through the bottom to get to the surface."

Another point that makes drinking at sea even more dangerous: Drinking passengers run a greater risk of losing their balance and falling overboard.

Of course, responsible boating involves a great deal more than simply avoiding alcohol. Since the Federal Boating Safety Act of 1971

was passed, annual boating fatalities have fallen from 20 deaths per 100,000 boats to less than 4 per 100,000.

But officials remain wary. An explosion in watercraft numbers and variety means that boats are traveling at more widely varied speeds, over more congested waters and in places they could not operate before.

The shame is that a large percentage of those fatalities could be prevented if boaters wore life jackets. "More than 800 people die each year in boating accidents, and tragically, 80 percent of them aren't wearing life jackets," said Richard Schwartz, president of BOAT/U.S.

There's no question that some recreational activities are inherently unsafe. Frequently that's part of their appeal. And while it's true that they can be made safer by education or regulation, risks can't ever be completely eliminated.

In the mid-1990s, so-called "squirt boats" came onto the pleasure boating scene. Almost all of them are propelled by a jet pump which, driven by the engine, uses an impeller to draw water into a narrow housing at the stern, where it is pressurized and forced out the back through a nozzle. Because there is no external propeller, they can operate in water as shallow as five inches. These boats are usually too small to be regulated by rules laid down for other personal watercraft.

Problems arise with these newer and smaller craft because many operators do not think of them as boats. Lack of required on-water certification of any kind remains a problem. You generally don't need a license to use squirt boats—and the lack of knowledge or experience can lead to bad decisions.

So, boating is considerably more dangerous than flying or driving. But you can improve your odds by taking a handful of precautions: avoid crowds, keep to boats at least 21 feet long, don't drink at sea, keep away from squirt boats and wear a life jacket.

THE DEBATE OVER MOTORCYCLE HELMETS

Like boating, motorcycling is a dangerous activity. The death rate per 100 million person miles of travel is more than 35 times the rate for cars.

Even a more conservative ratio—the rate of death per registered vehicle—finds motorcyclists have four times the fatality rate of drivers or passengers in cars. Fatalities are highest on weekends and at night.

Using the odds as a guide, the debate over whether states should pass laws requiring motorcyclists to wear helmets...isn't much of a debate.

There were 2,394 motorcycle-related fatalities in 1992. About half occurred in the 20- to 29-year-old group. More than 82 percent of the deaths associated with head injury in motorcycle crashes were among persons 15 to 34 years of age. And the death rate is about 11 times as high for males as for females.

The Centers of Disease Control reviewed U.S. death certificate data from 1979 to 1986 and found that head injury was involved in 53 percent of motorcycle-related deaths.

Given this estimate, of the 2,394 motorcycle deaths in 1992, approximately 1,296 were caused by head injury.

In March 1995 congressional testimony, the CDC's Mark Rosenberg talked about the debate over states enacting laws requiring motorcyclists to wear helmets:

> Motorcycle helmets are estimated to be 29 percent effective in preventing motorcycle fatalities and states with helmet laws that apply to riders of all ages have use rates of 99 percent while those with laws that only apply to minors or have no law show use rates of 34 to 54 percent.

From 1984 through 1992, an estimated 5,832 motorcyclists' lives were saved by wearing helmets. If all motorcycle operators and

passengers had worn helmets during those years...approximately 5,920 additional lives would have been saved.

A 1994 study, supported jointly by NHTSA and CDC, showed that unhelmeted motorcyclists were 2 times more likely to be hospitalized than helmeted riders. Unhelmeted riders' risk of brain injury was 3 times higher than helmeted riders and the risk of skull fracture was 4.5 times higher for the unhelmeted.

A 1991 Government Accounting Office report concluded that available studies, comparing fatality rates between helmeted and unhelmeted motorcycle crash victims, were consistent in reporting a clear safety benefit from helmet use. It concluded that, when universal helmet laws have been in effect, fatality rates have generally been 20 to 40 percent lower than during periods before enactment or after repeal.

Motorcyclists are especially vulnerable to fatal injuries. They are at great risk for death and long-term disability from their injuries. They need better protection in the event of a crash.

And helmets are effective in reducing injuries in motorcycle crashes.

CONCLUSION

Driving is more dangerous than most people realize. Jets are safe, but commuter airplanes may be trouble. Boats are dangerous, and so are motorcycles. Is there a safe way to get from one place to another?

Not entirely. Even riding a bicycle and walking can be more dangerous than driving a car, depending on how the relevant information is gathered and assessed.

Bicyclists account for less than 2 percent of all traffic fatalities in the country, according to the NHTSA. But bicyclists' death rates per trip, or per mile travelled, "greatly exceed the rates for car occupants," according to the Johns Hopkins Injury Prevention Center.

According to the NHTSA, the bicycle death rate peaks at ages 12 to 14, and the rate at all ages is five times higher among males than females. The peak risk time is from 3 p.m. to 8 p.m.

About 90 percent of all bicyclist deaths involve collisions with motor vehicles. Nonfatal injuries are generally caused by falls.

But if you're obeying traffic rules, they found you're no more likely to be in a crash than if you're in a car. The NHTSA reports that 66 percent of bicyclists killed in traffic crashes were doing something wrong, such as running red lights or stop signs.

Because so many bicyclists flout traffic rules, drivers don't know what to expect when they come upon someone on two wheels, and they fear a sudden maneuver will spell disaster. This apprehension doesn't seem to improve fatality rates.

But car-bike collisions are only 12 percent of serious bike accidents. Other accidents, mostly falls, send more than half a million bike riders a year to hospital emergency rooms.

The deaths and injuries caused by drinking and driving get a lot of press. But in the early 1990s, federal officials started to look into a related problem: drinking and walking.

Pedestrian deaths in 1992 totaled 5,546. Of these, 30 percent to 40 percent were intoxicated at the time of the accident. Most drunk walkers are males and between age 25 and 34.

Most fatalities occur in urban areas, usually on surface streets but not necessarily at traffic intersections. And two-thirds of the fatal accidents occur at night; most happen within an hour after sunset.

Car-pedestrian accidents account for almost half of traffic deaths of people ages 3 to 9—and more than one fourth of people 75 or older. About 70 percent of deaths are among men.

Ultimately, the relative risks posed by walking and bicycling aren't significant. Per mile travelled, these activities may be dangerous; but most people don't walk or ride a bicycle enough miles to make the risks comparable to cars or planes.

One key to assessing relative risks is not giving in to the sensation-alizing biases of media coverage. This sensationalism reflects the instinctual biases most people have about travel. People feel in charge of their cars, so they think driving is safe. They feel impotent in the coach section of a DC-8, so they think flying is dangerous. What they don't acknowledge is that a highway offers little protection from all the bad—or drunk—drivers on the road...or that the pilot flying a DC-8 is usually pretty good at what he or she does.

And, like so much else involving money, regulations and interested parties, the average person isn't helped by the lobbying that often passes for news in the popular media. When you think about travel, consider how far you have to go, how quickly you need to get there and how safe the various options are.

Every hour on a busy road adds to the risk of an auto accident. One solid day of driving can be a dangerous thing. It takes three solid days of driving to get from Los Angeles to Chicago.

The same trip takes three hours in a jet. More importantly, that's one takeoff and one landing.

7

Pensions need more than compounded interest

Retirement is expensive. Retiring with enough money to live comfortably requires strategy and discipline. That's why few people do their retirement planning alone. For the fifty years after World War II, most workers in the United States relied on pension programs set up by their employers.

Beginning in the 1980s, though, many employers started moving away from structured pension plans. This trend increased during the 1990s. By the end of the century, most people will be responsible for their own retirement planning.

And they will be making these decisions at younger ages. The median age at retirement has steadily declined since 1950, when it was 67 for men, 68 for women. By 2000, it'll be 62 for men, 61 for women.

You'll need about 80 percent of your yearly preretirement income to retire comfortably. For example, if you earn $50,000 a year, you'll need $40,000 for every year you stay alive after you retire.

An important point to remember: Most retirement projections tend to be low. They usually assume that all of your assets—mutual funds, annuities and savings accounts—are targeted for retirement. They don't usually calculate money you might need for things like

children's college expenses, medical bills for catastrophic illness or long-term care for you—or your aging parents.

Even with all of these unknowns, the main risk of retirement planning is the fact that most people don't know how long they'll stay alive after they retire. Everything from lifestyle to inflation makes exactly how much money you'll need at 65 impossible to predict.

Retirement planning includes some of the most difficult risk factors the average person has to calculate. Unlike the relatively straightforward prospect of gauging a lifespan, retirement planning factors in the specific needs of individuals.

That always causes problems for risk assessment.

In this chapter, we'll consider the various factors that contribute to the riskiness of retirement planning and the mechanisms that financial planners use to try to control the risks. We'll look at different kinds of retirement plans, the status of government programs and the impact of social and demographic trends.

SOME BACKGROUND

Pension plans in the United States hold over $4.8 trillion in assets. Frequently described as "the largest lump of money in the world," the nation's pension plans hold assets equal to almost $20,000 for every man, woman and child in the United States. They are an increasingly important force in the allocation of capital in the American economy.

The definition of risk for a pension fund is fundamentally different from the word's intuitive meaning: the possibility of loss. It's even different from volatility, the meaning most financial theorists give it. Your risk is not having enough money at some point in the future. This means there's no way to define a specific odds ratio you face.

The chief worry for pension funds is the possibility that they won't have the funds to pay off their long-term liabilities. In this context,

the least volatile asset—cash—can lose its value because of inflation and wreck pension budgets.

According to standard pension planning theory, funds which have members who will be collecting pensions for 30 years or more should invest their money overwhelmingly in equities. Stocks historically outperform bonds, providing better protection from the wage inflation that drives up the cost of final pay schemes.

But even this model doesn't always work.

"In the long run you may presume that equities will outperform on average, which helps cover increasing salaries," says Eric Sorensen, head of quantitative research at Salomon Brothers. "But there was a bear market for bonds from 1955 to 1980, and a bull market for bonds for the next 15 years. Those long periods can do a lot of damage."

Pension fund managers use a range of tools to manage, measure and control the risk of not meeting member needs. They conduct full-blown risk audits, review stochastic optimizers (computer programs telling them how to adjust investments) and stress-test their portfolios.

Despite these high-tech tools, common sense is sometimes in short supply. "People still get trapped by the same fundamental problem: They assume when something is earning higher than rational returns that it's not risky," says Richard Davis, managing director and head of risk management at J.P. Morgan Investment Management.

It's a kind of willful self-delusion that pervades many investment circles.

This is part of the reason that so many employers are getting out of the pension planning business.

Most employers don't abandon pensions plans altogether, though. They just change the kind of plans they offer. Most often, an em-

ployer will move from a defined-benefit plan to a defined-contribution plan.

Defined-benefit plans promise workers a certain amount of money—usually a percentage of their highest preretirement salary—paid on a regular schedule, just like a paycheck. For workers, these plans are easy. They require no input or thought—and they're usually insured by the federal government.

Defined-contribution plans are easier for the employer and the smart worker. They promise that a certain amount of money will be contributed on a regular basis to an account set up for the worker. They'll sometimes encourage the worker to save his or her own money by matching savings with contributions from the employer. But they don't make any promises about payments in the future. The worker's pension account has a fixed dollar value—and that fixed value is usually paid to the worker in a lump sum when he or she retires or leaves the company. The risk of managing the retirement funds shifts from the employer to the worker, who usually has control over how the defined-contribution funds are invested.

Talk about a crisis in the American pension system usually refers to the fact that so many employers are moving from defined-benefit plans to defined-contribution plans. This means two things: Workers have to be more sophisticated about investing their retirement money; and the government insurance program covering a shrinking number of defined-benefit plans may become too volatile to manage.

THE MECHANICS OF PENSION MANAGEMENT

Companies determine how much they need to fund their pension plans by making assumptions about how long their employees will work, draw pensions and how much interest pension savings will earn before workers start draining the fund.

If you assume your workers will all die within a few months of retirement or that your pension assets will double and triple through

the brilliant investments you make, you need less money to begin with.

According to one 1995 survey, four out of ten pension officers indicated that they were willing to accept more risk than they had been five years before. Fewer than one out of ten said they'd become more risk-averse.

Given this risk-taking propensity, it's not surprising that 93 percent of pension managers measured their investment portfolio risk. But they disagreed over how useful computer models such as stochastic optimizers were: 55 percent use them, 45 percent don't, and one sixth dismissed them as ineffective.

The federal government's Pension Benefit Guaranty Corporation, which picks up the tab when employers' assumptions prove flawed, controls the allowed parameters. The PBGC requires companies to use specific mortality tables and interest rate ranges.

Although a majority of retirees are fully covered if their plan has to be taken over by the PBGC, there are limits to the insurance fund's guarantee. It will only pay a maximum benefit of about $31,000 a year. If a worker is owed a pension larger than that, he or she has to seek the difference in civil court.

Making long-term forecasts based on current investment assumptions is always tricky. As a result, the 1980s and 1990s saw a boom in quantitative systems to measure and manage risk as fund managers diversified into new kinds of investments.

Many fund managers use stochastic optimizers like J.P. Morgan's RiskMetrics, introduced in 1993. RiskMetrics provides the core data on volatility and correlations that Morgan developed for its internal investment risk management.

Other banks and consultants have developed computer models that crunch data into usable reports like scenario analyses and portfolio constructions. One specific example of this kind of model: the so-

called "Monte Carlo simulation," which calculates random positive or negative spikes within long-term projections.

Critics complain that optimizers are both too sensitive and not sensitive enough.

They're too sensitive because they project tiny distinctions over many years. For instance, an optimizer may find that an 8 percent bond rate from a relatively strong company will be profitable over a thirty-year period, but an 8.25 percent bond rate from a slightly less strong company won't. But the two companies may be close enough in strength that the extra quarter of a percent paid by the weaker company is worth a lot more over thirty years.

They're not sensitive enough because they assume a normal distribution for returns. Critics say this often fails to take account of the big, sharp moves seen in many investments—even conservative ones. Normally distributed returns represent only what's likely to happen in two years out of three. Many nasty market surprises are simply the occurrence of a less probable event.

Besides, as models like the Monte Carlo simulation try to show, not all returns are normally distributed.

Don Harrington, vice president of Benefits and Compensation AT&T Corp., has summed up the inherent risks that remain in pension management:

> ...in the 1960s and 1970s, you had much different actuarial assumptions long term. You had come from the Depression and World War II, and you held back the economy. The long-term rates were 3.5 percent to 4 percent.

> In the late 1940s, if you happened to be waiting at the station in equities when the train came in, you made money, overpowering all assumptions. In 1982, if you were sitting in equities and had been earning 5.5 percent to 6 percent on a weighted average composite portfolio, when the train pulled out of the station and rates

started to float in at 12 percent and 14 percent, your funds built up much faster than your liabilities ever did.

As a result, many fund managers—despite all the complex computer programs—make mistakes because they focus on short-term gyrations and miss long-term trends.

PBGC PROBLEMS

Talk about a crisis in the pension system also focuses on the PBGC's chronic financial problems. Through the late 1980s and early 1990s, the government insurance plan was underfunded—it didn't have an investment portfolio large enough to cover all of its pension commitments.

All private-sector defined-benefits pension plans have to pay insurance premiums to the PGBC. (Defined-contribution plans aren't covered.) These premiums are determined by the size of the pension plan and—to a lesser degree—by the riskiness of its funding status and investment portfolio. The pension insurance is structured very much like bank insurance.

Most companies with pension plans insured by PBGC have fully funded plans with sufficient funds to pay for all the promised benefits. But some pension plans don't have enough money in their portfolios to cover 100 percent of their obligations.

The PBGC estimates that about 75 percent of all underfunded liabilities are in pension plans sponsored by financially sound companies, and the risk of default is remote.

By not having enough money in their portfolios, companies gamble that their employees won't all decide to retire, change jobs or otherwise withdraw funds at once. They usually don't. Most workers who participate in pension plans go at least fifteen years before withdrawing any money.

As long as the plans have enough cash to meet current withdrawals, they can stay solvent—though underfunded. Most use projections based on interest rates and the age of their work forces to estimate how much money they have to have on hand at a given time.

No matter how sophisticated the planning, an underfunded pension poses risks for its members. A common scenario: A marginal company with a large unfunded pension debt goes into bankruptcy reorganization and renegotiates workers' retirement benefits downward.

Total underfunding on the PBGC's list of 50 companies with the largest underfunded plans rose to $39.7 billion in 1993, $32.3 billion of which is guaranteed by PBGC. Although the underfunding increased from $38 billion in 1992, many of the companies improved pension funding.

Ten companies moved off the 1993 list because of improved funding and another 12 companies, although remaining on the 1993 list, saw their underfunding improve over the previous year. The improvement in some cases was due to increased pension contributions. Chrysler Corporation and Deere & Company, for example, made extra contributions and moved off the list.

But the PGBC continues to have problems. Because it uses the same risk mechanisms that pension plans use, even the PBGC is susceptible to the disagreement over how best to invest its pension portfolio. In 1994, rather than reducing the fraction of its $8.3-billion portfolio invested in equities, the PBGC increased its holdings—from 13 percent to 30 percent.

This exposed the insurance fund to the same risks that many of its insured pension plans faced. If the stock market started to fall, the insurance fund would find itself in the same trouble as the plans it had insured—with long-term fixed-money promises backed by short-term, risky assets.

Some pension managers complain that the PBGC is destined to run funding deficits. The creation of the PBGC determined what benefits should be insured in the case of plan failure. So, the methods by which the PBGC determines minimums and maximums it will pay become an important issue for member pensions—who have to pay the premiums to keep the insurance fund going.

Said one corporate pension manager: "We had a floor that was too generous and a ceiling that became arbitrary and inadequate....I don't like absolute numbers in any situation. You should use percentages and relative numbers. After all, this is replacement of pay."

But, in the mid-1990s, the PBGC did show some positive developments. In its fiscal 1994 report to Congress, the agency reported a reduced deficit and successes in legislative reforms, financial management, and enforcement.

The PBGC paid about $721 million in benefits to more than 174,000 people in fiscal 1994. By the end of the year, the agency was responsible for the pensions of more than 370,000 people and 1,971 pension plans. It charged all insured plans a basic fee of $19 per participant in 1994. Underfunded plans had to pay an addition premium of as much as $50 per worker.

Nevertheless, it received an unqualified "clean" opinion from the General Accounting Office on its financial statements for the second consecutive year. The GAO further recognized the PBGC's progress in 1994 by removing the pension insurance program from its list of high-risk government liabilities.

PENSION REGULATIONS

One reason the PGBC began to turn around in 1994 was the passage that year of the Retirement Protection Act. Bill Clinton signed the RPA into law as part of the General Agreement on Tariffs and Trade (GATT). Although world trade legislation seems an unlikely place to put a domestic employee benefits law, Congress included it as a means of raising revenue to offset the loss of tariff income.

Martin Slate, executive director of the PBGC, said the RPA would turn around the steadily increasing gap between benefits owed and the amount of money available to pay for them. In particular, he cited four points of the new law that:

- require pension plans that have the most underfunding to accelerate funding the most;

- increase premiums for plans with the greatest risk (grossly underfunded plans could see their premiums go from $72 to $142 per worker);

- require companies to give workers simple language notice when their plans are less than 90 percent funded; and

- allow the agency to use stronger enforcement measures—including advance notice of some transactions by privately held companies.

The RPA allowed the PGBC to enforce an aggressive funding rule on all delinquent employers. This was scheduled to eliminate the agency's $2.9 billion deficit within 10 years.

Companies whose plans are less than 90 percent funded must pay higher premiums and make annual reports to employees. About 1,500 companies were scheduled to issue these notices to about 4 million employees in 1995. Another 4,000 smaller companies would follow suit in 1996.

The notices explain that a plan's funding percentage does not take into consideration the financial strength of the employer. So, a company can have an underfunded pension but still be financially healthy. They also show the maximum guaranteed benefits payable by the agency.

The RPA also changed the rules affecting lump-sum payouts from defined-benefit pensions. These changes were some of the most difficult to understand—and resulted in the PBGC being flooded with phone calls from anxious pensioners through the end of 1994.

The new law requires plans to use the 30-year Treasury interest rate,

instead of a shorter-term PBGC rate, to calculate lump sums. The higher the rate, the lower the lump sum resulting from IRS actuarial assumptions.

A new IRS mortality table based on longer, more up-to-date life expectancies must also be used. The longer you're expected to live, the higher your lump sum, so the table will offset some of the damage done by the rate change.

The change was thought to reflect a better approximation of the cost to the plan when it makes a lump sum payout rather than paying a benefit over a period of years.

The effect: With higher interest rate assumptions, employers can offer lower lump sums, which become a more attractive alternative to years of portfolio management, PGBC premiums and paperwork.

When the RPA changes were passed into law, only a third of employers with defined-benefit plans allowed lump-sum payouts. But this number was expected to rise.

An explosion of 401(k)s

The use of defined-contribution retirement plans became increasingly popular in the 1980s and continues to expand.

The growth of 401(k) plans in particular has been especially strong. Such plans typically allow workers to make tax-deferred contributions (often matched by employers) to an investment fund that they withdraw when they leave the employer. Upon departure from the job, pension funds are distributed to the employee in a lump sum, which can be "rolled over" without penalty into a tax-deferred plan such as an individual retirement account or into another employer's plan. This increases the portability of contributions and avoids erosion of pensions as workers reinvest pension benefits and continue to contribute to one or more funds.

In 1993, 27 percent of full-time workers in the private sector were

participating in 401(k) plans, up from only 3 percent a decade ear-
lier. At the same time, the proportion of workers participating in other
types of pension plans fell from 50 percent to 33 percent.

The biggest problem with 401(k) plans can be the workers them-
selves. When employees invest too little in their plans, borrow from
them too freely or manage them too conservatively, the pile of money
waiting for them at retirement won't be as big as it should be.

Loan features in most 401(k) plans make the funds tempting for
down payments on homes, college bills and other needs. But when
funds are used to secure loans, they don't grow at the same rate they
would if left in the plan.

Despite having to pay taxes on the income, as well as incurring a
penalty for withdrawing funds before reaching a plan's official re-
tirement age, many workers spend their retirement money upon leav-
ing an employer, rather than transferring them into a savings or in-
vestment account.

A 1993 Social Security Administration report that focused on em-
ployee benefits examined the distribution of lump sums in that year
and found that only 32 percent of the disbursed funds went entirely
into retirement or other savings or investments.

Another risk for 401(k) participants, particularly those with years to
go before retirement, is being too conservative. More people are catch-
ing onto the fact that piling money into "safe" government-backed
securities won't allow the money to grow fast enough to beat infla-
tion and pay taxes.

Sophisticated portfolio analysis commonly applied to defined-ben-
efit plans has been used only rarely for 401(k)s. But consultants and
vendors are starting to subject 401(k) plans to the same sort of per-
formance probing as defined-benefit plans.

SOCIAL SECURITY AND MEDICARE

Private-sector companies have financial considerations to make. The federal government has to deal with demographic trends that make prudent financial management nearly impossible.

Demographic trends are often compared to a rabbit passing through a snake. The progress of a single event or group can be charted from one end of the social system to the other. In the case of the federal pension plans, the rabbit is the ubiquitous Baby Boom.

By all accounts, when Baby Boomers think retirement, they don't think down-scaling. Though a 1994 Merrill Lynch survey found Boomers born between '46 and '56 are saving at one-third the rate needed for a comfortable retirement, 75 percent of all Boomers expect to maintain, or even raise, their standard of living in retirement.

More than half of these Boomers expect to retire before 65, a fourth before 60, according to the Merrill Lynch survey.

The same gambles being taken by underfunded private pension plans are also being taken, on a broader scale, by the government's pension plans—Social Security and Medicare. These plans were intended to serve as a safety net to provide for old people with no other means. They've become a staple of middle-class comfort.

According to the U.S. Census Bureau, the average retiree gets 46 percent of his or her income from pensions, annuities and dividends and other savings plans; 38 percent from Social Security; and the remaining 16 percent from earnings and welfare programs.

That 38 percent is a disturbingly large slice of the retirement income pie. It's probably not sustainable for very much longer.

In Social Security's early days, the ratio of contributors to recipients was about 60 to 1. Average life span was just shy of 60 for men, 64

for women. Statistically, most people would die before collecting a check.

Over time, expanded benefits, changing birth rates and increased longevity played havoc with the numbers. Average life expectancy for Boomers ranges from 67 for those born in 1946 to 70 for those born in 1964. By the early 1990s, the Social Security contributor/recipient ratio was 3.5 to 1.

By 2025, when most Boomers are retired, it'll be 2.1 to 1.

In June 1995 congressional testimony, former PBGC head David Walker laid out some of the common concerns about the future of Social Security and Medicare:

> ...based on 1995 intermediate assumptions, the [main Social Security] Trust Fund is expected to turn a negative cash flow in 2013, just two years after the first Baby Boomer reaches age 65. As a result, while the program is arguably in the best relative financial condition of the four Social Security and Medicare programs, it's longer term financial condition is not good and it is deteriorating.

> ...when considered on a combined basis, our current Medicare and Social Security programs promise significantly more than this nation can reasonably be expected to deliver in the next century.

Conventional wisdom seems to reflect Walker's concerns. In a poll of working Americans taken in 1995, 93 percent said they didn't think they'd receive Social Security benefits.

Commonly-suggested Social Security reforms focus on reducing the benefits pensioners receive directly by raising qualifying ages or setting up multi-tier benefits plans, in which people entering the system receive less than older people in it now.

Other reforms focus on reducing benefits indirectly, by taxing them.

Either move will further encourage a trend which began in the late 1980s—pensioners going back to work.

THE END OF RETIREMENT

According to federal government figures, early pensioners returned to work at increasing rates from 1984 to 1993. This trend reflected several factors, some good and some troubling.

In the late 1980s, employers turned to older workers as a solution to growing labor shortages associated with a long economic expansion and a shrinking pool of young workers.

With the onset of a recession in 1990, concern about labor shortages quickly disappeared. Older workers were increasingly seen as a prime target for cost cutting through early retirement buy-outs, as well as layoffs. For some, this led to a second retirement.

The reason for the yo-yoing in and out of retirement is simple: Pension income greatly affects individuals' work and retirement decisions. This is evident from sharp declines in labor force activity that occur at just two ages—62, when workers can first receive Social Security retirement benefits (the largest source of income for many retirees), and 65, when they are eligible for full benefits.

Each March, the Current Population Survey (CPS), the monthly survey of 60,000 households from which the government obtains its official labor force estimates, includes supplementary questions on sources and amounts of income during the previous calendar year. This information, together with that from the regular monthly questions on work activity, sheds some light on the relationship between pension receipts and employment.

The overall proportion of men aged 50 years and older who received a pension increased slightly between 1984 and 1993. This reflected a continuing trend among men toward opting for reduced Social Security benefits at age 62, rather than waiting to receive full

benefits (including health insurance coverage through Medicare) at age 65.

More specifically:

- among men aged 50 to 54 years, the employment-to-population ratio increased from 64 percent in 1984 to 73 percent in 1993;

- among men aged 55 to 61 years, the ratio increased even more, from 37 percent in 1984 to 49 percent in 1993;

- among men aged 62 to 64 years, the ratio increased from 19 percent in 1984 to 24 percent in 1993.

The most obvious explanation for an increase in work activity among young pensioners would be a decline in the real (that is, inflation-adjusted) value of their pension benefits.

Private-sector pension may have lost value against inflation. Automatic cost-of-living adjustments have always been rare among private employers: only 4 percent of all private pensions included such adjustments in 1993, about the same as in earlier years.

Because private pension benefits are so rarely indexed, the value of most annuities quickly erodes. The erosion is further amplified by increasing lifespans. The average life expectancies for both 55- and 62-year-old men increased by about a year between 1984 and 1991.

However, data on private pensions, Social Security and total income indicate no overall declines during the period. In fact, the real value of Social Security amounts rose to compensate for losses in private-sector pensions.

However, the statistics did suggest another reason why people who retire early go back to work so often: It's the only way they can get health insurance.

At age 65, retirees are eligible for Medicare; before that time, however, employers often cover the cost of health care benefits for their

retirees. Those not covered by employment-based insurance must purchase individual policies or risk a period without insurance until they are 65.

Data from a Bureau of Labor Statistics employee benefit survey illustrate declines in retiree health coverage and increases in retiree health costs. In 1985, 73 percent of full-time employees in medium and large establishments could have their health coverage continue into retirement; by 1993, the proportion had dropped to 52 percent.

Similarly, of those employers that did offer a plan, 41 percent required retirees under 65 years to fund all or part of the coverage in 1985, compared with 75 percent in 1993.

A 1994 study using the Survey of Income and Program Participation found that about 1 in 5 men who were early retirees experienced a change in the source of their health insurance coverage at retirement. About 8 percent of these early retirees aged 55 to 61 and 6 percent of those aged 62 to 64 had no coverage at all after retirement; half of those in each group had been covered by their previous employers.

This may be a game of catch-up that Baby Boomers and those who come after them will never be able to win.

Periodic tinkering keeps shoring up the Medicare system. For instance, the age at which people can get full benefits is gradually being raised to 67. Starting with those born in 1938, two months per year are added to the qualifying age.

For people born between 1943 and 1954, the age requirement for full benefits will be 66. For those born after 1959, the age requirement will be 67.

THE DANGER OF LUMP-SUM SETTLEMENTS

While public policy wonks have complained since the 1960s that Americans don't save enough, an even more troubling trend has

developed in the wake of the 401(k) explosion. People are simply blowing their retirement money.

This may be another reason why so many people in their 50s and 60s go back to work.

The U.S. Bureau of Labor Statistics cites the CPS survey that showed only 21 percent of lump-sum recipients rolled the money into Individual Retirement Accounts. Nearly 30 percent spent their lump sums on consumer products or paid medical, educational or other expenses. Another 23 percent put the money into a business or house or repaid debts.

Younger employees were the likeliest to spend every dime. Less than half of workers aged 45 to 54 put their disbursements entirely into savings or investments; this group was also nearly twice as likely as the older group to spend the money.

Workers have a variety of chances to come into a lump sum—when they change jobs, retire early or work for a company that is sold. These situations are becoming more common. In 1984, 17 percent of companies surveyed by Hewitt Associates offered either an early retirement window or another separation plan. In 1991, 43 percent of employers offered such plans.

About a third of big companies that offer the familiar, monthly-check-for-life pensions now give departing employees the option of taking their pension accumulations in a lump sum when they retire, change jobs or are laid off.

By the end of the decade, about half of old-style pensions will be distributed this way. Lump sums are cheaper for employers to provide than a string of retirement checks because they don't entail continuing administrative expenses or premium payments to the PBGC.

Financial planners often encourage them to take lump sums, which may comprise cash, stock or both. The theory is that all they have to do is pick a sound investment strategy and tend to the money pru-

dently. Eventually, they'll be able to live on what they've accumulated.

FRAUD AND ABUSE

Finally, a number of economists and pension managers worry that the growing number of workers handling their own retirement finances will lead—or already has led—to a growing level of fraud and abuse.

The enormous size of the nation's private pension system is frustrating government watchdogs, who warn that the retirement savings of millions of working Americans are vulnerable to mismanagement.

The most alarming reports come from the Labor Department's inspector general's office, which says failure to shore up existing pension laws and bolster enforcement could result in a taxpayer-funded bail out dwarfing the recent savings and loan crisis.

"There's an insidious and steady siphoning off, which ultimately affects the employees," said Raymond Maria, acting inspector general for the Labor Department, in a 1995 press conference. "I am convinced there is substantial fraud and abuse."

One investigative report found that at least a fourth of the private pension plans audited by the government are in violation of the law. But, as Pension Rights Center director Karen Ferguson has pointed out, detection of fraud is slim, with only about 1 percent of the submitted plans subject to Labor Department audits.

The Pension Welfare Benefits Administration conducted 5,000 investigations of pension and welfare benefit plans between 1992 and 1994, with just 95 classified as criminal. There were 26 convictions.

"It's astonishing how much of the money is being stolen," Ferguson said. "The pension money is sitting there and nobody's looking."

CONCLUSION

The greatest risk you face as a potential retiree is that changes in the pension laws will make benefits systems so volatile that what you've got won't be worth very much when you want to move down to Florida.

The federal government offers you some stability in two ways.

First, it operates Social Security and Medicare systems that provide a basic package of benefits to older people. But these benefits barely provide a sustenance-level income now—and they're shrinking in real terms every year.

Second, the government operates the Pension Benefit Guaranty Corporation, which provides some insurance protection for the employees of bankrupt and otherwise troubled companies.

But neither of these programs assures you of a stable retirement. Demographic trends within the U.S. population will put so much pressure on the Social Security system that, by the year 2010, it will be nearly bankrupt itself. And the PGBC isn't in any shape to insure that.

In the meantime, more private-sector employers are shifting from defined-benefit to defined-contribution pension plans. Portable programs like 401(k) plans are becoming the norm. Even some traditional pension plans are offering workers the choice of lump-sum settlements when they leave or retire.

These moves put the job of risk management directly in the hands of each employee. A kind of hard social Darwinism will emerge as Baby Boomers grow into their 60s. The smart and self-disciplined ones will be fine. The others—including those who spent their lump-sum retirement payments on new cars, racing boats and trips to the mall—will be broke and remorseful.

What's lacking is a pension policy in the United States. As a country, our pension system conflicts with our objective of cutting the deficit, because that reduces the pension amounts that can be funded and the benefits that can be protected. We also face constant attacks when our tax policy conflicts with the concept of a private pension system.

The U.S. faces a looming retirement and inter-generational crisis. As a nation, we have to deal with the fundamental financial imbalance in the Social Security and Medicare programs and our related private pension, personal savings and health care systems.

As an individual, the risk you face in retirement is a sort of inverted system. If you're careful, the danger isn't so much that you'll lose your retirement money—it's that you won't be aggressive enough.

The trend among early and not-so-early retirees is to go back to work after retiring once. That's the risk you have to assess and avoid. The good news is that—more than other situations we've considered—you control the odds here.

8

Workplace safety means not getting shot by your ex

Since essentially everyone in the U.S. works for at least part of his or her adult life, being hurt or killed in the course of employment is a risk everyone has considered at some point.

Federal agencies like the Occupational Health and Safety Administration, the Bureau of Labor Statistics and the Environmental Protection Agency all issue rules and study trends relating to on-the-job injuries and illnesses. So do state agencies and various industry trade groups, on both the state and national level. All the interest stems from the matter of who pays when a worker gets hurt. Despite widespread reform during the late 1980s and early 1990s, workers' compensation programs remain a major money-moving mechanism.

As a result, workplace injury numbers are a big mix of data, methods and interpretations. They make a great laboratory for comparing the different ways in which similar numbers can be crunched.

Once again, the challenge is to focus attention on a few choice examples of good and bad odd calculations. In this chapter, we'll concentrate on three defining workplace injury issues: repetitive stress

injuries, back injuries and workplace homicides. These are three of the biggest and most controversial kinds of on-the-job injuries.

SOME BACKGROUND

In 1993, the total number of nonfatal workplace injuries for private industry was 6.7 million. Nearly 6.3 million of those resulted in lost work time, medical treatment, loss of consciousness, restriction of work or transfer to another job. The number of employed Americans averaged about 108 million through the early 1990s. This puts the average American worker's odds of being seriously injured on the job at about 1 in 16.

The number of what labor specialists call "serious" work-related injuries—which require recuperation and rehabilitation periods of more than a few days—was 2.3 million in 1992. This number includes fatal workplace injuries. It suggests odds of about 1 in 50 for an injury more serious than a cut or minor sprain.

The only place that has a higher injury rate is the home; but, according to federal government numbers, injuries that happen at home tend to be less severe. (Though some labor experts say this is because people sometimes blame work for serious injuries that happen at home.)

In 1994, there were 6,588 accidental workplace deaths, up four percent from 6,331 in 1993. BLS attributed the rise to more transportation accidents, primarily highway and commercial airline crashes.

The heavy load of workplace deaths carried by men moved Labor Secretary Robert Reich to note a "striking difference" between the 6,067 male fatalities and 521 female deaths. "Over 90 percent of the fatal injuries this past year were men, although men account for only 54 percent of the nation's employment," he said.

According to the BLS, the leading causes of workplace fatality in 1994 were:

Transportation (accounting for 42 percent of workplace deaths)

Violence (20 percent)

Machinery, falling objects (15 percent)

Environmental contamination (10 percent)

Falls (10 percent)

Fires/explosions (3 percent)

Breaking out major occupations, federal government data from 1992 found that the restaurant industry was the most dangerous in terms of the real number of workers injured. But, in terms of injury incidence for all workers, restaurants were fairly safe. Nursing and heavy manufacturing are the perennial leaders in terms of injury incidence.

However, the overall trends did show some hopeful signs. Through the 1980s, the annual fatality rate among civilian workers dropped from 8.9 per 100,000 in 1980 to 5.6 per 100,000 in 1989—a 37 percent decrease.

While the BLS statistics are rather straightforward, other workplace injury issues digress into less practical, and more political, subject matter. OSHA does this most often.

When OSHA sticks to matters like regulating the amounts of certain chemicals to which workers can be exposed or defining how certain heavy machinery should be used, it does an effective job of controlling workplace injuries. But, when it tries to expand into matters like how employers communicate with workers or the man-

ner in which office workers type memos, its effectiveness breaks down. A good example of this problem was OSHA's attempt to develop what it called an ergonomics standard.

Beginning in 1990, the agency tried to use ergonomics (a discipline intended to design jobs and tools to fit the physical and psychological limits of people) as the basis for a wide-ranging rule that would control how employees—from meat packers to computer programmers—worked.

Because experts disagree among themselves about the best way to handle ergonomic risks, the standard had difficulty finding broad-based support. One example: Although generally supportive of OSHA's plans for an ergonomics standard, Don Chaffin, director of the University of Michigan's Center for Ergonomics, criticized the standard's take on corrective actions. He called this "the weakest area" of the standard because problems and solutions are "multifactorial." Controls like an adjustable chair or re-designed workstation may not help if poor training, inadequate medical management and job stress are key factors, Chaffin said.

The issue became a focal point for the anti-government efforts of the Republicans who took control of Congress in the November 1994 elections. Texas Congressman Tom DeLay added $3.5 million—the estimated cost of OSHA's ergonomics program—to the agency's budget cuts. "The way to get bureaucrats' attention is to cut their budget," said DeLay. "I've been fighting OSHA's silliness for years."

REPETITIVE STRESS INJURIES

Defenders of the OSHA ergonomics standard argued that it was the surest way to combat repetitive stress injuries (also called cumulative trauma disorders), which include conditions like carpal tunnel syndrome and are a growing risk factor in workplace injuries.

In 1987, 100 repetitive-motion ailments were reported for every 100,000 full-time workers. More than 281,000 RSI complaints were reported to the Bureau of Labor Statistics in 1992. By 1993, there were 380 cases for every 100,000 workers.

This means the average American worker's chance of developing carpal tunnel syndrome or some other RSI have increased from about 1 in 1,000 to about 1 in 250.

Some of that increase, no doubt, results from increased awareness of the problem. But changes in the nature of the workplace seem to have more lasting impact. More than 40 million people—about 47 percent of the American work force—spend most of their workday typing at computer keyboards. By the year 2000, according to several studies, the number is expected to climb to 75 percent.

While the vast majority of people suffering from RSIs work in manufacturing, keyboard users accounted for 12 percent of RSI cases resulting in lost work time during 1992.

In the fall of 1994, researchers at Liberty Mutual Insurance Group, a leading workers' compensation insurance company, released figures on the cost of RSIs to business and industry. Liberty Mutual estimated the mean cost per case for so-called "upper extremity cumulative trauma disorders" was $8,070. This was a reduction from Liberty Mutual's 1991 calculation of nearly $10,000 per injury.

The total cost for upper extremity cumulative trauma disorders in the United States was estimated to be $563 million.

These cases represented 0.83 percent of all claims and 1.64 percent of all claims costs—so they were more expensive, per instance, than other kinds of workplace injury.

Medical costs represented 32.9 percent of the total costs. Indemnity costs—which include coverage for lost wages, rehabilitation and other employer liabilities—were 65.1 percent. So, these injuries are more expensive than they are physically disabling.

The causes of RSIs are not necessarily job related. Non-work-related risk factors include stress at home, exercise routines, pregnancy and vitamin deficiencies.

And, most of all, the kind of work you do has an even larger impact

on the odds that you'll be injured at work. The National Council of Compensation Insurers (NCCI), a clearing house of workers' compensation data, ranks industries by their rates of incidence for various disabilities.

The NCCI's RSI trouble spots—which include meat packing, various kinds of manual assembly and stenography—have rates of incidence five to ten times higher than the national average.

You can assess the RSI risk of your job without NCCI tables, though. If the work you do entails any of four signal risk factors, you should ask about RSI prevention. The four factors are:

- Repetitive motion for more than 2 hours at a time.
- Awkward postures for more than 2 hours per day.
- Vibrating tools or surfaces for more than 2 hours per day.
- "Unassisted frequent or forceful" manual handling.

(The fourth signal risk factor is sometimes phrased differently. It's also described as lifting, pushing or pulling objects weighing more than 25 pounds more than once per day.)

BACK INJURIES AND SUPPORT BELTS

As troublesome as an RSI can be, the most common workplace injury is more basic—and sometimes more disabling. It's a back injury related to awkward motion or heavy lifting.

According to data from the Bureau of Labor Statistics, strains and sprains ranked as the most common type of work-related injury, accounting for nearly half of the 2.3 million work-related injuries and illnesses reported in 1992.

Of those, 653,000 were for back injuries. Almost 400,000 resulted from lifting too much. A typical employee with a back injury took seven days off from work, the bureau reported. This puts the average American employee's odds of having a disabling back injury in a given year at about 1 in 150.

In their ongoing battle to reduce back injuries, many employers employed a new weapon: Flexible back support belts.

Made of spandex and elastic with hook-and-loop or velcro fasteners, the belts are worn just above the waist. When cinched up snugly, the belts help stabilize the spine and increase abdominal pressure to help lighten the load on the lower back.

Just how effective the belts are in preventing back injuries is still a matter of debate and study.

The National Institute for Occupational Safety and Health, the research arm of OSHA, reviewed scientific studies of back belts and concluded in July 1994 that there was no evidence that they reduce injuries.

"These devices are being marketed as a solution to back injury, and the existing scientific evidence does not support this claim," said Linda Rosenstock, a physician who directs NIOSH.

"Unfortunately, because workers think they're protected, they may attempt to lift even more with the belt than they would have without it, subjecting themselves to greater risk," Rosenstock said.

NIOSH said many claims about the benefits of belts are not supported by data, including claims that belts reduce internal forces on the spine, stiffen the spine, reduce bending motions and remind the worker to lift properly. Worse yet, back belts may give workers a "false sense of security," the Institute added.

In its book *Back Belts: Do They Prevent Injury?*, NIOSH concluded that:

> There is some research showing that workers believe they can lift more when wearing a back belt. If workers falsely believe they are protected, they may subject themselves to even greater risk by lifting more weight than they would have without a belt.

...Companies should not rely on back belts as a 'cure-all' for back injury, but should begin to undertake prevention measures which reduce the risks of lifting tasks.

"We were thinking that people wear them because they think they are protective, and the data really doesn't support that they are," said Marie Haring Sweeney, who headed the NIOSH group that examined belt use.

Instead of relying on back belts, Sweeney recommended that businesses help their workers by purchasing hoists, dollies and hydraulic lifting machines.

The federal report had its own limitations, though. Many of the studies it reviewed did not evaluate the type of industrial back belt most widely used.

"Only six of the 21 studies reviewed by the agency for this report even evaluated the effectiveness of flexible back supports versus rigid-style weight lifter belts," said Paula Newman, a spokeswoman for Ergodyne, a Minnesota-based developer of flexible back supports.

Also, the study focused only on healthy, previously uninjured workers. It did not seriously consider how back belts might help previously injured workers.

Newman pointed to a study published in 1993 by John Alden Associates, a Massachusetts-based industrial consulting firm, that found a 75 percent response from companies that said they experienced a drop in back injuries because of the belt usage.

Many ergonomics experts hedged their analysis of the conflicting information. David Blaustein, the medical director of a Massachusetts-based outpatient rehabilitation clinic, said the back belts can serve two purposes: A temporary splint for an acutely injured disc and a snug reminder to the wearer that improper posture and sudden, twisting movements can result in trouble.

Ultimately, however, Blaustein recommended that heavy lifters strengthen their back and stomach muscles by exercising. "If you use the right lifting mechanics and you create a brace by using your abdominal muscles, that's better than the brace itself," he said. "The most important thing they can do to prevent injuries is to remain in good physical condition in general."

WORKPLACE VIOLENCE

Nearly a million workers a year are victims of violence on the job, according to a 1995 Justice Department study.

As books, seminars, consultants and videos addressing workplace violence proliferate, some experts worry that employers may be reacting more to hype than reality.

Human resources professionals in corporate America became keenly interested in workplace violence during the late 1980s. However, most government agencies have been slow to track numbers about workplace violence unless it results in death. As a result, most numbers on non-fatal violence in the workplace are projections and extrapolations of questionable reliability.

In a 1994 survey of more than 500 human resource managers conducted by the American Management Association, one out of 13 respondents indicated one violent workplace death had occurred at their organization in the last four years. More than half (51.2 percent) of the managers reported some kind of violent incident since the beginning of 1990, and they expected the trend to continue. When asked to provide details regarding the most recent violent incident at their workplace, managers stated that the victim's relationship to the attacker was most commonly that of a co-worker (27.2 percent), followed by direct supervisor (15.3 percent).

Importantly, the AMA survey found that employees were attacked by strangers in only 12.3 percent of the cases.

If attackers are angry at their bosses, they're missing their marks. Superiors who were not the attacker's direct supervisors were the victims in 10 percent of the incidents. Another interesting point: Clients or customers were attacked in 5.7 percent of the incidents.

Among managers reporting violent incidents, 29.1 percent said the organization had ignored early warning signs displayed by the attacker, and 25.7 percent said the victim had ignored early signs of the potential violence.

In another 1993 survey—of 479 professions by the Society for Human Resource Management—38 percent of the respondents reported that personality conflicts motivated the most recent incident of violence in their organization. The other factors cited in the survey include family and marital problems (15 percent), drug or alcohol abuse (10 percent), work-related stress (7 percent), and non-specific stress (7.5 percent).

Of course, these statistics don't explain why workplace violence has become such an important issue to so many people. Public concern has been driven by dramatic, anecdotal evidence of a growing problem.

For instance, a series of headline-grabbing events have made the Postal Service almost synonymous with workplace violence. Indeed, the Postal Service has had nearly three dozen employees killed by co-workers since 1984.

Prominent among these:

- In 1994, after sexually harassing a female co-worker, Mark Richard Hilbun was discharged from his job at a small postal facility in southern California. After he was discharged, Hilbun continued to make threats against the female co-worker and wrote a series of violent, sexually explicit notes. Several weeks later, he walked into the facility where he had worked and opened fire, killing a letter carrier and wounding a clerk.

- In May 1993, postal employee Larry Jasion entered his Michigan office and shot three people, killing one. Jasion had expressed his displeasure at being passed up for a promotion that went to a female employee.

- Four people were killed in 1991 after former postal worker Joseph M. Harris allegedly went on a rampage that included the murder of a supervisor and her boyfriend in New Jersey.

- In 1986, 14 people were murdered in an Oklahoma post office by a postal worker, Patrick Henry Sherrill. Sherrill then killed himself.

This is all anecdotal evidence. It can suggest statistical trends, but it can't be the basis for reliable odds.

The workplace homicide rate for the Postal Service is 2.1 per 100,000, officials say. This suggests that postal employees are actually 2.5 times less likely to die on the job than other workers. However, a higher portion of postal workers who die on the job are killed by co-workers.

Workplace experts attribute the violence to the Postal Service's militaristic management style, a generally ill-educated and badly-managed work force and a restructuring that has cut more than 30,000 jobs since 1992.

As the nation's largest civilian employer—employing one out of every 170 full-time workers—the Postal Service says it sees post-office violence as a reflection of the larger society.

So, in 1995, Postmaster General Marvin Runyon announced several new measures aimed at controlling workplace homicides. These included: better plant security, a revamped employee assistance program to help workers cope with personal problems, and improved interviewing techniques that could help identify problem workers before they are hired.

In addition, he said, a violence-prevention program will go out to more than 40,000 managers, postmasters, supervisors, and union officials in the coming year.

WORKPLACE HOMICIDE

While the growing interest in non-fatal workplace violence is hard to support with numbers, fatal workplace violence—that is, workplace homicide—is easier to quantify.

Before the 1980s, murder in the workplace was rare; now it is one of the fastest growing types of homicide in the United States. The problem is so acute that NIOSH issued an alert in 1993 calling for "immediate action to prevent workplace homicides."

According to the BLS, workplace homicide is the second leading cause of work-related deaths (totalling 1,063 in 1993)—behind only motor vehicle crashes—and accounts for about 17 percent of job fatalities. Workplace homicide is the leading cause of death for women on the job, accounting for more than a third of all work-related fatalities among females. (A workplace homicide victim is defined as someone who is murdered while performing his or her job.)

In a 1995 article, Romuald Stone, professor of management at James Madison University in Virginia, gave one example of a workplace homicide:

> ...a young woman was harassed by a co-worker who repeatedly asked her out. She told him she wasn't interested and when he persisted, she filed a harassment claim. He was not deterred; the harassment continued. She then wrote a letter to the plant manager expressing fear for her safety. While the manager was deciding what to do, the woman's co-worker shot and killed the woman in front of 125 other employees before turning the gun on himself.

Most people still underestimate the number of workplace homicides that occur each year. In a 1994 survey of human resource profession-

als, researchers at the University of Oklahoma found that nearly 60 percent thought there were fewer than 500 workplace homicides in 1992, or they had no idea of the number. There were nearly 600 workplace homicides that year.

Since 1980, an average of 23 people become victims of homicide at work each week.

Most of these workplace homicides happen when thieves or other criminals kill workers who happen to be in their way. NIOSH's survey of the literature reports several risk factors that may increase the chance of homicide in the workplace. These risk factors include:

- exchange of money with the public;

- working alone or in small numbers;

- working late night or early morning hours;

- working in high-crime areas;

- guarding valuable property or possessions; and

- working in community settings (taxicab drivers, police, and so on).

Close to 80 percent of workplace homicides are associated with robbery—often of convenience stores and liquor stores open at night. An additional 11 percent of victims are police officers or security guards.

The occupational groups with the highest number of work-related homicides were sales (33 percent), service occupations (20 percent), transportation operators (12 percent), executives, administrators, and managers (11 percent), and taxicab drivers and chauffeurs (9 percent).

Surprisingly, the highest per capita rate of workplace homicide victims involves taxi drivers; between 1980 and 1989 there were over 15 cab drivers and chauffeurs murdered per 100,000.

The number of homicides committed by teenagers and young adults increased 92 percent between 1985 and 1994. These teenage murderers are the harbingers of future homicides in society and in the workplace. The portrait of the so-called "stone killer"—an individual who may act randomly without much planning in an environment that stimulates action—sticks in the minds of people who work in jobs that entail close contact to many strangers.

One of the first reactions of management to a potential risk to employees and customers would be to "fortify" the business establishment. The 1993 outlay for security equipment for use in businesses was $22 billion a year, up 16 percent from 1990. But none of this has reduced the growing number of workplace murders.

The reason for this ineffectiveness is that abusive spouses and partners may be a bigger problem than stone killers.

I LOVE YOU...I LOVE YOU NOT

People skeptical about a workplace homicide crisis argue that unless you drive a taxi, are a police officer, or clerk at a convenience store, you don't have much to worry about. But a growing number of workplace homicides occur during confrontations between personal acquaintances.

In 1994, 91 people were killed by co-workers, former co-workers, customers or clients (9 percent of total homicides on the job, versus 73 percent for robberies). This means that every three to four days someone is murdered on the job by a work associate or acquaintance.

Of this number, co-workers or former co-workers were the killers in 49 (or 5 percent) of the homicides. Customers or clients killed 42 people (4 percent). Personal acquaintances, including husbands and boyfriends, killed 43 (4 percent).

The main risk factor that experts link to these numbers: domestic violence. A 1995 survey of security directors at 248 companies in 27

states found that domestic violence is becoming an increasing problem in most companies. Ninety-four percent of respondents ranked domestic violence "high" on the scale of security problems, and 93 percent reported that domestic violence was increasing as a corporate security issue relative to other security issues.

Domestic violence and stalking know no boundaries—not class, race or sex. Women sometimes stalk men, and even other women. FBI statistics show that women are killing their husbands and significant others at a growing rate. In 1992, there were 623 murders of partners committed by women.

Unfortunately, reliable numbers are hard to find in these matters. No one knows how often estranged spouses or jilted lovers harass and eventually kill their jilters. But in the 1990s, some employers did report increasing numbers of jilted lovers stalking women in the workplace, perhaps because more women are working and leaving their abusers, who know they can find them at work.

"Often the only place a batterer can find a woman is at work," says Nancy Isaac, a researcher at the Harvard School of Public Health who is studying corporate responses to domestic violence. Companies are just now beginning to look at the issue, says Isaac. "I think corporate America's awareness of domestic violence is about where it was with substance abuse 20 years ago."

Some people argue that workplace homicide numbers are misleading—and inflated by a sensationalizing popular media.

An often-cited *Wall Street Journal* article, published in October 1994, contended that the fear of fatal violence in the workplace is "grossly exaggerated." The story went on to say:

> A federal census of workplace homicides found that 59 employees were killed by co-workers or former co-workers [in 1993], out of a total national work force of 120.8 million people. That is one in 2.1 million. The National Weather Service puts the odds of getting struck by lightning at one in 600,000.

This estimate was using only the number of employees killing other employees, which is relatively rare. And it didn't make any distinction for the differing numbers between the sexes. If you are a woman, the chances of being killed at work by someone are about the same as being struck by lightning.

That may sound remote. But consider the statistic another way: If the Environmental Protection Agency—with its 1 in a million odds threshold for acceptable risk—regulated the workplace, it would ban women from jobs.

"This is a relatively unexplored area for companies," says Richard Gelles, a University of Rhode Island professor of sociology and psychology. He and other experts predict civil actions—including those against employers—will increase under proposed federal legislation that makes battering a civil rights violation.

"Workplaces have taken on a lot of responsibility beyond handing out paychecks," said Marilyn Terry, director of a Massachusetts-based organization which provides counseling and shelter to abused women. "Women are working more, and this is a crime that is mostly focused on women. The quality of someone's life at home does affect their performance at work."

Survey results support researchers who suggest that the increase in violence in the workplace may be attributed to various triggering events: disciplinary actions, negative performance reviews, terminations, strikes, plant closures, the general state of the economy, the competitive nature of global business.

Unfortunately, psychology, psychiatry, sociology, anthropology, and criminology cannot predict with any degree of certainty who is or is not likely to become aggressive in the workplace.

Sociologist Keith Harris described this problem well in a 1990 paper:

> The study of violence, like the study of other human phenomena, deals with unpredictable human behavior, unlike physics or chem-

istry where processes are underlain by highly predictable physical laws....The possible combinations of behavior and interactions between variables are virtually limitless, and none can be isolated and studied under experimental conditions.

Because of this inability to predict or control workplace violence and homicide, many people have exaggerated the risks these possibilities pose.

CONCLUSION

The average worker faces the greatest risk of hurting herself or himself seriously from rather mundane tasks—lifting too much weight or typing too fast for too long. These kinds of injuries occur as much as 50,000 times more often than more flamboyant risks—like being shot by an irate ex-spouse or lunatic co-worker.

But business experts have focused on workplace homicide as a key issue. (At least the popular media isn't solely to blame for misperceptions in this chapter.) They talk a lot about postal employees going on killing rampages and armed, despondent lovers confronting employees at work.

In a March 1995 article in the magazine *Business Horizons*, Michael Harvey and Richard Cosier of the College of Business Administration, University of Oklahoma, described some of this obsessive overreaction to workplace homicides:

> The impact on people is like that of an airplane accident. For years we have heard that, mile for mile, traveling in an airplane is much safer than driving an automobile. Yet fear of flying seems more prevalent than fear of car travel. When an air "disaster" occurs, it receives several days of national news coverage.

> ...The workplace seems to be under siege. Fortunately, threats to kill someone on the job are not always acted out. However, the threats themselves can create an intimidating and aversive place to work. Employees may be afraid to be on the job. Granted,

perceptions may not match reality. But the incidences of work-place homicide that do occur, and the magnitude of their consequences, cause great concern when a threatening situation arises. Employees may feel they are under siege by disgruntled workers or terminated employees.

Furthermore, most people are aware of the general increased attention being paid to violent crime. And they are afraid— perhaps justifiably—that this societal violence is creeping into the workplace.

These management professors are describing a bad response to a risk and the inevitable flawed assessment that follows.

As the case of the U.S. Postal Service shows, despite the colorful anecdotes and serious personnel problems, its overall rate of incidence for workplace homicides makes it a relatively safe place to work.

PART THREE:

How analysis is interpreted

3

9

Fanning secondhand smoke

There has been no modern risk issue as divisive as the alleged health effects of environmental—or so-called "secondhand"—tobacco smoke. Secondhand smoke is what people who don't use cigarettes or cigars inhale when living or working around people who do.

In 1993, the U.S. Environmental Protection Agency classified secondhand smoke as a "Class A" carcinogen, the most serious category for cancer-causing compounds. This classification is reserved for substances, such as asbestos, that have been proven to cause cancer in humans.

An EPA analysis of secondhand smoke concluded that it contained 4,000 compounds, including 43 known carcinogens and other hazardous substances, such as ammonia. However, there's considerable dispute over whether the EPA had sufficient cause to put secondhand smoke on the Class A list.

Public-health experts estimate that more than 50,000 Americans a year die from diseases linked to passive smoking, making it the nation's third-leading cause of preventable death after active smoking and alcohol abuse. (More than 400,000 a year die from active smoking.)

But not everyone agrees with these numbers, either.

Considered from the odds perspective, light smoking can bring your lifetime odds of killing yourself to 1 in 100. A nonsmoker living with a smoker will be exposed to a lifetime risk of something like 1 in 700.

The secondhand smoke numbers are erratic. The way information is gathered and analyzed in these studies is disputed. The odds for nonsmokers living with smokers could be off by a factor of 10.

The debate between those who believe secondhand smoke is a cancer risk factor that should be regulated and those who don't is driven by passions as much as by numbers.

The EPA report allowed anti-smoking activists—like AIDS activists before them—to claim that everyone is at risk.

Edward Garrity, a member of the board of the American Lung Association of Metropolitan Chicago, said, "Anything associated with primary smoking is likely to be associated with secondhand smoking. There is no reason to believe it is safer."

Roger Jenkings of the Oak Ridge National Laboratory disagrees, arguing that, "Individuals may believe they're being exposed more than they are [to carcinogens in secondhand smoke]...their actual exposure is very low."

As passionately as Garrity might believe secondhand smoke is dangerous, his statement is meaningless in terms of risk assessment. Jenkings's statement promises to rely more on facts than feelings—but his research was funded in part by a big cigarette maker.

The entire debate over the dangers of secondhand smoke is like this: driven by biases, hard feelings and vested interests.

SOME BACKGROUND

Smoking cigarettes is definitely bad for you. Studies of cancer patterns implicate tobacco smoking—the kind where you inhale, not

the secondhand kind—in cancers of the head and neck, pancreas, esophagus, bladder and cervix.

Using the U.S. Surgeon General's figures for the total number of smokers and the number who die from the habit, risk analysts calculate that each cigarette you smoke diminishes your life span by about 10 minutes.

The 1986 Surgeon General's report on secondhand smoke suggested the methodology for the test used by the EPA to declare secondhand smoke a known carcinogen. The Surgeon General's report included the following observations and conclusions:

> ...although the risks of involuntary smoking are smaller than the risk of active smoking, the number of individuals injured by involuntary smoking is large....

> ...Of the epidemiological studies reviewed in this Report that have examined the question of involuntary smoking's association with lung cancer, most (11 of 13) have shown a positive association with exposure [to secondhand smoke], and in six the association reached statsitcial significance.

> Given the difficulty in identifying groups with differing [secondhand smoke] exposure, the low-dose range of exposure examined, and the small numbers of subjects in some series, it is not surpirsing that some studies have found no association and that in others the association did not reach a conventional level of statistical significance.

> The question is not whether cigarette smoke can cause lung cancer; that question has been answered unequivocably by examining the evidence for active smoking. The question is, rather, can tobacco smoke at a lower dose and through a different mode of exposure cause lung cancer in nonsmokers?

> The answer must be sought in the coherence and trends of the epidemiological evidence available on this low-dose exposure to a known carcinogen.

...A number of studies have demonstrated a dose-response relationship between the level of ETS exposure and lung cancer risk. By using data on nicotine absorption by the nonsmoker, the nonsmoker's risk of developing lung cancer observed in human epidemiological studies can be compared with the level of risk expected from an extrapolation of the dose-response data for the active smoker.

All that was missing was another government agency to act on the method. The EPA stepped into this void when it declared secondhand smoke a known human carcinogen. Throughout its report, the EPA repeatedly cited the 1986 Surgeon General's Report.

To its authors' credit, the EPA study admitted a number of problems that could raise questions about their conclusion.

...the risk of lung cancer is relatively low in nonsmokers, and most studies have a small sample size, resulting in a very low statistical power (probability of detecting a real effect if it exists). Besides small sample size and low incremental exposures, other problems inherent in several of the studies may also limit their ability to detect a possible effect....

...Although ETS is a major source of indoor air contaminants, the actual contribution of ETS to indoor air is difficult to assess due to background levels of many contaminants contributed from a variety of other indoor and outdoor sources.

...While there are statistical and modeling uncertainties in this estimate, and the true number may be higher or lower, the assumptions used in this analysis would tend to underestimate the actual population risk. The overall confidence in this estimate is medium to high.

...uncertainties remain, such as in the use of questionnaires and current biomarker measurments to estimate past exposure, assumptions of exposure linearity, and extrapolation to male never-smokers and ex-smokers.

In adding secondhand smoke to the Class A list, the EPA found 33 published epidemiologic studies on the subject, 13 of which were conducted in the U.S. Most used standard epidemiologic technique: They looked at nonsmoking women who developed lung cancer, to see whether they were more likely to be married to smokers than were women who didn't get the disease.

26 of the 33 studies indicated a link between secondhand smoke and lung cancer. Those studies estimated that people breathing secondhand smoke were 8 to 150 percent more likely to get lung cancer sometime later. Of the remaining seven studies, one found no connection with lung cancer rates. Six suggested that people exposed to secondhand smoke had lower rates of lung cancer, although no one suggests passive smoking really reduces the risk.

Seven of the 26 positive studies included enough subjects and found a dramatic enough result to attain statistical significance—meaning there was no more than a 5 percent probability that the results in those studies occurred by chance. In contrast, just one of the negative studies reached statistical significance.

In terms of determining cancer-causing potential, strong positive epidemiology is what risk experts call *indicative*. According to the EPA, only exposures where epidemiology studies have confirmed a link can be classified as known human carcinogens.

On the other hand, only epidemiology studies that achieve large enough numbers of subjects for significant statistical power are of value in showing the absence of risk.

In other words, it's a lot easier to prove some risk exists that to prove that no risk exists.

Even nonsignificant studies can still be valuable when combined with all the rest for analysis. This technique, called meta-analysis, is commonly used with carefully designed randomized clinical trials of drugs. But its use in epidemiology is controversial, since no two studies have identical designs and the analysts must make certain assumptions as they combine data.

So, the result of a meta-analysis is supporting evidence but is not definitive by itself.

Epidemiology is an observational science—where subjects and variables cannot be controlled or manipulated by the investigator. Investigators must often rely on incomplete and inadequate data on both exposure and outcome. Qualitative judgments by investigators through the course of conducting a study are commonplace.

Epidemiologists evaluate the assocations between disease and exposures. In general, their investigations compare either the occurence of an illness in exposed or unexposed groups (this is called a cohort study) or the history of exposure in diseased and non-diseased groups (this is called a case-control study).

Cohort studies are of most value in studying diseases which occur commonly in a population—but they are expensive and time-consuming.

Case-control studies are useful tools for the study of rare conditions. Because case-control studies compare past exposures in diseased and non-diseased individuals, fewer subjects are usually needed to complete a rigorous study. However, the background prevalence of exposure must be high enough for significant numbers of cases and controls to have been exposed. This can be diffcult to establish.

Case reports are observational in nature; they are not scientific or analytical attempts to solve defined problems. Because they don't have defined scientific controls, some case reports are more rigorous—and therefore more useful—than others. The information provided is best used for suggesting hypotheses to be tested by other studies.

Because epidemiological studies are observational in nature, control for biases and confounding is critical. Also, precise exposure quantification is often difficult to achieve—and in many instances epidemiological study results are equivocal or difficult to interpret.

The non-experimental nature of epidemiological investigation leaves

every epidemiological study open to questions of validity and appropriateness of interpretation.

Even though a difference is shown to be statistically significant, it may have no practical significance.

So, when the EPA says that it has found a causal link between secondhand smoke and lung cancer based on a meta-analysis of epidemiology studies, what it's saying is that there's such a strong correlation between secondhand smoke and lung cancer that it believes the two are linked. It hasn't established a cause-and-effect relationship.

Most epidemiologists have no quarrel with meta-analysis, and two panels of outside scientific experts deemed the agency's conclusions valid.

Women with the greatest lifetime exposure—from smoking by parents, husbands, friends, and co-workers—had a 225 percent increase in risk. (That's much less than the hazard posed by active smoking, which causes a 1,100 to 2,400 percent increase in lung-cancer risk.)

For any given nonsmoker, the lifetime risk of getting lung cancer remains small—4 to 5 in 1000 ordinarily, 6 to 7 in 1000 if he or she has a smoking spouse.

Exposure to secondhand smoke is so common that, according to the EPA's calculations, it causes 3,000 lung cancer deaths among adults in the U.S. each year.

In 1993, a New York research team reported that it had measured the metabolic products of a tobacco carcinogen, NNK, in the urine of nonsmokers exposed to the conditions of a smoky bar. The measurements were 10 times as high as those taken before the volunteers were exposed to smoke.

For its study, the EPA found nicotine levels in homes of smokers had averages that ranged, from study to study, between 2 and about 11 micrograms; in offices, the range of averages was about 1 to 13.

Restaurants were even smokier, with averages between about 6 and 18 micrograms.

THE IMPORTANT STUDIES

One of the most comprehensive studies of secondhand smoke, was published in the summer of 1994 by epidemiologist Elizabeth Fontham of Louisiana State University Medical Center. The largest such study ever done, it's also considered by experts in the field to be the best in design and execution.

Fontham's research team interviewed nearly 17,500 women with lung cancer to find some 650 who were nonsmokers. Then, they selected about 1,250 women at random who didn't have lung cancer. They tried to match the random samples with the lung cancer patients according to race, family income and education.

Both the lung cancer patients and the controls, as the randomly selected women were called, were asked about exposure to smoke as a child, as an adult and other topics—such as diet. In some cases, relatives were interviewed because cancer patients had died or were too ill to talk.

Among 651 nonsmoking lung cancer patients, the LSU researchers found that 433 (about 66 percent) had been exposed to smoke from their husbands' tobacco use. Among 1,253 nonsmoking women who didn't have lung cancer, 766 (about 61 percent) had been exposed to tobacco smoke from their husbands.

To make the difference between 66 percent and 61 percent meaningful, the LSU researchers calculated a risk number—called an odds ratio—of 1.29. An odds ratio of 1.00 indicates there is no added risk; an odds ratio of 1.29 works out to a 29 percent added risk, which was rounded to 30.

Published in the *Journal of the American Medical Association*, the LSU study took the odds ratio to conclude that a nonsmoking woman who lives with a smoker faces a 30 percent higher risk of lung cancer.

Fontham found increased risks of lung cancer with increasing exposure to secondhand smoke, whether it took place at home, at work, or in a social setting.

James Repace and Alfred Lowrey, two statistical researchers who studied the effects of secondhand smoke, have concluded that a lifetime increase in lung-cancer risk of 1 in 1,000 could be caused by long-term occupational exposure to air containing more than 6.8 micrograms of nicotine per cubic meter of air.

Concentrations that heavy occur regularly in many homes and workplaces. (The nicotine itself doesn't cause lung disease but is a marker for smoke concentration.)

If Repace and Lowrey were right, the lifetime added risk of developing lung cancer from prolonged exposure to secondhand smoke is roughly 1,000 times greater than the one-in-a-million lifetime cancer risk considered unacceptable for many other environmental contaminants.

HEART DISEASE VERSUS LUNG CANCER

Experts say 70 percent of the deaths linked to secondhand smoke—37,000 of the 53,000 total—come from heart disease. A much smaller number of deaths—3,000—are attributed to lung cancer, but because of the dreadful power of the word cancer, it was cancer that the EPA emphasized in its report.

The first major conclusion, listed at the top of Page 1 of its 137-page report, said secondhand smoke is "a human lung carcinogen, responsible for approximately 3,000 lung cancer deaths annually in U.S. smokers."

Not surprisingly, that statistic was the lead paragraph in virtually every major media story on the EPA report.

The epidemiologic evidence on secondhand smoke and heart disease is not as abundant as that on lung cancer. About a dozen studies exist, and they consistently show an elevated risk.

Among nonsmokers who are exposed to their spouses' smoke, the chance of death from heart disease increases by about 30 percent.

(Active smoking about doubles a person's chance of dying from a cardiovascular condition.)

Although the heart-disease evidence isn't as strong as that for lung cancer, a number of authorities—including OSHA, the American Heart Association, and the American College of Cardiology—quickly declared secondhand smoke a risk factor for heart disease.

In 1994, researchers from the Cardiovascular Institute at the University of California at San Francisco published an article in the *Journal of the American Medical Association*, strengthening the link between passive smoking and heart disease.

"The evidence keeps getting stronger and stronger that passive smoking causes cardiac deaths and non-fatal heart attacks," UCSF researcher—and established tobacco industry critic—Stanton Glantz said.

He said passive smoking causes heart problems in a variety of ways, including reducing the ability of the blood to deliver oxygen to the heart.

If exposure to secondhand smoke does increase the risk of heart disease by 30 percent, then it is causing an estimated 35,000 to 40,000 heart-disease deaths a year in the U.S.—about 10 times the number of lung cancer deaths attributed to secondhand smoke. That would make the annual toll from secondhand smoke comparable to that from motor-vehicle accidents.

In 1986—the same year that Surgeon General C. Everett Koop published his report—and the National Research Council warned that passive smoking caused lung cancer in adult nonsmokers and that it caused respiratory infections in children whose parents smoked.

Joseph DiFranza, a family doctor at the University of Massachusetts who has conducted research on smoking, reported findings on pas-

sive smoking and cardiac deaths that were even more shocking. DiFranza published the results of his study in the *Journal of Family Practice*.

He and fellow researcher Robert Lew estimated that each year up to 2,200 American children die from Sudden Infant Death Syndrome (SIDS) because their mothers smoked. That's about 35 percent of SIDS cases.

The federal EPA and the California EPA corroborated the findings, reporting strong evidence that infants whose mothers smoke are at increased risk of dying from SIDS—but they pointed out problems separating the effects of maternal smoking.

CRITICISMS OF SECONDHAND SMOKE REPORTS

Although no one outside the tobacco industry doubts that smokers run a much higher risk of lung cancer and other diseases, the science on secondhand smoke is more problematic.

Critics in science, medicine and the nonpartisan Congressional Research Service argued that in its 1993 meta-analysis the EPA ignored contrary studies, used unreliable methodology, failed to consider such "confounding factors" as diet, health care, poverty, heredity and consumption of alcohol and caffeine and changed its statistical standards midstream to produce the politically desired result.

Scientific studies publish results with confidence levels set at 95 percent, meaning that a 5 percent possibility exists that the study's findings occurred purely by chance (this is the same definition as statistical significance).

The EPA's secondhand smoke report relaxed this measure to 90 percent—doubling the chance that its reported findings of elevated risk for nonsmokers could have occurred randomly.

"I am adamantly opposed to smoking; I completely agree about the magnitude of this health threat for people who smoke," says Michael

Gough, senior associate in the congressional Office of Technology Assessment. "But I think that the EPA played very fast and loose with its own rules in order to come to the conclusion that [secondhand] smoke is a carcinogen."

Most people might conclude that the difference between 66 percent and 61 percent (the incidence rates found by LSU's Fontham) isn't much, and they'd be right.

In the wake of Fontham's study, the American Medical Association found a causal relationship between secondhand smoke and cancer. That was more than the LSU professor herself was willing to do. She admitted that a risk ratio of less than 2.0 was small—if steady and "measurable."

The odds ratio of 1.29 suggests a precision that Fantham's study didn't have. Random chance could move the study's odds ratio anywhere from 1.04 to 1.60—any figure in that range is consistent with the study's result. So, the increased risk could have been as low as 4 percent.

That uncertainty range, which is part of any statistical report, was clearly stated in the study, but it wasn't mentioned in the American Medical Association news release about the finding.

"Given these and other contrivances employed by the EPA, it is difficult to avoid the conclusion that policy has dictated science in the case of [secondhand smoke]," wrote Jacob Sullum, the managing editor of *Reason* magazine and a critic of tobacco critics.

UCLA epidemiologist James Enstrom says using meta-analysis with retrospective case-control studies, such as those examined by the EPA, is "fraught with dangers," because the studies are apt to differ in the way they define smokers, the types of lung cancer they include and the confounding variables they consider, and so on.

In any event, the EPA's conclusion—that being married to a smoker raises a woman's chance of getting lung cancer by about 19 percent—is justified only according to the looser definition of statistical significance chosen especially for these data.

By the conventional standard, the meta-analysis does not support the claim that secondhand smoke causes lung cancer.

Of the 30 studies the EPA used in its meta-analysis, only six reported a statistically significant association and 24 reported no correlation between secondhand smoke and lung cancer. Nine of the 24 studies actually reported that nonsmokers in smoking households experienced a lower-than-expected rate of lung cancer.

At one Washington symposium, even the biostatistician who co-authored the EPA secondhand smoke report downplayed its health risks. "I don't think [the relative risk] is very high," Steven Bayard told listeners. "I don't think the risk of lung cancer in nonsmokers in general is very high."

A risk ratio of 1 indicates the absence of statistical evidence of an illness-producing agent. By way of comparison, a smoker's risk ratio for developing lung cancer is in the neighborhood of 10 or more.

The EPA's meta-analysis resulted in a risk ratio for secondhand smoke of 1.19, a figure perhaps closer to 1.11 in the wake of three additional studies completed after the agency announced its findings.

None of the regressions and correlations published in connection with the EPA study quantified the lung-cancer risks run by non-smoking spouses of smokers. They implied that the risk was some 30 percent greater than it would be if the spouse were also a non-smoker. But what was the baseline to which the EPA added the 30 percent?

Donald Austin of the Oregon Health Division and a contributor to the *JAMA* report on secondhand smoke reported that the odds were 1 in 20,833 that a nonsmoker married to another nonsmoker will get lung cancer in any one year. This figure rises to 1 in 16,393 if the nonsmoker's spouse is a smoker.

Austin indicated that when you go from annual to lifetime risks, a smoking spouse increases the odds of your dying from lung cancer from 1 in 304 to 1 in 236.

"Even if you believe the EPA, you're talking about six days of life expectancy," says UCLA epidemiologist Enstrom.

"The EPA set out to determine that environmental tobacco smoke is a carcinogen," says Thomas Lauria, a Tobacco Institute lobbyist in Washington, D.C. Technically, this might be true.

In an evaluation of the EPA findings, Harvard University epidemiologists Charles Hennekens and Julie Buring told *Consumer Reports* magazine that the lowered confidence standard fell within accepted practices:

> The agency used a standard statistical technique, called a one-tailed test, that allowed a 5 percent change of wrongly concluding that secondhand smoke increases the risk of cancer. This technique, taught in every introductory statistics course, is appropriate when, as in this case, there is already independent evidence that a substance is harmful.

So, in a specific context, tobacco industry apologists like Lauria have a point. The EPA's methodology assumes that secondhand smoke is harmful.

THE POLITICS AND P.R. ISSUES EMERGE

In a June 1994 article in *Investor's Business Daily*, conservative science writer Michael Fumento cited a paper by Texas epidemiologist Gary Huber, which concluded:

> In this case, the EPA's risk assessment is built on the manipulation of data, ignores critical chemical analyses and key epidemiological data, violates time-honored scientific principles, fails to control adequately for confounding influences...and violates its own guidelines for assessing and establishing risk to a potential environmental toxin. It lacks credible quality control and adequate external unbiased peer review....

Tobacco industry critics and anti-smoking activists quickly jumped on the fact that Huber has long been the recipient of tobacco indus-

try grants. This is true, though Huber insists his research foundation keeps an arm's-length distance from its benefactors.

After denying for 30 years that active smoking has been proved hazardous, the tobacco industry—not surprisingly—took an even more skeptical view about secondhand smoke. A group of major tobacco firms challenged the EPA report with a lawsuit filed in federal court in North Carolina.

In the lawsuit, the industry group argued that the agency carefully selected data to reach a foregone conclusion and violated the rules of statistical analysis. (The lawsuit was part of the natural course of business for cigarette makers. The tobacco industry, which earned $5.2 billion in 1993 on $47 billion in sales, spends about $600 million a year on attorney fees.)

The group claimed that "virtually all of the substances reportedly found in environmental tobacco smoke are found in the air from sources unrelated to smoking." That was a smart public relations strategy. It exploited the public's unfamiliarity with research methods and the common perception that one week's scientific report will be debunked the following week.

About the same time, the industry-subsidized Tobacco Institute cited the 1986 surgeon general's report and the 1993 EPA report that said there was not adequate evidence to link heart disease to passive smoking. The institute said a 20 percent increased risk of heart disease found in the study is "too weak to interpret."

In a lengthy national advertising campaign, the tobacco industry portrayed the issue of secondhand smoke as one of individual rights versus an overzealous government agency.

This kind of political posturing wouldn't normally have anything to do with the odds of getting lung cancer or heart disease from secondhand smoke. But cigarette maker R.J. Reynolds Co. ran an advertisement in 1994 that interpreted the secondhand smoke issue in terms of how many "cigarette equivalents" nonsmokers were ex-

posed to when they live or work with smokers. This invited scrutiny that the tobacco industry didn't want.

The Reynolds ads said that a nonsmoker working among smoking colleagues would inhale the equivalent of just 1¼ cigarettes a month. A nonsmoker living with a smoker would inhale only 1½ cigarettes a month. And a nonsmoking waiter working full time in a restaurant would inhale just 2 cigarettes.

The flaw in the system: The ad used nicotine as the standard for comparison. Nicotine is addictive to active smokers, but it's not a carcinogen. In fine print, the ad said "use of other compounds may give different results."

Katharine Hammond, an environmental health expert at the University of California, Berkeley, tested that fine print proposition. She used some of the other compounds found in cigarette smoke to create some other comparisons.

In testimony she submitted to the U.S. Occupational Safety and Health Administration, Hammond considered the hypothetical nonsmoking office worker in the ad and added up a month's exposure. She found that: "In that same room, at that same time, the nonsmoker is getting as much benzene [a known human carcinogen] as a smoker gets in smoking six cigarettes; as much 4ABP, a known human carcinogen, as if smoking 17 cigarettes; and as much NDMA, the potent animal carcinogen, as one who smoked 75 cigarettes."

The tobacco industry stopped using the cigarette equivalents soon after Hammond's report to OSHA.

CONFOUNDING FACTORS

The most valid criticism raised against studies finding secondhand smoke a danger is that these studies don't do a good job of accounting for confounding factors. These are other things—such as diet or alcohol use—that might explain higher incidence rates of lung cancer and heart disease in nonsmokers.

Since epidemiologists can't control everything that happens in the lives of their subjects, they have to be wary of confounding factors. Relatively small risks, like that from secondhand smoke, are especially vulnerable to confounding.

All epidemiologic studies have a built-in imprecision. Even though they're generally accepted, the 1 in 6 odds of dying from disease caused by directly smoking a pack of cigarettes a day could be off by a factor of three. The real number could be three times higher—1 in 2—or three times lower—1 in 18.

Epidemiologists readily concede they can never account for all the factors that affect health. For example, stress and personality may be more important predictors of heart disease than smoking.

In 1991 Gary Huber, the University of Texas professor and alleged apologist for the tobacco industry, examined the 30 secondhand smoke studies discussed by the EPA in its report. "At least 20 confounding variables have been identified as important to the development of lung cancer," he wrote in *Consumers' Research* magazine. "No reported study comes anywhere close to controlling, or even mentioning, half of these."

If the tobacco industry is right—or even partly right—and these studies start with assumptions or biases that lean toward finding a connection, there could be consistent errors.

Fontham may be sure there's a link; she has a lengthy study to defend. To the objective decision-maker, there will always remain questions about exactly how dangerous secondhand smoke is. The math underlying statistical analysis relies on assumptions that are never perfectly met in real-world situations.

It's difficult to know exactly how much passive smoke a smoker's wife breathes at home—or how much she breathes on the job. Occupation, age, diet, income level and lifestyle can influence the risk of cancer. The best studies—and Fontham's LSU study was one—try to take these other factors into account as much as possible.

But even the best studies cannot eliminate all possible sources of errors. Statistics, like anecdotal evidence, can suggest trends but never offer certainty.

A 1993 study done in Australia showed almost no difference between children living in households with or without smokers. Sickliness of children was deemed more a function of poor nutrition, poor hygiene, genetic factors and generally unhealthy living conditions.

The Australian study called heavy smoking one risk factor in cancer and coronary heart disease, along with many other risk factors, including genetic makeup. But it stressed that causal effect remains unestablished.

The best objective conclusion that you can draw from randomized epidemiology studies and meta-analyses are relative risks.

Using the LSU study and several cited by the EPA in its known-carcinogen decision, some relative risk numbers for lung cancer emerge:

Nonsmoker with high fruit, vegetable diet 0.7

Nonsmoker .. 1.0

Nonsmoker with smoking spouse 1.3

Nonsmoker with high fat diet .. 2.8

Former smoker ... 4.7

Smoker ... 12.0

A caveat: Since the above figures are from several studies, comparison gives only a rough estimate of the factors contributing to lung cancer.

SMOKING BANS

Motivated more by potential liability than true odds, many businesses and local governments have proceeded with plans to ban smoking entirely from their premises.

An August 1991 survey conducted jointly by the Society for Human Resource Management and the Bureau of National Affairs found that "total bans on smoking have been established by 34 percent of the surveyed companies, compared with just 7 percent of responding firms in 1987, and just 2 percent in 1986.

"Among employers without smoking policies, more than half either have definite plans to adopt a policy by 1992 (16 percent) or have smoking restrictions under consideration (44 percent)," the SHRM report concluded.

In 1994, the U.S. Labor Department proposed a ban on smoking in the workplace that would affect 70 million workers. About the same time, "no smoking" signs appeared in food-chain outlets, such as McDonald's restaurants, and at military installations.

In March 1995, OSHA estimated annual employer costs for eliminating secondhand smoke to range from nothing for employers who ban smoking to a maximum $68 million if all employers opt for separate ventilation systems.

The tobacco industry insisted the costs would be much higher.

Michael Ogden, a chemist in R.J. Reynolds's Research and Development Department, said during testimony for hearings on an OSHA smoking ban that "a limited number of outdated, nonrepresentative and extreme data sets...[OSHA] has overestimated typical worker exposures at least 10 to 100 times."

The study Ogden claimed was most comprehensive was one supervised by Oak Ridge National Laboratory's Robert Jenkings. It concluded that secondhand smoke exposures outside the workplace are higher than those at work.

Other groups were less certain than Ogden.

The American Lung Association did not advocate a total ban on workplace smoking. "We're reasonable," said a spokeswoman for

the ALA, adding that her organization would support separately ventilated workplace smoking rooms.

"[The] scientific evidence is sufficient to establish that [secondhand smoke] may produce a small excess risk of lung cancer in nonsmokers, as well as other deleterious health effects," testified John Tiffany, a member of the American Industrial Hygiene Association's Indoor Environmental Quality Committee.

So, the bans on smoking in public places stalled during the mid-1990s. And, given the small real effects of secondhand smoke on nonsmokers, that was probably a reasonable response.

NICOTINE SPIKING AND TOBACCO ADDICTION

Media coverage of the hazards of smoking has become so aggressive that studies show Americans believe that more than 40 percent of the people who smoke heavily will die of lung cancer.

Even though it is true that the death rate from lung cancer has doubled in the past 30 years, the real figure is less than 10 percent—and perhaps as low as 5 percent.

Certainly, part of the reason that public health advocates have had such success with public opinion is that the tobacco industry makes a good villain.

In congressional hearings during the spring of 1994, industry executives were called to testify about whether they manipulate the level of nicotine in cigarettes to make them more addictive. The executives denied the allegation.

However, there was testimony about a 1983 study by a Philip Morris scientist that indicated nicotine is addictive.

In a study based on an examination of internal company papers, Stanton Glantz at the University of California, San Francisco, documented how for decades cigarette makers deliberately concealed the dangerous and addictive nature of their products.

Glantz reviewed more than 4,000 pages of confidential memos, letters and reports spirited from the Brown & Williamson Tobacco Corp., of Louisville, and sent unsolicited to him in 1994.

The company had sought to bar public access to the documents but was rebuffed by the state Supreme Court.

In the summer of 1995, more internal documents were leaked to more objective media sources than Glantz. Outlets as staunchly pro-business as the Wall Street Journal came to the same conclusion: Cigarette makers chemically manipulate the nicotine in the tobacco they use to increase its addictive qualities.

This has nothing to do with the risks posed by secondhand smoke, but it makes the tobacco industry look like a group that can't be trusted.

CONCLUSION

In the *Journal of American Medical Association*'s review of the EPA's decision to list secondhand smoke as a known carcinogen, the entire AMA board of directors joined the journal's editors in an editorial that concluded:

> No right-thinking individual can ignore the evidence....We should all be outraged, and we should force the removal of this scourge from our nation and by so doing set an example for the world.

Be careful of risk analysts who use phrases like "right-thinking." They're not usually up to the task of looking at hard facts.

The EPA has reported that, if you are over 35 and are regularly exposed to secondhand tobacco smoke, the chances of contracting fatal lung cancer from that smoke are roughly 1 in 30,000.

There are a lot of things more dangerous that we might want to spend some money on before secondhand smoke. Consider these odds:

- you will kill yourself (if you're a male): 1 in 5,000
- you will die of breast cancer (if you're a female): 1 in 5,000
- you will kill yourself (if you're a female): 1 in 20,000
- you will die from a fall: 1 in 20,000
- you will be killed in an accident at work: 1 in 20,000

Tobacco industry spokespeople often argue that the EPA ignored two 1992 studies because they didn't support its conclusions.

In one, University of South Florida researcher Heather Stockwell found that nonsmoking women married to smokers had a 60 percent higher risk of lung cancer than women married to nonsmokers. The most highly exposed group—women exposed for 40 years or more—had a 130 percent increase in risk.

In the other study, Ross Brownson, then of the Missouri Department of Health, found no risk increase for all exposed women as a group— but the most highly exposed had a 30 percent increase.

Neither study suggests the EPA is wrong. But that's the problem with epidemiologic studies—they're virtually impossible to prove wrong because they state very little in concrete terms.

10

Air bags and
anti-lock brakes
cause accidents

Automobile safety devices offer some of the purest examples of various interpretations of risk data.

National Highway Traffic Safety Administration research consistently concludes that large cars are safer than similarly equipped small cars. The only way that small cars can have fatality ratings comparable to large cars: Add safety devices like air bags, shoulder-harness seat belts, anti-lock brakes and four-wheel drive.

How much do these devices decrease the odds that you'll be squashed when your Geo Metro collides with a Dodge pick-up? That's a matter of interpretation.

In general, shoulder/lap belts, worn correctly, reduce the odds that you'll die in a collision by a little less than half (45 percent, according to the NHTSA).

The NHTSA estimates that in 1990, 4,800 deaths and 120,000 injuries were prevented by seat belts. This is the one undisputed success among auto safety devices.

In March 1995 congressional testimony, Mark Rosenberg, director of the National Center for Injury Prevention and Control at the

CDC emphasized the importance of seat belts in auto safety:

> In this country, we have made significant progress in reducing motor-vehicle fatalities. This progress has resulted from a comprehensive approach to the problem and can largely be attributed to reductions in drinking and driving, increases in safety belt use and motorcycle helmet use, and improvements in roadway and vehicle design.

> ...In 1992, 54 percent of the 7,742 motor-vehicle-related deaths of people under 20 years of age had an underlying cause of death— head injury.

> ...safety belts can help reduce this toll. Safety belts are widely recognized as effective in reducing fatalities and nonfatal injuries.

Still, according to several estimates, national seat-belt usage averages about 60 percent. And use is least common among those at greatest risk, such as teens, drunk drivers and speeding drivers.

Even though two in five don't wear seat belts, consumers will fork over hundreds of dollars for optional devices in the pursuit of a safer car. Insurers encourage them by offering discounts. Auto companies, meanwhile, have poured billions into developing, making and heavily promoting the new safety systems.

Air bags can save lives in collisions. The National Highway Traffic Safety Administration had concluded that the chance of a seat-belted driver's death in an accident was reduced by 50 percent in a car equipped with a driver's-side air bag, compared with 45 percent for a seat-belted driver with no air bag.

What is unclear is how much protection air bags offer from injuries short of death. NHTSA fatality ratings are based on the results of a controlled environment with consistently repeated crash tests. It's not clear that air bags and the rest have any significant impact in the real world.

Since they've bought into the effectiveness of safety devices, it's no

surprise that auto makers and insurance companies defend the things. What is surprising is that auto insurers put themselves in the position of arguing the safety devices minimize risk when they might not. The companies might be arguing against their own best interests.

In this chapter, we'll consider the effectiveness of auto safety devices—and whether auto insurance companies that subsidize them are doing a smart thing.

SOME BACKGROUND

At the center of the auto safety device debate is the theory of offsetting behavior, pioneered 20 years ago by University of Chicago professor Sam Peltzman. The theory suggests people adapt to safety improvements by taking more chances.

(Some risk analysts refer to this same phenomenon as the more technical-sounding risk homeostasis. Actually risk homeostasis doesn't require behavioral factors—it covers any situation where one kind of risk replaces another. But the two concepts are similar.)

In 1975, Peltzman conducted a study predicting that government-mandated safety measures such as seat belts and lower speed limits would have little or no impact on the financial losses from auto accidents. He maintained that demand for safety already was being addressed by the market, and that mandated safety devices could encourage driver carelessness.

"I found that risk-taking behavior completely offset the lifesaving effects of mandated safety equipment," Peltzman says. The bottom line, he says, is that safety equipment "lowers the price of driving more aggressively."

Just as people drive more aggressively on a clear and dry day, the argument goes, they will drive more aggressively when they believe their cars are safer because of equipment.

Peltzman's most political critics argue that his theory is merely a big-business rationalization for not spending money on safety measures. Others, mostly economists, concentrate on what they consider counterintuitive guesswork on Peltzman's part.

There are ongoing debates among economists and risk theorists about the validity of the offsetting behavior theory, but it is clearly something that should be taken into consideration.

THE AIR BAG DISPUTE

During the 1980s, the insurance industry complained that cars should have air bags. The auto industry complied and phased in air bags as a standard feature on most models. For its part, the insurance industry offered discounts on premiums for cars with the devices as a sign of good faith.

More than anything else, air bags prevent people involved in front-end collisions from going through the windshield. Injuries and deaths caused in this manner have traditionally been a major cost borne by insurance companies.

The federal government has made air bags mandatory in all 1996 cars. Consumers pay an average of more than $600 per vehicle for air bag systems. But—regardless of technical fine points like offsetting behavior—some auto safety experts argue that the money is wasted.

A lap/shoulder belt reduces fatalities in front-end crashes 42 per cent. Add an air bag and you buy yourself only another four per cent protection.

"If you want real protection, buy a big car. Something 3,000 pounds or more," the University of Hawaii's Larry Laudan says. "You are less likely to die in a large car wearing no seat belt than you are in a small car with a seat belt."

NHTSA crash tests back up this argument. Some safety-equipped small cars perform relatively well, but the federal ratings consistently rise with the curb weight of the car in question.

The dispute over air bags reached full stride in 1993, when researchers at Virginia Commonwealth University looked into 206 fatal auto crashes and found that cars with air bags were more crash-prone than vehicles without them. The study analyzed accidents involving 1990-1993 model cars, 43 percent of which contained air bags.

Their explanation: The vehicles were safe but drivers—aware the air bag was protecting them—felt emboldened to take greater risks. This was a clear example of Peltzman's offsetting behavior theory.

The study found drivers with air bags were disproportionately responsible for multi-car accidents and placed their own passengers at greater risk than did other drivers. It suggested that air bag drivers were driving in such a manner as to offset the effectiveness of the protection, believing technology would bail them out.

Two findings were particularly pertinent. First, in fatal crashes between an air bag vehicle and a non-air bag vehicle, the driver of the air bag vehicle was responsible for 73 percent of the accidents. Second, of 13 single-car crashes in which only passengers died, nine of the drivers were in vehicles with air bags.

What seemed to be happening when a driver settled behind the wheel of a car equipped with air bags was a dangerous change in attitude. The driver became overconfident and was more willing to take chances that otherwise would be shunned. That overconfidence was a development that had not been considered when insurance companies originally advocated the devices.

Virginia Commonwealth University economist George Hoffer, the report's principle author, said it was "not a diatribe against air bags. Air bags are good....If you don't change your driving habits, you're clearly safer with an air bag. What [the study] suggests is that air bag drivers are driving in such a manner as to offset the effectiveness of the air bag."

A GENERAL TENDENCY TOWARD CAR PROBLEMS

In a separate study analyzing insurance data, the same Virginia Commonwealth University professors found that owners of 31 models of cars equipped with air bags filed more personal-injury claims than owners of like cars without air bags.

The second study was published in 1994 in the Journal of Consumer Research. Hoffer said they conducted the study because they were interested in the effects of air bags on driver behavior.

The researchers compared like models of cars to eliminate differences in behavior between typical buyers of Volvo station wagons and Ford Mustangs.

They analyzed insurance data collected between 1989 and 1991 on 20 car models equipped with air bags. For 12 models, the relative frequency of personal-injury claims increased after air bags became standard equipment. After the study was completed, the researchers gathered data for 1992 models equipped with air bags. That data showed that six out of 11 vehicles equipped with air bags reported a higher frequency of personal-injury claims. In total, 18 of 31 models from 1989 to 1992 saw the relative number of personal-injury claims rise.

The study measured the number of injury claims filed, not the extent of the injuries suffered or the dollar amount paid to the insured. Using this information, it established an index in which 100 represented an average claims rate and 0 represented no claims.

In the study, a 1990 Honda Accord scored a 91 for personal-injury claims. But 1992 Accords, in which air bags were standard, had more claims and scored 98.

THE INSURANCE INDUSTRY'S UNEXPECTED RESPONSE

Brian O'Neill, president of the insurance industry-sponsored Highway Loss Data Institute, called the VCU air bag findings mislead-

ing. He said that, in some instances, the injury claim frequencies rise, but the comparisons of cars with and without air bags are complicated by other design issues.

Hoffer said his numbers were adjusted for such variables.

O'Neill complained that the VCU study measured the frequency of all injury claims in cars with and without air bags, even though air bags deploy only in relatively serious collisions. "Air bags are not designed to prevent minor injuries. They are designed to prevent serious injuries and deaths, and the evidence is now clear that they are doing just that," he said.

Whether cars equipped with air bags should have insurance discounts may be another question, though.

If, as the Hoffer studies indicate, personal-injury claims rise with air bags, they should raise insurance premiums.

(The air bags themselves add an additional cost. It costs about $1,200 to replace an air bag that has deployed in a crash. And the theft rate for the devices grew sharply in the early 1990s.)

Hoffer attributed all of the cost-driving elements of air bag use to offsetting behavior. "If you build a safer ladder, people will climb higher," he said.

Kim Hazelbaker, senior vice president for Highway Loss Data Institute, rejected the offsetting behavior theory out of hand. "We find no credibility in that argument whatever....Safety research from all over the world has shown that that's not the fact."

Actually, safety research is decidedly ambiguous on the subject of offsetting behavior.

The Virginia Department of Taxation put it plainly: "We have concluded that offsetting behavior is real and should be included in the policy-making process" for auto safety. He wrote a study in 1993

that compared auto safety improvements with accident and death rate statistics from the mid-1960s to the present.

IN DEFENSE OF AIR BAGS

In an April 1994 letter to editor of the *Wall Street Journal*, HLDI President Brian O'Neill attacked the VCU studies in harsh terms:

> air bags are reducing the severity of injuries reported to insurers. They are also reducing the frequency with which people need to be hospitalized.

> ...Unfortunately, some economists apparently are intent on reviving the totally discredited notion that people take more risks when cars are made safer, ignoring the overwhelming evidence that safety features such as air bags, which are mandated by federal standards, are saving thousands of lives each year.

> There is overwhelming evidence in the scientific literature that safety features mandated by federal safety standards...have substantially reduced the numbers of deaths and serious injuries occurring in motor-vehicle crashes.

Throughout the letter, O'Neill used contentious language. He called the VCU research "an incompetent study" whose "purported findings...are wrong because they were derived using invalid arithmetic." He objected strongly to "the speculative hypothesis that a purported increase is due to high-risk individuals choosing to buy air bag-equipped cars."

More than just fighting words back up the insurance industry's support of air bags—even though the virulence of the support remains...unexpected.

A 1993 Department of Transportation study of air bag effectiveness concluded that "air bags alone are estimated to be 42 percent effective in reducing moderate-to-critical injury; air bags plus manual lap/shoulder belts are estimated to reduce this risk by 68 percent."

Two 1991 studies conducted by the HLDI found air bags highly effective in preventing death and serious injury in car crashes, especially frontal wrecks.

One study was based on an analysis of fatal accidents between 1985 and 1991. It showed that driver deaths in frontal crashes were 28 percent lower in cars equipped with air bags, compared with automobiles with manual lap-and-shoulder belts. In all kinds of crashes, the reduction was 19 percent.

The other study was based on an analysis of insurance claims of driver injuries in serious frontal crashes. It showed that drivers in air bag-equipped cars were 25 percent to 29 percent less likely to have moderate or severe injuries and 24 percent less likely to be hospitalized than were drivers of cars with automatic belts. The study involved 1990 models involved in accidents resulting in at least $5,000 damage to the car.

In issuing the 1991 studies, Charles Hurley, an Insurance Institute for Highway Safety spokesman, took aim at then-incomplete results that VCU's Hoffer had announced.

Hurley complained that Hoffer's results left the mistaken impression that air bags don't reduce serious injuries. He set the model for future disputes by arguing that Hoffer's analysis was skewed because it included all types of injuries, even minor ones, whereas air bags are designed to prevent serious injury in frontal crashes.

ANTI-LOCK BRAKES

Anti-lock brakes have become a hot item on cars. Designed to help drivers come to a safe stop in the event of a panic stop, they were standard equipment on about half of all 1994 models and will eventually be on every new vehicle. The *1995 Car Book* reports only six models for 1995 do not have anti-lock brakes.

Most anti-lock brake systems use a computerized device to apply and release the car's brakes more quickly than a person can. As a

result, when a driver steps hard on the brakes, the effect is like the "pumping" that auto safety experts recommend for wet or icy roads.

The HLDI estimates that 10 million cars on the road in the U.S. are equipped with brakes that help drivers keep control during skids. But in 1995 it released a study concluding that the computer-assisted braking systems aren't "reducing either the frequency or the cost of crashes that result in insurance claims for vehicle damage."

The Institute said vehicles with four-wheel anti-lock brakes are involved in as many accidents and suffer as much damage as those without the system.

The study contradicts what had become an accepted truth: that anti-lock braking systems can help prevent accidents.

The HLDI study measured data based on the frequency of accidents involving certain U.S.-model cars with and without anti-lock brakes and the dollar amount of insurance payments made to those in accidents. The study didn't address injuries or medical costs.

The data included 55 percent of the total number of cars privately insured in the institute's files. It involved the equivalent of 1.2 million cars over a one-year period.

The Institute found that overall insurance losses for 1992 Chevrolet Cavaliers equipped with anti-lock brakes were higher than overall losses for the same 1991 models with regular brakes. On a scale in which a score of 100 represents average insurance losses and zero represents no losses, the 1991 Cavaliers without anti-lock brakes scored 95. The 1992 Cavaliers with anti-lock brakes scored 96.

The average claim costs for 1992 cars equipped with anti-lock brakes totaled $2,293, compared with $2,215 for like 1991 models without anti-lock brakes (though inflation accounted for part of the higher costs for the later-model vehicles).

The institute focused on the GM vehicles because they had no significant design changes other than the addition of anti-lock brakes.

One hopeful sign: The study found that vehicles with anti-lock brakes had 5 percent to 15 percent fewer fatal collisions with pedestrians or cyclists and fewer collisions with animals.

Getting a handle on driver error could be the key to assessing the benefits of anti-lock brakes. HLDI official Kim Hazelbaker says that, strictly speaking, the anti-lock brake study results don't show a statistical difference between cars with and without the systems.

The NHTSA says it had insufficient data to draw any conclusions about the effect of these devices.

Other studies by General Motors and the U.S. Department of Transportation also came up with disappointing results for anti-lock brakes.

Some auto insurance industry experts say they aren't surprised at the studies, even though many insurers discount portions of medical and personal-injury premiums by as much as 40 percent on cars equipped with both air bags and anti-lock brakes. Some states require insurance discounts for vehicles with air bags, and Florida and New York require discounts for anti-lock brakes.

A spokesman for State Farm Mutual Automobile Insurance Co. said, "We never felt there was any strong evidence that showed it reduces the number of accidents....We offer discounts only because we're supposed to, not because we feel they're justified."

Indeed, even Brian O'Neill, the HDLI president who so staunchly defended air bags, found anti-lock brakes a less certain safety factor:

> The study found no change in the frequency of insurance claims for damage to cars equipped with anti-lock brakes compared with otherwise similar cars without such brakes. While these results may be disappointing, they should not be totally surprising to anyone familiar with anti-lock technology.

...anti-lock brakes do not offer substantially improved stopping distances on most road surfaces. Only on very slippery surfaces are there pronounced improvements in stopping distances for cars with anti-lock brakes and, on some surfaces such as gravel or loosely packed snow, anti-locks can actually increase stopping distances.

Because anti-lock brakes have been promoted as some kind of wonder brake that will enable motorists to stop on a dime and thus avoid collisions, expectations for them have been unrealistic.

Anti-lock brakes can be very effective in helping drivers maintain control in emergency braking situations on very slippery surfaces. In circumstances in which a vehicle with regular brakes may skid out of control, anti-locks can help prevent the skid and also allow the driver to steer to avoid a possible collision. However, these situations are relatively rare for the average driver.

The average reaction time to a highway hazard is three-quarters of a second—though some drivers may take two or three seconds to get their foot on the brake. Even with average reaction time, a car at 60 miles an hour will travel 66 feet before a driver even gets his or her foot on the brake.

Other than reaction time, stopping a car on a clear road is a basic matter of physics, so technology has less impact on it than on other aspects of driving. Anti-lock brakes, due to superior braking action and greater control, may shorten stopping distance, but on most road surfaces they won't make much difference.

According to the California Office of Traffic Safety, a car traveling 60 m.p.h. travels the length of one-and-a-half football fields in five seconds.

SPEED LIMITS

In 1973, a 55 mile-per-hour national maximum speed limit was introduced in the U.S. as a reaction to that year's oil embargo enforced by the Organization of Petroleum Exporting Countries (OPEC).

The speed limit was made permanent in 1975, with the belief that it would greatly enhance safety on the nation's highways.

Auto fatality rates declined during the oil embargo, but they increased over the first few years the permanent law was in effect. This led some experts to conclude that trends in highway speeds and fatalities are independent of posted speed limits. Overall, though, during the 1980s highway fatality rates began a steady, long-term decline.

The National Academy of Sciences determined that from 1974 through 1983, the 55 m.p.h. speed limit saved 2,000 to 4,000 lives every year, prevented tens of thousands of injuries and reduced the economic costs of highway crashes to the American public.

At the same time, real highway speeds were increasing. One study released in the late 1980s estimated that 80 to 90 percent of traffic on the interstate system was traveling well in excess of 55 m.p.h.

As a public policy, the 55 m.p.h. speed limit was a failure. Many states were in jeopardy of losing federal highway funds because they didn't effectively enforce the speed limit. Motorists were visibly and verbally annoyed with the whole situation.

In 1987, Congress made exceptions to the 55 m.p.h. speed limit that permitted states to raise their limits to 65 m.p.h. on selected highways. This legislation was a stop-gap measure, intended to pacify motorists and prevent the complete collapse of the national maximum speed limit concept.

According to some sources, in the first three years the 65 m.p.h. option caused over 1,400 additional deaths. Other groups dispute the numbers. While the real number of fatalities has increased since the shift back to higher speed limits, it's hard to link the one trend with the other.

The most telling sign: By 1994, 42 states had taken advantage of the option, and not one of those had returned to a 55 m.p.h. limit.

The issue has broken down to a partisan dispute.

On one side, self-styled safety organizations and public-interest groups don't want to see a 65 m.p.h. speed limit. They argue points like elderly drivers will be reluctant to drive faster and that the risk to them will increase.

On the other side, some auto experts argue that the greater danger for drivers on interstates is speed differential—the mix of vehicles going various speeds. And most surveys find the majority of motorists wants to see the 65 m.p.h. speed limit.

The list of studies confirming that higher speeds cause more deaths is long, including impartial government agencies such as the NHTSA, research organizations like the University of Michigan Transportation Research Institute and leading researchers in publications like the *Journal of the American Medical Association*.

Speed is a critical factor in one-third of all fatal crashes, second only to impaired driving. At higher speeds, drivers have less time to perceive and react to trouble ahead. The loss of even a second can mean the difference between a safe stop or avoidance maneuver and a deadly crash.

A crash at 65 m.p.h. has nearly twice the force of an impact at 55 m.p.h. Crash severity and the chances of death or serious injury increase geometrically—and therefore disproportionately—with speed.

Insurance industry officials say the experience of some states has been that, when speed limits rise to 65 m.p.h., more drivers will go 75 m.p.h. or higher—and that the number of fatal accidents will increase. "There will surely be increased death and injuries," reported the lobbying group Advocates for Highway and Auto Safety. "Every state has experienced it."

This is a variation on the offsetting behavior theory that the insurance industry rejects so vehemently with regard to air bags.

CONCLUSION

Even when conflicting parties can agree that data are true and useful, they don't always agree on what the data mean. The issue of offsetting behavior is a good example of the different ways in which people can interpret risk data.

These disagreements usually turn on issues of causality and degree of influence.

Auto air bags are a great example of this kind of issue. Seat belts clearly do a lot to lower the odds you'll die in a car wreck. Anti-lock brakes clearly don't. The results aren't so clear for air bags.

Highway traffic fatalities, like many statistics, can be influenced by various factors. The number of people who die each year in auto accidents rose steadily during the early 1990s. At the same time, two things happened: Most car makers started putting air bags in their cars and many states raised maximum speed limits from 55 to 65 miles per hour.

Different analysts can conclude that one or the other development contributed more significantly to the rising death toll. The matter of who is right—or who is more precisely right—is left to a battle of well-chosen statistics and sound bites.

Offsetting behavior suggests that air bags and anti-lock brakes cause more accidents than they prevent by subtly encouraging people to drive more recklessly than they would if they didn't have these safety features. The argument makes sense psychologically as much as statistically.

But proponents have the risk theory advantage of basing their arguments on risk scenarios taken from actual numbers.

The critics of offsetting behavior have a more difficult task. They can point to the number of people saved each year by air bags; but

this number is small and made questionable by the fact that air bags only engage in serious accidents.

More difficult still, they base a lot of their argument on the fatalities that haven't happened because of air bags. This gets difficult. Even government agencies inclined to support safety devices in cars—like the NHTSA—have a hard time calculating how many lives air bags save.

So, the critics are left basing their arguments on the theoretical risks averted by the devices.

Normally, risk theory advises you to assume a potential loss will occur unless you can discount that occurrence with a reasonable degree of certainty. In the context of the air bag dispute, this means assuming they do encourage reckless driving unless there's proof they don't.

There isn't.

Which leaves only one question. Why did the insurance industry advocate the things so strongly?

11

The moral hazard
of buying insurance

Terms like *offsetting behavior* and *risk homeostasis* try to describe circumstances in which people or groups respond to reductions in certain kinds of risks by taking more or other kinds of risk. These theories have an important relative in the insurance business.

Common sense suggests that people will act differently when they have insurance than when they don't. They will usually feel less risk-averse—meaning they're less afraid of losing their valuables. In the insurance industry, this sense of recklessness that insurance can cause is called *moral hazard*.

The familiar bumper sticker that reads "Hit me. I need the money." gets to the spirit of moral hazard.

A related issue is the theory that the people most likely to want insurance are those most likely to need it. In other words, people who do dangerous things will try to buy insurance to offset some of the risks they know they take. This is called "adverse selection."

The actuaries and risk theory specialists that insurance companies employ spend a lot of time thinking of ways to minimize the effects of moral hazard and adverse selection. The most radical of these

gurus go as far as to argue that certain kinds of insurance shouldn't be sold because they encourage dangerous behavior.

But these gurus tend to be promoted less quickly than the ones who keep their radical theories to themselves.

Nevertheless, moral hazard, adverse selection and other factors influence the way insurance works. Because their influence is gradual and long-term, they are usually difficult to study among individual people. The best studies on the matters focus on large groups of people, business sectors or government entities.

The factors we consider in this chapter do have an impact on how you should think of risk.

Many people who buy insurance—especially more complex coverages like long-term care or umbrella liability—are plagued by the nagging feeling that they've wasted their money protecting against an unlikely loss. More importantly, and more sadly, some despondent people feel a greater temptation to kill themselves when they believe that their life insurance will leave a lot of money to loved ones.

In this chapter, we'll consider these risk factors and try to shed some light on the ambivalent feelings many people have about insurance.

SOME BACKGROUND

Federal deposit insurance assures you that money you deposit in a federally-chartered bank will be replaced—up to a certain limit—if the bank goes out of business. A government-run entity called the Federal Deposit Insurance Corporation underwrites this insurance in the United States.

This insurance was an important influence on the large number of bank and savings-and-loan failures that the U.S. experienced in the 1980s and, to a lesser degree, the 1990s.

The important question: Does deposit insurance cause banks to take more risks or does it merely attract the most risk-prone banks?

Because of insurance coverage, depositors have little or no incentive to investigate the riskiness of the banks they use. In a perfect world, depositors would check out the riskiness of banks and charge the risky ones higher interest rates for their deposits. This would raise a bank's cost of funds proportionally with its risk of insolvency.

In this scenario, depositors flock to conservative banks—banks that can afford large cash reserves. Although cash and other reserve items generate low (or no) interest income, a high reserve-to-deposit ratio better enables a bank to absorb unexpected deposit outflows without resorting to high-priced borrowing. It pays for itself by reducing the bank's cost of funds.

Deposit insurance subsidizes risk-taking among banks. It creates a moral hazard. Banks find it best to keep lower reserve-to-loan ratios and more risky investment portfolios with insurance than they do without insurance. In essence, deposit insurance lowers the cost of deposits relative to capital—so, banks will choose greater leverage than they would otherwise.

In the 1980s, federal regulations on where savings-and-loans could invest their money were relaxed but no changes were made to the insurance system. Hometown S&Ls were allowed to invest in risky junk bonds with cheap money. The number of failures rose dramatically during the decade.

During the 1990s, increased competition eroded bank charter values and increased risk-taking. The competition increased the demand for insurance, as well as the incentive to take on additional risk.

As the S&L crisis of the 1980s showed, if deposit insurance premiums are not adequately tied to risk, then risk-prone banks will have more to gain from deposit insurance than conservative banks and hence be more likely to join a voluntary insurance system.

In its 1991 study *Deposit Insurance: A Strategy for Reform*, the General Accounting Office concluded:

> ...If regulators can accurately monitor bank risk and charge risk-adjusted premiums, there would be no incentive for banks to assume more risk than they would in the absence of insurance. Several studies...have proposed risk-adjusted premiums and since January 1, 1993, the Federal Deposit Insurance Corporation has imposed premiums based in part on risk.

One criticism is raised most often about risk-based premiums. Although financial risk ratios reflect a bank's condition, they are after-the-fact measures of risk-taking. A traditionally cautious bank can start writing lots of high-risk loans and get into financial trouble—even fail—before the insurance system finds out what has happened.

AN HISTORICAL PERSPECTIVE

In the U.S., federal deposit insurance was enacted in 1933 in response to the bank failures of the Great Depression. Deposit insurance was not a new policy, though. A number of states had experimented with their own insurance plans.

In the 1930s, deposit insurance opponents pointed to the unsatisfactory performance of many of these plans as evidence that federal insurance could not work. For instance, the American Bankers Association argued:

> As a matter of unbiased history...the guaranty of deposits plan proved fallacious and unworkable....It has proved to be one of those plausible, but deceptive, human plans that in actual application only serve to render worse the very evils they seek to cure.

In fact, some state plans worked better than others.

The Indiana insurance system minimized moral hazard problems by giving insured banks the incentive and ability to monitor each other and enforce conservative behavior.

Other state plans—the troubled New York Safety Fund was one—suffered extensively from moral hazard and from adverse selection, that is, that risk-prone banks chose to join the insurance system while conservative banks stayed out, leaving depositors without credible insurance.

The Kansas system had a number of unique features that were intended to limit risk-taking. Kansas officials assumed that deposit insurance would be most attractive to the most risk-prone banks, so they set up a number of regulations to limit adverse selection.

- Banks had to have been in business for at least one year and undergo a state inspection before being admitted to the insurance system.

- Once in the system, banks had to keep a capital base of at least 10 percent of total deposits and maintain profits of at least 10 percent of total capital.

- Banks were encouraged to keep even higher capital reserves. They were charged premiums based on their total deposits minus capital and cash surplus; the larger a bank's capital base, the lower its premiums.

- The system imposed interest rate ceilings on insured deposits.

- Banks could withdraw from the insurance system with six-months' notice. But they remained liable for assessments needed to reimburse depositors of failed banks during that period.

- The state bank commissioner had the authority to suspend insurance for any bank found in violation of state regulations.

Most importantly, membership in the Kansas system was voluntary. This came in response to complaints about adverse selection in plans like the one in New York—where conservative banks ended up subsidizing reckless ones.

From 1909 to 1920, the number of insured banks and the deposits in those banks grew faster than those of noninsured state and national banks. The deposit insurance system was popular with both bankers and depositors. Twice as many banks were insured in 1914 as in 1910.

But that popularity declined after a collapse of farm prices in mid-1920 brought increased loan defaults and bank failures. Members of the insurance system were the most susceptible to failure. They tended to be less adequately capitalized than noninsured banks.

So, again, did the system encourage banks to be reckless or did it attract banks that already were?

If the banks with the greatest preferences for risk were more willing to pay the costs of insurance system membership, then less well capitalized banks should have been more likely to join the insurance system than other eligible banks.

In the February 1995 issue of the *Journal of Money, Credit & Banking*, authors David Wheelock and Subal Kumbhakar used a historical survey of the Kansas banking system to make several relevant conclusions:

> It seems that the first members of the Kansas deposit guaranty fund were riskier than those banks electing to not join the system. Did adverse selection continue to characterize the system over time?

> ...Between 1910 and 1914 the mean capital/asset ratio of uninsured banks rose, as it did for those insured in both years. It fell, however, for banks acquiring insurance between 1910 and 1914.

> ...Loans are generally the most risky assets that banks hold....Presumably insurance lowered the cost of deposits, and hence the more a bank relied on deposits as a source of funds the greater its demand for insurance.

In the days before insurance, banks routinely advertised their strength and conservatism. Risky banks with weak balance sheets

had to pay higher interest rates to attract deposits, and therefore might have relied less heavily on them as a source of funds. This suggests that the coefficient on the ratio of deposits to assets should in fact be negative.

If moral hazard alone had characterized the Kansas insurance system, the researchers would have expected to find that membership had a negative impact on surplus-to-loans and cash-to-deposits ratios. At the same time, membership would have had a positive impact on loans-to-assets ratios.

Although the Kansas system seemed to have encouraged insured banks to hold less capital than uninsured banks, the researchers found no systematic impacts on the surplus-to-loans, cash-to-deposits or loans-to-assets ratios.

Wheelock and Kumbhakar tried modelling bank risk and the decision to join the Kansas system as a simultaneous system.

> If moral hazard is present, insurance should increase risk-taking, whereas if adverse selection is present, then higher-risk banks should be more likely to join the insurance system.

> ...We thus reestimated the models for each of the four financial ratios simultaneously with a linear probability model of insurance system membership.

> The Kansas deposit insurance system appears to have suffered from both adverse selection and moral hazard.

> ...Adverse selection continued to characterize the deposit insurance system throughout its first decade.

>Since risk-prone banks gain the most from deposit insurance, it makes sense that a voluntary deposit insurance system in which premiums are imperfectly tied to risk would attract the most risk prone banks. Moreover, in order to avoid subsidizing other insured banks, an insured bank would have an incentive to increase risk.

One reason the Kansas system's risk controls didn't hold up was that they didn't go far enough. Because the premium assessment was relatively mild, the reward for holding extra capital was small.

Ultimately, the Kansas deposit insurance system collapsed, and depositors of failed banks were not made whole.

The Kansas system illustrates the difficulty of designing a system that doesn't ultimately break down. It also shows that the 1980s S&L crisis was not an isolated incident in the history of banking.

So, even though you feel safe that the FDIC insures your life savings (up to $100,000 per account in the early 1990s), that insurance actually increases the odds that a given bank might run itself into insolvency. That raises the premium costs for everyone.

LONG-TERM CARE INSURANCE

One of the most ignored health issues of our time is how to pay for long-term medical care of people who are chronically ill. These people are most often the elderly—but anyone can need long-term care.

People who can't perform basic activities of daily living, such as bathing, dressing, and preparing meals, need long-term care. These people may have a long-lasting disability or a cognitive illness such as Alzheimer's disease. The care can be provided in the person's home, in a community-based facility such as an adult day care center, or in a residential facility.

Nursing home care costs from $30,000 to $50,000 a year. With an average stay of almost two-and-a-half years, a family without long-term care protection will deplete its assets by about $100,000—assuming the family has this much to start with. Even less-expensive in-home care runs from $8,000 to $15,000 a year.

In 1992, nursing home care costs generated in the U.S. totaled $45 billion. Home health care added another $8 billion. Individuals paid an estimated 43 percent of the $45 billion aggregate bill.

According to a 1994 study by the American Association of Retired Persons, 12 percent of care-givers switch from full-time to part-time jobs and another 12 percent of women care givers leave their jobs to become full-time care givers. As many as 30 percent of all workers over age 30 now care for an elderly parent at least 10 hours a week.

The number of people 65 and over is expected to reach 35 million in 2000 and 68 million in 2040. In 1990, the Census Bureau estimated that there were 3 million Americans 85 or older, an increase of 35 percent from 1980. Their number is expected to increase to almost 7 million in 2020 and to 19 million in 2050, when the 85-and-older group will account for more than 5 percent of all Americans. The increase in the number of people 100 and over will be even more explosive, growing from an estimated 77,000 today to 1.4 million in 2040.

In the meantime, a Harvard University study found that 46 percent of those admitted to a nursing home are impoverished within three months and 72 percent become penniless within the first year. But this happens at least partly by design.

Government programs for the poor—primarily Medicaid—paid more than half of the country's total long-term care bills. But these programs only take effect when a person has spent all of his or her assets. As a result, smart families use devices like living trusts to organize their finances so that an older member has limited resources left as he or she gets older.

Usually, the family will leave enough money in the accounts of an older member so that he or she can pay the admissions fees to a better facility. Then, the estate "zeros out" and Medicaid benefits take over ongoing costs.

"Zeroing out is, technically, a form of Medicaid fraud. But it's a scheme that everyone's part of—seniors groups, the nursing homes, even the Social Security Administration. It's moral hazard writ large," says Washington, D.C.-based risk management consultant William Bell. "People aren't supposed to do it. It defeats the pur-

pose of Medicaid. But smart people find ways to beat government rules and actuarial tables."

Although long-term care is a ticking financial time bomb both for individual families and society as a whole, legislators would rather not address this problem on the public policy level.

Many people believe, wrongly, that Medicare or their existing health insurance will cover their long-term care needs. Other prefer to put off facing the disturbing prospect of being chronically ill or disabled.

This is true even though long-term care insurance is relatively cheap. Under some standard group programs, in 1994 a 40-year-old person paid about $250 a year for lifetime benefits that can be used to pay for any combination of care at home or in an institution. Over a 30-year period, the individual's payments would total $7,500—less than the cost of three months in a nursing home in 1994.

Even though the odds are 3 in 5 that anyone over age 65 will need long-term care during his or her lifetime, only 3.4 million people—about 1.25 percent of the U.S. population—had long-term care insurance in 1993 for in-home or nursing home care.

Contrast this response with homeowners' approach to fire insurance: They buy that coverage even though the odds are less than 1 in 100—over a 30-year period—that their home will be damaged by fire.

Insurance companies don't sell long-term care coverage very aggressively precisely because so many people will need it. And they sell fire insurance hard because so few claims are ever made.

The biggest cost driver for long-term care insurance is your age at the time you start buying. The cost of long-term care insurance for someone who starts coverage at age 70 is five times greater than coverage begun at age 50. At age 75, the cost is two and one-half times greater than the cost of coverage initiated at age 65.

The odds of someone over 65 making a claim on a long-term care insurance policy are 60 times greater than the odds of a homeowner

making claim on a fire insurance policy. Long-term care insurance for a 65-year-old is more expensive than fire insurance—but more like three times than 60 times. If you were running an insurance company, which business would you rather pursue?

HOW CONSUMER ACTIVISM AFFECTS INSURANCE

In 1995, the appointments of Howard Metzenbaum and Robert Hunter to the Consumer Federation of America raised the anxiety level in the insurance industry. Metzenbaum and Hunter were widely viewed as zealots, intent on searching for moral hazards inherent in the system.

The new stepped-up focus on insurance included merging NICO into CFA and retaining several senior NICO officers.

Metzenbaum had distinguished himself as an insurance industry watchdog during 20 years in the U.S. Senate. Hunter, a founder of the National Insurance Consumer Organization and former Texas insurance commissioner, had long been considered the industry's most vocal and controversial consumer advocate.

Hunter, who created NICO with financial backing from consumer activist icon Ralph Nader, sees behavioral risk factors like moral hazard as phenomena that permeates insurance. On the individual level, they may translate into insured people or businesses becoming more risk-prone. On the industry level, they translate into rampant collusion.

For example, in 1992, Hunter accused New York-based property/casualty insurer American International Group of "blatant, us-first price fixing" when it attempted to raise homeowners' insurance rates following Hurricane Andrew.

Hunter says, "The way insurers are allowed to collude on prices is an outrage."

Metzenbaum agrees, charging, "The insurance industry is the most

powerful economic factor in America and the least regulated; the insurance regulators in this country are an embarrassment."

Hunter was fast to attack product liability reforms sought by much of the insurance industry. In testimony to Congress, he noted that product liability costs manufacturers only 26 cents per each $100 of product sales. "Let's ask the insurance industry and manufacturers where the crisis is. You've got a system that's costing only about one cent per every five dollars of sales. That's cheap," he said.

CFA has had some victories against excesses in the insurance industry. In 1990, the group began a campaign asserting that credit insurers were grossly overcharging consumers. The association concluded in its own research that consumers were receiving only 44 cents on each premium dollar for that kind of insurance. Between 1990 and 1995, 18 states lowered allowable rates for credit insurance products, and last year the National Association of Insurance Commissioners adopted a model law requiring insurers to return at least 60 cents per premium dollar collected.

Ultimately, though, the arguments raised by people like Robert Hunter have little bearing on the influence of risk on insurance costs. Even if insurance companies publicly disclose their underwriting guidelines and submit to federal—instead of state—regulation, only procedural details will change.

Allowing for the sake of argument that Hunter is right and his proposals will lower premiums for consumers, they won't effect the legitimate issue that moral hazard raises insurance costs.

In this sense, to the extent consumer activists use terms like *moral hazard* and *adverse selection*, they don't seem to understand their true meaning.

GENDER DISTINCTIONS IN INSURANCE

The role of gender in setting insurance premiums illustrates why differences in risk perception between consumer advocates and insurance companies may never be resolved.

The insurance industry has fought vigorously against any attempts to limit the use of what it considers cost-based pricing, arguing that gender is clearly a significant and reliable cost factor in insurance.

In the Maryland Human Rights Commission's lawsuit against a big life insurance company that charged different premiums for men and for women, the American Council of Life Insurance presented the industry's arguments that gender is a distinct risk factor. It argued that medical research has shown that there are biological differences between men and women that give women an edge in longevity.

The state of Maryland produced scientists arguing against the immutability of gender-based factors and an actuary who argued that the issue of longevity is more complex than the industry's portrayal.

The state's main actuary testified:

> We cannot conclude from data showing that women as a group live on average longer than men as a group that any individual woman lives longer than a man of the same age.

The state of Maryland also claimed that all life expectancy numbers—regardless of gender—are highly volatile. Its actuary testified that the average life span of those who die before the group expectancy is about half that (meaning if the group expectancy is 60 years, people who die young do so at an average age of 30).

The actuary also said the average life span of those who die after the group expectancy is about 1.5 times that (meaning, in the group with an average life span of 60 years, people who live a long time reach an average age of 90).

A volatility range of 50 percent on either side of a group average is very high. It makes the average unreliable.

The volatility of a statistic is sometime referred to as a beta factor or simply a "beta." It's usually expressed as a decimal value rather than

a percentage—in the Maryland case, the beta for the insurance industry's life expectancy was 0.5. The change in expression doesn't change the fact that the number in this case is very high.

In the 1980s, it appeared there was enough momentum to eliminate the practice of sex-distinct rates.

Sweeping change was predicted following the *Arizona v. Norris* and the *City of Los Angeles v. Manhart* federal court decisions, mandating the use of unisex mortality tables for employment-related retirement benefits.

In addition to these federal rulings, there was considerable activity on the state level.

- In 1984, Montana signed into law rules forbidding the use of sex or marital status in determining rates for all lines.

- In 1987, a broad anti-discrimination regulation in Massachusetts banned sex discrimination in policy rates or benefits for all lines of insurance.

- Hawaii, Michigan, North Carolina and Pennsylvania passed laws to prohibit the use of gender in setting rates for automobile coverage.

- At least fifteen other states tried to enact unisex rules, but fell short at the legislative or administrative levels.

In a 1987 report considering the effects of unisex underwriting, the American Academy of Actuaries predicted that, for some types of insurance, a change to sex-neutral premiums would cause women to pay less and men more than they currently paid for the same coverages. For other types, men would pay less and women more.

The actuary group predicted life insurance premiums would increase for women and decrease for men, health insurance premiums would decrease for women and increase for men and automobile insurance premiums would increase for women and decrease for men—particularly at the younger ages.

But, by 1994, many insurance companies—especially ones in the disability market—started going back to sex-distinct rates in 1994. "Because men have a lower rate of disability, they're less expensive to insure," said Michael Schiffman, vice president of disability for The Guardian insurance group.

Automobile insurers argue that sex is a significant variable for evaluating risk posed by youthful drivers. They say that statistics gathered over many years indicate women have better accident records than men, particularly in the case of drivers under age 25.

In approved training materials, the American Institute for Chartered Property and Casualty Underwriters noted "other things being equal, females traditionally generated lower loss levels than males, and most classification plans resulted in lower rates for females than for males of the same ages. With respect to drivers involved in fatal accidents, males have worse loss experience than females."

In 1994, the National Association of Independent Insurers reported that the impact of unisex premiums was restricted mainly to drivers under age 25. The unisex rates for young drivers caused moderate increases in average premium for young women and moderate decreases in average premium for young men. The report concluded:

> The average premium data and the Michigan residual market survey information show that elimination of gender as a rating factor for automobile insurance is not nearly as radical an idea as it might appear to some on the surface.

The All-Industry Research Advisory Council, sponsored by the property/casualty industry, described the effects of the legislation in Montana in a report published in 1987. In general, the report said that women drivers under age 25 had to pay more; 19-year-old single females experienced the largest dollar increases.

It concluded, "The balance of the state's insured cars, 88.2 percent, was unaffected or was affected only to a slight degree."

RACE AND RISK FACTORS

In 1994, the Department of Justice joined the National Association for the Advancement of Colored People in a discrimination lawsuit against American Family Mutual Insurance Co.

The move allowed the feds to broker a consent decree between the NAACP and the insurance company. Settling the charges, American Family agreed to invest $14.5 million in inner city insurance.

People in the insurance industry worried that the deal put every insurer in the U.S. at risk of being prosecuted on grounds that had nothing to do with intentional, illegal discrimination.

While the deal may have been unavoidable for American Family, it promised to be trouble for other insurers.

Specifically, the deal:

- set minimum premium and policy limits that could be offered in predominantly black communities,

- prohibited the use of age of building and location as underwriting factors,

- set the ratio of market value to replacement policies,

- stipulated agents' commission schedules,

- required the hiring of an urban underwriter and urban marketing director, and

- dictated the types of models appearing in advertisements and the publications in which those ads had to appear.

More importantly, the deal suggested to the insurance industry that establishing that insurance is harder to get or more expensive in one place than another could prove discrimination. Defensible business reasons for an imbalance—such as high risk neighborhoods or building code violations—could be ignored by a court.

Jack Ramirez, chief operating officer of the Illinois-based National Association of Independent Insurers, complained that:

> In the case of insurance, the Justice Department is relying on the unproven supposition that the Fair Housing Act is being violated because would-be homeowners, renters or borrowers can't close a housing deal due to a lack of insurance. No evidence has been presented to prove such a case.
>
> Actually, the opposite is true. Mortgages are not being denied for lack of insurance. It is persons who do not qualify for mortgages that have trouble obtaining insurance. Once a mortgage is granted, coverage is available somewhere.

The number of poor and minority homeowners who cannot obtain full-coverage property insurance is nearly 50 percent greater than that for residents of mostly white, middle-class areas. Poor Americans also pay more than twice, on average, what residents of middle-class neighborhoods pay for property insurance.

Insurance carriers' loss costs are demonstrably higher for urban areas—accounting for more stringent underwriting rules and higher premiums.

Even so, a 1993 study from the National Association of Insurance Commissioners reviewed three decades of insurance industry performance in urban areas and concluded: "Insurance redlining is widespread and has adversely affected residents of poor and minority neighborhoods."

In its study, the NAIC collected data on the cost and type of policies sold in 33 metropolitan areas in 20 states. The study was considered the most comprehensive ever done on the subject. After statistically ruling out other factors, the NAIC found that only 57.6 percent of the houses in high-minority, low-income areas were insured at all, compared with 81.5 percent in white, high-income areas.

People in the insurance industry argued that inner city neighborhoods had experienced risk flight—a factor akin to risk homeostasis, offsetting behavior and adverse selection.

Risk flight occurs when the cost of managing risk in one place becomes so expensive that entities with considerable assets to protect find it more cost-effective to move to another place. (The places can be geographic or demographic. The entities can be people or companies.)

In central cities with populations of one million people or more, the national average was 65 burglaries per 1,000 households in 1994. In outlying suburban areas, the average was 45 per 1,000 households.

When the entities with considerable assets to protect leave a place, the ones left—as a group—have fewer resources. If the cost of managing risk continues to increase, the entities with even moderate assets to protect will also leave. Eventually, the only entities left in a place are those who have the fewest resources, the least to lose.

This is part of the reason that inner city neighborhoods become bankrupted—spiritually and financially.

The NAIC may call response to this phenomenon racist redlining, but that's an oversimplification. Companies don't have to be racist to avoid doing business in urban wastelands; people don't have to be racist to avoid living there. They just have to be risk-averse.

And insurance companies, most of all, are risk-averse.

In the wake of the American Family deal, a vice president with Illinois-based State Farm Insurance Co. expressed the risk flight theory more basically: "There really isn't evidence of intentional discrimination by insurers against urban residents. What you have are neutral underwriting rules that have a disproportionate impact upon minority, urban residents."

CONCLUSION

Behavioral risk factors like moral hazard, adverse selection and risk flight don't just apply to deposit insurance or homeowners' insurance in urban ghettos. They apply to all transactions—including those that people enter into as a society.

There's an old saying that society is the insurer of last resort. (A variation on this is "Our children are the insurer of last resort.") So, it's useful to consider how behavioral risk factors usually associated with insurance impact the functions that define a society.

Sociologists call these things "nonexclusive public goods."

With privately-produced goods, a market exists between the producers of a good and their consumers. The consumer can weigh the costs and benefits the good entails and make a risk-sensitive decision to buy or not buy on this basis. When perfect competition and perfect knowledge of risk exist, effective legal rules will encourage efficient output and safety for both producers and consumers.

This system stumbles when it tries to handle the functions of public-sector transactions.

The critical feature of a nonexclusive public good is the inability of a private provider to capture all of the benefits from its provision. Therefore, the consumer has no way to calculate the risks of buying the public good.

Injury to life and property can result from the provision of a public good. But there's no market to signal producers and consumers how to calculate this risk. So, the public good will be underproduced if its provision is left to the private sector.

For example, consider the public provision of police services.

Police work can include high-speed chases, improper searches, unjustified use of deadly force, or any other instance in which dam-

ages are inflicted on the public. A society will decide what level of risk it's willing to accept. But the individual people in that society may respond differently.

Part of the outrage over the 1989 police beating of motorist Rodney King in Los Angeles was due to the fact that, as a society, Americans don't agree on how much risk to accept in exchange for the public good of police protection. Police brutality is a risk.

While damages from the provision of police protection services may be more notorious, the presence of risk and the implications of government liability for the safety of public goods apply to the entire spectrum of goods and services provided by government.

In the July 1995 issue of the journal *Public Finance Quarterly*, economist John Speir considered the relationship between a public entity providing services like police protections and an individual citizen:

...When a normal state is the sole provider of safety, only strict liability generates the efficient levels of both output and safety. Negligence generates the efficient level of safety but an overprovision of output. No liability results in no provision of safety and the overprovision of output.

...With rules of negligence and strict liability with contributory negligence, either the state or the victim will choose whether to absorb damages. With a rule of negligence, the state must decide if being negligent or nonnegligent is more effective at maximizing its net benefits, with the state's decision then limiting the victim's options. With a rule of strict liability with contributory negligence, the victim must decide whether being contributorily negligent will minimize his costs, with his decision then limiting the state's options.

...With a rule of no liability, the victim is liable for damages. Under this condition, the victim selects the efficient level of safety, as long as the state is providing the efficient amounts of output and safety.

...Under strict liability, the state must absorb all damages. The victim pays only those costs associated with providing safety.

Speir concluded that any legal system other than strict liability posed a moral hazard to public entities and individual citizens. Adverse selection could result from this, and risk flight could follow that.

This explains, in part, why so many people view society's public goods in the same skeptical manner that others view complex insurance—like long-term care or umbrella liability coverage. A nagging feeling of waste is a by-product that insurance and social policies share.

12

One of America's most notorious encounters with risk assessment began in 1988, when an environmental group's report charged that Alar—a chemical sprayed on agricultural products to slow ripening—was a carcinogen and should be banned. The Alar debate remains the clearest recent example of how interested parties can interpret risk data in vastly different ways.

It was an all-time low in the opportunistic manipulation of risk information.

The saga was set off by a report on the television news show *60 Minutes* that apples sprayed with Alar might cause eventual cancer in thousands of children who ate the fruit. One of the reporters on the show called Alar "the most cancer-causing agent in our food supply."

The show relied on questionable research from an environmental activist group that found Alar was causing cancer in 250 to 910 children out of a million. Even at the low end, that risk estimate was six times what the Environmental Protection Agency had concluded.

The TV show didn't mention the EPA risk number. Instead, it of-

fered an unofficial story that EPA sources had said that Uniroyal had threatened to sue if the agency attempted to ban Alar.

Nobody in the media questioned the credentials of the self-proclaimed research group, nor its unscientific approach to gathering its data.

In the days following the television show, people around the country dumped apples and apple juice. Some consumers called the EPA to find out whether it was safe for the ground water to pour apple juice down the drain.

Images of kids eating poisoned apples filled the nation's—or, at least, the popular media's—thoughts. Outraged stories and opinion pieces damned apple producers for spraying their product with a dangerous chemical pesticide.

The fact that Alar isn't a pesticide didn't diminish the outrage. Neither did the fact that it wasn't dangerous.

The unprecedented media coverage led to dramatic sales declines for all apples, whether or not they'd been treated with Alar. Parents quit buying apples and threw out cans of apple juice and applesauce. The apple bins in the markets went untouched. Growers and distributors found themselves stuck with their stocks.

In all, the apple industry lost more than $100 million in the resulting panic.

Congressional testimony looking into the cancer risks posed by Alar were highlighted when actress Meryl Streep, recruited by a group of environmental activists, testified about her concerns—as a mother of young children—about the chemical. Not wanting to miss the extensive media exposure provided by the cameras following Streep, various members of Congress huffed and puffed about looking into the...Alar...matter.

In this chapter, we'll consider how the odds of being poisoned by

Alar were twisted into a environmental issue. We'll also consider the various ways in which risk assessment applies to environmentalism.

SOME BACKGROUND

Alar is the trade name for daminozide, a growth regulator used to keep apples growing on the tree longer, so they are more colorful and crisp at harvest. The chemical was produced by Connecticut-based Uniroyal Corp. Before the scare, the chemical was used not only on apples but cherries, nectarines, peaches and pears. It also turned up in milk, meat, peanuts, chickens and tomatoes.

But the largest amount went to apples, which received top billing in the media play.

The EPA had been studying Alar for many years, and some lab scientists had reported that the chemical seemed to cause cancer in animals.

The first special review of Alar, begun in 1980, was quietly dropped after what one bureaucrat called "closed-door negotiations" between regulators and Uniroyal executives.

In 1984, the EPA circulated a report based on outside research that found Alar could be linked casually with cancer in humans—but a board of outside scientists advising the agency determined that the studies linking Alar to cancer in humans were flawed and weak.

In early 1989, the New York-based Natural Resources Defense Council launched its Pesticides Program, which was designed to "improve public health by reducing exposures to toxic pesticides and by fostering increased public demand for safe food." The kick-off of the Pesticides Program coincided with the release of an NRDC report titled *Intolerable Risk: Pesticides in our Children's Food*.

In its study of environmental advocacy groups, the Missouri-based Center for the Study of American Business described the NRDC

Alar report:

> One of the report's most alarming claims was that exposure to the eight pesticides examined in the study increased the risk of children developing cancer to 250 times what EPA regards as an acceptable level. Of particular concern was Alar....According to the NRDC, more than 6,000 children would develop cancer as a result of eating apples containing traces of Alar.

> To ensure that its claims regarding Alar were dispersed to as wide an audience as possible, the organization hired Fenton Communications, a Washington, D.C., public relations firm.

> An October 3, 1989 editorial in the *Wall Street Journal* quoted David Fenton, director of the firm, "Our goal [with the Alar program] was to create so many repetitions of the NRDC's message that average American consumers (not just the policy elite in Washington) could not avoid hearing it—from many different media outlets within a short period of time"

> ...The "60 Minutes" coverage along with a masterful PR campaign created a flurry of media stories. Segments about Alar appeared on "Donahue," the "MacNeal/Lehrer NewsHour," all three network evening newscasts, as well as multiple spots on the NBC "Today" show, "CBS This Morning," and ABC's "Good Morning America."

> *Time*, *Newsweek* and the *USA Today* made the health effects of pesticides their cover stories. In addition, articles about Alar and the NRDC appeared in the *New York Times*, *Washington Post*, *Los Angeles Times*, *People*, *Redbook*, *Family Circle*, *New Woman*, *Woman's Day* and thousands of local newspapers....

John Wisburger, one of the most respected cancer specialists in the country, characterized the NRDC's conclusions as "absolutely incorrect." But the effect of the media campaign changed the government's position. In February 1989, Acting EPA Administrator John Moore said, "There is an inescapable and direct correlation

between exposure to [Alar] and the development of life-threatening tumors in mice."

Apple growers using Alar scoffed at the alarms, and some of them said that a human would have to eat 28,000 pounds of apples a day before getting as much Alar as caused cancer in rats.

In March 1989, Administrator Frank Young said the FDA never has discovered residues of Alar in apples anywhere close to the minimum allowed by the EPA. In 800 samples tested since 1981 for Alar, he said that the highest residue level found was 8 parts per million. The EPA allowed a maximum level of 20 parts per million. "There does not appear to be a need for panic," Young said.

The FDA, EPA and Department of Agriculture issued the unusual joint statement on apple safety. "The FDA, EPA and the U.S. Department of Agriculture believe there is not an imminent hazard posed to children in the consumption of apples at this time, despite claims to the contrary," the statement said. "The federal government believes that it is safe for Americans to eat apples, and the responsible federal agencies are working to reassure the public of this fact."

The EPA responded spearately to the brewing Alar debate:

> Recently, the Natural Resources Defense Council has claimed that children face a massive public health problem from pesticide residue in food. Data used by the NRDC, which claims cancer risks from Alar are 100 times higher than the EPA estimates, were rejected in 1985 by an independent scientific advisory created by Congress. Alar has been used for decades in apple growing, and has been the subject of many studies on possible harmful side effects.
>
> ...NRDC's estimates of risk posed by pesticide residues in food are far out of line with existing data.
>
> ...The primary and greatest difference between EPA's and NRDC's estimates arises from the fact that NRDC used cancer

potency estimates from data on UDMH which were rejected in 1985 by an independent Scientific Advisory Panel.

...The practice of using data rejected by scientific peer review, coupled with food consumption data of unproven validity to calculate risk estimates is misleading.

...EPA believes that the potential risk from Alar is not of sufficient certainty and magnitude to require immediate suspension of the use of this chemical.

The NRDC claimed that apples, apple juice and other products containing the chemical posed an "unacceptable risk" to infants and small children, for whom apples are a dietary staple. It argued that the EPA had not paid enough attention to the high amounts of fruit eaten by children, nor to indications that they were especially susceptible to carcinogens.

That view was strongly endorsed by congressman Gerry Sikorski of Minnesota, who denounced what he called the "don't worry, be happy" attitude of the federal agencies who have refused to regulate the substance. Sikorski charged that the EPA "is turning American parents into the malevolent stepmother in Snow White, handing out enticingly red but fatal apples to our children."

Within three months, the EPA caved in to pressure from the NRDC and its allies. A June 1989 EPA press release described an agreement with Uniroyal—in which Uniroyal agreed to voluntarily halt the sale of Alar products registered for food use.

...A preliminary review of the 12-month interim sacrifice report of the UDMH rat study shows it to be negative for oncogenicity after one year of treatment. A preliminary review of the 12-month interim sacrifice report of the UDMH "low dose" mouse study is also negative for carcinogenic response after one year. However, the 12-month interim sacrifice report of the UDMH "high dose" mouse study indicates that UDMH causes blood vessel tumors at the highest dose level tested (80 parts per million)....

...based on the information available, the Agency has prelimi-
narily estimated the lifetime risk of cancer for adults due to di-
etary exposure to [Alar] to be 4.5 persons per 100,000....

Suddenly what had been touted as a way to keep the doctor away
was a health menace. Although health officials from the surgeon
general on down advised parents not to worry, many of them pan-
icked, and schools yanked apples off their lunch menus.

THE REPORT THAT STARTED THE SCARE

The NRDC's paper was based on one discredited 1977 study by
cancer researcher Bela Toth.

In 1985 a federal Scientific Advisory Panel reviewed the 1977 Toth
data and found that he had fed the animals far more than the maxi-
mum tolerated dosage—something like 266,000 times the average
human exposure. One of the panelists concluded that the Toth study
was "useless for assessing carcinogenic risk from Alar, and provided
no basis for canceling its registration."

Uniroyal took careful aim at Toth's study:

...The Toth study is an unreliable scientific experiment. The Toth
study cannot be used for risk assessment.

...[Alar is] extensively used in agriculture for 18 years, yet only
one reported adverse reaction—dermal irritation....

Only one dosage level was used [in the Toth study]. These stud-
ies were conducted as basic carcinogenicity screens and should
not be viewed in that light....No concurrent control groups were
used for analysis of data. The reported controls were not appro-
priate even for a basic research study.

...None of the calculations, observations or records were signed
or dated....the test chemical was administered in water, creating
an unrealistic exposure pattern [and] the design and conduct of
the study were replete with flaws....

Every other major study of Alar done—before and after Toth's—had found no link between the chemical and cancer. The first study, in 1966, had shown no cancers in animals eating large doses of the chemical. In 1978, a National Cancer Institute study on 344 laboratory mice and rats showed no increases in tumors.

Despite all of these findings, in 1986 the EPA ordered Uniroyal to conduct additional studies. Those studies failed to produce any cancers at the 20 parts per million dosage level. It didn't find anything at 40 parts per million.

At 80 parts per million the Uniroyal researchers were able to produce significant tumors in a group of 90 mice. But that dose level was 22,000 times a typical human exposure as calculated by the EPA.

The NRDC reached back to Toth's study and looked for a way to rationalize his absurd dosage levels. It found a way, taken from a series of unrelated studies which had concluded that young children absorbed higher levels of all kinds of chemicals because they eat a great deal more in relation to their body weight than adults do.

Then NRDC number-crunchers projected this higher base over a lifetime of eating Alar apples. This allowed them to approach the reasonable end of Toth's numbers. As a result, the NRDC concluded that the lifetime cancer risk for preschool children consuming an average amount of apple products was about 1 in 4,000.

Of course, by finding a way to stretch its numbers into the range of Toth's 1977 study, the NRDC had made its own numbers questionable.

Nevertheless, the NRDC demanded that the EPA immediately cancel the use of Alar and not wait for it to be phased out gradually. The EPA responded that under the law it was obliged to hold hearings and go through other procedures before a ban could become effective.

The NRDC enlisted the support of the National Academy of Pedi-

atrics. A spokesman said the pediatrics group had warned the EPA for more than two years that residues of Alar could be hazardous to children at very low doses and should not be used on any foods that youngsters consume.

After a series of maneuvers designed to excite media attention for its report, NRDC gave exclusive rights to *60 Minutes*, which dutifully aired the story.

WHAT DOES THE NRDC HAVE TO DO WITH THE EPA?

The NRDC serves as a good example of the kind of power-wielding special interest group that often shapes the way the federal government calculates risks.

Founded by a group of Ivy League-trained lawyers in 1970, the NRDC has become a kind of shadow agency, acting as its activist leaders believe the EPA should. It influences public policy debate effectively. Like many lobbying groups, it drafts proposals for members of Congress and uses the courts to advance its agenda.

The difference is that its agenda is radical environmentalism.

A key difference between the NRDC and the EPA is their respective approaches to defining acceptable risk for chemical substances in food. Both start at the same point—a 1 in 1,000,000 chance of contracting fatal disease—but, from there, they head in opposite directions.

The Federal Insecticide, Fungicide and Rodenticide Act allows the EPA to permit a risk greater than one in a million if identified benefits outweigh identified dangers. This applied in the case of Alar: Agriculture groups insisted the productivity and output gains Alar allowed were more important than the slight chance of contracting cancer from its use.

While the NRDC tolerates 1 in a million odds of getting the cancer

from food, some of its leaders and legal strategists believe there is no safe threshold for carcinogens.

The NRDC, like most of environmental activist groups, thrives in the political culture of Washington. Its influence comes from mastering the rules of the political game.

Getting nowhere in court or Congress with its crusade against Alar, the group paid $40,000 to public relations firms to get the story on TV. It followed that exposure with a TV commercial in which Meryl Streep—an NRDC member—explained to a little boy that the government was allowing poison to get into food.

The commercial had an even shakier factual base than the NRDC's report. But it also had a high effect on public perception of the cancer risk Alar posed. Schools from New York to Los Angeles pulled apples from their lunch programs. Supermarkets pulled apple juice off shelves.

In February 1995 congressional testimony, NRDC scientist Linda Greer gave the group's perspective on risk assessment and cost/benefit analysis in regulatory reform:

...The American public has recently had an experience with inconsistencies in risk assessment (without realizing it) with the "bug" in the Pentium computer chip.

...Intel, the manufacturer, published results of an internal risk assessment showing that "average" computer users would only get wrong answers once every 27,000 years of normal computer use.

...But on December 13, 1994, IBM announced it was halting all sales of IBM computers built around the Pentium chip; IBM said its own risk assessment had shown Pentium could cause an error once every 24 days for average users, not once every 27,000 years.

The example shows that risk assessment is not a tool for reaching true and reliable conclusions....

Risk assessment...requires sophisticated predictive models that show how, on a molecular level, pollutants travel when released into the air, water, and soil, or once inside the body of a plant, animal, or person.

It also requires that we know how effects in laboratory animals will affect human beings in the real world. None of these things are currently well understood, and thus we have a very weak scientific underpinning in risk assessment.

But it was exactly this kind of projection—from laboratory animal to human—that the NRDC had used as its basis for damning Alar.

Later in her testimony, Green struck closer to the traditional contempt of business that seems to motivate the NRDC politically.

...Quantitative risk assessment stops or slows controls on environmental problems until a full array of data are available. This leads to a strong disincentive on the part of the regulated industry to generate the necessary data on adverse effects, exposure, etc. The more delay in data development, the more delay in regulations. Thus, those with the most money to develop information have it in their power to slow down the flow of information and regulation in the system.

The NRDC is primarily a legal organization that was established to, in the words of one of its founding trustees, "act as a law form for the environment." Even though it employs a number of scientists, the organization's core activity is litigation. The NRDC is far less qualified to assess the human health risks associated with pesticides.

The NRDC suspects that corporate America dissembles and delays. This suspicion clouds its judgment.

Are there some large corporations who have done things like illegally pollute the environment? Yes. Does this mean that risk assessment should be junked? No.

The Nature Conservancy's Tom Wolf recently explained this down-side of environmentalists' success:

> The environmental organizations courted disaster when they "suc-ceeded" American-style. When they got too big, too rich, and too remote from the environmental effects of their actions....Most of all, when we abandoned moral appeal for fund raising appeals...when the solutions we offered lost out to our insatiable need for money.

CHEMICAL RISK ANALYSIS

In the wake of the Alar scare, Americans bought more apples than ever. Growers were able to produce strong crops without using the chemical. The whole debate gradually faded from the collective memory.

What didn't fade, at least in scientific circles, was the question spot-lighted by the Alar flap: Does a chemical that causes cancer in ani-mals in huge doses also cause cancer in people in small doses?

An October 1989 study by researchers from Stanford University and the University of California, Riverside, found that assumptions used by the National Research Council and the EPA about consumer ex-posure to chemicals in food are too high: by a factor of 21,000 for apples, 2,600 for tomatoes and 300 for lettuce.

For example, instead of the NRC's estimated cancer risk of 1,462 deaths per million from pesticides on apples, the researchers found only 0.07 per million. (Alar was confused with agricultural pesti-cides by many people.)

One EPA calculation indicated that pesticides remaining on foods could be responsible for 6,000 cases of cancer annually. For the aver-age U.S. citizen, that means lifetime odds of about one in 600. A report from the National Academy of Sciences, using another method, figures the chances at one in 170. Both figures probably exaggerate the danger. They assume that all the produce you eat has been sprayed with all the pesticides that can be legally used.

For these and other reasons, the EPA's listing of pesticide residues on foods as a high-priority risk (the third greatest environmental cancer risk, in a 1987 report) was recently criticized by its own Science Advisory Board as way out of line.

A spokesman for the EPA's Office of Prevention, Pesticides and Toxic Substances said critics rightfully fault the agency for failing to modernize its methods to stay on the cutting edge of risk analysis.

"We would desperately prefer to have more accurate data about the consumption of food by infants and children," he said.

Sanford Miller, dean of the Graduate School of Biomedical Science at the University of Texas Health Science Center, sums it up: "The risk of pesticide residues to consumers is effectively zero."

Yet the sensationalized reports continue. In 1995, the Washington-based Environmental Working Group published a report—similar in tone to the NRDC's Alar hit piece—called "Pesticides in Baby Food."

The EWG report found that 53 percent of the infant products it purchased had trace residues of pesticides and other farm chemicals. None of the residues, however, was above the legal levels allowed by the federal government.

Even so, any amount of carcinogens, reproductive toxins or neurotoxins in baby food should be a concern because of infants' physical vulnerability, the report stated. The EWG cited a 1993 National Academy of Sciences study that concluded that infants and children may be more susceptible than adults to the long-term health effects of chemicals in foods.

"What we are trying to do is point out that—under the current regulatory system—there are no standards that explicitly protect infants from pesticides or combinations of pesticides in food," said Richard Wiles, vice president for research at EWG.

Residues in foods, however worrisome they may be, are probably the least important danger from pesticides. The greater threats are the health hazards to agriculture workers and the drainage of the chemicals into water supplies.

COST-BENEFIT ANALYSIS

Cost-benefit analyses are essential tools for the public to understand environmental issues and how they can be addressed cost effectively. Too much environmental regulation has been driven by fear and inadequate knowledge.

National Academy of Sciences researchers, focusing on the naturally-occurring carcinogen dioxin, estimated that a substantial fraction of an individual's lifetime burden of the substance—as much as 12 percent—is accumulated during the first year of life. Nonetheless, the benefits of breast-feeding infants, the EPA and most everyone else would agree, far outweigh the hazards.

In his 1994 study of the environmental movement, Christopher Boerner of Washington University in St. Louis suggested that, in order to have lasting influence on the public policy debate, environmental activists have to re-examine their shock-and-outrage approach. He concluded:

> Now they are confronted with what environmentalists call the unholy trinity—risk analysis, cost-benefit analysis and property rights. To impact Congress, environmental groups should follow the example of the Nature Conservancy and join hands with the public to promote market-based solutions to problems.

The risks and benefits of chemical pesticides are difficult to calculate precisely, and the need for them is being questioned after studies showing that some organic farms can make as much money as farms that use chemicals.

A 1994 Cornell University study concluded that pesticide use on many crops could be cut in half without decreasing yields and without significant increases in costs to consumers.

An NRDC report on seven principal California crops calculated that pesticide use could be reduced from 20 to 50 percent, saving the farmer money.

Farm groups did not agree with all the figures but felt the main point had some validity.

PUBLICITY AND RISK PERCEPTION

When Meryl Streep hit the talk-show circuit to raise the specter of a toxic drug invading preschoolers, she was surely effective.

Despite having facts on its side, Alar's manufacturer was eventually forced to pull the drug from the market.

But the actress's comments—on TV talk shows, in ads and in her congressional testimony—offered few solid reasons for banning Alar. In retrospect, the entire campaign against Alar appears based on suggestion and subliminal image. Consider the main, and much-quoted, points Streep made:

- She questioned whether anyone knew the extent of the danger from Alar and other pesticides on food products: "I think what we don't know about this issue is what's so alarming."

- She said many of the older pesticides have yet to be re-examined using current health standards: "Even now, right now, we don't know what is on our food....When they tell us the food supply is safe, my question is, how do they know?"

- She used the image of her children as guinea pigs: "I just no longer wish my children to be part of this experiment....What's a mother to do?"

- She noted that consumers are losing confidence in products: "As parents, we lose it completely."

The reaction of people like Senator Dan Coats of Indiana—who called the NRDC campaign "hysteria and half-truths"—seems rea-

sonable. But their position didn't resonate so well with the population at large.

In an article in the Journal of Consumer Affairs, University of Georgia economics professor Chung Huang offered some reasons why this is so:

> ...Evidence consistently suggests a high level of perceived risks about pesticide residues among consumers.

> Consumers are apprehensive about the safety of their food because the risk associated with chemical residues is perceived as involuntary and its effect, involving the possibility of the most dread disease of cancer, delayed.

> ...the risk perception variable is highly significant in explaining respondents' attitudes toward imposing a ban or greater restrictive measures on the use of pesticides in fresh produce production.

> ...having children in the household increases the probability of greater risk perceptions by about 20 percentage points compared to other households.

> ...perceptions of food-related risks are often skewed from reality and at odds with scientific evidence and expert opinion, and possibly, regulatory concerns. If education is a proxy for an individual's ability to assimilate information and assess potential risks and benefits, then consumers with higher levels of education would be less likely to perceive pesticide residues as a high food safety risk.

In other words, less-educated and less-informed people are most susceptible to misinformation about dietary risks. The effects of this susceptibility can be dire.

Huang concluded: "If perceptions are faulty, efforts at personal, public, and environmental protection are likely to be

misdirected....consumers' perceptions and concerns about pesticide and animal drug residues in foods can cause and translate into volatile and unpredictable market behavior."

From a technical vantage point, that explains the Alar scare.

"The risks that people worry about and the risks that experts think they ought to worry about are just very different," risk communications consultant Peter Sandman told one newspaper in the wake of the Alar scare. He said that people get more exercised over "high-outrage" risks involuntarily thrust upon them than "low-outrage" risks that occur naturally or that they can control in some manner. This is another way of describing the risk telescoping that seems to occur in various contexts.

ENVIRONMENTAL ISSUES IN GENERAL

Fine airborne particles from diesel engines and other industrial sources reduce average life expectancy from one to three years in the most polluted U.S. cities according to a June 1995 study of the nation's largest metropolitan areas.

Ozone was long believed to be the worst pollutant in the soupy chemical mix called smog. But the study showed that fine particles of sulfates, nitrates and ammonium appear to be more dangerous.

C. Arden Pope of Brigham Young University and Douglas Dockery of the Harvard School of Public Health compared health and lifestyle data compiled by the American Cancer Society on 552,138 people to air-quality monitoring data in the 151 largest U.S. metropolitan areas.

For each subject who died during the study period, cause of death was determined from death certificates. After factoring out effects of age, sex, tobacco use, occupational exposure to pollution, obesity and alcohol use, researchers found high sulfate and fine particulate levels raised the risk of premature death by 15 and 17 percent, respectively.

Those averages reflected a 30 percent difference in death rates from heart disease, respiratory diseases and lung cancer between the most and least polluted cities, Pope and Dockery reported in the *American Journal of Respiratory and Critical Care Medicine.*

The fine particles associated with increased mortality rates seen in the study are a type of pollution that is not separately regulated under the clean-air standards.

Even though some critics might question how Pope and Dockery "factored out" six major risk factors, the general conclusion of their report seems hard to dispute—living in cleaner locations is better for you than living in polluted ones.

DIMINISHING RETURNS

Researchers like Pope and Dockery don't pay attention to what it might cost to fight environmental pollution. Their role is to identify problems. Government agencies like the EPA should be the ones that prioritize expenditures. Unfortunately, they don't always see this as their mission.

For one thing, bureaucrats at the EPA don't have the perspective to see that the easy victories of cleaning up the big, obvious sources of pollution have been won. Airborne levels of lead have declined 98 percent since the 1960s. Auto emissions have been reduced by as much as 95 percent. Acid rain is declining and rivers are cleaner.

Additional gains will be tougher to achieve and more expensive. These gains are what former EPA Administrator William Reilly has called "bruises" instead of "true broken bones."

Total costs of compliance with environmental laws and regulations exceed $100 billion annually, according to Commerce Department data. In 1995 dollars, from 1970 to the present, the numbers add up to $2 trillion.

"If they did away with the entire Clean Air Act, that would take a

huge chunk out of the burden," says Edward L. Hudgins of the libertarian Cato Institute.

One of the few attempts to quantify the productivity losses associated with environmental regulation was made by the U.S. Bureau of the Census. Instead of an expected dollar-for-dollar tradeoff, the bureau found that productivity in the oil, paper and steel industries tumbled by $3 to $4 for every dollar spent on environmental improvements.

Several risk assessment reform bills before Congress in 1995 call for cost-benefit comparisons between perceived risks and the money that would be required to abate them. The bills also would require the establishment of comparative risk guidelines contrasting particular environmental risks with, for example, an individual's chances of being involved in a car accident or being struck by lightning.

Risk assessment and cost-benefit analysis should help government regulate smarter, set better priorities, issue rules that are effective and affordable and better protect the public interest. But not everyone agrees with this argument.

For example: Reform bills passed in the 1990s permit the EPA to use a risk range for carcinogenic risk between one in ten thousand and one in a million. Environmental activists have been opposed to this risk range because it affords EPA the latitude to provide similar communities with a one hundred-fold difference in protection.

These groups also complain about the use of "central tendency" assumptions that would only protect the average exposed individual. They argue that standard risk assessment methodologies don't deal appropriately with people who live in highly contaminated areas or take into account the special sensitivities of children and the elderly.

"EPA should use reasonable estimates of high-end exposures that do not exaggerate risks by inappropriately compounding multiple hypothetical conservative assumptions," said a spokesman for the Environmental Defense Fund in congressional testimony.

THE POLITICS OF A CLEAN PLACE TO LIVE

Margaret Ann Reigle, chairman of the Maryland-based Fairness to Land Owners Committee, said the environmental movement "took a very seriously wrong turn" in the late '70s "when it walked away from public resource issues"—polluted air and waterways—and "marched onto private property and began demonizing private land-owners."

John Shanahan, environmental policy analyst for the Heritage Foundation, says federal regulators "with no authority from elected officials" have "tossed people off their land, saying they don't need any compensation."

Shanahan was particulary critical of the way the EPA assesses cleanup costs at Superfund sites:

> Superfund is the most command and control and un-American act ever passed. The law was not designed to reduce risks but to clean up chemicals...and they must be cleaned up beyond 99.9 percent purity. We've spent at least $22 billion in private dollars and $11 billion in public dollars for Superfund...and a study by the Office of Technology Assessment found that most sites that have been cleaned up posed no risk to human health and safety.

The unavoidable fact is that politics blurs almost all research related to environmental risks.

Case in point: the Environmental Working Group published a study, *Tap Water Blues*, purporting to show that more than 14 million Americans living in the Midwest are subjected to unreasonably high levels of cancer-causing herbicides in their drinking water.

The group, which based its finding on an analysis of raw drinking water, expressed the risks of cancer as a multiple of the government's acceptable level of one additional cancer per million people exposed. It called on the government to phase out the chemicals within two years.

Based on the group's own data, water quality researchers David Baker and Peter Richards of Heidelberg College in Tiffin, Ohio, found the actual risk translated into less than three cancer cases a year among the 12 million Midwesterners with the highest exposure. Put another way, that figure represents .006 percent of annual cancer cases from all causes in a population of that size.

"It's little wonder the Environmental Working Group did not express their results as cancer incidence rates," Baker said. "What kind of press attention would they have gotten if they did? 'Tap Water Blues' makes an excellent argument that herbicides in drinking water do not pose a significant health risk."

CONCLUSION

There are four times as many natural sources of chlorine—volcanoes and the oceans, for instance—as man-made sources. But environmental lobbyists have persuaded a credulous public that anything designated "hazardous" or "toxic" must be carcinogenic, irrespective of dosage, length of exposure, differences in individual susceptibility and the alternative risks of substituting something even more dangerous.

The EPA itself, in a 1987 report entitled "Unfinished Business: A Comparative Assessment of Environmental Problems," suggested that hazardous wastes account for no more than 0.2 percent of the nation's total of 1 million new cancers annually.

John Baden—chairman of the Foundation for Research on Economics and the Environment and a teacher at the University of Washington Business School—made the case for risk analysis despite political opposition in a 1995 article:

> Not all activities generate equal benefits. Since we can't do everything, risk-benefit analysis helps us choose among our options.

[Environmental groups] have shown a curious reluctance to accept risk analysis. Some groups have included it in the "unholy trinity" of principles they oppose in environmental legislation.

...the leaders of other organizations, including Greenpeace and the Natural Resources Defense Council, see a niche in crisis entrepreneurship. They use shoddy science and biased media coverage to exaggerate (as with chlorine) or fabricate (as with Alar) environmental dangers. These efforts pressure government officials to adopt wasteful policies.

Even some environmentalists agree that decisions to rip asbestos out of school buildings were probably ill considered. In many cases, sealing the dangerous fibers in place would have provided a more prudent and less costly remedy.

The Alar scare was a particularly-focused example of this phenomenon. For a short time, the chemical was a topic of general discussion and debate. In what looked to some like an effort to exorcise years of uncertainty about chemical safety, Americans decided they wanted the chemical off of their apples.

In subsequent years, the severity of the risk posed by Alar has been questioned repeatedly by scientists and other industry representatives who called the original report alarmist.

The fallout brought into question the government's ability to effectively regulate farm chemicals. And the Environmental Protection Agency and the Food and Drug Administration have been on the defensive since.

When faced with potentially damaging news about pesticide residues, the food industry's rallying cry has been "Remember Alar."

After Alar, the *New York Times* reported that the media "began asking newer, tougher questions about risk issues and proposals for eliminating risks—How do you know? What data are you using? How much does this cost?"

No one is eager to touch off the kind of hysteria that preceded the government's decision to move against Alar, the growth regulator once used by apple growers.

In 1993, when cases of e.coli bacteria poisoning occurred in the northwest, Agriculture Secretary Mike Espy made a point of preventing another Alar flap.

Prompt action by the Agriculture Department "helped avoid the hysteria" that accompanied a 1989 report on the now-banned apple ripener Alar, Espy said.

It also stopped the spread of any misinformation and headed off any intervention by Hollywood celebrities. Referring to Meryl Streep's congressional testimony, he said, "This administration is committed to sound science, not sound bites."

This more careful approach is a hopeful sign. Phantom risks and real risks compete not only for our resources but also for our attention. As real as her concern may be, it's a waste of effort when a mother worries about minute levels of toxic chemicals on produce and lets her children ride in a car without seat belts.

How

PART FOUR:

response is
influenced

4

13

Business risk, investments and game theory

Management gurus and investment advisers write libraries of books and fill lecture halls telling people how to take the risk out of business and investment decisions. But, when you compare what most of these people have to say, you find that they fill their advice with truisms and personal anecdotes. This combination can make easy reading and interesting speeches—but it doesn't offer people much in the way of tools for understanding business risks.

The reason for the impasse: Business risk isn't about losing money in one huge gamble. Like pension risk, it has more to do with lost opportunity than lost capital. It's a kind of risk that emerges from a series of decisions, rather than one or two egregious errors.

In 1994, three economists—two Americans and one German—won the Nobel Prize in economics for work in game theory. To many people, game theory is one of those trendy terms that sounds good at a dinner party but doesn't seem to relate to anything concrete in life. That's an unfortunate perception.

Game theory has a big impact on how business is done—especially in an age of growing competition on all levels and a proliferation of contract and sub-contract work.

An example: In the summer of 1995, the Federal Communications Commission began a new method of granting broadcasting licenses to private communications companies. Developing its new system, the federal agency had moved to the practical forefront of an economic discipline called game theory.

Among other responsibilities, the FCC controls broadcasting rights. It decides which companies have access to the limited number of so-called "spectrum bands" available for various kinds of wireless communications. The most important of these bands, in the early 1990s, were the ones used for cellular telephones.

Traditionally, the FCC had awarded licenses on a non-competitive basis. It ran a kind of lottery that was designed to distribute licenses evenly among various business groups (including minority-controlled companies and individual investors).

But this lottery hadn't created a diversity of cellular communications companies. In most cases, when a small player won a license, it would just sell out to a larger cellular phone company. This made a nice profit for the few people smart enough to apply and lucky enough to win the licenses—but the FCC weathered some heavy criticism for missing an easy opportunity to make money for a federal government that was running sizable debts.

Part of the reason the FCC had been awarding the licenses the way it had was that it didn't know for sure what companies would pay for them. Cellular communications—even in the early 1990s—was still an emerging technology. Spectrum band licenses were clearly worth something, even a lot; but exactly how much, the federal regulators couldn't predict.

So, the FCC consulted with several economists who specialized in game theory. The dismal scientists helped the government agency set up an auction system which combined the best elements of sealed bidding (in which each bidder makes a single offer and no one knows what anyone else has bid) with open bidding (the classic version, in which bidders can watch each other and respond).

Under the FCC format, the spectrum band auctions would proceed in multiple rounds, with bids being sealed in each round. By announcing the amounts of the bids after each round, the FCC could benefit from the information exchange of an open auction. By concealing the identities of the bidders, the agency could limit the threat of collusion.

Collusion is a real threat in auctions involving things as valuable as cellular phone licenses.

In 1990, New Zealand conducted a so-called "second-price sealed-bid auction" for spectrum band licenses it was selling. Under this scheme, the highest bidder wins—but, instead of paying its own bid price, it pays the next-highest. Many of the Kiwi bidders got spectrum rights for prices far below what they had offered. In one case, the top bid was NZ$100,000 but the winner paid only NZ$6.

Some New Zealand officials believed that the bidders had colluded to cheat the government out of its proceeds. But they couldn't prove their suspicions.

The FCC meant to avoid this kind of disaster by consulting the game theory experts.

In this chapter, we'll consider some of the main tenets of game theory and how they're being used by businesses and investors to make money. The point of game theory is to deal systematically with unknown factors. While this doesn't do anything to control the odds that you'll make money on a specific investment, it can help you approach all investments—or other business decisions—in a way that maximizes your odds of success.

SOME BACKGROUND

At the heart of all auctions lies the notion that a thing—whether it's a painting by Picasso or an FCC spectrum band—is worth more to one person or company than it is to another. Bidders have to make decisions without knowing all the facts. Who are the other bidders?

How much do they have to spend? What did they do in earlier auctions? And what is the painting actually worth?

If the bidders are collectors, they may think the thing will create more value for their collection than anyone else's. If the bidders are businesses, they may think they can create more profit from the thing than anyone else can.

So, an auction serves two purposes. By awarding scarce resources to the highest bidders, it promotes economic efficiency. By comparing the amounts that various bidders will pay, it establishes a true value of a thing.

A well-designed auction accounts for several kinds of uncertainty. First, a seller does not know how much its object is worth to bidders. Second, bidders are unsure how much profit they can make if they win the auction and buy the object. Third, none of the bidders knows what its rivals think the object is worth.

This is where the so-called "greater fool" theory comes into play. In an auction environment, traditional valuations don't apply. The essential standard for determining value is the question: Will someone—the greater fool—pay more for an object than the amount you just bid?

Game theory considers how all of these unknowns influence the behavior of the sellers and bidders. It tries to calculate what the sellers and bidders know, what they think the others know, and how they expect the others to use their knowledge.

In an article in the August 1994 issue of the *Journal of Economic Perspectives*, University of California, San Diego, economist John McMillan described how the game theory specialists helped the FCC avoid the three most common problems of auction economics.

The first problem is known as the winner's curse. If all bidders can earn the same profit by winning a particular license, yet each bidder has a different belief about what the profit will be, a lot of bidders are

going to be wrong. Bidders whose belief about the value is too low will lose the bid; but those whose belief is too high may win the bid but will lose money on the license.

To reduce this risk, smart bidders discount their own estimates when submitting their bids, and the auction will bring in less revenue.

The specialists' answer was for the FCC to soften the effect of the winner's curse by using open bidding. Bidders start with a low initial bid and then raise their bids until a winner emerges. By allowing the exchange of information, open bidding makes overly cautious bidders more confident and overly confident bidders more cautious.

"Winner's curse is one of the main problems people try to solve in using game theory," said Neil Wright, chief investment officer at Illinois-based ANB Investment Management & Trust Co. Wright developed a game theory-based investment plan. "You win because you miscalculated," Wright said. "The outlier"—the one with the winning bid— "has a tendency to be incorrect. That means the best estimate tends to be in the middle of the bids," rather than at the extreme.

Having resolved the winner's curse, the FCC was confronted with two other difficulties: the threat of collusion and the benefits of aggregation.

With sealed bidding, firms do not see their rivals' bids until it is too late, thereby making any collusive agreement hard to enforce. With open bids this threat is far more real.

The other problem, that of aggregation, occurs because a particular object can be more valuable to a firm if it can buy related objects as well.

This skews the bidding process. It's the reason a particular collector will be willing to pay a premium for certain works of art at auction. In the context of the FCC auction, a company bidding that already

owns the license for a particular band of the spectrum will have a greater interest in adjacent bands. It will often be able to afford to pay more than other bidders for the adjacent bands.

So, the FCC added the close-bidding element of the multiple-round format to prevent collusion and reduce the effect of aggregation.

This solution may seem complex. Game theory experts say it has to be. Part of game theory holds that, the more complex the problem, the higher the costs of using a simple approach.

Game theory, pioneered in the 1940s by the mathematician John von Neumann, has become an important tool for economists and businesses. Businesses apply it in sharpening their marketplace skills, drawing on available information, as a poker player does, to plot their next moves and guess the reaction of competitors. Economists use it in a broader sense to forecast interactions of all kinds.

Political think tanks have applied it to plotting ways to anticipate the diplomatic and military moves of governments.

Von Neumann's 1944 book, *The Theory of Games and Economic Behavior*, was the first to delve deeply into the likely consequences of strategic interactions, where all sellers and bidders—and other economic actors—must consider the potential for reaction.

THE STRATEGY OF GAME THEORY

This scenario includes the prisoner's dilemma. This dilemma involves a situation in which you and a friend have been arrested on suspicion of committing a misdemeanor. The detectives who arrested you offer you a choice. You can testify against your friend on a felony charge and avoid any conviction, or you can say nothing and be convicted either of the misdemeanor or—if your friend testifies against you—a felony.

Most game theorists argue that your best decision is to say nothing and hope that your friend says nothing also. Testifying against your

friend creates a system in which everyone might betray everyone—and you can't be sure of anything. That's not conducive to steady business.

This is the practical application of Nash's equilibrium. It's also the economist's explanation for codes of silence like the Mafia's *omerta*.

In the early 1980s, University of Michigan professor Robert Axelrod started a competition of computer programs designed to play the prisoner's dilemma.

The competition—structured like a round-robin tournament, pitted every program against every other. Fifteen programs faced off. Each competition consisted of five games of 200 moves.

The first competition was won by a program called Tit for Tat, written by a psychology professor from the University of Toronto. The program cooperates with its opponent for the first move, then emulates the opponent for the rest of the game.

Tit for Tat works because it's cooperative but can't be exploited. It will change its behavior to match its opponent's behavior. Therefore, a noncooperative strategy has to change itself before Tit for Tat will cooperate again.

Tit for Tat can never outscore an individual opponent—but it will systematically outperform a group of opponents.

The main mathematical outcome of the prisoner's dilemma: If you cooperate with Tit for Tat, you can stay even, but you won't be able to pull ahead. As Michigan's Axelrod said:

> What accounts for Tit for Tat's robust success is its combination of being nice, retaliatory, forgiving and clear. Its niceness prevents it from getting into unnecessary trouble. Its retaliation discourages the other side from persisting whenever defection [nastiness] is tried. Its forgiveness helps restore mutual cooperation.

And its clarity makes it intelligible to the other player, thereby eliciting long term cooperation.

Axelrod used prisoner's dilemma strategies in a model simulating survival of the fittest. A computer program simulated competitions. After each simulated tournament, winners were rewarded by having programs like themselves added to the next tournament population in proportion to their score.

Strategies that did well reproduced more than ones that did badly.

As cooperative strategies grew in number, they had more interactions with themselves and grew at an even faster rate. In the early rounds of the simulation, aggressive strategies did well—but only as long as they had sucker strategies to exploit. As rounds progressed, strategies that could be exploited became extinct.

The aggressive strategies that relied on sucker strategies had nothing to exploit and became extinct, too. Because they wouldn't cooperate, the most aggressive strategies died away.

THE ECONOMICS OF GAME THEORY

The three economists who shared the 1994 Nobel Prize—Reinhard Seltin of Germany, and John Nash and John Harsanyi of the United States—won the award for their statistical conclusions based on players' responses in games like poker and chess.

Because it comes from economics, game theory shares a lot of the dismal science's assumptions—even though it defies many of the tenets of classical economics. For instance, economics has been dominated by the concept of perfect competition—competition among so many participants that no single buyer or seller need worry about the responses of others.

Under perfect competition, market forces will cause resources to be used in such a way that it is impossible to make somebody better off without making somebody else worse off—in this sense, perfect com-

petition avoids waste. Such a pattern of resource allocation is called a Pareto optimum.

Game theory rejects this optimum. Instead, it looks for ways in which to analyze systematically the uncertainty that marks most personal and small business decisions.

Classical economics works for international markets with thousands of decision-makers and no one controlling information, game theory works better in smaller markets where information might be distributed unevenly.

Among economists, Princeton University professor John Nash is the best known of the three Nobel Prize winners. His "Nash equilibrium" was specifically cited in the Nobel economics award. Essentially, Nash equilibrium occurs in game theory when both players see no need to change their actions.

Wall Street executives are often guided in the high-stakes poker of corporate take-over bids by the Nash equilibrium. It tells each side when to go forward and when to back out. Nash's equation assumes that executives know something—but not everything—about the resources and motives of their rivals.

Nash is widely credited with laying out the formal mathematical principles of "games" in which everyone knows what everyone else knows and everyone behaves in his own self-interest. One limitation of Nash's work is an assumption about perfect knowledge of rivals' motives and resources.

Reinhard Seltin refined the equation by separating reasonable possible outcomes from unreasonable.

John Harsanyi, a professor at the University of California, Berkeley, added another refinement. A way to make decisions when very little information is known:

Things become very difficult and complicated when you realize that your opponents are not an undistinguished mass, but rather many individuals with all their personal idiosyncracies, and you have to try to predict what they are going to do.

...Each participant tries to select the best possible strategy from his own personal or institutional point of view, given what strategies the other participants will follow.

In the Harsanyi world, nothing need be known for certain as long as it is predictable in terms of chance. Competitors need to assign probabilities to each other's uncertain responses and counter-responses.

Game theory views business decisions as an evolving series of complex trade-offs. For example, executives have to decide how much of a product to make each year on imperfect information—too many and they'll have to discount prices to sell excess inventory; too few, and they'll miss potential sales.

GAME THEORY AS A BUSINESS STRATEGY

It's not easy to use game theory in business.

For example, when the price range of a corporate stock is large, there is uncertainty about how the company will do. To buy the stock, an investor would have to bid up at some extreme from the consensus. When the price range of a stock is narrow, the consensus is pretty close. An investor buying this stock wouldn't have to bid much more than the consensus.

Some economists argue that the prisoner's dilemma requires a zero-sum game, in which one person's gain must be another's loss. Poker and war are zero-sum games. So is a fight for market share.

But this is an unduly narrow perspective. Most of the time, especially in business, decision-makers are not in a pure conflict or zero-sum situation. Turning competition into cooperation is an essential part of game theory.

In a 1994 interview in *Forbes* magazine, Barry Nalebuff, a Yale School of Management professor and game theory expert, explained one well-known market-share example:

> If Coke lowers its price to gain market share from Pepsi, Pepsi will follow. Neither gains new customers, but both make less money. Neither should act without considering what the other would do.

> ...this is not collusion. There are many ways that companies can compete while making the market better for themselves and customers. [Smart decision-makers] try to avoid mutually destructive competition, such as a price war between Pepsi and Coke.

However, as important as it may be to deal with competitors cooperatively, game theorists also acknowledge the importance of taking a hard stand. So-called "strategic inflexibility" is another tool of game theory.

Inflexibility can be an advantage. In his conquest of Mexico, Cortes' invading army burned its own ships. Vastly outnumbered, the conquistadors purposely eliminated retreat as an option, giving themselves no choice but to fight and win.

GAME THEORY AND PUBLIC POLICY

Economists who focus on the public-sector—governmental regulatory structures, social programs and fiscal mechanisms—are often critical of the theory of perfect competition. Their criticism is often reciprocated by economists who advocate free markets. This contention produces the familiar debate in America between Keynesian economists associated with ambitious government programs and supply-side economists associated with ambitious plans to cut government programs.

Because of their mutual distrust of perfect competition, you might expect game theorists and big-government advocates to have a lot in common. They don't.

Game theorists take a skeptical view of public policy programs—especially regulatory schemes. They doubt these programs have much effect on the odds something good—or bad—will happen to you.

In 1960, University of Virginia economist Ronald Coase published a book called *The Problem of Social Cost*. It remains the best explanation of the relationship between game theory and government regulation.

Coase argued that, as a rule, no form of government action is required to deal with public goods like clean air, monitored workplaces or subsidized industries. So long as property rights already exist, there is no need for taxes, subsidies and public provision.

Coase's main point was simply that legal entitlements—property rights—can be bought and sold. They are commodities whose exchange can be analyzed like that of any other.

At this point some economists will argue that the initial allocation of property rights affects the distribution of income. In other words, if you already own something, you are better off than if you don't. But Coase argued that the economic forces ensure that the same efficient allocation will happen in either case. This idea is known as the Coase theorem.

The Coase theorem admits that the market efficiencies necessary for clear communications will fail if transaction costs are prohibitively high. As a result, economists who support the Coase theorem are interested in correcting inefficiencies by reducing the costs of doing business. While these economists may not be pure free marketers, they also aren't big supporters of pursuing efficiency through cleverer and more ambitious regulation.

The Coase theorem and the model of competition it defends are at their weakest when trying to account for deals struck between small numbers of transactors. This is not so much a matter of transaction costs as of the unpredictability of offer and counter-offer. It moves economics firmly into the realm of game theory, which assumes that efficient outcomes cannot be taken for granted.

That's the biggest criticism that game theorist have of Keynesian economists and other big-government advocates: They assume they can predict the economic outcomes of rules and regulations. The objection isn't so much that the outcomes are wrong—it's that they're not predictable at all.

Coase won the Nobel Prize for Economics in 1991. His prize, which made game theory an accepted academic discipline for assessing risk, set the stage for Seltin, Nash and Harsanyi to win in 1994.

A PREDECESSOR OF GAME THEORY

If John von Neumann and Ronald Coase are the founding fathers of game theory, the discipline has a kind of crazy uncle in the pre-WWII philosopher—and, only avocationally, economist—Frank Knight.

As crazy uncles often do, Knight deals with important issues more bluntly than his more traditional relations. In this case, he explores the definition and role of risk in business.

For decades, economists have struggled to interpret Knight's most famous book, *Risk, Uncertainty, and Profit*. To many people who read it, Knight's writing takes on a mystic or even religious quality—they draw profound conclusions from somewhat cryptic utterances.

Especially in his early work, Coase drew key ideas from Knight. This makes sense, because Knight—despite the cryptic utterances—was the first person to apply a consistent definition of uncertainty to macroeconomic modeling.

Knight clearly believed in the theory of perfect competition. More importantly, his distinction between risk and uncertainty has been taken to differentiate between the measurability/immeasurability or objectivity/subjectivity of probability.

Some readers argued that, when he talked about risk, Knight meant situations in which one could assign probabilities to outcomes; and,

when he talked about uncertainty, he meant situations in which one could not.

But another—more technical—explanation has emerged. This holds that Knight understood perfectly well that decision-makers could form subjective probability assessments of any situation. The distinction he intended was that between situations in which insurance markets can operate smoothly (risk) and situations in which insurance markets collapse because of moral hazard and adverse selection (uncertainty).

A similar debate focuses on the interpretation of Knight's theory of the firm.

In this case, some readers argue that Knight explained the firm on the basis of differential risk aversion between entrepreneur and worker. Their interpretation rests on Knight's description of a firm as:

> the system under which the confident and venturesome "assume the risk" or "insure" the doubtful and timid by guaranteeing the latter a specified income in return for an assignment of the actual results.

Other readers insist that Knight also had a second theory of the firm. This one is based on the failure of markets in the presence of risk factors like moral hazard and adverse selection. In this context, firms play a kind of contrarian role—staying in business when the marketplace panics.

Still others argue that Knight anticipated the more current theory of asymmetric information. This theory holds that no market can distribute perfect information because individual decision-makers interpret the same data differently. Therefore, perfect competition is limited by every individual's imperfect perceptions.

Knight believed that the task of meeting uncertainty in an economic system is analogous to the brain of a living organism. He argued that uncertainty arises out of partial knowledge:

The essence of the situation is action according to opinion, of greater or less foundation and value, neither entire ignorance nor complete and perfect information, but partial knowledge.

Knight's use of partial knowledge reveals that his distinction between risk and uncertainty has more to do with the classification of random outcomes than with the assignment of probabilities to the outcomes:

When our ignorance of the future is only partial ignorance, incomplete knowledge and imperfect inference...it becomes impossible to classify instances objectively.

The point is not so much that we do not know probabilities as that we do not know the classification of outcomes.

Knight contrasts situations of uncertainty with the world described by the competitive models, arguing that "it is unnecessary to perfect, profitless equilibrium that particular occurrences be foreseeable, if only all the alternative possibilities are known and the probability of the occurrence of each can be accurately ascertained."

Notice here both sides of the conjunction: you must first know which alternatives are possible. The distinction between risk and uncertainty arises not because there is no basis for assigning probabilities, but because "there is no valid basis of any kind for classifying instances."

UNCERTAINTY AND THE LEMON MODEL

Knight's distinction between risk and uncertainty leads to the so-called "lemon model" used to illustrate the role of imperfect information in game theory.

Sellers know better than buyers whether a particular car is a lemon. But both sellers and buyers know that there are both lemons and non-lemons in the market. And both sides agree on what it means for a car to be a lemon.

By contrast, Knight's definition of uncertainty was based on the inability to agree on what the possible outcomes might be. In the lemon model, it means not knowing that there are lemons and non-lemons because you don't know what it means for a car to be a lemon.

To see this more clearly, consider Knight's use of the expression "estimate of an estimate" in describing uncertainty:

> Fidelity to the actual psychology of the situation requires...recognition of these two separate exercises of judgment, the formation of an estimate and the estimation of its value.

> [For example:] A manufacturer is considering the advisability of making a large commitment in increasing the capacity of his works. He "figures" more or less on the proposition, taking account as well as possible of the various factors more or less susceptible of measurement, but the final result is an "estimate" of the probable outcome of any proposed course of action.

> ...a judgment of probability is actually made in such cases. The business man himself not merely forms the best estimate he can of the outcome of his actions, but he is likely also to estimate the probability that his estimate is correct.

In risk situations, categories—like "house burns down" or "house doesn't burn down"—can be shared and agreed upon. This allows markets (that is, simple contracts mediated by price) to function well enough. But, when the categories of knowledge themselves are unknown, they cannot form the basis of interpersonal agreement and fair—let alone perfect—market exchange.

WHY BUSINESS OWNERS ARE PAID MORE THAN EMPLOYEES

Knight contrasts decision-making in business with the formal processes of logic by recognizing that business decisions are not reasoned knowledge, but "judgment, common sense or intuition."

Distinguishing between situations of risk and of uncertainty, Knight says:

> the best example of uncertainty is in connection with the exercise of judgment or the formation of those opinions as to the future course of events, which opinions (and not scientific knowledge) actually guide most of our conduct.

Because of the organic nature of economic life, novel possibilities are always emerging. These can't be easily categorized in a subjective way as predictable occurrences. To deal with this "uncertainty," you have to rely on judgment. Such judgment will be one of the skills in which people specialize.

Knight sees business as a series of contracts, with rights that are either specific or residual. Residual rights are claims to whatever is not specifically mentioned in a contract. To the extent that parties cooperating in production cannot fully specify all the possible contingencies, their contracts will be incomplete. This will leave residual rights, namely, the rights to exercise control in the absence of specific rights. Possessing residual rights is what it means to own a company.

A person should own residual rights if his or her behavior is most costly to monitor or regulate. The other parties cooperating in production receive fixed-pay contracts—i.e., a salary instead of equity.

The incomplete-contracts view offers a clear interpretation of Knight's definition of "guaranteeing": it's not so much that the residual contract owner insures the other parties (although Knight did use this word). Instead, because of non-contractibility, the optimal arrangement is one in which the people with the skills most difficult to replace end up with the equity.

This may sound like a truism, but it gets to the underlying value theory that investment gurus from Benjamin Graham (and his protege Warren Buffett) to Peter Lynch look for in the stocks they buy.

It also explains the sometimes complicated process by which some people advance through a corporate hierarchy while others do not.

CONCLUSION

In the context of business risk, game theory is a key discipline. It offers a decision-maker the tools to respond to odds that can't easily be calculated. It shows that the best risk management doesn't always have to be risk-averse.

You don't have to play it safe to play it smart.

The credit card business serves as a good example. Game theorists like to point out that banks usually focus on the wrong risk factor when they issue cards. Their primary concern is whether a cardholder is likely to default. As a result, the best customers appear to be "maxpayers"—people who pay their balance in full each month—and they account for roughly one-third of credit card charge volume.

But, next to outright defaulters, maxpayers are the worst customers, because credit card issuers lose money on charge volume that does not carry beyond the first month. Because most banks only charge interest on credit card balances that carry more than a month, maxpayers get an interest-free loan from the bank.

For each dollar charged on a Visa card, only about 1.4 percent goes to the issuing bank. Even including the annual fee, that doesn't cover the cost of promotions or billing, customer service and other administrative expenses. As a result, banks have to keep interest rates high on balances that do last more than a month to cover their costs.

So, the selection criteria for cards should be changed to increase the company's real payoffs. Cardholders should be rewarded for carrying debt, not charging and paying off the balance.

Doing the conservative thing can put you in the position of losing opportunity. Game theory gives you some context for being intelligently risk-prone.

14

Ebola—the uncoming plague

During the late 1980s and early 1990s, epidemiologists in the United States have battled what many took to calling an epidemic of epidemics. The roster includes:

- Cryptosporidium, a protozoan that infected the water supply of Milwaukee, threatening to sicken large numbers of people in a city of more than 400,000;

- hantavirus, a newly identified virus akin to the Bubonic plague and spread by rodents that killed 23 people in 15 states in 1993 after an outbreak in the Southwest;

- e. coli infections traced to a new bacterial strain in undercooked hamburger served by a fast-food chain;

- medication-resistant strains of tuberculosis; and

- streptococcus A—the hugely overhyped flesh-eating bacteria. The bacteria, which causes a disease known as necrotizing fasciitis, usually gains entry to the body through open lesion. It can result in a fatal, toxic-shock-like infection.

"The thing that's impressive is that we've been used to thinking of it (streptococcus A) as the cause of an occasional sore throat. Now

we're thinking about it as (causing toxic) shock and prolonged hospitalization and death," said Luther Rhodes, an infectious diseases specialist at Lehigh Valley Hospital in Pennsylvania. Rhodes noted that genetic changes in the organism appear to be resulting in more of the more virulent types being produced.

Dozens of others have appeared in the past 30 years, including the microorganisms that cause AIDS, Lassa fever, Lyme disease, Legionnaire's disease, Rift Valley fever, Brazilian purpuric fever and Venezuelan hemorrhagic fever.

The syndrome isn't just domestic. In the United Kingdom during 1994, doctors became alarmed after they realized they were seeing hundreds of cases of Dengue fever, a tropical disease virtually unheard of before 1981. Cholera broke out in Mexico and in detention camps in the former Yugoslavia.

And then, in 1995, there came the outbreak of the Ebola virus in rural Zaire. This disease brought a weird mix of advanced technology and backward public hygiene into striking contrast. Millions of dollars were spent moving television news crews from around the world to Zaire and transmitting reports. A few hundred thousand dollars in sewer pipe and clean bandages and syringes might well have prevented the entire problem.

The mania in the U.S. and the rest of the developed world over the danger posed by Ebola served as a kind of Rorschach test for late twentieth-century cultural angst. People in Manhattan and Beverly Hills were seriously frightened of dying from Ebola. The odds of this happening were as close to zero as odds can get.

So, the Ebola outbreak works better as an exploration of people's perception of risk than as a case study for calculating odds.

SOME BACKGROUND

Between 1970 and 1995, scientists in the U.S. discovered more than 40 previously unidentified disease-causing bacteria, viruses, parasites and other organisms.

According to the Centers for Disease Control, deaths in the U.S. from infectious diseases rose 50 percent between 1985 and 1995.

Outbreaks of contagious diseases are becoming more common, growing not only in frequency and intensity but in prevalence and in parts of the world where they were previously unknown.

Part of this may be a matter of perception: In an age of scientific miracles like the electron microscope and supercomputers that can sort individual DNA strands, the ability to differentiate individual virus types and catalogue their likely effects is stunning.

But, since the end of World War II, localized—and once dormant—diseases have spread into the global scene. Medical science, with all its advances, has consistently lagged behind.

For example: In the early 1990s, workers at London's Heathrow Airport and residents living near Paris's airports were hospitalized with malaria believed caused by mosquitoes aboard jets arriving from Third World countries.

Another example: In 1994, the alert was sounded that bubonic plague could be spread by travelers from India, where the disease had surfaced. Bubonic plague was considered to be almost a relic of the Dark Ages that modern medicine had wiped out. But public health officials were concerned the deadly disease could enter the United States through its airports.

A number of reasons for this resurgence of infectious diseases appear consistently in scientific analyses and public health reports:

- population growth crowds millions of poor people in cities with little or no sanitation, an ideal breeding ground for malaria, yellow fever and cholera;

- permissive sexual behavior and intravenous drug use encourage the spread of disease—as they have AIDS, expanding it from a regional African illness into a worldwide epidemic;

- the loss of forests and other natural habitats drives disease-carrying animals and insects into contact with people;

- jet-age travel whisks germs around the world;

- medical advances have eliminated or reduced major threats, so minor and developing ones seem important by comparison;

- bacteria develop new strains that are resistant to existing antibiotics;

- after 40 years of filling ourselves with penicillin, erythromycin and other wonder drugs, humans have lost much of our natural immunity; and

- epochal climate changes—whether natural or technology-induced—accelerate infectious disease.

Different experts will emphasize different items on this list. Some will reject some as politically-motivated junk. But these factors are the points of debate. Some combination of them likely explains the modern focus on killer viruses and other plagues.

"We've always had plagues and we're going to continue to have plagues," Calvin Linnemann, an infectious disease specialist at the University of Cincinnati, told one local newspaper during the Ebola coverage. "AIDS is the classic modern example. It's what in the Middle Ages would have been the plague."

Like the black death of the Middle Ages, AIDS has prepared people to think apocalyptically about disease. Having grown up in a culture almost arrogant in its confidence that technology and social programming could eliminate risk, Americans (and people in other industrialized countries) were shocked by a disease's ability to confound the medical establishment. And if AIDS could confound the establishment, a fatal blow like Ebola could made it irrelevant.

Emerging diseases have become enough of a concern that the Centers for Disease Control has set up monitoring centers in Oregon, California, Connecticut and Minnesota. The CDC hopes to accu-

mulate information that will make it possible to warn doctors when a disease is about to strike.

Infectious disease fascinates people more than the mundane technical issues that make up most public health management. This seems to have something to do, once again, with impressions of control. Ebola was captivating because it was quick and deadly and—as it was portrayed in the popular media—impervious to technological response.

But the Ebola portrayed by the popular media wasn't exactly the true version.

THE MECHANICS OF THE EBOLA FEVER

Ebola is a virus—and an extremely rare one. It's also a fairly new one, identified in 1976 when two outbreaks occurred simultaneously in Southern Sudan and Northern Zaire. The number of cases was 284 in Southern Sudan with 53 percent mortality and 318 in northern Zaire with 88 percent mortality. Another fatal case was reported one year later from the same zone of Zaire and a small epidemic was recognized in 1979 in the same town of Sudan.

The various strains of Ebola and its cousin Marburg are thin threads a little less than a thousandth of a millimeter long. From their shape they get the name filoviruses.

There are seven proteins in the thread, wrapped around a coil of the chemical RNA on which the viral genes are recorded. One of the proteins provides most of the virus's rigid framework; another plays a role in copying the genes; a third has been shown to help the virus enter the cell. The roles of the others are obscure.

It is easy to understand why Ebola and its genetic kin get so much attention: The symptoms of the diseases they cause are truly gruesome.

The incubation period for the Ebola hemorrhagic fever is 21 days. A person infected with Ebola usually first complains of an abrupt, splitting headache followed by high fever and by pain in muscles and joints. Chest and abdominal pains may occur early, and the victim rapidly becomes so sick and exhausted that he or she cannot climb out of bed.

As a result of the fever and severe watery diarrhea that develops, the victim's system loses salt and water—causing even more weakness. A raised or splotchy red rash often develops about a week into the illness. After this, the flesh may peel off in places.

After a week, the blood of most victims fails to clot, and they begin to bleed (this is why the illness is called Ebola hemorrhagic fever). Victims bleed into their lungs and cough up blood clots. They bleed into their intestines and vomit blood and pass bloody stools. They bleed from the nose, gums and other orifices. They bleed into their skin, developing bruises, and the whites of their eyes turn blood red.

Most victims die in one to two weeks after massive blood loss, death of internal organs and shock.

One thing about the Ebola virus which has not been exaggerated is its efficiency. By May 16, 1995, less than two months after the virus came to light in the general hospital of Kikwit, Zaire, the World Health Organization (WHO) had reported 93 infections and 86 deaths. As one public health expert said during the Kikwit outbreak, "A disease that kills over 90 percent of the infected is a rare and horrible thing."

Beyond this, the CDC Ebola expert C.J. Peters admitted that the most significant thing about the Ebola virus was how little even experts knew about it:

> ...when you hear various experts predicting on what's going to happen and what's known about filoviruses and so on, they're predicting from a knowledge base that's a lot shakier than the average guy uses to play a lottery number.

THE RESPONSE TO KIKWIT

According to Peters, news of the 1995 outbreak did not reach the CDC through formal channels.

> We often get calls from an informal surveillance network of people we know, friends, people we've worked with, and then people who are at embassies, are connected with embassies, who just pick up the phone and call us, and the latter is what happened with this outbreak.

> We got a call from Dr. Jeannette Weeks, who was working with the U.S. Embassy in Kinshasa [Zaire's capital], and she said we've got this problem....

Weeks sent blood samples to a lab in Belgium, which had been closed for several years. Fortunately, the samples got to the doctor who had run the laboratory. He called Peters at the CDC.

The samples arrived in Atlanta the next day—via a commercial overnight courier—and Peters and his colleagues took them into their maximum containment facilities to start testing them for Ebola.

Officials at the WHO in Geneva had also gotten word of the outbreak over the weekend, but their notification came from the Zairean government. Zaire officials invited WHO to send a team of experts to evaluate the situation.

Earlier Ebola outbreaks had shown that transmission usually occurs when people have close contact with patients who are extremely sick. That meant hospitals were the usual transmission grounds.

The virus is passed principally by physical contact with patients. Even touching patients' skin can spread the virus, as can handling feces, vomit or urine. As a result, hypodermic needles, other medical devices and the lack of hygiene in hospitals pose the greatest risk of transmission.

Most of the infection cases that the WHO team identified had occurred among health workers who lacked adequate medical supplies. In fact, 44 percent of the victims were medical workers who had been treating other victims.

By applying simple hygiene and infection-control measures in caring for victims, the WHO team expected to stop the outbreak. Simple isolation procedures like masks, gloves and gowns had stopped the outbreaks in the 1970s.

CONTAINMENT EFFORTS

According to WHO standards, an epidemic outbreak can't be declared ended until 42 days after the last identified victim either dies or recovers fully from the virus. By early June—just three weeks after the first WHO medical experts reached Kikwit—organization spokespeople were predicting an official end by late August or early September.

James Le Duc, a medical officer at WHO's Communicable Diseases Division said:

> The problem is quite serious in the outbreak area. But it does not represent a serious international risk or even a problem outside the area....We know what we are up against and we know how to solve the problem....We see a small spreading outbreak, but we feel it can be controlled....this does not represent an international emergency.

At the same time he was saying this, several ostensibly responsible popular media news outlets were still shrieking about body counts and the prospects of Ebola going global.

The work of containing the disease was fairly ordinary.

WHO team members had improved conditions in the 326-bed Kikwit General Hospital to prevent transmission of the disease. After that, they identified infected people who had stayed at home.

In late June, there was a small reoccurrence of new Ebola cases in the Kikwit area. The WHO reported 13 new cases reported between June 9 and 30, describing them as a fifth wave of the epidemic.

Doctors on site blamed a common response: People were starting to relax efforts to combat the disease. The WHO representative in Zaire's capital also cited local religious practices which assumed that members of some sects were immune to the virus.

Whatever the reason, epidemiologists agreed that slight levels of recurrence—which even experts call hiccups—are a frequent part of containing an intensely communicable disease. "There seems to be some inherent impulse in people to press the limits of their safety," says one American doctor who has worked with WHO disease containment efforts. "It's like they want to get away with as much as they can—regardless of who they are or where they are."

By mid-July, the WHO reported that 296 people had contracted the Ebola fever and 233 had died. (Earlier numbers had been unreliable because the region had also been suffering an outbreak of shigellosis, a form of dysentery whose symptoms were easily confused with Ebola's.)

In the meantime, WHO had notified countries on how to handle potential patients and advise travelers as air and sea ports around the world rushed to tighten screening for the virus.

Customs inspectors at Chicago's O'Hare International Airport were already monitoring travelers for tuberculosis, cholera and a slew of other infectious diseases when they received the WHO data on Ebola.

In looking for travelers who fit the symptom profile of a disease like Ebola fever, customs officials end up using methods that aren't a whole lot more sophisticated than the instinct a parent uses in looking at a child's face for signs of illness.

Because of the slim chances of an infected person making it from

Kikwit, U.S. health officials decided against asking the airlines to identify any passengers whose travel originated in Zaire. CDC spokesman Thomas Skinner said: "It hasn't come to that—not yet. And we hope that it won't."

It didn't.

CONTAGIOUS RISK

The Ebola virus is ill-suited to sustaining an epidemic. It kills victims so quickly that they don't have much chance to infect others.

Moreover, the virus is not all that easy to pass along. Unlike the most highly contagious illnesses—tuberculosis or influenza, for example—Ebola can't be transmitted with a sneeze or cough.

Ebola is more like HIV. Direct contact with a victim's blood or other body fluids appears to be the only way to catch the virus. And contact with someone who's bleeding from every body opening is likely to be shunned in any case.

The instability of diseases that are so quickly and certainly fatal acts as a kind of self-correcting mechanism in natural law (if such a thing exists).

As occurs with most viral infections, some people contracted the Kikwit Ebola and didn't develop any virulent symptoms. But medical experts don't know why some people can resist—nor how many do.

Viruses often have various strains or versions that occur, sometimes even during a single outbreak. Because viruses are living things, they change and adapt—"mutate" is the technical word—to the circumstances they encounter.

One WHO antibody survey concluded that as much as 20 percent of some populations in Central Africa have been infected with versions of Ebola. Epidemiologists guess that weakened versions of the virus

account for some of the anti-Ebola antibodies found in perfectly healthy Africans.

The strong and weak strains of Ebola suggest another reason why so many healthy Africans tested positive for antibodies to the virus. After the Kikwit outbreak was contained, WHO researchers began investigating whether the virus becomes less contagious as it is transmitted.

In the earliest cases that occurred in Kikwit, just touching an infected body was enough to transmit the virus in 80 percent of exposures. The risk dropped to 50 percent for the next exposure, and less after that.

Humans can be infected by innocuous strains of Ebola. Hard evidence of this came in 1989, when military researchers studying the disease in Virginia were infected by Ebola virus spread from infected monkeys. The researchers didn't get sick, though the monkeys all died.

One troubling aspect of the Virginia experience: The monkeys transmitted the virus through the air. This supported conclusions that Army researchers had made in the early 1980s.

Based on tests conducted at the U.S. Army's disease research center at Fort Detrick, Maryland, military epidemiologists had discovered that a strain of primate Ebola could indeed pass airborne. The virus contaminated lung fluid of sick and dying monkeys, who then coughed and sneezed it into the air.

The barrier between monkeys and humans isn't reliable. Just months before the Kikwit outbreak, researchers in the Ivory Coast discovered an Ebola strain that jumped across the evolutionary turnstile.

They discovered this strain the hard way—it infected one of them. A 34-year-old Swiss zoologist performed an autopsy on one of several chimpanzees that had mysteriously died.

As her colleagues reported in the British medical journal *The Lancet*:

> She was hospitalized...for acute fever resistant to anti-malaria treatment and presented with acute diarrhea and pruritic rash during the next few days. She was evacuated five days later to Switzerland where she recovered without [any further effects].

> ...Our preliminary data demonstrates that this new strain is serologically related to, but distinct from, the deadly Ebola Zaire. The new strain is lethal for chimpanzees and we may suppose for humans: the patient developed a severe syndrome similar to that described among the Ebola cases who survived.

> ...Although risk of infection after exposure to infected tissue may be high, the transmissibility from human patients seems to be low outside hemorrhagic episodes. Progress in applying good nursing practices such as disposable injection devices due to the AIDS epidemic may have circumvented a second...episode.

The woman survived after intensive treatment that included intravenous fluids and administration of blood-clotting compounds.

The Ivory Coast episode was the first clear documentation of Ebola infection in wild primates. Earlier cases of infection had been limited to laboratory animals.

WHERE DOES EBOLA HIDE?

An important part of stopping the spread of any virus-based disease is locating the places the virus lives when it's not making people sick.

One of the things scientists are most anxious to learn is where the Ebola virus lives when it's not infecting someone. Until the Ivory Coast episode and Kikwit outbreak, no case of Ebola had been confirmed for nearly 15 years in Africa. Where had the virus been lurking all those years?

Viruses can't live on their own. They need a host—also called an incubator or reservoir—where they can live and breed in relative seclusion. In the case of a virus as deadly as Ebola, this has to be an organism that's immune to the disease it causes. Small or large mammals, biting insects or even plants are all possible incubators of the virus, allowing it to go into hibernation.

WHO specialists traced the Kikwit outbreak back to a local farmer who made charcoal in the outlying forest to supplement his income. WHO doctors deduced that the man must have been infected with the virus from some kind of animal. They spent months after the outbreak trapping all kinds of creatures, testing for the virus.

However, the animal incubator theory contrasts with two alternatives that other experts have suggested. First, Ebola might be a plant virus that occasionally infects animals—including humans. Second, Ebola might be a hyper-mutating virus that shifts from lethal to nonlethal status more quickly than scientists can follow.

Some virus research supports the second theory. In a study not related to the Ebola outbreak, scientists at the University of North Carolina in Chapel Hill discovered that a benign version of Coxsackie virus mutates into a virulent, pathogenic form in mice deprived of selenium, a trace mineral. The work was inspired by the observation that in parts of China where the soil and crops are low in selenium, people are susceptible to Keshan disease, an inflammation of the heart that could be associated with Coxsackie virus.

The evidence suggesting that Ebola weakens as it spreads among people also supports the mutation theory. But other evidence from the Kikwit outbreak runs against it.

In the wake of the Kikwit outbreak, the CDC's C.J. Peters pointed out that the genetic make-up of viruses normally changes a bit over time. But:

...the viruses that we've gotten out of humans so far look exactly

like—almost exactly like—the 1976 Ebola Zaire virus. That is to say, there's not much genetic variation. That's something of a mystery to us....

Finding the incubator—whether it's animal or vegetable—will go a long way toward stunting any further spread of Ebola.

FEAR AND POLITICS

While epidemiologists remained certain throughout the Kikwit outbreak that the odds of Ebola coming to the U.S. were nil, some public health experts tried to use Ebola as a analogy for local diseases. "It's like tuberculosis," said Johns Hopkins School of Medicine professor Diane Griffin. "You quit paying attention because you've thought you've accomplished everything. And before you know it, you're in trouble again."

The biggest scare tactic experts used was to voice concern about deadly Ebola strains that could be passed on as easily as the common cold.

Karl Johnson, formerly with the CDC—and the man who hypothesized that the Ebola virus resides in plants—wondered: "Suppose we get a virus that is both deadly to man and transmitted in the air?"

"Viruses have a tremendous potential to mutate and change," one Johns Hopkins University researcher told a national newspaper. "Most of the changes are detrimental to the virus. But sometimes changes occur that are advantageous and increase its ability to cause epidemics. HIV is a classic case. It's changing all the time. And we've seen it change its genetic pattern that apparently increased its transmissibility."

Others pointed out that a slightly less deadly Ebola, more delayed in its action, would make even the Kikwit horror fade to nothing.

There may be one slightly cynical reason we heard so much about the deadly but unstable Ebola virus in the summer of 1995: The Centers for Disease Control and Prevention had been facing budget

cut-backs. An outbreak of a gruesome, deadly disease was like an advertisement for the agency's services.

Amidst the pictures of dying Zaireans, CDC officials reminded TV viewers and newspaper readers that budget cutbacks and a result-ant hiring freeze could hamper the agency's ability to do its job as the world's premier facility for tracking and controlling disease.

Stephen Morris, a virologist at the Rockefeller University in New York, told a number of media outlets that the world's ability to re-spond to emerging infections was dwindling at a time when the danger from viruses like Ebola appears to be proliferating.

Morris told the radio news show *All Things Considered*:

> Whenever you have a prevention measure that's effective, or an outbreak control that's effective, it does make people feel, "Whew, we're over that. That's behind us. We don't have to worry about it. Maybe we won't have to worry about Ebola for another 20 years."

> ...Ebola is not likely to land on our shores and cause an epidemic, but some years ago, of course, HIV did, and that very likely started out in an equally isolated place, but it just did not get the atten-tion that Ebola got. And influenza epidemics are still very much a part of life as we know it. So, I think that a disease, originating anywhere in the world, has the capability to spread and start a pandemic throughout the entire world, and reach our own shores.

This analysis ran exactly counter to the experience in Kikwit. Once the WHO teams were able to make a few basic hygiene changes in a few key locations, the disease—as contagious as it was—was con-tained.

"Scaremongering is a terrible thing and so is losing freedoms we like," said Graham Reid of Canada's International Development and Research Centre—anticipating the criticisms of bigger public health budgets. "But we have to ask ourselves: Do we not now need

to develop a more logical and maybe more intrusive surveillance system when people travel from one part of the global village to another?"

CONCLUSION

The apocalyptic fear of killer "pandemics" says a lot more about the psychology of people in developed countries that it does about the science of disease. This fear comes when rates of almost every illness—especially infectious viral and bacterial diseases—have plummeted and life expectancy has made its greatest strides forward.

So, how many rights do we take away from the sick to protect the healthy? And vice-versa?

Even in the face of the bubonic plague, 14th-century Italian merchants fought the practice of quarantining ships, saying it infringed on their right to do business.

In the healthy twentieth century, governments have passed hundreds of laws restricting personal freedom in the interest of public health. And they turn more invasive when epidemics threaten the general health of a society. Public health experts turn positively blase when it comes to enforcing invasive investigations.

George Rutherford, associate dean of the University of California, Berkeley, school of public health, points out that mandated testing is already done for syphilis and other conditions. "This isn't breaking new ground. This is an extension of current practice....I don't think you can continue to legislate protections out to the nth degree," he said. "In an American society, there is always a heavy counterbalance about individual freedom."

Addressing this issue, both sides of the American political spectrum agreed that the Ebola scare wasn't cause enough to sacrifice any domestic freedoms.

Conservative science writer Michael Fumento argued:

...what is most remarkable about this latest hype is that by Africa's sad standards, Ebola is a pipsqueak. The current Ebola epidemic will probably fall short of the previous one in 1976, which killed several hundred people. Yet each year malaria kills an estimated 1 million Africans, tuberculosis kills 3 million, and tropical diseases other than malaria kill as many as 2 million.

In a similar vein, liberal environmental writer Gregg Easterbrook pointed out that:

...during the months when world attention focused on 300 deaths from transmission of the exotic Ebola virus in Zaire, thousands died from entirely banal diseases carried by impure drinking water in that country.

...Infectious diarrhea, a cause of death essentially eliminated in the West, last year not only killed more people in the developing nations than did any form of exotic disease, it also killed more people than did cancer.

But, as serious a problem as impure drinking water might be, Americans perceive no risk of it affecting them. Like car driving, clean drinking water is a danger people think they can control. Like jet flying, an exotic mutating disease is a danger they know they can't— so they're afraid of it.

This persistent fear of things beyond control doesn't say much about people's trust in jet pilots and WHO scientists—the experts charged with controlling the more complicated dangers.

A faulty understanding of science heightens the fear. Worse still, anti-technology bigots don't hesitate to tell fearful people that genetic experiments create diseases—both intended and unintended. (This includes fear mongers who tell easily-exploitable, undereducated groups that AIDS was produced by the federal government as a biological weapon.)

The best answer to all these Luddites and technophobes: The worst

disease mutation of this century—and possibly in history—was the 1918-19 influenza outbreak that killed some 25 million people worldwide. That's six times as many people as have died from AIDS and 50,000 times the number who've died in all Ebola outbreaks through Kikwit. And it took place when rain forests were pristine and no one had even heard of recombinant DNA.

The odds you'll contract Ebola are almost zero. The odds you'll contract another killer disease—like the flesh-eating streptococcus bacteria or the hantavirus "plague" that surfaced in Utah and New Mexico in the early 1990s—are less than 1 in 1 million.

Even when you travel, infectious disease is a slight risk. Of the Americans who die while travelling abroad each year—fewer than 300 through the 1990s—only 5 percent die from an infectious disease. That translates into a 1 in 20 million chance. An accident is four to five times more likely to kill you while travelling—even in Zaire.

If you must obsess about an infectious disease, don't waste your time with Ebola. Tuberculosis remains the number one killer worldwide.

15

Americans, like most people in the developed world, worry a lot about what they eat. While dieting to lose weight may still be something more common among middle class women than other groups, just about everyone thinks in some way about what he or she eats. Fad diets cross all kinds of demographic boundaries. The popularity of loosely-defined *natural food* has lasted more than a generation. Even inner-city drug addicts have protocols for the best foods to eat...or drink.

In July 1994, the Physicians Committee for Responsible Medicine kicked off an ad campaign advocating far-reaching changes in Americans' diets. The group's public service campaign featured a newspaper and magazine ad which read, "Last year, over a million people left the same suicide note." Below the bold heading is a picture of a shopping list with the words, "butter, eggs, mayo, potato chips, ham, bacon."

PCRM President Neal Bernard elaborated the point: "Americans are not gluttons. Our error is not how much we eat, it is what we eat. The problem is the type of food we buy at the store and bring home to our families."

Bernard cited a University of California, San Francisco, study which found that 82 percent of heart patients using a vegetarian diet, modest physical activity, smoking cessation and stress reduction show "demonstrable reversal of their coronary blockages within a year."

He continued:

> A study published in the *Journal of the National Cancer Institute* showed that, for women with metastatic breast cancer (cancer which has already spread at the time of diagnosis), the risk of dying at any point in time is increased by 40 percent for every 1,000 grams of fat consumed per month.
>
> In practical terms, a typical American diet and a vegetarian diet without added oil differ by about 1,500 grams of fat per month. Food choices are that powerful. Hypertension, diabetes, gallstones, obesity and many other conditions are also strongly linked to dietary factors.

American Heart Association guidelines limit fat intake to 30 percent of calories and include poultry, fish and so-called lean red meat, all of which contain cholesterol and fat.

Bernard acknowledged that switching to a diet consisting primarily of vegetables, fruits, grains and legumes would be "a big change for Americans, but it is both easier than we might imagine and powerful for health."

Earlier in 1994, a Gallup poll commissioned by the American Dietetic Association organization found that obesity among women had jumped by nearly one-third in a few years, despite the perception among most that their diet is healthy.

According to Susan Calvert Finn, former president of the ADA, "There's so much reporting of isolated facts and contradictory studies, and putting it together takes skill. You can't take that isolated information and make it work in your own diet. So people just walk away in anger."

In this chapter, we'll consider the various ways that foods are analyzed for safety and nutritional value. We'll also consider how different groups—people with particular health conditions—respond to these analyses. Finally, we'll try to make some conclusions about what an average smart person can do to improve his or her diet.

SOME BACKGROUND

People diet for two basic reasons: To avoid dangerous foods and to lose weight.

Determining what constitutes a dangerous food can be difficult, though. Poison can be defined as too much of anything. But how much is too much for humans? Is there a threshold at which small amounts of foods that cause cancer or heart disease are not harmful? In most cases, no one can answer these questions with certainty.

Douglas Hofstadter, the mathematician who coined the term *innumeracy*, also coined the term *number numbness*—which refers to people's inability to comprehend numbers that are either very large or very small. This numbness applies to many dietary risks.

During the 1960s and 1970s, scientists learned how to measure particles in parts per billion or more. They were able to detect substances that may cause cancer in mice in ever-smaller amounts. This ability to measure tiny elements is called *technical intensity*.

Technical intensity tends to obscure risk assessment, because it's spread unevenly among scientific pursuits. Scientists can measure tiny traces of substances in your bloodstream and they can measure rates of incidence for diseases that apply to you—but they can't always link the two causally.

What they're left with is a correlation between parts per billion of a substance and incidence rates of a disease. This may sound conclusive because it's exact, but it's not.

Dietary risks, like others, are usually described in the odds of causing a fatal illness or in the average number of days or years by which they shorten your life. So, you might hear that drinking milk every other day adds a 1-in-7,200 chance of getting liver cancer from a mold that produces aflatoxin.

Three pats of butter on a slice of toast takes a half hour off your life. A steak dinner, complete with a snifter of brandy afterward, will cut 20 minutes off your life—though this sounds like a bargain compared to the three pats of butter.

All of these statistics are of questionable value, though. They're usually based on one of two methods—both of which have flaws.

First, some of these diet numbers are based on aggressive extrapolation from standard dietary impact charts. Extrapolations lose their effectiveness the farther they move from empirical numbers. In the case of the three pats of butter on a piece of toast, that number is taken from an American Heart Association statistic on daily fat intake over a lifetime. To extrapolate such a small number out of a lifetime measure makes it essentially meaningless.

Cancer statistics are often based on animal tests. An important flaw in animal testing is that animal experiments necessarily involve large doses. To pinpoint a risk of one in a million, you'd have to perform a million tests, involving as many as 1,000 animals each. The cost could be prohibitive.

So, the best scientists can do is experiment with very large doses, adjust for the weight or surface area and metabolic activity of the animals compared with humans and extrapolate to the possible results of small doses on people.

A lot of guesswork is involved, but so far all known human carcinogens also cause cancer in laboratory animals. There's no way to conduct laboratory tests on humans and wait for a body count. So animal tests, for all their uncertainty, are the best available alternative.

Of course, not everyone diets because they're afraid of cancer or strokes. Many people diet because they want to lose weight. This involves one main risk—that you'll regain whatever weight you lose.

Begin a denial-based diet and you'll probably lose weight. For how long is an entirely different question.

Losing weight at the rate of two to three pounds per week produces the best long-range effects. Many experts say the odds are against dieters losing weight and keeping it off permanently, so it's better to set a realistic goal that you can manage.

"By nature, we all still look for that single food...or that magic pill that cures," American Dietary Association spokeswoman Alicia Moag-Stahlburg says. "We think we have to have a major overhaul or change to make anything worthwhile happen. Dietary changes are important, but maybe it's time we lighten up."

DIET AND SUPER-NUTRITION

Through the early 1990s, an intense debate took place in scientific circles over whether some nutrients—taken at levels well above the federal government's recommended daily allowance (RDA)—provide benefits beyond their traditionally defined "essential functions."

The use of foods for medical purposes dates back many centuries. But advocates of this super-nutrition argument base their position on modern science—specifically, anecdotal evidence that certain nutrients, taken in huge doses, can reverse early-stage cancerous tumors.

They argue that cancer is not an on-off switch. It's more like a gradual deterioration, with built-in stops. These stops are biological mechanisms: DNA repairs, cell-to-cell communications and others in the body that are there to check the spread of cancer. The super-nutrition theory holds that you can "feed" these stops so that the body can participate more effectively in the recovery process.

One example: Several early 1990s studies offered evidence that vitamin E can reverse fiber-cystic breast disease.

Patrick Quillin, of the Oklahoma-based Cancer Treatment Centers of America, summed up this position:

> Maybe above-RDA levels equal above-normal health. Americans get six colds per year, are overweight, plagued with lethargy, depression and constipation, get dentures by age 45; they get sick in their 60s and die in their 70s of cancer or heart disease. So that equals normal.

> ...Nutrition and exercise ought to be protective factors. Unfortunately, they are not. On any given day, only 18 percent of Americans eat cruciferous vegetables, only 16 percent eat whole grains. The rest of us are eating junk food.

Admitting that many people consume nutrients far above RDA levels, John Hathcock, director of FDA's Office of Special Nutritionals, warns that this level of ingestion sometimes has well-documented adverse effects.

To assess the relative safety of different nutrients, he developed the "nutrient safety index." He defined this as "a ratio similar to the therapeutic index for drugs." The index is equal to the lowest observed adverse intake level divided by the RDA—giving a hint of how many multiples of the RDA can be tolerated safely.

(In this analysis, a safety index of 10, for example, doesn't mean that an intake of up to 10 times the RDA is completely safe. It means that an intake that is 10 times the RDA would provide no margin of safety.)

Jeffrey Blumberg of the Department of Agriculture's Human Nutrition Research Center at Tufts University stresses the difficulty of finding optimal levels of vitamins and minerals. Acknowledging the nutritional health effects beyond prevention of deficiency diseases, Blumberg admits new uses are bound to follow.

At a 1995 seminar on the use of nutrition to fight disease, he said:

> [The current debate] started in 1955, when the hypocholesterolic
> effects of niacin were pinpointed by scientists. One demographic
> factor has been longer life expectancy in much of the world, with
> a corresponding base of knowledge of the causes of death in older
> people. They include diabetes, heart disease, pneumonia, infec-
> tious diseases and cancer.

The medical establishment has gradually begun to embrace a more
aggressive standard for gauging recommended daily allowances of
some nutrients.

In a switch from previous methods of establishing the government's
RDAs for vitamins and minerals—which have been set for healthy
individuals—the National Academy of Sciences' Food and Nutri-
tion Board began asking the question "Should criteria for the pre-
vention of chronic diseases like cancer be included as part of the
criteria for developing RDAs?"

DIET AND IMMUNE SYSTEMS

The relationship between nutrition and immune function has been
recognized for many years, showing that malnutrition can impair
the host defense, which in turn will decrease the resistance of the
host to infection. The presence of infection itself can have an effect
on the status of the nutrient.

While the immune function has been associated most closely with
AIDS research, it also plays an important role in the health status of
the elderly, who have higher incidences of infectious diseases. T-
cell mediated functions are the ones most affected in the elderly—
the ability of the body to fight against tumors, parasites, infectious
diseases.

The changes that occur with aging in the immune function are
partly due to changes in the nutritional status of the elderly and, by
manipulating the diet appropriately, you should be able to reverse
or delay these changes in immune responses and aging.

Simin Meydani, director of the USDA Center at Tufts University, offered a familiar argument for minimizing calorie intake:

> There are several approaches—one that has been very effective with rodents is calorie restriction—anywhere from 40 percent to 60 percent reduction in calories. It has not been determined yet if this regime would be effective in humans; primate studies are ongoing now. There are some practicality problems, too, because it will be difficult to convince many people that they have to reduce their food intake by 60 percent.

Another approach was to give a general protein-calorie supplement with RDA levels of most nutrients. But the Tufts researchers concentrated on individual nutrients, rather than on dosing test subjects with multivitamins. They focused on the antioxidant nutrients—for example, vitamin E, which is a powerful biological antioxidant.

Vitamin E is one of the few nutrients for which supplementation with more than the recommended level has been shown to actually enhance above recommended levels, and that has been demonstrated in rodents by several different investigators.

Tests done on animals receiving various doses of vitamin E have indicated increased resistance to infectious diseases.

Again, though, the nutritional leads the Tufts group followed all required animal testing of questionable applicability.

DIET AND HEART

Dieting carefully does the most good by what it prevents. Being overweight increases the likelihood for diabetes, cardiovascular problems and several kinds of cancer. So, it's good not to be overweight. Having high LDL cholesterol increases the odds of heart disease—by as much as 200 percent for some groups. So, it's good to lower your cholesterol.

On the other hand, there's nothing inherent in the acts of losing weight or lowering cholesterol that's good for you.

This is a common mistake people make. They think that losing weight or lowering cholesterol will make them healthy. That's not really true. These things will simply make you less unhealthy.

Typically, 100 people have to lower their cholesterol in order for one of those 100 to live a few years longer. And if you're one of the other 99, you might feel like you cut out delicious food for nothing.

But you haven't. Since the 1950s, Americans have gradually raised the average weight that people carry. This isn't a good thing. As a society, Americans need to reverse that trend.

A 1995 Harvard University study reported that weight gain among mid-life women increases their risk for heart disease. Even a modest gain, such as 11 to 17 pounds, increased the risk by 25 percent. The study, by JoAnn Manson of Brigham and Women's Hospital and Walter Willet of the Harvard School of Public Health, was based on data collected since 1976 from 116,000 female nurses. Manson and Willet encouraged women to follow height-weight charts published by the Metropolitan Life Insurance Co. in 1959.

Those tables suggest that a medium-frame 5-foot-6-inch woman of any age should weigh between 124 and 139. Since the 1950s, gaining a few pounds a year over a couple of decades has became so common in this country that the charts were adjusted upward in 1990.

At that time, the Department of Agriculture and the Department of Health and Human Services reissued new guidelines that were considerably more generous. And according to the new standards, older people could weigh more without being regarded as overweight. The 5-foot-6-inch woman under 34 could weigh 118 to 155. Over 35, she could span 130 to 167.

This upward adjustment is a dietary version of the phenomenon economists call bracket creep (when inflation raises the incomes of middle-class people into upper-class tax brackets). In this case, overweight people are reclassified as not overweight.

This may make people feel better about themselves, but it hints at trouble in the long-run. The fact remains that overweight people are two to six times more likely to develop hypertension. When overweight adults lose weight, there is a notable reduction in the incidence of hypertension. Most health experts say that if you are more than 10 percent above your ideal body weight, you should try to lose the weight and keep it off.

American Heart Association dietary guidelines emphasize reducing total fat (not just cholesterol) but keeping a balanced diet. In 1995, the AHA reduced its recommendation of no more than 30 percent of fat in the daily diet to no more than 20 percent to 25 percent. Less than 10 percent of the fat in the daily diet should come from saturated-fat (animal) sources. But AHA dietitians insist that simple adjustments to the average balanced diet can achieve these goals.

The sodium debate has been raging for years. Research indicates that reducing sodium intake actually can prevent hypertension from developing. About 80 percent of consumed sodium comes from processed foods; 20 percent is added during cooking or at the table.

Lynne Scott, director of the Diet Modification Clinic at Baylor College of Medicine adds another threshold to this model: Consume less than 3,000 milligrams sodium daily (that's about 1.125 teaspoons of table salt).

With the fat and salt parameters set, you have considerable flexibility in constructing a diet that will minimize your odds of dying from heart disease. But a few other points might be worth considering:

- Potassium-rich foods, such as bananas, may play a role in the prevention of high blood pressure. The National Academy of Sciences estimates 1,600 milligrams a day to be a minimum goal. One banana provides about 450 milligrams of potassium. Other potassium-rich foods are cantaloupe, dairy products, orange juice, beans, broccoli and potatoes;

- You can still drink coffee in the morning—even with caffeine—without worrying about hypertension, as long as you drink it in moderation.

- Onions and garlic contain quercetin, which many scientists believe has a preventive role in heart disease linked to free-radical tissue damage, and S-allyl cysteine, which has been shown to lower levels of LDL.

- A USDA study found that as the substance homocysteine increases in older people, so does the risk of artery narrowing. Fortunately, folic acid can correct elevated homocysteine—and it's easy to get folic acid through your diet. Green vegetables and citrus are excellent sources.

A caveat on these dietary standards: Too little fat in the diet may be as risky as too much. Below 20 percent, key fat-soluble vitamins (A, D and E) may not be absorbed, and the body does not produce essential fatty acids.

Essential fatty acids are necessary to prevent hardening of the arteries, increased risk of clot formation, high blood pressure and heart disease.

ALCOHOLIC ODDS

Among dietary items, alcohol is a risk factor of unparalleled proportions. The complication: Some health experts say light or even moderate alcohol use may be good for you.

A light drinker who confines indulgence to a pint of beer a day is subject to a one in 50,000 chance of getting usually fatal cirrhosis of the liver in any single year. Over a drinking lifetime of 50 years, the odds narrow to one in 1,000—on only one beer a day.

Heavy drinkers obviously take heavier chances. Their odds of dying from the habit are one in 100.

And both of these projections only calculate disease. They don't count the even greater risk of accidents—in a car or on foot.

Other researchers have claimed that moderate drinking is associated with lower death rates from other diseases—particularly coro-

nary artery disease. The National Institute for Alcoholism and Alcohol Abuse (NIAAA) took a long look at this theory.

NIAAA Director Enoch Gordis carefully presented the alcohol and the heart "tradeoffs" in a paper that asked the obvious question: "Will the cardioprotective effects of drinking outweigh the risks associated with alcohol use?"

Gordis' study described the mechanisms by which alcohol is thought to protect against cardiac illness, explored the potential risks and benefits of alcohol use and recommended a method by which people could determine the benefits and risks of alcohol use.

Epidemiologic studies show that those who drink light to moderate amounts of alcoholic beverages are at lower risk than non-drinkers for heart disease. Likewise, studies show that light drinkers are at lower risk of sudden death or death from acute heart attacks than either abstainers or heavier drinkers.

Several plausible mechanisms support the possibility that drinking some alcohol protects against coronary artery disease.

Of these, the best documented is protection by raising the high-density lipoprotein (HDL), or so-called "good" cholesterol, and decreasing the low-density lipoprotein (LDL), or "bad" cholesterol.

LDL may be involved in at least two later steps of heart disease: the gathering of cellular debris in fibrous plaque and defects in the integrity of the layer of cells lining the inside of blood vessels of the heart.

The body produces antioxidants to protect itself from the effects of toxic molecules such as LDL. But it may need some help. Flavonoids, a large group of compounds found in plants, are able to prevent particular types of LDL oxidation. The potent antioxidant activity of phenolic substances in red wine, in particular, has been proposed as an explanation for the "French Paradox" (the apparent incompatibility of a high-fat diet with a low incidence of coronary heart disease among French people).

"To date, red wine antioxidants as well as some antioxidants found in white wine have been shown to protect LDL from oxidation in vitro," Gordis admitted. "A recent study has demonstrated that ingestion of red wine is associated with an elevation of antioxidant activity in the serum. But these effects were achieved at relatively high doses of alcohol (350 ml per 30 minutes)."

The rest of alcohol's healthy impacts have to do with its anti-clotting effects.

Alcohol increases the body's release of plasminogen activator, an enzyme involved in clot degradation. An anti-clotting effect would explain the apparent protective effect provided by relatively small amounts of alcoholic beverages.

For at least some imbibers, moderate alcohol consumption appears to decrease risk of ischemic stroke, caused by blockage of blood flow in blood vessels. However, due to the anti-clotting effects of alcohol and the effect of alcohol on blood pressure, moderate drinking also increases the risk of hemorrhagic stroke—caused by the loss of blood through the walls of a blood vessel.

Age is an important factor in weighing the risk versus benefit of moderate alcohol consumption. "Coronary heart disease impacts primarily on men age 45 and older and women age 55 and older," Gordis concluded. "Individuals in these groups who are moderate drinkers and who do not have any of the contraindications mentioned above may well reap the cardiac benefits conferred by moderate alcohol consumption."

According to a study published in the May 1995 *New England Journal of Medicine*, Harvard's Graham Colditz and several colleagues considered the beneficial aspects of alcohol among middle aged women. In a prospective cohort study of over 85,000 women between the ages of 34 and 59, the doctors concluded:

> Among women, light to moderate alcohol consumption is associated with a reduced mortality rate, but this apparent survival

benefit appears largely confined to women at greater risk for coronary heart disease.

The researchers pointed out that women are statistically less inclined toward heart disease than men—so they have less to gain from the slight benefits provided by alcohol. Also, because of their lighter weight, women tend to suffer more liver disease and higher rates of breast cancer if they drink moderately.

As compared with abstinence, light to moderate alcohol consumption was assoicated with a significantly reduced risk of death due largely to a lower risk of fatal cardiovascular disease. In contrast, heavier drinking was associated with an increased mortality, due largely to an increased rate of death from noncardiovascular disease, including breast cancer.

...the apparent benefit of light to moderate alcohol consumption was mainly confined to women at greater risk for coronary heart disease, specifically older women with one or more coronary risk factors.

DIET AND CANCER

The American Cancer Society has issued several dietary recommendations to improve your odds in the area of cancer prevention. While the Cancer Society has bent risk analysis in some cases, its diet suggestions make basic sense.

- Avoid obesity. This isn't just the five extra pounds that some people carry around, but being more than 10 percent overweight.

- Cut down on total fat intake. Most health experts agree that we need to keep the use of saturated fat to a minimum; saturated fats come mostly from animal products, but also come disguised in many processed foods in the form of coconut oil and palm oil.

- Eat more high fiber foods. Most Americans consume 8 to 12

grams of fiber a day. The Cancer Society recommends we get at least twice that amount.

- Include cruciferous (cabbage, cauliflower and broccoli) vegetables in your diet. These vegetables can be good sources of cancer-preventing vitamins A and C. They are also naturally low in fat and contain fair amounts of fiber.

- Cut down on salt-cured, smoked and nitrite-cured foods. Foods are preserved to protect them from rapid spoilage. Unfortunately, some methods of preservation have been found to be cancer-causing. Compounds found in smoke and charred or burnt meats can be cancer-causing.

- If you drink, keep alcohol consumption moderate. The Cancer Society cites studies that show an increased risk of certain cancers in persons drinking as little as an average of two drinks daily. The risk tends to go up the more a person drinks.

Again, the focus on these recommendations is to cut the amount of fat in many diets. Foods high in fat may increase cancers of the colon, breast, prostate and lining of the uterus. Low-fat foods may reduce risk.

Fat is also a factor that promotes colon cancer; the problem occurs when most calories in the diet are derived from fat, said Michael Wargovich, researcher at M.D. Anderson Cancer Center.

Colon cancer is the second leading cause of cancer deaths in men in America (lung cancer is first). The risk of colon cancer increases significantly over the age of 50.

Wargovich, like several others, points to garlic as a cancer-fighting food. "We're still in the research stage, but S-allyl cysteine, a chemical in garlic, is a cancer preventive," he says.

In one study of laboratory rats, researchers fed a 99 percent purified garlic compound, diallyl sulfide, had a 50 percent reduced incidence of tumors. In the control group that did not receive diallyl sulfide, 80 percent developed gastrointestinal tumors.

Drawing a liner extrapolation from this animal data is dubious risk theory—even though the conclusion would be a hopeful one. In the meantime, Wargovich and his colleagues look for more convincing connections. "We cannot translate this to humans yet, but, aware of the scientific evidence, I'd hedge my bets by eating garlic and onions every day," he said.

And a trend has begun to emerge. A 1993 study of 41,000 women by the University of Minnesota School of Public Health also showed a connection between high garlic consumption and reduced risk of colon cancer.

DIET AND PREGNANCY

For more than a generation, doctors have recommended that women eat carefully when they are pregnant. Starting in the mid-1990s, pre-natal health specialists began urging women planning a pregnancy to start eating carefully at that point.

The reason: The developing fetus is most vulnerable between days 17 and 56 after conception when critical organs such as the brain and heart are being formed—and when most women don't know they are pregnant. Prepping for pregnancy can be the foundation for a baby's solid growth and development.

A series of early-1990s studies confirmed that women who consume moderate amounts of folic acid every day for at least a month before conceiving cut their baby's risk of neural-tube defects, such as spina bifida, in half.

The evidence is less clear on the role of caffeine consumption. Some studies suggest caffeine may increase the risk of miscarriage and low-birth weight babies. Most doctors advise women to avoid or limit caffeine intake to two cups or less a day.

The debate over caffeine heated up in 1994, when researchers at Canada's McGill University published a study which found that women who continued to consume caffeine during pregnancies had a higher rate of miscarriage.

The study, based on sizable and diverse test and control groups, was well structured. But not everyone agreed with its conclusions.

Soon after the McGill results were published in the *Journal of the American Medical Association*, the International Food Additive Council issued a news release citing research over the past decade which said that moderate caffeine consumption during pregnancy causes no adverse health effects to the mother or her children.

Explaining the release, IFIC Foundation Vice President Susan T. Borra said:

> While the consensus of scientific research on caffeine and women's health shows that normal caffeine consumption is safe, these studies rarely make it into the larger arena of consumer publications. Putting the research into language consumers can understand benefits the public, while enabling health professionals to communicate sound advice to their patients.

Other critics pointed out that the odds of fetal loss should have been lower among women who used little caffeine before their pregnancy than among women who cut back once they got pregnant. But, according to the McGill study, the odds of fetal loss were similar in the two groups.

But researchers from Milan, Italy, said their work offered support for an association between caffeine intake and risk of miscarriage in the first three months of pregnancy.

"Nausea in early months of pregnancy may in fact cause a reduction in coffee consumption and nausea is less frequent...in pregnancies that miscarry," said Fabrio Parazzini, leader of the Italian group.

In fact, the Italian researchers offered conclusions even better from a risk assessment perspective than the McGill researchers.

The Italians reported their preliminary case-control study data of

303 women, median age 31, admitted for miscarriage within 12 weeks of conception and a control group of 303 women, median age 28, who gave birth at term at the same Milan area hospitals. All were asked about their coffee consumption in the three months before conception and during the first trimester.

The answers from the test subjects tended to report an intake of two more cups of coffee daily before pregnancy slightly more frequently than the control subjects, "but the finding was not statistically significant."

The numbers consuming caffeine during pregnancy were more conclusive. A total of 69 percent of the tests versus only 56 percent of the controls reported drinking coffee during the first trimester. The corresponding relative risk estimates for miscarriages, in comparison with nondrinkers, were 1.1 for drinkers of one cup of coffee and 1.8 for those who consumed two or more cups. As the Italians concluded, "the trend was significant."

CONCLUSION

The best way to control the odds of diet-related risks is to take moderate steps toward a balanced mix of foods and substances like vitamins and minerals.

The primary rule: Lower the fat content of what you eat. After that, you should lower the amount of sodium you consume and raise the amount of fiber.

The American Dietary Association offers a couple of suggestions to assist in the process:

- on individual foods with a nutrition label, check to see there are no more than 3 grams of fat for every 100 calories in a serving. When this is the case, the food contains no more than 27 percent of its calories from fat—just below the recommended level. The formula works regardless of serving size; it's also valid for single items as well as meals;

- to estimate an average recommended level of dietary fat (in grams) for any day, take your daily calories and divide by 30. For an individual eating 2,100 daily calories, the daily fat allowance would be 70 grams (2,100 divided by 30 equals 70 grams).

But, even with these parameters, you do best to avoid any kind of extremism in your diet. Some dietary fat is necessary. And some rigorous diets can create undesired risks.

For example, a 1995 report on "Vegetarian Diet as a Risk Factor for Tuberculosis" considered dietary links to disease among ethnic Indians in the London area.

Immigrants from the Indian subcontinent diagnosed with tuberculosis during the past 10 years and two Asian control groups (community and outpatient clinic controls) from the Indian subcontinent were investigated.

Unadjusted odds ratios for tuberculosis among vegetarians (common among Indians) were 2.7 using community controls, and 4.3 using clinic controls. There was a trend of increasing risk of tuberculosis with decreasing frequency of meat or fish consumption. Lactovegetarians had an 8.5 fold risk compared with daily meat and fish eaters.

Adjustment for a range of other socioeconomic, migration, and lifestyle variables made little difference to the relative risks derived using either community or clinic controls.

These results indicated that a vegetarian diet is an independent risk factor for tuberculosis in immigrant Asians.

While the British researchers didn't find a conclusive mechanical cause for this connection, they did suggest that "vitamin D deficiency, common among vegetarian Asians in south London, is known to affect immunological competence. Decreased immunocompetence associated with a vegetarian diet might result in increased mycobacterial reactivation among Asians from the Indian subcontinent."

Trying to maintain an ideal weight by keeping the perfect diet isn't the smartest way to go. Exercise regularly and you can enjoy more kinds of food and still lower your risks.

So, don't expect dramatic health impacts from what you eat. Diet is a long-term, gradual risk factor. Your best bet is to shave at mortality and lifespan odds by eating a balanced, low-fat diet—including lots of mineral-rich fruits and vegetables.

The rest of it is pretty much negotiable.

16

Lotteries are a tax on the stupid

All forms of legalized gambling are bad investments. The odds for most games are slanted in favor of the casino. But people are drawn to casinos and other betting outlets in growing numbers. Buying a lottery ticket is just about the worst investment anyone can make. The odds against winning anything substantial are astronomical. But millions of people play state-run lotteries every day.

In simple terms, the take-out rate in lottery games—that is, the gross profit that states take out before winners are paid—is very high compared to other forms of gambling. So, it's natural to ask why anyone would play.

A Baptist minister in Biloxi, Mississippi—a city treated roughly by casino gambling—answered the question:

> Look at the lottery where the odds are even worse [than casino games]. The jackpot gets big enough and even people who would normally never think of gambling will start buying tickets. It's that hope of winning big.

The odds are greater you'll be struck by lightning than win even the easiest lottery. They're better that you'll be dealt a royal flush on the opening hand in a poker game (1 in 649,739). They're better that you'll be killed by terrorists while traveling abroad (1 in 650,000).

Bill Eadington, director of the Institution for the Study of Gambling and Commercial Gaming at the University of Nevada at Reno, looks at it this way: If you bought 100 tickets a week your entire adult life, from age 18 to 75, you'd have a 1 percent chance of winning a lottery.

"[Lotteries] really play on the inability of the general public to appreciate how small long odds are," Eadington says. This is the same number numbness that surfaces often in other risk issues.

And because they're numerically numb, plenty of people pay a dollar per play to daydream about beating odds of 1 in 15 million and becoming what advertising campaigns call an instant millionaire.

As a result, the lotteries running in most of the United States are a $25 billion a year industry.

In this chapter, we'll consider why lotteries are such a booming business—and what this means to your chances of winning a Lotto fortune. We'll also look at odds gamblers in casinos, horse tracks and sporting events face. And, throughout, we'll consider what these odds mean about how people calculate risk in their lives.

SOME BACKGROUND

There's a formula for computing a player's average winnings (or losses) over repeated play. It's called expected value. As the expected value of a bet rises, the price of the bet falls.

At the roulette wheel, player's expected value of a $1 bet is 94.7 cents. That's $1 minus the 5.3 percent advantage to the house.

In the 1650s, the French con man Antoine Gomband—known as the Chevalier de Mere—offered even money odds that, in four rolls, a die would turn up at least one 6. The Chevalier reasoned—wrongly—that since the chances of a die turning up a 6 are 1 in 6, the chances of it turning up in four tries would be 4 in 6...or 2 in 3. Still, he made money with the game.

When interest in the game died down, the Chevalier modified it. He figured—again wrongly—that since the odds of throwing two 6's at the same time on two dice are 1 in 36, in 24 rolls the odds would be 24 in 36...or, again, 2 in 3.

He started losing money on the new game, so he contacted an acquaintance—the mathematician and philosopher Blaise Pascal—for help.

Pascal told the Chevalier that his first game offered him an advantage—what contemporary risk experts would call the house's edge—of 4 percent.

His second game offered his players an edge of 2 percent or an expected value of 1.02 francs per franc wagered. Put another way, players would win 51 times out of a hundred. Over time, the Chevalier was bound to lose money.

In modern times, this is known as "the gambler's ruin" —the fact that in a game with a negative expected value, a player will eventually lose his or her money over time.

In calculating an expected value, the ratio to remember is the number of favorable outcomes to the number of possible outcomes.

The payoff on a bet on red or black in roulette is 1 to 1. If you bet $1 on red and win, the casino will give you back your $1 and another $1 of its own. The payoff on betting a single number in roulette is 35 to 1. If you bet $1 on number 23 and it wins, the casino will give you back your $1 and $35 of its own.

If you bet $1 on red repeatedly, you'll win an average of 18 out of 38 bets. Since there are 18 red sections on a 38 section roulette wheel, the law of large numbers says that red will come up 18 times and not come up 20 times out of every 38 spins.

That will leave you with a net $2 loss. This means an average loss of $2 per 38 plays or 5.3 percent.

If you bet $1 on numer 23 repeatedly, you'll win an average 1 out of 38 bets and you'll win $35 when you do. This leaves you with the same $2 net loss. And the casino keeps the same 5.3 percent edge.

In fact, all bets in roulette give a 5.3 percent edge to the house.

THE HOUSE'S EDGE IN LOTTO

If you want to win $1 million for $1, play a single number on a roulette wheel and win. Put all the winnings on another single number and win again. Do it again. And again. You'll have just over $1 million. The odds of doing this are over 1 in 2 million.

That's still seven times more likely to happen than winning a standard 6/49 Lotto game.

If $20 million is bet on a Lotto jackpot, the state will take between 40 and 50 percent out of that figure immediately. From the half left, smaller prizes are deducted. In most cases, you're left something like $5 to $8 million for winning a 14 million to 1 bet. And if 20 million people play, it's likely 2 people will win. So they'll have to split that pot.

Criticizing lotteries can sound like a humorless exercise in cultural snobbery. What's the harm in someone spending a few dollars a week on a long-shot rip-off?

The best defense that proponents of state lotteries make is that the cost of playing is small and you have to play to have a chance—no matter how slight—of winning. But a small rip-off is still a rip-off.

Many state lottery directors insist that the demographics on people who play lotteries contradict the common criticism that poor people spend their food money on lottery tickets. But, even if only 1 in 4 Lotto players makes less than $25,000 a year (as is the case in Illinois), that's still a lot of people playing who'd be better off saving.

Relative to other arguments, the demographic defense makes sense. The people who defend lotteries more actively often sound intolerably cynical.

Social critics and some politicians argue that the desire for legalized gambling is a sign of the fraying of a country's social fabric. These people say that, in healthy societies, people believe that hard work and perseverance will make their fortunes. In sick societies, people have to rely on luck. They conclude that lotteries—more than other forms of gambling—prey on the poor, selling a false hope of an easy life.

Other less moralizing critics look at lotteries as a tax on the stupid...because the odds of winning are so slight and the payoff, when someone does win, doesn't reflect the odds.

Social commentary aside, gambling is a useful issue for risk analysis because it is the purest practical application available. Stripped of politics, special interests and other baggage, gambling is risk assessment at its core.

Economic studies have a hard time quantifying why and how people gamble. They come up with basic conclusions like: The bigger the jackpot, the more people play. "It appears that there is a perceived value equation that's going on," said one academic. "I don't think it's an intellectual process. I think it's very emotional. They think, well, for a million, it's not worth a dollar. But if it gets over $5 million, they'll spend a dollar this week on Lotto."

When people behave irrationally, opportunities exist for others to profit. That's why casino gambling became a Wall Street darling in the 1980s.

The three most common lottery products are instant (or scratch-off) games, numbers games, and Lotto. To win the grand prize in a typical Lotto game, a player buys a one-dollar ticket and must correctly match six numbers drawn randomly without replacement from, say, forty-four numbers. This is called a 6/44 game. The prob-

ability of any ticket winning the jackpot in a 6/44 game is 1 out of 7,059,052.

Lesser prizes are often awarded for matching fewer than six of the numbers. Lottery agencies take out from 40 to 50 percent of each dollar bet, some of which covers operating costs and the rest of which is turned over to the state.

Individual rationality is put to the test in the gambling market. In order to win a 6/49 Lotto-style game, you have to match 6 numbers picked at random out of a 49 number universe. The odds of doing this are nearly 1 in 14 million. The average jackpot in this kind of game in 1994—on a $1 bet—was less than $2 million. That's a risk-reward ratio of 7 to 1, in favor of the lottery agency.

There are lesser prizes than the jackpot in most of these games. But the risk-reward ratio for these prizes aren't much better...and can be worse. The odds of matching 5 numbers out of 49 is 1 in 2.3 million. For one Canadian Lotto game, the average award in 1994 for matching five numbers was $113,666. That's a risk-reward ratio of 20 to 1.

The way to make money in a lottery is to be the one running it.

In 1995, Great Britain started a national, state-run lottery to compete with the various privately-run games that exist in that country.

By July 1995, 30 million British people were betting 100 million pounds a week on the National Lottery.

As one Brit pundit said, "When tickets for the National Lottery go on sale, I'll bet you a pound to a penny you won't find many true gamblers in the queues."

The reason: True gamblers recognize a bad bet when they see one.

To give yourself an even-money chance of winning the British National Lottery, you'd have to spend five pounds a week on tickets—for 28,000 years. And, when you finally won, you might have to share the prize money.

THE ECONOMICS OF LOTTO

Considering horse racing and lotteries, economist Richard Thaler defined weak efficiency as existing if there is no betting opportunity available that will yield a positive net expected return. In other words, there are no profitable betting opportunities before the outcome is determined.

Thaler defined strong efficiency as existing if all bets have expected values equal to (1-t) times the amount bet, where t is the house's edge.

Thaler pointed out that the conditions for learning are optimal in Lotto games because there is quick and repeated feedback. If an efficient market equilibrium does not exist in Lotto, you shouldn't be optimistic about finding one in more complicated financial markets.

Lotto games differ from other lottery products because the expected monetary value of a ticket depends on the behavior of other players. The expected value also depends on the amount of money rolled over (if any) from the previous drawing's jackpot. Repeated drawings of a Lotto game thus present players with a range of betting opportunities, some more favorable than others.

The concept of a rational expectations equilibrium is useful in this context. If expectations are not correct on average, then they won't be confirmed by the outcomes of the game. Rational players will be caught once or twice in the wrong position and adjust their expectations—and possibly stop gambling.

For example: When a Lotto jackpot is headed for $10 million, a player might find the expected value of $0.30 for a lottery ticket attractive. He or she will buy tickets. If the actual jackpot only reaches $5 million, the expected value of a Lotto ticket will be something less—$0.20 or $0.15.

If the player is able to process this information, he or she will buy fewer tickets in subsequent games.

A rational expectations equilibrium occurs when expectations generate an outcome that conforms to those expectations. In the context of lotteries, equilibrium means that players' decisions to play generate a level of sales that conforms to their original expectations of jackpot size and, therefore, expected value of the lottery tickets.

In the ideal context, players aren't concerned about the size of the jackpots—what they care about is the expected value of a bet. The problem with this ideal is that it requires players to make a sales projection for that jackpot and combine it with their understanding of probability to generate a forecast of expected value.

However, buying patterns in lotteries suggest that players don't care about expected value as much as they should. More precisely, they value the pleasure factor of buying lottery tickets in such an erratic way that the results are effectively random—that is, they offer no discernible conclusions.

THE MATH OF LOTTO

If players knew before they bought tickets what the expected value of a ticket would be in each drawing, then an analysis of Lotto demand would be like any other commodity whose price is known with certainty. It is not so simple, however, because the expected value of a ticket depends on the behavior of other players and is only known with certainty after the drawing. Players must project expected value based on what they think other bettors will do.

But this doesn't mean you can't calculate the odds of winning a lottery.

Winning the Lotto is an extremely low probability event. Even if a given draw is characterized by a positive net expected return, the dollar expenditure and transaction costs of covering even a small proportion of the possible combinations would be prohibitive for most players.

Lottos have several other interesting features. If the jackpot is not

won on a given draw, the jackpot (minus prize payments for any partially correct tickets) is rolled over into the jackpot for the next drawing. These rollovers can create jackpots in the tens of millions of dollars. In addition, Lottos are pari-mutuel games, which means that there can be multiple winners. Winning ticket holders share equally the grand prize. Finally, the grand prize usually is paid out over a twenty-year period. The advertised jackpot is naturally the undiscounted sum of the twenty annual payments.

The expected monetary value of a $1 Lotto ticket depends on several factors, namely, the structure of the game, the value of previous jackpots (if any) rolled over into the current jackpot, and the number of tickets bought in the current drawing.

In deciding whether to purchase tickets, players must evaluate the expected monetary return, which requires them to forecast sales. Like investors, Lotto players must project an expected return on their investment. And, like financial investments, expected monetary return in Lotto games depends on the behavior of other players.

Unlike investing in the stock market, however, the outcome of the purchase of a Lotto ticket is based on objective probabilities.

ARE LOTTERIES EFFICIENT?

Because most lottery products have a negative and unchanging expected monetary return, only limited research has been done on the efficiency of lottery markets.

Most academics have studied Lotto games to evaluate the possibility of favorable investment opportunities arising from popular and unpopular numbers.

But numbers chosen at random would follow a more standard binomial distribution. The expected monetary value of this kind of Lotto bet follows well-defined laws of probability and depends on readily available information.

In the April 1995 issue of the journal *Economic Inquiry*, University of Kentucky professor Frank Scott and Bentley College professor David Gulley argued that players decide whether to play the Lotto based on their reservation price and their assessment of the expected value. The expected value depends on other players' behavior; therefore, each player must generate his or her own forecast of total sales.

The relevant question becomes: Do Lotto players make systematic errors in their forecasts of sales and, therefore, of expected value?

The expected value of a Lotto ticket depends on the structure of the game, the dollar amount rolled over from previous drawings, and the number of tickets purchased by players.

Since players under ordinary circumstances are only willing to buy a limited number of tickets, in any given draw of an actual Lotto game expected value will depend largely on the size of the rollover.

Scott and Gulley claimed that, with a large enough rollover and a small enough level of sales, the expected value of a $1 ticket could be more than $1. The potential for profit from such a situation would likely encourage additional betting, which would reduce the expected value to no more than $1. This would be a form of equilibrium.

Scott and Gulley concluded:

> ...we find that even in the presence of a pleasure component which we are not able to incorporate explicitly, lotto markets tend to be efficient...either of two conclusions is possible.

> One is that financial forces do not work towards efficiency, and that whatever direction they do work, they are exactly offset by pleasure forces working in the opposite direction.

> Alternatively, it may be that financial forces work towards efficiency, and pleasure forces are relatively insignificant. While we are willing to admit that the first alternative is possible, we find the second explanation much more convincing.

Because the state keeps so much of the proceeds in most Lotto games, the economic pursuit of a positive expected value is difficult.

Exploiting a pure profit opportunity is difficult in practice because of the logistical problems encountered in buying a large number of Lotto tickets. Such a strategy is not impossible, however, as was demonstrated in 1993 when an Australian syndicate attempted to make money by covering all the numbers in the Virginia Lotto.

It failed.

IF LOTTERIES ARE EFFICIENT, WHY AREN'T PLAYERS?

Economists and other students of gaming programs have tried to reconcile the risk-seeking behavior implicit in lottery play with the observation that individuals in general display risk aversion.

In this endeavor, economists differentiate two kinds of efficiency in Lotto games: weak-form and strong-form.

Weak-form efficiency requires relatively simple player behavior: They must be able to recognize the potential for abnormal profits. Their collective response then eliminates this potential.

Strong-form efficiency involves more sophisticated player behavior: the ability to forecast the expected value of a Lotto ticket given the information available to them. Strong-form efficiency exists if all bets have expected values equal to one minus the takeout rate.

In their study of state Lottos, Scott and Gulley considered three games in detail:

- In the Kentucky Lotto, expected value varies from $0.09 to $0.58. These figures assume that players realize the announced jackpot is the undiscounted sum of twenty annual payments and are able to calculate present value. If that is so, then the Kentucky Lotto market is weakly efficient. If

> players use the announced (undiscounted) jackpot, the expected value would vary from $0.18 to $1.17. That suggested they were motivated by non-monetary factors.

- The Massachusetts Megabucks expected values also relied on discounted present value of the jackpot. Only once in six years did the game yield a positive net expected return.

- The Ohio Super Lotto expected values, which ranged from $0.16 to $0.76, indicated weak efficiency. That expected returns were consistently negative suggested risk-seeking behavior or nonpecuniary returns or both on the part of players.

The significant negative relationship between sales and the residuals indicates that bettors systematically underpredict expected value when rollover is small, and vice versa.

In addition to the monetary return of the bet, there also exists a nonmonetary return (the value derived from watching the numbers being drawn on television, thinking of how any prize money would be spent, etc.).

Market efficiency is a critical concept in economics and finance. Only infrequently do situations arise where relatively clean tests of rational player behavior or market efficiency can be conducted. State-sponsored Lotto games do seem to offer such an opportunity, because the mathematical expectation of a bet depends on, among other things, players' aggregate behavior.

In deciding whether to play, each player must predict how others will behave and then act on that prediction.

A slowdown can generate a gambling Catch 22 for lottery officials. Smaller jackpots generate slower sales. Slower sales generate smaller jackpots.

During the 1990s, most state Lotto games have changed formats, adopting longer odds that lead to more rollovers. The marketing philosophy seems to be that more rollovers create bigger jackpots and disproportionate increases in subsequent sales.

POWERBALL AND OTHER MULTI-STATE LOTTERIES

Powerball is an interstate lottery designed to make money for small states by offering jackpots larger than their lotteries could alone. Sixteen states and the District of Columbia participate in the program, which is based in Iowa. In 1994, sales of $1 Powerball tickets were $850 million.

The game is a slight variation on the Lotto standard. It requires players to pick five numbers from 1 to 45 and then to pick one number—the Powerball—from 1 to 45. Players can choose the numbers themselves or have the computer do it for them.

The odds of winning something from Powerball are one in 35. In addition to picking all six numbers, there are eight other ways to collect prizes from $1 to $100,000.

In 1994, as drawing after drawing went by without a winner and the jackpot climbed higher, the lines to buy Powerball tickets stretched out the doors of some stores, even though the odds of winning the jackpot were nearly 1 in 55 million.

A Wisconsin couple claimed the record jackpot—$111 million. It was one of 13 multimillion-dollar jackpots claimed in 1994, each to be collected in 20 annual payments—with the federal government deducting 28 percent for income tax.

The first payment is made in cash. Then Powerball management takes what is left in the fund and buys U.S. Zero Coupon Treasury Bonds or other securities guaranteed by the federal government.

In 1995, securities that mature with a value of $1 million in a year cost about $957,000; those with a value of $1 million in 19 years—the final Powerball payment—cost about $225,000.

As in state lotteries, only half of every $1 Powerball sale is used for prizes. About 30 cents of that goes to the jackpot to buy securities and about 20 cents goes to cash prizes.

Each member state keeps the other 50 cents from every Powerball ticket sold within its borders.

That is used to pay retailers a commission and other costs, such as advertising.

Powerball has worked well enough that it has attracted competition. In March 1995, two days after the multistate Powerball lottery yielded a $101.8 million jackpot, the Coeur d'Alene Tribe of Idaho announced an ambitious lottery that could generate far larger payoffs as it links players in up to 36 states.

The Tribe hopes to offer its game in all 36 states, as well as the District of Columbia, that run lotteries.

The National Indian Lottery would permit players to call a toll-free number to set up an account, registering with a credit card and receiving a password and personal identification number. They could then call and make $5 minimum purchases, picking six out of 49 numbers at $1 a game.

Jackpots for the Saturday night drawings would be paid in lump sums; states spread the big winnings over many years. Taxes would be withdrawn before pay-outs, which would be mailed as certified checks.

The Tribe said that the jackpot probably would start at $50 million or more, and that subsequent payoffs could hit $200 million.

Normally, 50 percent of the amount wagered would be returned in prizes. Players matching three or more numbers would be awarded prizes. The odds of matching all six numbers and winning the grand prize are 1 in 14 million.

THE MANIA FOR GAMBLING

Gresham's law says that bad money drives out good. Critics of casino gambling must see this as a fact of life in America in the 1990s.

In late 1994, pressure was building in Maryland to join the growing number of states that allow casino gambling. Without casino gambling, some feared the state would lose millions of dollars in potential taxes and that gamblers would abandon race tracks there, devastating the state's $1 billion horse racing industry.

At the same time, a group in nearby Washington, D.C. was pushing riverboat casinos as the cure for the district's employment ills. Another regional neighbor—Delaware—was considering allowing casinos. And at least six other states considered some form of legalized casino gambling in 1994.

The trend follows the Foxwoods casino in Connecticut, opened by the Mashantucket Pequot Indian Tribe in 1991. Foxwoods proved to be a gold mine. During the first half of 1993, crowds poured $954 million into slot machines alone, according to a report in *Gaming & Wagering Business* magazine.

Hampshire College professor Robert Goodman discovered while conducting a separate study that budget projections are often performed by the gambling industry itself or related interests.

In 1986, for example, two reports were released estimating the economic impact of proposed casinos on New Orleans. One was prepared by an econometrics company working for Resorts International. The other came out of an accounting firm working for the New Orleans Tourist and Convention Commission.

The experience has not been so positive for the city.

Goodman estimates conservatively that society pays $13,200 for each pathological gambler, a figure that puts the social costs of problem gambling in Connecticut alone at $539 million per year.

"Most states have not considered those kinds of costs," says Hampshire's Goodman, a professor of environmental design and planning.

THE ODDS OF GAMBLING

The odds in a lottery are worse than other forms of gambling. But those other forms are also slanted toward the people running the games.

Casinos have something called the vig (short for vigorish), the advantage the house enjoys on all so-called "even money" and "true odds" bets, on which you're paid, respectively, what you've bet or an amount proportional to your risk.

In horse racing, you bet against everyone else at the track, and typically, the house takes 17 percent of all money bet. With breakage (the house rounds every payoff down to the nearest dime), add another 2 percent. That's 19 percent you have to overcome before breaking even.

Statistical edges against the player for various casino games

Baccarat	1.17-14.1
Blackjack	
Normal	10.0-20.0
Perfect strategy	1.2-2.0
Strict card counting	0.0-2.0
Craps	
Normal bets	1.4-16.7
Single odds	0.8
Double odds	0.6
Ten times odds	0.0
Keno	29.5
Roulette	5.26
Slot machines	2.0-35.0

Sports Betting

Football and basketball

 Single bets ... 4.54

 Two-bet parlays ... 10.0

 Three-bet parlays .. 12.5

 Four-bet parlays ... 31.3

Horse racing .. 19.0

These numbers are the percentages of defeat built into every casino game, sports game, or horse race you bet. They are the odds stacked against players. If you're betting $100 an hour on roulette, you will, in the long run, lose an average of $5.26 an hour.

Craps is extremely complicated—but much of its fascination lies in its complexity. In the game, one player—the shooter—throws a pair of dice and bets, along with other players at the table, on specific numbers turning up.

On the shooter's first roll, the wager—called a pass line bet—is on whether he'll throw either 7 or 11 (a win) or 2, 3, or 12 (a loss). If he hits 4, 5, 6, 8, 9, or 10, that number becomes his point; your original wager is then on whether he'll roll that number again before he throws a 7.

After making a pass line bet, when a point has been established, you can make an odds bet. You do this by placing another bet—equal to one, two...up to ten times the original bet—on the point number. The casino will pay true odds on this second bet, based on the probability of the point number coming up.

These true odds bets reduce the house's edge in craps to less than 1 percent. Next to blackjack played with extreme discipline, this is the best bet you'll have in casino.

The odds on slot machines are terrible. Casinos make two thirds of their profits from slots. But smart gamblers avoid slots as surely as they do Lotto machines.

Roulette, in which you're betting on whether a ball spinning above a wheel will land on a certain number, group of numbers, or color, has a simplicity that makes it a perfect game for anyone wishing to meet destiny face-to-face.

In addition to the numbers 1 through 36, the roulette wheel has the numbers 0 and 00, which gives the house a 5.26 percent advantage on all bets—a significant edge.

Most people believe that Blackjack, the casino version of the card game 21, is the easiest and best game to play in a casino. Depending on how you play, this can be true.

The object of the game is to take cards that bring you close to a total of 21 without going over. Face cards count as 10. Aces count as either 1 or 11.

Each player at a Blackjack table plays only against the dealer—not other players. If a player takes too many cards and goes over 21, he or she loses. If the dealer takes too many cards, the players all win. Otherwise, if your hand is closer to 21 than the dealer's, you win.

You bet your money before you see any cards. In some situations, you can raise your bet after seeing your first two cards. When you win, you're paid 2 to 1. If you get a Blackjack—an ace and any card worth 10—you win a slightly higher multiple of you bet.

The most popular way to play Blackjack is the so-called "perfect strategy." Based on the law of large numbers, which states that averages and tendencies gain strength over time[1], the perfect strategy was derived by computers simulating millions of twenty-one hands. It results in some counter-intuitive rules. Two examples:

[1] The law of large numbers also has several corollaries. The most important is that short-term contexts allow—and even statistically encourage—exceptions to averages and tendencies.

- You have sixteen, the dealer's showing a ten. The chart says hit. You'll lose 75 percent of the time. If you don't hit, you'll lose 77 percent of the time. Twice in one hundred—in a game in which the dealer shouldn't beat you more than fifty-one hands per hundred—is a huge margin.

- You have a pair of aces or 8's, and the dealer's showing a ten. The chart says split—despite the intuitive impulse to keep one bad hand instead of making two.

Played correctly, this system assures you of being at no more than a 2 percent disadvantage against the casino. In practice, the house wins at a rate ten times higher—because few players follow the perfect strategy...perfectly.

For example, the perfect strategy demands that you always split pairs and "double down" (double your wager by placing a second bet next to your original on the table) when you're supposed to. Most players prefer to follow their instincts.

Some players prefer to count cards as they are played at a Blackjack table, adjusting their bets according to how many tens and aces are left to be played in a given hand.

In the more complicated card-counting system:

- 7's and 8's are considered neutral and aren't counted;

- 2 through 6 are counted as a negative 1;

- 9's, 10's, and Aces are counted as 1.

A simpler version counts 9's and 10's in one column, aces in another, and hands played on your fingers.

A high (or minus) deck—with a good half of the deck dealt and a large number of aces still unplayed—favors the player. When the count is high, you should increase you bets.

BETTING WITH YOUR HEART AND WITH YOUR HEAD

Most players prefer to "play the action" and follow their instincts about how and when to wager.

But the key to surviving at a casino is the proper use of progression and regression. This means increasing and decreasing your wagers at a fixed rate. Often, you start with bets twice the table minimum, 2x, follow with x, then work back up to 2x, or higher, as you win. Progressive/regressive betting is the player's only hope of beating the house's odds in the long run. If you bet flat (the same each time), you'll always lose.

Progressive/regressive betting is important in twenty-one, in which an hour of flat betting will make you drift and lose concentration. Unless you hit a real streak (fourteen to seventeen wins out of twenty hands), however, you won't have much chance to up and pull. That comes more often in craps.

Some basic rules of thumb:

- Predetermine a goal for winnings, pocket a sizable fraction once achieved, then play with the remainder, more or less aggressively, depending on your nature and intuition.

- Play only at tables you can afford. You should be able to cover at least twenty-five to thirty bets, so don't sit at a $5 table with less than $125. This is your only protection against inevitable cold streaks.

- Never let your winnings ride. If you win the first hand, then lose the second, you have nothing but a loss to show for having played even against the house.

Considerable work has been done on the efficiency of the horse race betting and sports betting markets.

While you can earn above-average returns by following certain betting strategies, don't expect positive returns. The house's edge collected from these bets—in the form of fixed percentages of the total amount wagered—is steep.

According to a detailed study performed in the late 1980s, players tend to over-bet longshots and under-bet favorites. Again, this reflects the triumph of hope over experience that gambling requires.

CONCLUSION

One economist said, exaggerating somewhat, that the difference between playing a Lotto game and not playing was a statistical insignificance. This isn't literally possible because there's no chance that a player could win a Lotto without playing by accident. But, in a more general sense, the statement does have some truth because it's virtually certain that a player who wins does so by accident.

This is why most Lotto ad campaigns emphasize the fact you've got to pay to win. The odds—and the expected value of playing—go down from there.

But lotteries and other forms of gambling do offer a pure sample of how ordinary people calculate risk in their lives.

The expected value people assign to a lottery ticket reflects the expected value they assign to other expenditures in their lives—savings, investments, education, dwelling, entertainment. It's this expected value which determines how most people react in the face of unknown outcomes.

Even if they don't realize they're doing it, people calculate expected values. The problem is that, if they don't understand the process, people tend to be undisciplined about the calculation. They'll let short-term gratification, superstition or personal biases cloud their thinking.

In the short term, this kind of behavior can turn odds in your favor. In the long term—over a lifetime—it turns the odds against you.

The law of large numbers denies streaks of winning and losing that balance each other out. The best way to think of a streak is as a corrective measure that brings you closer to the house odds. Just

because you lost the last 10 bets doesn't mean you're due to win the next 10.

We're all subject to the law of large numbers.

CONCLUSION: The politics of risk

con_{clusion}

The politics of risk

Understanding how risk affects your everyday life requires two things: the tools of risk assessment and access to reliable information. Throughout this book, we've considered how both of these elements influence the decisions people make.

As a steady parade of dangers, risks and schemes marches past, the tools of risk management seem fairly straightforward. Getting to the reliable information emerges as the bigger challenge.

We're surrounded by natural toxins; there are natural pesticides in the food we eat that are some 10,000 times more abundant than what we ingest from chemical sources. We're exposed to natural radioactivity in rocks and in the soil. Even the cleanest air contains microscopic poisons.

Medical researchers have begun to realize that the processes of aging and of cancer are related and that cancers are ultimately caused by damage to cell material from the oxidants created in our cells by natural metabolism. We increase cancer risk just by living a long life.

Nevertheless, the futile hunt for zero risk continues to influence the societal debate over how government should govern, companies should do business and people should live.

The challenge for you, as a smart person in a transient world, is to see through the confusion to the important risks you face.

A good example: In 1976, environmental activist Samuel Epstein told a congressional panel that 20 percent of Americans were dying in "an epidemic of cancer" and that 70 percent to 90 percent of human cancers were environmentally induced. This sort of testimony garners headlines and votes on Capitol Hill. Never mind that his analysis was based entirely on hypothetical "risk models" that extrapolated large estimates of deaths from small pieces of evidence.

As those risk estimates accumulated, they began to predict far more cancer than the nation was actually experiencing. This prompted Congress' Office of Technology Assessment to commission a study by Sir Richard Doll and Richard Peto, two world-renowned epidemiologists at Oxford. In 1981 they concluded that pollution accounted for only 2 percent of cancers, not the 70 percent and more that Epstein found. By contrast, smoking, diet and other lifestyle choices accounted for 75 percent.

In 1986 the National Cancer Institute confirmed much of what Doll and Peto reported. The NCI said the best way to cut U.S. cancer levels in half by the year 2000 was to focus primarily on smoking, diet and sexual behavior.

Another thing we have to do is find some way to adjust our notions of risk to match our ability to detect minuscule dangers—the technical intensity that seems like the unexpected price of progress.

"Fifteen years ago we couldn't even detect 35 parts per billion," says National Center for Toxicological Research Director Ronald Hart. "Now we identify one part per quintillion. That's almost the equivalent of filling the entire Great Lakes with gin and putting a single tablespoon of vermouth in it. That would be a pretty dry martini."

Hart says that Americans are busy tripping over dollars to pick up pennies:

For example, we know that diet accounts for about 35 percent of all cancer deaths, or about 178,000 a year—and maybe a lot more.

Yet the federal government now spends less than $50 million a year on nutrition research, or about $280 per nutritionally caused death. Do we really want to say that the person who dies of cancer from bad nutritional habits is worth less than $1,000, while the person who dies of air pollution is worth $30 million or more?

The problem is that deaths from things like bad diet rarely make the local news, while any cancer scare—no matter how twisted and inflated—seems to lead the broadcast.

And, as we've seen throughout this book, it's not hard to inflate the numbers.

A billboard campaign popular in the late 1980s announced "Radon will kill 20,000 Americans this year." This radon risk was extrapolated from studies of the occupational exposures of 375 uranium miners who died of lung cancer-exposures that are as much as 12,000 times the level found on average even in the nation's "hottest" 0.2 percent of homes. That's the worst 2 of every 1,000 homes.

A statistical analysis of 415 U.S. counties turned up no correlation between radon levels and lung cancer rates. A leading epidemiologist, Yale University's Jan Stolwijk, sums up the situation: "Epidemiological studies suggest that without smoking radon is an unimaginably small public health risk."

LAWS AND STANDARDS DON'T HELP

Federal laws and regulatory standards condition people to think uselessly about risk. A good example: the Delaney Clause of the Food and Drug Act, which enforces a zero-tolerance standard for carcinogens in food and pharmaceuticals.

The Delaney Clause, enacted in 1958, reflected a national commitment during the Eisenhower administration to rid society of cancer.

Sin in haste, repent at leisure.

The Delaney Clause has inspired other legislation, including Superfund, the Clean Air Act and extreme standards for drinking

water. And it continues to have an effect. As the result of a 1993 consent decree, the EPA committed to implementing the Delaney Clause for specific pesticides, pursuant to a specific timetable, eliminating their presence in processed foods and, where necessary, in the relevant raw commodities as well.

Under the settlement, certain pesticides found by EPA to induce cancer in man or animal and that are present in processed foods (either through "concentration" when raw commodities are processed or from post-harvest application) would be phased out of use.

If Americans applied the Delaney Clause strictly to all food, we would never get to die of cancer. We'd all starve to death.

In the late-1980s, Agriculture Secretary Clayton Yeutter announced a plan to reform the Delaney Clause and begin weighing risks against benefits. In response, Natural Resources Defense Council lawyer Janet Hathaway said, "Allowing EPA to consider the continued use of a chemical whenever the benefits outweigh the risks is absolutely anathema to the environmental community."

In a more reasoned tone, Vernon Houk, director of environmental health at the Centers for Disease Control, says:

> The effect of EPA's exaggerated risk models is very often to force massive expenditures of money on minuscule risks. When we push risk [thresholds] to 1 in a million, we are talking scientific—not to mention economic—nonsense. Do you know what 1 in a million really is? It's the risk you take in driving your car 40 miles; taking a commercial jetliner 2,500 miles; canoeing for six minutes.

These disputes may seem like trivial matters, best left to the petty debates between bureaucrats and political activists. But that's not entirely true. Notions of risk have an impact on people's actions.

As University of Georgia economist Chung Huang has pointed out:

...people respond to the hazards they perceive. But perceived risk isn't always related to the probability of injury or illness calculated on an actuarial basis.

Computer models usually fare poorly when trying to explain and predict consumer behavior. One reason: They fail to consider the psychological, sociological, and other noneconomic factors that guide consumer behavior.

GOVERNMENT REGULATIONS AND THE ROAD TO HELL

In a 1992 monograph on regulatory costs, economist Thomas Hopkins concluded:

> The Lord's Prayer is 66 words, the Gettysburg Address is 286 words, there are 1,322 words in the Declaration of Independence, but government regulations on the sale of cabbage total 26,911 words.

The scientific quality of the risk analyses produced by federal agencies is uneven. In fact, some federal agencies, such as the Environmental Protection Agency, conduct risk analyses in a very peculiar manner. They appear stubborn about maintaining various "default assumptions" —a euphemism for biases—and consequently do not make good use of new scientific information.

Environmental consultant Kathryn Kelly has reported in the newsletter *EPA Watch* that the government's 1 in a million standard for cancer risk was created by the FDA in the 1970s to regulate animal drug residues. Now it's employed for everything from hazardous waste sites to pesticides—even though scientists have generally concluded that risks of less than one in a thousand can't even be quantified.

When scientific information about risk is uncertain, some agencies use worst-case estimates without providing any realistic indication of what the actual risk is likely to be.

A 1994 study by the Harvard Center for Risk Analysis points out that billions are wasted dealing with "slight and speculative dangers" to public health and the environment while larger problems are ignored.

A similar conclusion was reached by the EPA's Science Advisory Board, which observed that agency resources tend to be directed to problems "perceived" to be the most serious rather than those that actually pose the greatest threat.

In December 1994, the Department of Energy released a report titled *Choices in Risk Assessment*, prepared by a nonprofit research group. The report made some strong statements:

> Most environmental risks are so small or indistinguishable that their existence cannot be proven.

> [Scientific policy, a key aspect of government rule-making is] inherently biased and can be designed to achieve predetermined regulatory outcomes.

> Policymakers, the media and the public are unaware of the role of science policy because of a lack of full and fair disclosure.

Another common regulatory flaw: Effects observed from megadoses of a substance ingested by animals are sometimes considered typical of normal human exposure. Using this kind of linear extrapolation, the government banned Alar because it found cancers in mice that ingested the equivalent of 80,000 bottles of apple juice a day for a lifetime.

Extrapolation is a shaky basis for making risk decisions. It ignores the fact that there are thresholds for chemicals, radiation and risk factors, below which there are no known adverse effects.

Steven Milloy of the Regulatory Impact Analysis Project, which drafted the DOE Report, complains that government agencies "are chasing risks that are completely hypothetical and formalizing a process that is the equivalent of the Salem witch trials. If you tie a

brick to a witch and she sinks, she's a witch. If you tie human risks to animal risks, it's a foregone conclusion that you'll predict cancer."

HOW ONE HARD DECISION WAS MADE

The harsh reality of risk and public safety found a clear illustration in the 1994 legal settlement between the federal government and General Motors Corp.

GM's 1973-1987 full-sized pickups equipped with "side-saddle" gasoline tanks, critics allege, are susceptible to fire when struck in the side during an accident.

There is compelling evidence to support that contention: Approximately 150 people have died as a result of side-impact fires in these vehicles—accidents that were otherwise survivable.

In October 1994, Transportation Secretary Federico Pena accused GM of knowingly producing millions of these defective trucks and choosing not to alter the design of the pickups for at least 15 years—based upon cold calculations of fatalities, lawsuits and sales.

Yet, with the same cold calculations, Pena announced a few weeks later that he was dropping efforts to force GM to recall the vehicles in exchange for a $51.3 million GM contribution to support safety programs unrelated to the vehicles.

Pena said that while the government has calculated that 32 people would die in fires resulting from that flawed design before the GM vehicles are removed from the road, even more lives would be saved through the GM-sponsored safety programs—such as buying child safety seats for poor families ($8 million) and public education programs aimed at enacting tougher seat-belt and anti-drunk-driving regulations in states ($12 million).

He argued that more lives would be saved through the safety programs financed in part by GM. For example, the government said one program, to buy child safety seats for poor families, would save at least 50 lives and prevent 6,000 injuries.

Part of Pena's harsh calculus was the possibility that he would lose in court. GM had a strong case in defense of its vehicle, including a report by a DOT Deputy Inspector General that the staff of the National Highway Traffic Safety Administration had told Pena the case against GM was unwinnable because the vehicles did not pose "an unreasonable risk" to public safety.

The federal standard that applied to the trucks—which GM met—required only that the vehicles withstand a side impact without leaking fuel at 20 miles an hour. Most of the fatal side-impact collisions occurred at speeds in excess of 50 miles an hour.

Department of Transportation officials insisted the settlement was unique and would not be a precedent for future safety cases.

"This was not a model," said Stephen Kaplan, the general counsel for the department. "It's the secretary's view, and it's the legal staff's view that there should be no precedent here."

This weak attempt to separate the risk reality from the legal posturing calls to mind something National Center for Toxicological Research Director Ronald Hart said about societal problems with risk assessment:

> There's a fundamental incompatibility between writing law and doing science. Blackstonian law deals in absolutes and in definitions. But science is an evolving beast, constantly changing as new knowledge is acquired. Unless you make laws compatible with science, a technology-based society is doomed.

HOW TO SOLVE RISK MYOPIA

In the wake of the November 1994 federal elections that shifted power from the Democratic party to the Republican party, the U.S. Congress considered several regulatory reform bills that called for risk assessment and cost/benefit comparisons between perceived risks and the money that would be required to abate them.

Some of these bills required the establishment of comparative risk

guidelines contrasting particular environmental risks with, for example, an individual's chances of being involved in a car accident or being struck by lightning.

But sound risk assessment isn't just a cost/benefit issue that can be debated by egocentric political partisans and petty bureaucratic clerks. It's a disciplined approach to prioritizing the actions we take—as individuals and a society—in a world of unknowns.

Of course, the scientific function of assessment needs to be separated from the regulatory function of risk management. Risk management—which involves assumptions about degree and length of exposure, decisions on safety factors, and the setting of standards—is a detailed, clinical process.

In the case of government regulations, it might be most useful to separate risk management and assessment institutionally—housing them in different government departments.

Economist Robert Hahn has pointed out that federal agencies will issue regulations at any cost, as long as there are any benefits.

That is why we have such rules as the one on formaldehyde exposure, which costs an estimated $80 million for each life saved. Far more lives could be saved at a fraction of the cost by, for example, inoculations against measles, mumps and rubella for children, increased screening for cancer and larger campaigns to discourage smoking.

In February 1995 congressional testimony, Harvard University professor and risk expert John Graham detailed some of the problems governments have identifying and dealing with risk:

> ...The basic problem is that Congress has never embraced the fundamental principle that all regulatory decisions should be influenced by a consideration of risk, benefit, and cost.

> ...Remarkably little analysis is devoted to identifying and quantifying the risks caused by federal regulation. The "target risks"

discussed in the media often become a preoccupation of federal agencies while the "countervailing risks" induced by regulation are ignored altogether.

...Strengthening the role of risk analysis is a threat to traditional power centers in Washington, D.C., that have controlled the agendas of regulatory agencies.

When those opposed to regulatory reform ask, "Who can put a dollar value on a human life?" they obscure the issue. The point here is not whether a human life should be valued at $80 million or some other figure. The issue is whether agencies are writing regulations that protect the most lives and produce the greatest incremental benefits from the resources consumed for these purposes.

In March 1995 testimony, professor Peter Strauss of Columbia Law School (and a former head of the Nuclear Regulatory Commission) gave Congress some advice for encouraging regulatory agencies in the direction of effective risk assessment:

...The recommendation is that you use the discipline of cost-benefit analysis as best you can in considering this legislation itself— that is, that you pay attention to possible unintended consequences, to regulatory overlaps, to less costly alternatives including approaches that rely on managerial standards and incentives rather than command and control approaches.

AN OPTIMIST'S FINAL WORD

There's hope for effective notions of risk in society.

In 1992, the University of Kentucky conducted a national survey of consumers' major food-safety concerns and the actions they take to reduce food-safety risks in fresh produce. The survey also sought to find if food shoppers would pay more money to reduce their risks from pesticide residues, and if the amount they will pay would correspond to the level of risk reduction.

The top three concerns consumers mentioned were fats and cholesterol (33.7 percent of respondents), bacterial food poisoning such as salmonella and botulism (30.0 percent), and pesticide residues on food (18.4 percent).

While previous consumer surveys had ranked pesticides as the top food-safety concern, the rankings in the Kentucky survey reflected current scientific evidence—indicating that pesticides pose a lower risk to consumers than does microbial contamination.

The Kentucky study suggests that smart consumers are open to the truth about health factors in the food they eat. What people need is the tools to sort out the good information from the bad, the real risk from bogus ones. And they need the perspective to apply these tools in a steady manner.

Those tools and that perspective is what this book has been about. The challenge remains for you, as a smart decision-maker, to put them to use.

bibliography

Doing the research for a book like this takes a lot of time and input from many sources. Periodicals—and some books—are cited throughout the various chapters. On a more general level, these are some books that have proved useful in making *True Odds*.

Jad Adams, *AIDS: The HIV Myth*. St. Martin's Press, 1989.

Back Belts: Do They Prevent Injury? National Institute for Occupational Safety and Health, 1994.

Bob Berger, *Beating Murphy's Law: The Amazing Science of Risk*. Delta Books, 1994.

Mark Blaug (ed.), *Frank Knight, Henry Simons and Joseph Schumpeter*. Ashgate Publishing Co., 1992.

Stephen Breyer, *Breaking the Vicious Circle: Toward Effective Risk of Regulation*. Harvard University Press, 1993.

Ronald K. Brown, *AIDS, Cancer & the Medical Establishment*. Speller Publishing, 1986.

M.G. Bulmer, *Princples of Statistics*. Dover Publications, 1979.

James Burke, *What Are the Chances?: Risks & Odds in Everyday Life.* Citadel Press, 1992.

Charles Caulfield and Billi Goldberg, *The Anarchist AIDS Medical Formulary: A Guide to Guerrilla Immunology.* North Atlantic Press, 1994.

Ronald Coase, *The Problem of Social Cost.* 1960.

Don Dennis, *Breaking Crime's Vicious Cycle.* Broadman Publishing, 1993.

A.K. Dewdney, *200% of Nothing.* John Wiley & Sons, 1993.

Avinash Dixit and Barry Nalebuff, *Thinking Strategically.* W.W. Norton, 1991.

Ronald Doerfler, *Dead Reckoning: Calculating without Instruments.* Gulf Publishing Co., 1993.

Charles Handy, *The Age of Unreason.* Harvard Business School Press, 1990.

Steve Heims, *John Von Neumann and Norbert Wiener: From Mathematics to the Technologies of Life & Death.* MIT Press, 1980.

Robin Hogarth and Melvin Reder (eds.), *Between Economics and Psychology.* University of Chicago Press, 1987.

Mary Kemeny and Paula Dranov, *Beating the Odds Against Breast & Ovarian Cancer.* Addison-Wesley Publishing, 1992.

Frank Knight, *Risk, Uncertainty, and Profit.* Houghton Mifflin, 1921.

Les Krantz, *What the Odds Are: A to Z on Everything You Hoped or Feared Would Happen.* HarperCollins, 1992.

Mary Levenstein, *Everyday Cancer Risks & How to Avoid Them.* Avery Publishing, 1992.

Edward MacNeal, *Mathsemantics: Making Numbers Talk Sense*. Penguin Books, 1994.

Justin Mamis, *The Nature of Risk*. Addison Wesley Publishing, 1991.

John T. Marlin, *The Livable Cities Almanac*. HarperCollins, 1992.

Steven Medema (ed.), *The Legacy of Ronald Coase in Economic Analysis*. Ashgate Publishing Co., 1995

M. Orkin, *Can You Win?* W.H. Freeman, 1995.

Clinton Oster, John Strong and Kurt Zorn, *Why Airplanes Crash: Aviation Safety in a Changing World*. OUP, 1992.

John Allen Paulos, *A Mathematician Reads the Newspaper*. Basic Books, 1995.

John L. Phillips, *How to Think about Statistics*. W.H. Freeman, 1995.

William Poundstone, *Prisoner's Dilemma: John von Neumann, Game Theory, & the Puzzle of the Bomb*. Doubleday/Anchor Books, 1993.

Derek Rowntree, *Probability Without Tears*. Charles Scribner's Sons, 1984.

Bernard Siskin, Jerome Staller and David Rorvik, *What Are the Chances?: Risks, Odds, & Likelihood in Everyday Life*. Signet Books, 1993.

George Stigler, *Memoirs of an Unregulated Economist*. Basic Books, 1988.

Daniel Tarantola, *AIDS in the World*. Harvard University Press, 1987.

John Urquhart and Klaus Heilmann, *Risk Watch: The Odds of Life*. Books on Demand, 1984.

John von Neumann and Oskar Morgenstern, *The Theory of Games and Economic Behavior.* 1944.

Oliver Williamson, *The Economic Institutions of Capitalism.* Free Press, 1985.

index